Jewish Art and Culture

Edward van Voolen

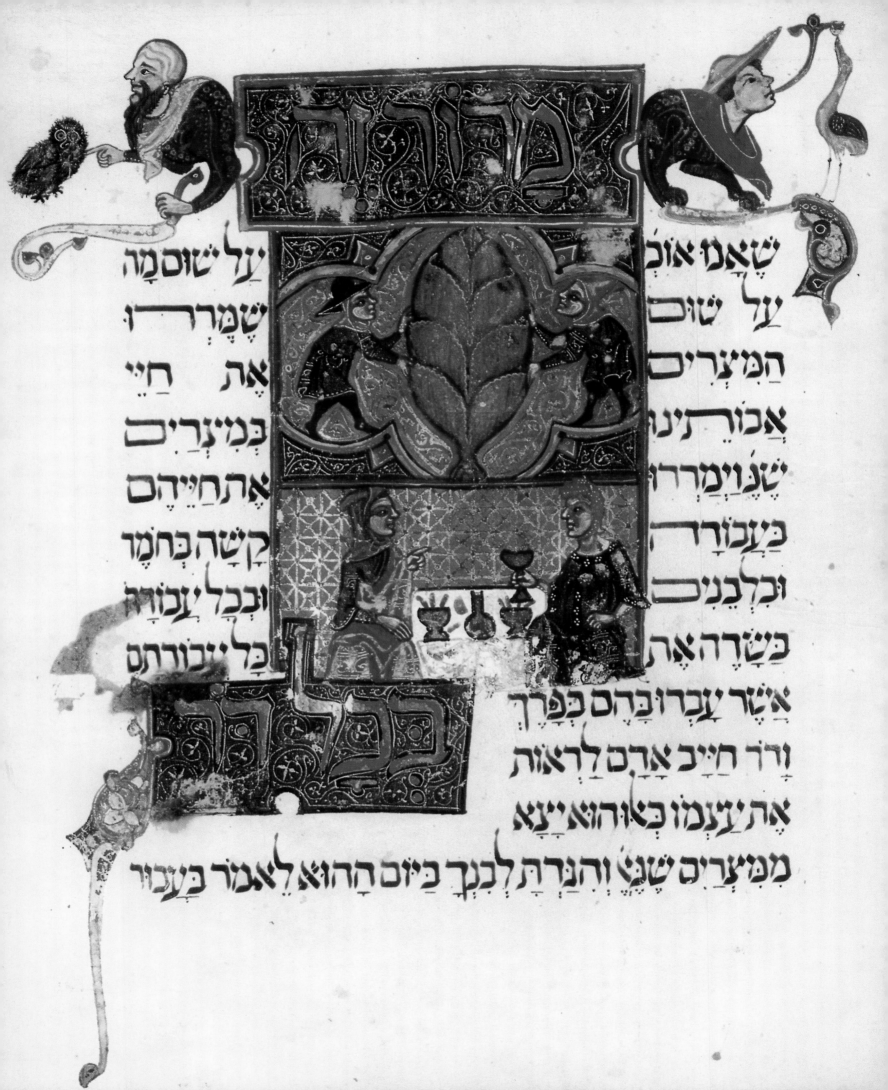

מרורה

על שום מה שֶׁאָמ אוֹ

שֶׁמָּרָרוּ עַל שׁוֹ

אֶת חֵיֵי הַמִּצְרִים

בְּמִצְרָיִם אֲמָרְתִּינָ

אֶת חֵייהֶם שֶׁנֶּאֱמְרוּ

קָשָׁה בְּחֹמֶר כְּעֹבֹרָה

וּבְכֹל עֲבוֹרָה וּכְלְבְנִים

כָּל עֲבוֹרָתָם כְּשָׂרֶה אֶת

אֲשֶׁר עָבְרוּ בָהֶם בְּפָרֶךְ

וַרֹד חַיָּב אָרָם לִרְאוֹת

אֶת עַצְמוֹ כְּאִלּוּ הוּא יָצָא

מִמִּצְרַים שֶׁנֶּ' וְהִגַּרְתָּ לְבִנְךָ בַּיּוֹם הַהוּא לֵאמֹר בַּעֲבוּר

Jewish Art and Culture

Edward van Voolen

Prestel

Munich · Berlin · London · New York

Contents

The Image of Judaism

Jewish Emancipation and Jewish Art

Holocaust and its Remembrance

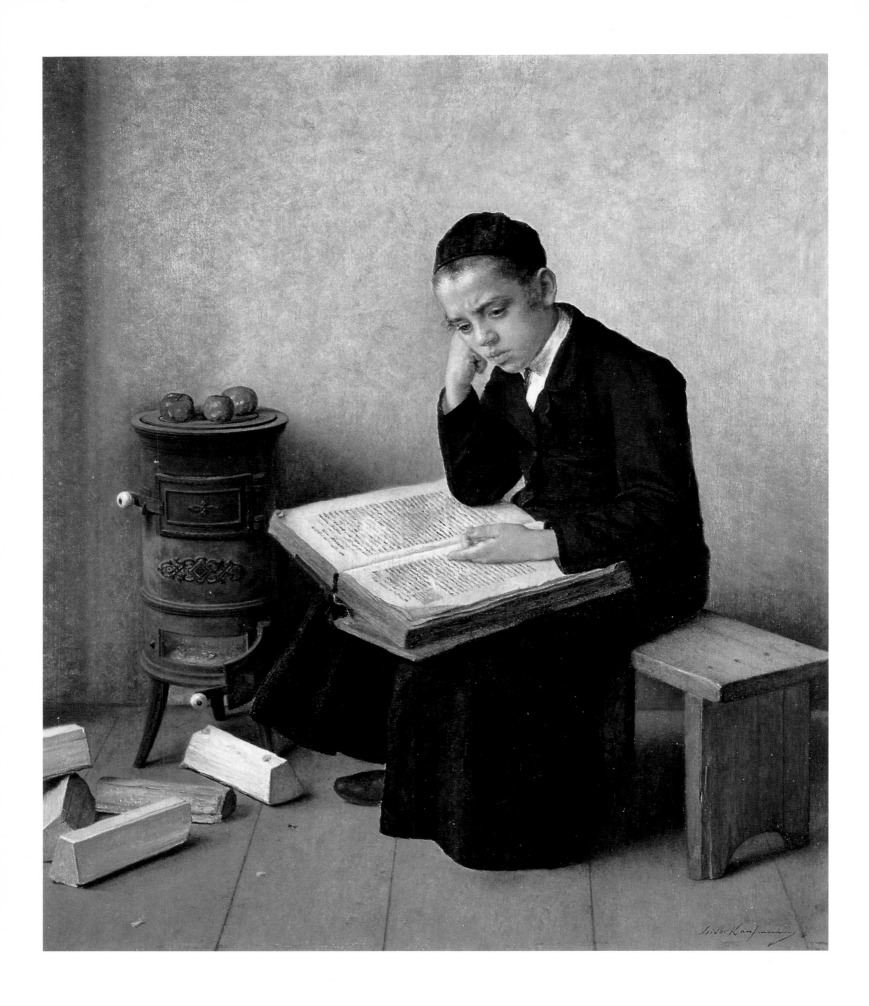

Jewish Art and Jewish People between Israel and Diaspora

Edward van Voolen

What is Judaism?

When discussing Jewish art and culture, the first question is obvious: what is Judaism? Judaism is the religion and culture of a people alternately known as Jews, Hebrews, or Israelites. The term "Hebrews" refers to the Biblical patriarchs who lived some thirty-three centuries ago: Abraham—who wandered from Mesopotamia (present-day Iraq) to Canaan, Isaac, and Jacob. After wrestling with an angel and prevailing, Jacob was renamed Israel ("he wrestled with God"), and his twelve descendants are called the children of Israel or Israelites. Famine in Canaan forced them to seek refuge in Egypt. One of Jacob's sons, Joseph, initially found favor with the pharaoh and rose to viceroy, but the succeeding generation was enslaved and threatened with extinction. In about 1250 BCE, Moses led their Exodus from Egypt and, after four decades wandering through the desert of Sinai, the Israelites, at the time divided into twelve tribes, returned to Canaan, the Promised Land. Around 1000 BCE, King David united the tribes with Jerusalem as the capital. After the death of his son Solomon, ten tribes seceded to form the kingdom of Israel in the northern part of what is modern-day Israel; its capital fell in 722 BCE to the Assyrians and the ten tribes were deported, disappearing forever.

The tribe Judah gave its name to the southern kingdom with Jerusalem as its capital, and later, in the Greco-Roman period, to the province Judea. The word "Jew" is derived from the Judeans, inhabitants of the kingdom Judah (in Hebrew, *yehudim*; singular, *yehudi*), their descendants, and all those who joined them in the course of time. This explains why Judaism is not a race, and that Jews, physically, do not differ much from the people in whose midst they live, as you will find white and black, blond and dark-haired Jews. In 586 BCE, the southern kingdom also fell; Nebuchadnezzar destroyed Jerusalem and its Temple and deported part of the Jewish people in what became known as the Babylonian Exile. But his empire in turn fell victim to the Persians, whose king Cyrus allowed the Judeans to return home in 533 BCE and rebuild the Temple. Some decided however to remain behind and the dispersion of the Jews—the Diaspora—from then on was a fact of Jewish life.

Even today, after the foundation of the State of Israel in 1948, the majority of Jews still lives in the Diaspora, where, in fact, most of Jewish history has been written. Exile is as much an essential experience of the Jewish people as the memory of the land of Israel, "If I forget you, Jerusalem, may my right hand wither; let my tongue stick to my palate if I cease to think of you, if I do not keep Jerusalem in memory even at my happiest hours" (Ps. 137:1–5), as the psalmist sung by the rivers of Babylon when the first Jewish exiles sat and wept while thinking of Zion. Currently Jews are spread over the whole world: about fifteen million in total, of which almost six million live in the United States, about five million in Israel, over 700,000 in Russia, about 600,000 in France, 400,000 each in Canada and Argentina, 300,000 in the United Kingdom, 140,000 in the Ukraine, 107,000 in Germany, and smaller numbers in other countries.

In the nineteenth century, "Israelite" became the usual term for a Jewish person, as the term "Jew" had, over time, taken on a negative connotation. Currently Israelite is used as a technical term in the synagogue for a Jewish man who is not a descendant of a biblical priest (*kohen*) or his servant, a Levite. The name chosen for the Jewish state was Israel (rather than Judah), and since its foundation in 1948, all inhabitants of that country are called Israelis irrespective of their religion—Jews and non-Jews alike.

A Jew may also be called a "Hebrew," but this term is no longer commonplace. Rather, Hebrew is the term for the language and literature of the Jews. *Ivrit* (Hebrew), the language of the Bible, is over three thousand years old and belongs to a family of languages classified as Semitic, after the sons of the biblical Shem, the son of Noah. To this family of languages also belongs contemporary Arabic and Aramaic, a language still spoken by Christians and Jews in the Near East.

Hebrew is an alphabetic script with twenty-two consonants, originally similar in appearance to cuneiform and adopted from the Phoenicians in the twelfth century BCE. The characteristic square shape of the letters

Judaism stresses learning. Isidor Kaufmann gives an idyllic picture of an East European boy in *A Difficult Passage in the Talmud*, ca. 1900

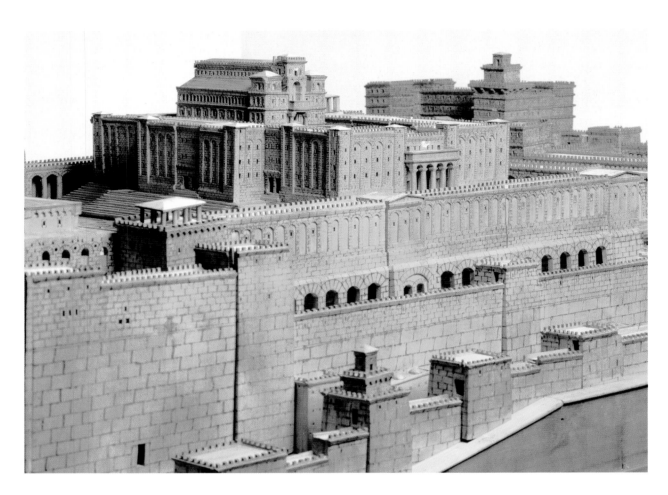

Model of the Second
Temple in Jerusalem.
Germany, ca. 1920

goes back to a more simplified script used for Aramaic in the fifth century BCE, then the lingua franca of the ancient Near East. Each consonant has a numerical value, and since the early Middle Ages, vowels have been added. The discovery of the Dead Sea Scrolls in Qumran in 1947, along with the earliest rabbinic texts of the second century CE, illustrate the development of biblical Hebrew as a spoken language until the revolt against the Romans in 66–70 CE. At least up until that time Hebrew was spoken and written, and later served as the second language for religious and literary use next to the vernacular Jewish languages like Yiddish (medieval German with Hebrew words) and Ladino ("Jewish Spanish"), both written in Hebrew characters. When Jews in the late nineteenth century immigrated to Ottoman Palestine and needed a common language, Hebrew was modernized and revived as a vernacular language and, since 1948, is the official language of Israel.

So, what *is* Judaism? If it refers to anything Jews have ever created and done over the past thirty-three centuries in innumerable places, then at least it is clear that no monolithic Judaism ever existed, but rather many different ones—the Judaism of the patriarchs differed from that of Moses, and, later, that of the prophets. Biblical Judaism differs from that of the Pharisees, the sects of Qumran, and the early Christians. Medieval rabbinic Judaism was divided on many practical and philosophical issues, and modernity created a plethora of movements in Judaism—religious, political, and cultural. It should therefore be obvious that many Judaisms existed and still exist next to and often in conflict with one other. What unites them is a common text, the Hebrew Bible, however differently interpreted by various groups over the centuries, a shared origin and historical memory, transmitted over the centuries at home and in synagogues (houses of meeting, prayer, and study), a common way of life primarily focused on the here and now, and finally, a future perspective about justice and peace at the end of times.

From the earliest biblical times until the present day, the question, "Who is a Jew?" has been hotly debated. Officially, anyone is considered Jewish that matrilineally traces their ancestry back to the patriarchs and matriarchs, those who stood at the foot of Mount Sinai to receive the constitutive text and who transmitted its values while adapting to changing circumstance and environment. It includes everybody who upheld these values and accepted these challenges; and indeed, from biblical times to the present day, proselytes joined born Jews and integrated into the Jewish people. Examples of proselytes abound, but most striking are those of the wife of Moses and the Moabite Ruth, the ancestor of King David, and according to tradition from whose house the

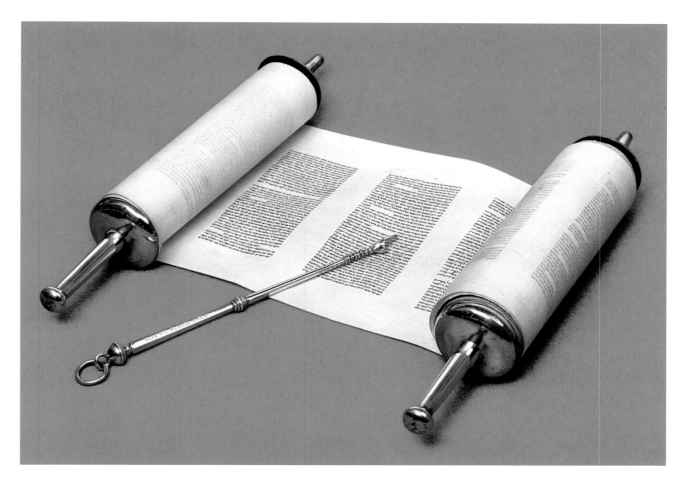

redeemer of all mankind will arise. But who determines who is a Jew? The rabbis, but here a problem presents itself—the rules and regulations of Jewish law can be and are interpreted in a wide variety of ways by Orthodox, Conservative, and Reform religious authorities, and since a secular admission to Judaism does not exist, even the most sincere conversion candidates are often intimidated by conflicting interpretations.

The purpose of this book is to give a glimpse of what Judaism has meant and still means to creative people over the ages, and how individual artists convey their own Jewish identity in much the same way as had Rabbi Hillel, a Jewish scholar in first-century Roman Palestine. One day a gentile approached Rabbi Hillel and asked him, "Tell me the essence of Judaism while you are standing on one foot," and Hillel answered, "What is hateful to you, do not do to your fellow human being." He continued, "That is the essence. All the rest is commentary. Go and learn." (*Babylonian Talmud*, Tractate Shabbat, Folio 31a). Asking questions and proposing a range of answers creates the lively debate that has characterized Jewish culture over the centuries.

Jewish History in Biblical Times

To explore Jewish history and culture one must start at the beginning, with the core text of Judaism (and of Christianity), the Bible—called *Tanakh* in Hebrew after its three constituent parts: *Torah* (Teaching or Law, its five books also called *Pentateuch*), *Nevi'im* (Prophets) and *Ketuvim* (Writings, the other books), and roughly equivalent to what Christians call the Old Testament. The biblical drama begins with the expulsion of Adam and Eve from Paradise. From Abraham onward (who was himself born in Ur, Mesopotamia), Jewish history moves between the Diaspora and the Land of Israel with all its heroes continually wandering between various places in the ancient Near East—between Mesopotamia, Canaan, and Egypt. Equally, the *Pentateuch's* core events take place outside the land of Israel: the Exodus starts in Egypt, and the giving of the *Torah*—the constitution—takes place during the wanderings through the Sinai desert. In the desert, the Jews had their first movable cultic space, the Tabernacle, a sort of tent. After the twelve tribes gradually conquered most parts of the Promised Land, King David united them in approximately 1000 BCE and established Jerusalem as their political capital; later, his son Solomon founded the Temple there as the religious center. After Solomon's death, ten tribes seceded to form the Kingdom of Israel in the northern part of the current geographic area of that name. In 722 BCE,

Torah scroll with pointer. The first five books of the Bible contain the earliest history of the Jews, and guiding principles for life. The complete Hebrew text is chanted in synagogue over the course of the Jewish calendar year. The Netherlands, 18th century

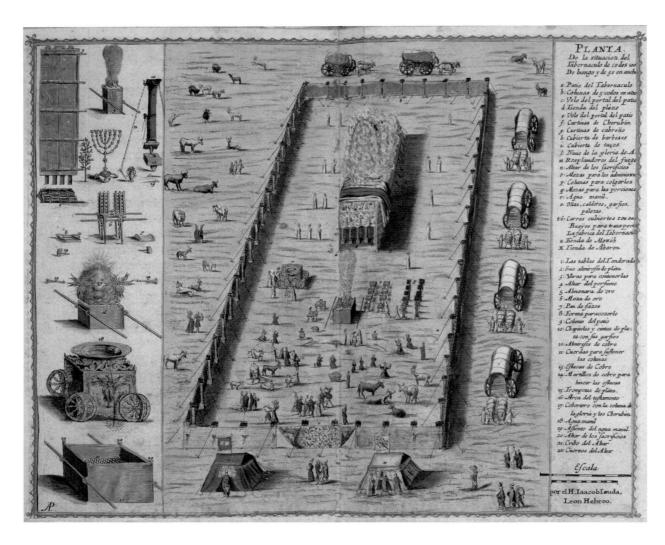

PLANTA.
Do la situacion del
Tabernaculo de codes co
De luengo y de 50 en ancho.

The Tabernacle, the travel-
ing sanctuary of the Jews
during their wanderings
from the Sinai desert to the
Promised Land. Engraving
by Jacob Judah Leon, The
Netherlands, ca. 1660

Right: The Arch of Titus in
Rome (81 CE) commemo-
rates the Roman conquest
of Jerusalem in 70 CE. The
relief in the interior depicts
the spoils from the temple,
amongst which includes
the seven-branched Meno-
rah.

when its capital Samaria fell to the Assyrians, the ten tribes were deported by their conquerors and seemingly disappeared, the so-called Lost Tribes of Israel. Jews dwelled in the southern kingdom from roughly 1000 BCE until 70 CE, only briefly interrupted by the Babylonian Exile in the sixth century BCE, which marked the beginning of settlements outside the land of Israel.

By the time Alexander the Great (336–323 BCE) finished conquering much of the ancient world—from Greece and Egypt to as far as Persia—important Jewish settlements existed everywhere in his vast empire and the Jewish Diaspora became a fact of life. Jews became familiar with the Hellenistic culture and the Greek language; institutions like the synagogue are of Greek origin, Greek words entered the Hebrew language, names became Hellenized, and the Bible was translated into Greek. For the Jewish people, the challenge lay in the transformation of an agricultural society, previously concentrated around Jerusalem, into dispersed societies of city dwellers living too far from the cultic center to offer sacrifices on a regular basis.

Rabbinic Judaism

The destruction of the Second Temple in the year 70 CE by the Roman emperor Titus marked the first decisive transition in Judaism—with the central sanctuary defunct, sacrifices could no longer be brought there and the hereditary class of priests was out of work. In response to this challenge, scholarly lay people, called rabbis, took over religious and social leadership, reinterpreting the Bible in synagogues that could be erected In Israel, or wherever Jews dwelled. Central to rabbinic Judaism is the concept of a dual revelation—that oral traditions passed down by generations of rabbis held nearly the same status as the written law revealed to Moses on Mount Sinai. In the face of the destruction, and the growth of the Diaspora, rabbinic Judaism recognized the need not only to definitively define the Biblical canon and to reorganize the calendar, but also to commit the oral law into writing. Thus they created the *Mishnah* (second century CE) and both *Talmuds* (fifth and sixth century CE), one from Jerusalem and the authoritative one from Babylonia. This concept of the "dual *Torah*" was the concrete

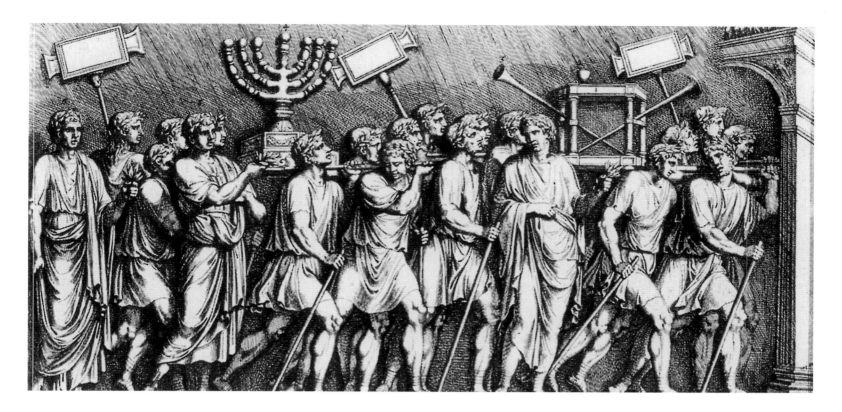

rabbinical answer to Diaspora and destruction, and became an indispensable tool for Jews in coping with new circumstances, whenever in time, and wherever they dwell.

After the Roman conquest of Palestine in 63 BCE, Italy and the eastern Mediterranean region became destinations for Jewish emigration. The Jewish community of Rome, the oldest in Europe, numbered some 40,000 members in the first century; Alexandria, Egypt had three times as many Jewish inhabitants as Jerusalem in its best days—the lowest estimate is 200,000. The abortive Jewish revolts against the Romans in Palestine in 66–73 CE and in 132–135 CE resulted in large numbers of Jewish refugees and slaves; with the expansion of the Roman Empire to Spain, France, and the Rhine valley in Germany, the first instances of a Jewish presence in these areas was documented.

An apothecary's shop in Northern Italy testifies to the interest among Jews for the medical sciences throughout the ages. Northern Italy, ca. 1438–40

Medieval Judaism

Although Jews remained in the land of Israel and preserved Jewish life and culture under Byzantine and later Muslim and Ottoman rule, the focus of Jewish history had shifted to the Diaspora. In the first centuries of the Common Era, both Jews and Christians sought to win over proselytes, a battle won by the latter when Constantine the Great made Christianity, originally a Jewish sect, the Roman Empire's State religion in 313 CE. What started as an internal family battle between Jesus and the rabbis grew into an ideological problem. Church leaders and theologians viewed Judaism with ambivalence—on the one hand, Jews preserved the true text of the "Old" Testament; on the other, they had rejected Jesus and the "good news" of the "New" Testament—and Judaism ultimately came to be seen as superseded by Christianity.

In spite of their physical closeness to Christians, Jews themselves came to be considered outsiders, becoming scapegoats for all the real problems or alleged dangers that threatened the Christian majority. This ambivalence would all too often lead to outright hostility, discrimination and exclusion, expulsion, and

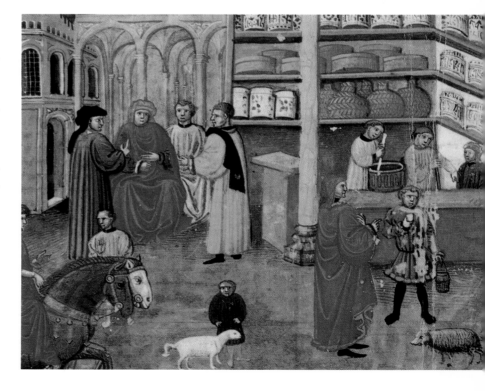

even the murder of Jews. Massacres took place in medieval Christian Spain, in the Rhineland during the Crusades (1096 and 1147) when pious soldiers killed Jews on the way to the Holy Land, and during the Black Death, an epidemic of pestilence that raged throughout Europe (1348–1350). Ultimately, several hundred thousands of Jews would be expelled from England (1290), France (1394), and Spain (1492), whereas in Germanic lands Jews were ghettoized for the first time, in Frankfurt (1462).

Despite this darker side of the Middle Ages, new forms of Judaism developed during this period in Muslim Spain (eighth to tenth century), along the Rhine from the tenth century onward, and in the gradually re-conquered Christian kingdoms of the Iberian peninsula (1085–1492). These traditions are the expressions of a new Jewish culture, the central European variant being called Ashkenazic (Ashkenaz is the medieval rabbinic term for Germany) and the Spanish-Portuguese variant Sephardic (Sepharad is the equivalent for Spain). Ashkenazic Jewry expanded after the Crusades and the Black Death in an eastward direction and became famous for its detailed, verse-by-verse exegesis of biblical and legal texts, whereas Sephardic Jews specialized more in secular poetry, philosophic texts, and legal codes, summarizing the lengthy discussions of the Talmud into practical rules of behavior. Not only do these two traditions differ from each other (despite common features), but they also differ from Judaism in the Islamic parts of Spain and North Africa, and from the Italian rites—forms that maintained contact with the center of oriental Jewry in Baghdad and with the Greek-influenced Romaniot tradition in Asia Minor. The larger Jewish communities in the Christian empires of medieval Europe had an autonomous self-administration, with their own jurisdiction based on Jewish legal codes. Between the fifteenth and eighteenth centuries, the area of Poland and Lithuania became a major Jewish center with a flourishing rabbinic scholarship, counting some 750,000 Jews by 1764. The golden age of Polish Jewry suffered a serious setback, however, when Cossack leader Bogdan Chmielnicki killed some 100,000 Jews in 1648–49.

Jewish life in the pre-modern European Diaspora was diverse and pluralistic—it knew rationalists and mystics, scholars and merchants—though women remained marginalized and the poor anonymous and ignored (except by Jewish charitable organizations).

Jewish Identity

What kept all these different Jews together? Jewish identity was—and partially still is—based on a common memory of the past, a shared sacred language, a joined cycle of festivals and life-cycle celebrations, a similar communal structure, and a shared vision of a future of justice and peace for all humanity. Jewish identity is shaped in the home, where children are taught the basics of Hebrew and Jewish tradition, and in the synagogue.

The Synagogue

For Jews, the synagogue is the "little sanctuary" where people, primarily men, meet for prayer, study, and social gatherings. Usually modest buildings, the earliest examples date back two millennia. Wherever Jews lived securely, synagogue architecture and art prospered. As soon as the Diaspora became a reality—before the destruction of the Second Temple—the synagogue became the primary Jewish institution. As a building, the synagogue is often part of a complex including a school, ritual bath, library, a kosher restaurant, and reception hall—a community center in the modern sense of the word.

Two essential requirements characterize a synagogue. The first is the Ark, the Hebrew name of which, *aron ha-kodesh*, recalls the Ark in the Holy of Holies in the Tabernacle of the desert and the Temple in Jerusalem. This shrine, placed in a niche or cupboard directed toward Jerusalem contains the holiest and most precious object Jews possess, one or more handwritten parchment scrolls with the text of the *Pentateuch* (*Torah*). Each scroll, with the text of the first five books of the Hebrew bible, is carefully dressed in protective textiles and decorative silver. The Ark is the synagogue's sacred space and is traditionally the place where these ritual objects are stored, collected, and carefully preserved.

Equally important in the synagogue is the presence of a platform (*bimah*) from which the *Torah* is read and expounded on. This platform is situated in the middle of the sanctuary, but may also be found towards the rear, or directly in front of the Ark. In pre-modern synagogues and today in traditional synagogues, women sit separately in the back or in a gallery.

The temporality of the synagogue is accentuated by an unfinished piece of wall, a reminder of the destruction of the Temple (*zekher le-hurban*) or, for that matter, any destructive act. The synagogue kept Jewish collec-

tive memory alive long before Jewish museums assumed this function for secularized Jews in the late nineteenth century.

The service consists of prayers and liturgical poetry with, at its center, readings from the *Torah* and other books of the Hebrew Bible (sections from the Prophets and the Writings). It is in the synagogue where the *Torah* is read each week in a yearly cycle, and expounded on by the rabbis who apply its stories and lessons to contemporary Jewish life.

Jewish Art

At first glance, Jewish art seems to be in conflict with what is known as the second of the ten commandments, which states, "You shall not make for yourself a sculptured image, or any likeness of what is in the heavens above, or on the earth below, or in the waters under the earth" (Exod. 20:4 and Deut. 5:8). Literally interpreted, the verse prohibits the possibility of visual arts amongst Jews and, according to some scholars, reflects a Jewish aversion towards images. However, an absolute prohibition against the making of images only concerns the adoration of idols, as it says in the verse immediately following, "You shall not bow down to them or serve them" (Exod. 20:4). But there is no prohibition against making objects in the context of the sacred service. Thus, shortly after the laws were given, God commands Moses to construct a Tabernacle, the details and furnishings of which were exactingly described to him. Since Moses could not read the blueprints, the execution of cherubs— winged animals on top of the Ark of the Covenant, and the seven-branched Menorah—a candelabrum in the form of a tree, was left to Bezalel (his name means

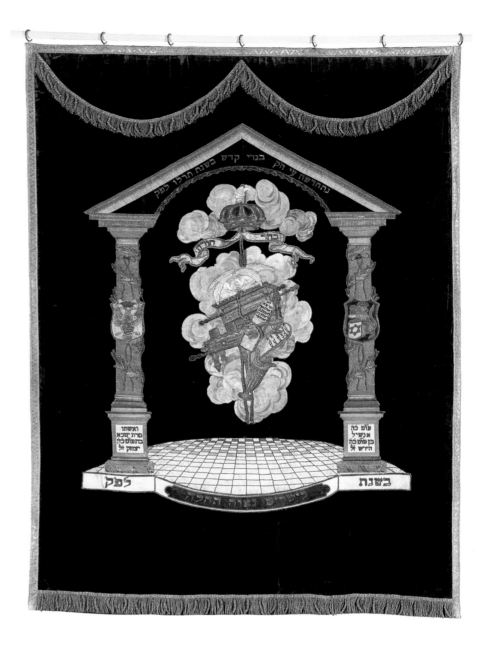

Curtain for Torah Ark with attributes of the Tabernacle and the Temple flanked by two twisted columns— Jachin and Boaz—as in the Temple of Solomon. The Netherlands, 1830, 1876

"in the shadow of God"). This first Jewish artist is described as a man endowed "with a divine spirit of skill, ability, and knowledge in every kind of craft; to make designs in gold, silver, and copper, to cut stones and to carve wood" (Exod. 31:2–5). The Tabernacle and its implements are the first examples of Jewish art and architecture within the parameters of the second commandment—not in the service of idolatry (as is the Golden Calf built in the shadow of Mount Sinai), but the abstract God of Judaism.

A few centuries later, King Solomon invited Hiram, a foreigner from Tyre, to create all the metalwork for his Temple in Jerusalem, including a giant bronze laver (a basin supported by twelve oxen). In this first permanent sanctuary for Jewish worship were to be found such naturalistic forms as lions, flowers, pomegranates, trees, and cherubs (I Kings 7:1–51). In Solomon's own royal palace there was an ivory throne overlaid with fine gold, two lions standing beside the arms, and twelve lions standing on the six steps, six at each side (I Kings 10:18–20).

The battle against all kinds of idolatrous practices pervades the Bible, and lasted till the Hellenistic period; the Maccabees revolted successfully against the placing of Greek gods in the Temple in the second century BCE, giving rise to the festival of Hanukkah. After this event, the fear of idolatry gradually diminished and gave in to a more tolerant interpretation of the second commandment. In the first post-Christian centuries, several stories in the *Mishnah* and the *Talmuds* relate that rabbis permitted works of art, even in the synagogue. These written testimonies coincide with the wall paintings in the synagogue of Dura Europos (third century CE) and mosaics in Israeli synagogues. Medieval rabbis were more concerned with the question of whether the faithful would be distracted by images than by concern for a literal interpretation of the second commandment. Opposition to art

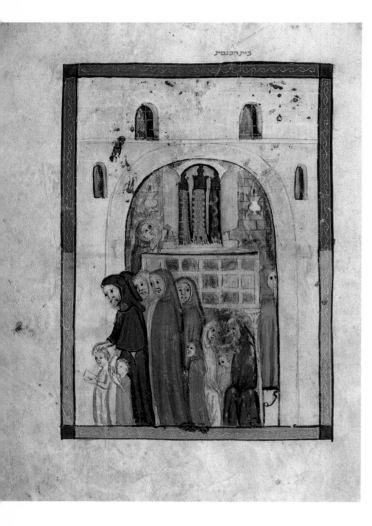

on religious grounds coincides with iconoclasm (in Christian Byzantium or sometimes in Islamic-ruled countries), and with ascetic trends in Judaism amongst the pious in twelfth- and thirteenth-century Germany (*Hasidei Ashkenaz*). However much the pietists expressed in their writings an opposition to aesthetic manifestations in private or public spheres, figurative art did not disappear. On the contrary, most communities and rabbis supported the idea that ceremonies should be performed in a beautiful synagogue with attractive objects, some executed by Jews, others by non-Jews for their Jewish clients.

Liturgical Books and Objects

The Jewish people hold in high regard scripture and books, and above all the holy book, the *Torah*, a scroll of which they could carry wherever they traveled. The emphasis on and love of texts by the "People of the Book" fostered the development of an extensive religious literature, and stimulated the creation of beautiful manuscripts, carefully written and at times illuminated. Preserved manuscripts elucidate the differences between Sephardic and Ashkenazic Judaism, reflecting local aesthetic preferences at a specific moment in time. In accordance with their intrinsic value, these manuscripts were preserved within the community, bequeathed to descendants, and, beginning in the Renaissance period, increasingly attracted the attention of Christian bibliophiles.

Torah scrolls used in synagogue service are never decorated; biblical manuscripts in book form, however, may contain abstract carpet pages, drawings of the Temple, or historiated initial capitals. Other manuscripts include rabbinical writings, such as both versions of the *Talmud*; they are rarely illuminated and, if so, only with an initial page, or with sketches of the Temple. Prayer books for the festivals (*mahzorim*) and for the Sabbath and weekdays (*siddurim*) are equally preserved in manuscript form—the most precious of these containing historiated initial capitals and text illustrations accompanying liturgical poems. Widespread are the *haggadot* designed for the domestic Seder ceremony held at the beginning of the Passover festival. From the Middle Ages until well into the eighteenth century, specimens are found with illustrations to the various stories contained in this popular booklet. The biblical Book of Esther, read from a scroll (*Megillah*) on the boisterous *Purim* (Feast of Lots) may also be illustrated, as it is the only Biblical book that does not contain the divine name.

Compared to Hebrew manuscripts, a far smaller number of medieval Jewish ceremonial objects have been preserved. Here again we already start to note differences between Sephardic, Ashkenazic, Italian, and Oriental Judaism. Torah ornaments as well as artifacts for public festivals and private celebrations were often made of precious materials according to the precept to serve and glorify the divine with beautiful objects (*hiddur mitzvah*, based upon Exodus 15:2). Many objects were lost during persecutions or as a result of looting or robbery, while others were preserved in their original setting or in museums.

Jews decorate their sanctuaries, embellish their ceremonial objects, and illustrate their sacred texts, all with the intent to glorify their abstract God, who is never depicted. The Bible forbids idolatry, but not the making of images, as long as they are within the context of the official religion. The image of Judaism is as multi faceted as Jewish life. The synagogues of antiquity—and historical Jewish centers like Toledo, Prague, and Amsterdam —have retained their magical attraction until the present day, preserving traces of the golden ages when Jewish religion and culture flourished.

Interior of a medieval Spanish synagogue, showing an open Ark with *Torah* scrolls and worshippers leaving the building. On the left, a man blesses two children, one of them carrying a prayer book. *Sarajevo Haggadah*, Barcelona, Spain, 14th Century, folio 34 verso

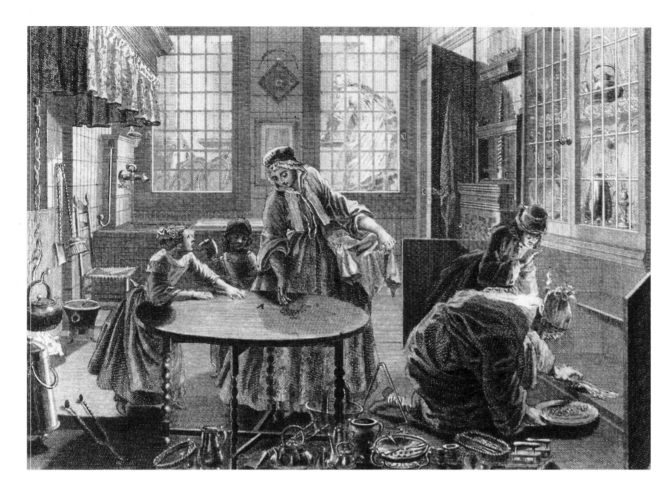

On the evening before Passover, one ceremonially searches the home with a candle for remainders of bread and other leavened products, as Bernard Picart depicts in this engraving of a canal house kitchen in Amsterdam. The Netherlands, 1725

Below: Hanukkah lamp for use at home. It has a bench for oil wicks and is lit on the eight days of the festival with the help of a detachable servant light on the back plate; it is adorned with fleur-de-lis, two oil jugs, and a five-pointed star. The Netherlands, 18th century

The Jewish Year and its Festivals

As was mentioned earlier when describing the centrality of the synagogue to Jewish life, the liturgical calendar with its weekly Sabbaths and seasonal festivals, with its sermons, liturgical poetry, rituals, and customs became the main vehicle of Jewish history and Jewish memory. Celebrated at home and in the synagogue, the festivals transmit Jewish identity form generation to generation.

The references to the land of Israel are as numerous as those to slavery during the Egyptian exile; both impressed themselves indelibly on Jewish consciousness and influenced the celebration of all festivals and lifecycle events. Three seasonal festivals—Passover, the Festival of Weeks, and Tabernacles—celebrate, on the one hand, the agricultural cycle of harvesting the land, originally with a pilgrimage to Jerusalem and, on the other hand, commemorate on a historical level the Exodus, the giving of the *Torah*, and the desert wanderings, respectively—events which took place outside the land of Israel. The High Holidays (New Year's and the Day of Atonement) in autumn are not related to agriculture, but solemnly recall the service at the long since destroyed Temple in Jerusalem. Purim, the Feast of Lots, recollects how Jews were saved from physical extinction during the Persian Diaspora in the fifth century BCE, and its source can be found in the biblical Book of Esther. Hanukkah is of post-biblical origin and celebrates the rededication of the Jerusalem Temple in the second century BCE. Since its inception, the focus of Hannukah has shifted from the Maccabean military victory to a Festival of Lights focusing on the miracle of the spiritual survival of Jews, wherever they live. Significantly, no festival marks the entry of the Jewish people into the Biblical land, though the destruction of the First and Second Temples (in 586 BCE and 70 CE)—recalling the Exile—is commemorated by way of a fast day, on the ninth of the month of *Av* (in summer).

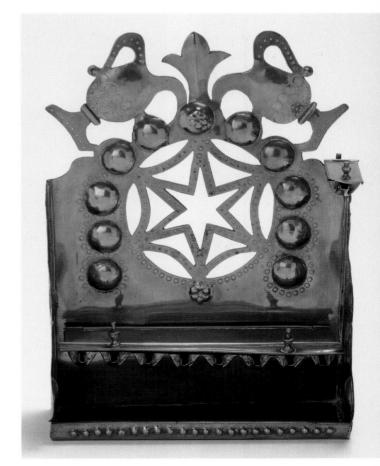

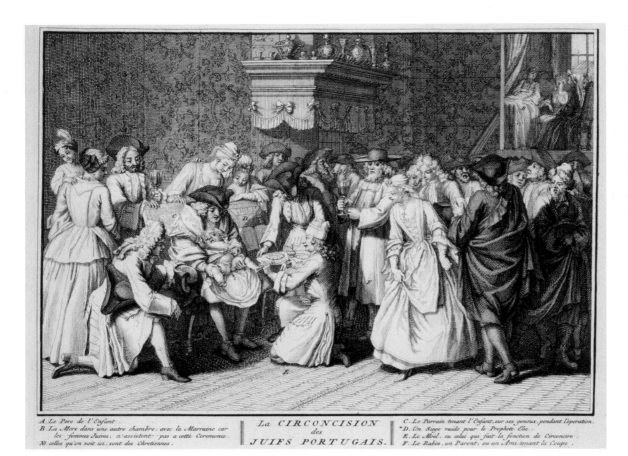

Circumcision performed in a Jewish home in Amsterdam. The boy, eight days old, is held by his grandfather, while the chair next to him is reserved for the prophet Elijah, protector of children and who — according to the Hebrew Bible — will one day herald the coming of the Messiah. Family and friends welcome the child into the covenant of Abraham. Engraving by Bernard Picart, The Netherlands, 1722

The day on which the Holocaust (a word meaning whole burnt offering in Greek), the mass destruction of European Jewry during World War II, is remembered is not associated with the ninth of Av. Rather, the Shoah (this preferred Hebrew term means destruction) is remembered on the twenty-seventh of the month of Nissan, a day close to the start of the Warsaw Ghetto Uprising in April 1943. This time of year coincides with the destruction of many Jewish communities by the Crusaders who are seen as the forerunners to the Nazis. The day is officially called *Yom ha-Shoah veha-Gevurah* (Day of Destruction and Heroism), the latter term countering the popular myth of Jewish passivity in the Diaspora and addressing the "shame" of victims and survivors. In the calendar, *Yom ha-Shoah* falls immediately after Passover, which celebrates the liberation from bondage in Egypt, and before Israel's Independence Day (*Yom ha-Atzma'ut*) that marks the proclamation of the state on May 14, 1948, and bestows a new dignity on the survivors.

The cyclical structure of the Jewish year enables Jews to relive their past, and can be applied to all subsequent Jewish experiences in the course of time. After the destruction of the Second Temple, the festivals were reinterpreted by the rabbis, and adapted from sacrificial services in Jerusalem to celebrations at home and in the synagogue. Since His house was destroyed, even God Himself was perceived as having then gone into exile, His divine presence accompanying His people during their wanderings. Protected by the divine presence (*shehinah*), each Jew in every generation could imagine himself as if he went out of Egypt. This ancient rabbinic motto for the communal celebration during the Passover meal was aptly applied to all annual festivals.

Jewish Life

Jews are also obliged to sanctify life in active daily practice. The holiness of life is remembered each day in word and action, through elevating texts, and concretely via good deed, charity, and dietary laws, all meant to create a higher spiritual awareness. Outward signs such as covering the head (men), the hair (married women), a case at the right hand doorpost of a Jewish home (*mezuzah*), or a prayer shawl during morning prayer may serve as helpful reminders of this call for dedication to Judaism.

The main transitions in human life — birth, attaining adulthood, marriage, and death — are all marked with specific ceremonies. Like the Jewish festivals, they have Biblical origins but their present form is the result of a long development in which outside influences reveal the lively exchange between Judaism and surrounding soci-

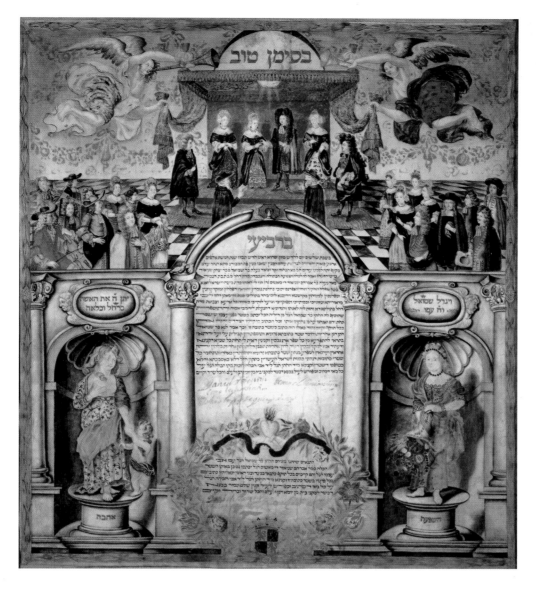

ety. The first commandment in the Bible is to "be fruitful and multiply" (Gen. 1:28), interpreted by the rabbis as fulfilled when a man has begotten at least one son and one daughter. The biblical stipulation to circumcise a baby boy eight days after his birth goes back to Abraham; considered a sign of the covenant between God and the Jewish people, it is still widely practiced. After the foreskin is removed surgically, the baby is welcomed with the words, "may he grow up into the study of *Torah*, into marriage, and the doing of good deeds." In contemporary times, baby girls are welcomed and named in a special ceremony with the same blessing.

According to the rabbis, adulthood starts at age twelve for girls and age thirteen for boys. Boys are from then on counted in the traditional prayer quorum of the ten men needed for a complete synagogue service; in modern Judaic movements this is applied to girls as well. Since the Middle Ages, it has been customary for the boy to read from the Torah scroll in public, and explain the text. This initiation into Jewish life with all its responsibilities is the result of years of study of Hebrew, the texts, and their interpretation. Jewish education begins as soon as the child can talk, and children occupy a central place in many Jewish ceremonies.

Marriage is considered a sacred act, as reflected in its Hebrew name *kiddushin* (sanctification) and the words spoken by the groom when he hands a ring to his bride, "you are sanctified to me by this ring, according to the laws of Moses and Israel." Jewish marriage is intimately related to God, who, after creating the world, is said to have dedicated his time to matchmaking as, according to his own words, "it is not good for man to be alone" (Gen. 2:18). A business-like contract of rabbinic origin specifies the financial obligations of the man, and the ceremony itself takes place under a baldachin. After seven blessings are spoken and the couple has shared a cup of wine, the groom breaks a glass, the guests shout *"mazal tov"* (good luck!), and the festivities begin.

Death and mourning in Judaism are observed through many customs that involve both the bereaved family and the community. Mourning for close family members may last for up to one year, during which—and annu-

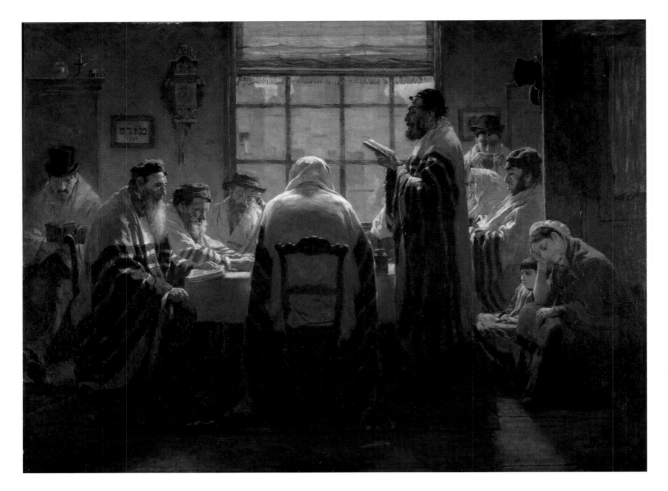

ally on the anniversary of the death—the family recites the *Kaddish* prayer in the synagogue, an ancient Aramaic text used when the dead are publicly bereaved.

Although Judaism is no longer thought of as a proselytizing religion, conversion is possible. Traditionally, rabbis discouraged non-Jews from seeking conversion, warning them of the inherent dangers of belonging to an often-discriminated minority. Most modern movements in Judaism today accept proselytes, though the rabbinic requirements differ between them. Knowledge of Hebrew, religious practice, and history are presumed. "Jews by choice" are found throughout Jewish history.

Modern Jewish History

When did the Middle Ages end and Modernity start? The general consensus is around 1500, but Jewish historians oscillate between 1492 and the Emancipation during the eighteenth and nineteenth centuries. Actually, both mark the beginning of Jewish modernity, the first related to the expulsion of the Spanish and Portuguese Jews from the Iberian Peninsula in 1492, the second the result of the granting of equal rights in the century following the late-eighteenth-century American and French revolutions.

As a result of the expulsion from Spain (as well as the Thirty Years War in Central Europe, 1618–1648), Jewish life in Western Europe began to reestablish itself; in the seventeenth century, both Sephardic and Ashkenazic refugees found refuge and a home in the tolerant Netherlands, and Jews were again permitted in England (1656). Settled in port towns like Venice, Amsterdam, London, and Hamburg, the Iberian Jews—the majority forced to convert to Catholicism and unlearned in their own religion—had to reeducate themselves as Jews, learn Hebrew, and conform themselves to Jewish norms. Yet, they chose to be Jews, a decision analogous to contemporary Jews who have the freedom to associate or dissociate from organized Jewish life. Also similar to today, the former converts restricted Judaism to the synagogue, excluding other areas of traditional Jewish law. They saw their exile as a messianic sign, a reason why so many of them in the 1660's endorsed Sabbetai Zevi's claim to be the messiah, and followed him in abrogating substantial parts of Jewish ceremonial law. Like them, most contemporary Jews ignore most, if not all, Jewish laws. At the same time, in Amsterdam, Baruch Spinoza

(1632–1677) began to undermine scriptural and rabbinic authority, and in its stead formulated a rationalist ethics. In this sense, he too is a precursor of a Jewish modernity that doubts in God and prefers philosophy to the adherence to religious laws. In eighteenth-century Eastern Europe, Hassidism successfully began to undermine the authority of traditional rabbis, thus setting the tone for the diversity of Jewish movements from the nineteenth century onward.

The expulsion from Spain—the major pre-modern catastrophe—led to the birth of a new "creation myth" amongst Kabbalists (Jewish mystics). Whereas classical rabbinic thinking postulated that exile and destruction are ultimately caused by the sinful behavior of Jews themselves, sixteenth-century Kabbalists explained evil by claiming that an endlessly perfect God had to withdraw part of Himself in order to make the creation of the world possible. In the creative process that followed, divine light flew into ten vessels, but the vessels were too fragile to contain such powerful radiance—the upper three were damaged and the lower seven completely shattered. The elements that had resisted creation were the source of evil; trapped in the lower world they need access to the light in order to become whole and repaired again. In other words, exile was the essence of God Himself, and brokenness the condition of the world. The primary human task became the process of restoring the sparks to the divine world and thus mending the world and completing the creation (*tikkun olam*). This myth, spread and popularized by Hassidism, influenced modern Jewish thinking after the Holocaust and such modern artists as Barnett Newman.

The Enlightenment was the second harbinger of modernity and resulted in an emancipation movement that gradually accorded Jews equal civil rights, first in the United States (1776), then in France (1789), the Netherlands (1796), and in the course of the nineteenth and early twentieth centuries all European states. Jews were no longer a semi-autonomous separate "nation within a nation," but individual adherents of the Jewish religion, which became a matter of personal choice. In the footsteps of Spinoza, Moses Mendelssohn (1729–1786) had already argued that religious authorities had no right to coerce, religion being a private, personal matter. With real political power limited to biblical times and to the pre-modern, semi-autonomous Jewish minority in Europe, Jews would now be loyal to the state. Jerusalem and the biblical state were considered of minor impor-

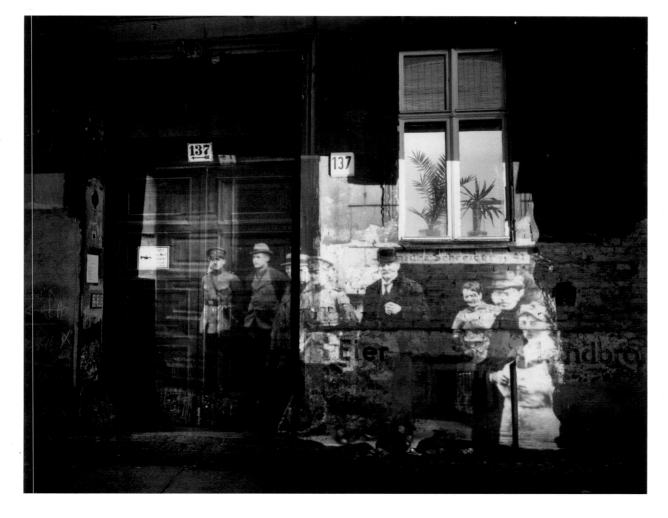

Slide projection of a police raid on Jewish residents (1920) in Linienstrasse, in the former Jewish working-class area of Berlin. Shimon Attie, *The Writing on the Wall*, Berlin, Germany 1992–93

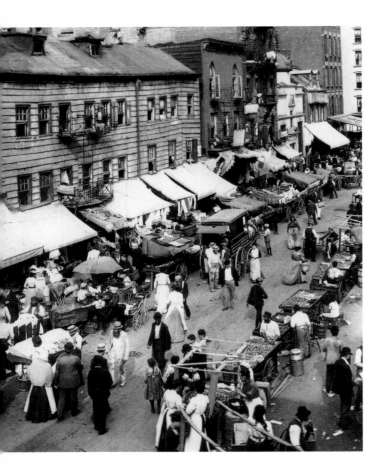

tance; Jews if anything could serve as "a light unto the nations," as Jewish thinkers, both Orthodox and Reform, consistently emphasized during the nineteenth century.

The battle for equal rights proved difficult—in Germany it took three generations before Jews received citizenship in 1871, which only lasted until its revocation in 1935; in France, the anti-Semitic campaign against captain Alfred Dreyfus led to a political crisis and raised doubts about the sincerity of the French towards their Jews. In Russia, anti-Semitism seemed endemic; pogroms between 1881 and 1914 resulted in a massive exodus of Jews form the tsarist empire, with some two million Russian Jews immigrating to the United States. The center of gravity had now moved definitively to the Anglo-Saxon world. Soviet communists prevented further emigration, whereas America introduced a quota system in 1924. Another large exodus took place under the threat of Nazism in the 1930s, when 280,000 German Jews (of a total of a half-million) managed to escape: almost half to the United States, and about 55,000 to British Palestine. The Holocaust claimed six million victims amongst European Jews. Most affected numerically were Jews in Poland (2,900,000 victims, 88 percent of the Jewish population), the former Soviet Union (1,000,000, 33 percent), Rumania (420,000), the former Czechoslovakia (300,000), Hungary (200,000), and the Baltic republics (220,000, 90 percent); followed by Germany (200,000), France (130,000), and the Netherlands (107,000, 80 percent).

Many survivors emigrated to Israel, before and right after the foundation of the Jewish State in 1948, followed by Jews from Arabic counties in the nineteen sixties and seventies, and Jews from the former Soviet Union and its successor countries in the last decades of the twentieth century.

Movements in Modern Judaism

Due to the shifting realities brought about by the Emancipation, it was inevitable that Judaism began to redefine itself. For most reformers, restorative national messianism, as expressed in liturgy, ceded ground to a secular, utopian variety of messianism, in which the emancipation would progressively lead to universal equality and peace for all humanity. To become equal citizens meant recognizing national rather than Jewish law, which was then relegated strictly to religious issues. The modern Jewish movements—Orthodox, Conservative, and Reform—had to come to terms with this new reality, to accept personal autonomy, and consequently to redefine Judaism. The Orthodox claimed that Judaism was the highest embodiment of secular humanist culture, in which one could be a Jew at home, and a "mensch" outside; Conservative Jews found precedents in past Jewish laws in adjusting to modernity; and the Reform movement abrogated laws perceived to run contrary to the spirit of universal progress. As a result, European and American Judaism became fragmented while in North Africa and the Middle East modernization was more gradual and accommodating.

Towards the end of the nineteenth century, Jewish political nationalism was added to the spectrum of Jewish religious movements. The return to Zion, once a dream rabbis carefully avoided putting into practice, became a serious political

Jewish immigrants from Eastern Europe settled in New York's Lower East Side; here Hester Street, ca. 1910

The Dutch children Benjamin Pais (b. 1934) and his sister Jansje (b. 1933) from Harlingen were, like all Jews, forced to wear a yellow star. Both were deported to Auschwitz and killed in 1942, together with their parents.

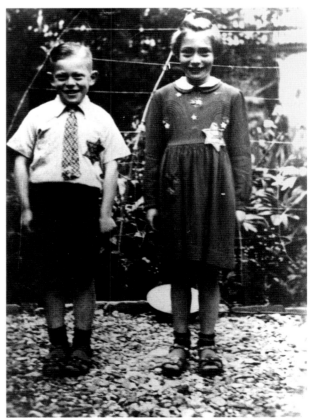

option for those Jews confronted with the winds of anti-Semitism and nationalism in nineteenth-century Europe. Palestine was no longer a destination for Christian pilgrims only, but for Jews as well, this time as pioneers. Zionism saw Judaism threatened by assimilation and by anti-Semitism expressed in the Russian pogroms in the 1880s and the Dreyfus affair in France. This secularized messianism formulated by Theodor Herzl (1860–1904) was at first strongly opposed by Reform and Orthodox rabbis, but was gradually accepted by nearly all Jewish movements, as evidenced by the diversity of the modern Israeli political scene—one finds liberal, utopian, socialist, and religious Zionists, just as there are Zionist and non-Zionist Orthodox and Reform Jews. Some traditionalists see the Jewish presence in Israel as just the "beginning of the redemption," others are more activist and try to "force the end of times" by occupying land once inhabited by Jews during biblical times, or preparing for the rebuilding of the Temple. The ideals of prophetic, universal Judaism received a severe blow after the Shoah, the systematic murder of six million European Jews initiated by the Germans—

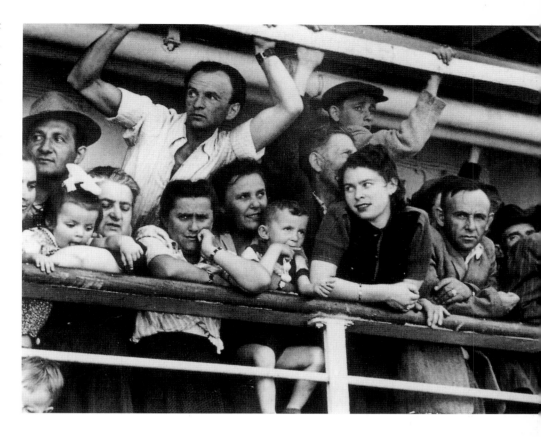

Photograph of Jewish refugees arriving to Haifa by boat. Robert Capa, 1948

considered one of Europe's most civilized nations—and their collaborators in other advanced countries.

Judaism today, whether in Israel or the Diaspora, is highly fragmented. Jewish socialism appears moribund, and so does secular Yiddish culture in spite of nostalgic efforts to revive and retain this millennial Eastern European heritage. Zionism started out as a secular movement but has been increasingly sacralized as the Hassidim and ultra-Orthodox generate a messianic fervor. In some circles, war and the destruction of Jews during the Holocaust are seen as an anticipation of the pending redemption. The renewed battle between secularity and sacralization so characteristic of today's society is mirrored in the undecided struggle within Judaism itself.

Jewish Art in Modernity

The Jewish people have been deeply involved in the arts from Biblical times onward, whether as commissioners or creators. After discriminatory measures—such as the exclusion form guilds—were lifted, Jews were permitted for the first time to express themselves in art and architecture unhampered by official restrictions. The wish to be accepted went hand in hand with the search for identity. In the nineteenth century, the first successful Jewish artists emerged, occasionally reflecting on a Jewish theme.

As a result of their emancipation, architecture could more openly express Jewish identity. In their commissions for synagogues to Jewish as well as non-Jewish architects, communities quite consciously chose building styles that reflected their desire to embrace the country in which they lived. Romanesque synagogues stressed the Jews' centuries-old presence in Europe while Oriental (Moorish) architecture made reference to the Jewish golden age in medieval Spain while self-confidently accentuating their historical origins in the Orient. Building commissions and their architects frantically searched for the proper architectural style to represent modern, emancipated Judaism, a challenge until early-twentieth-century modernism presented a more neutral stylistic ground. The Jews, who until the Emancipation eschewed impressive architectural constructions in favor of "cathedrals in time"—celebrating traditional festivals rather than physical space—began to build the Jewish equivalents of the great Europe cathedrals. Such mid- and late-nineteenth-century synagogues as those in Berlin, Budapest, Brussels, and Paris radiate the optimism of a recently emancipated Jewish bourgeoisie. Wherever possible, synagogues were turned into landmarks in the cityscape and outward symbols of a new self-confidence.

In the nineteenth century, Jewish artists successfully contributed to the fine arts for the first time, whether openly exhibiting their Judaism to the outside world or indirectly alluding to their ancient background. Inspired by the search for national roots then popular in many European nations, Jewish artists explored the trails of their

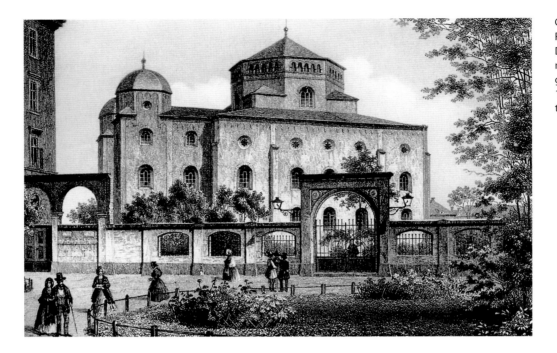

Gottfried Semper's neo-Romanesque synagogue in Dresden was one of Germany's first modern synagogues. It was built in 1838–40, and destroyed by the Nazis a century later.

past material culture and contributed to a modern renaissance of Jewish art in around 1900. The same current had given rise to the search for an Israeli art once the first pioneers had settled there. Others, in the early twentieth century, became innovators of the arts in general, with Judaism playing only a marginal role in their work. Despite the prejudice which hounded them—namely that Jews were by nature or "race" more inclined to the word than to the image—the spirit of optimism prevailed: in Europe, in Israel, and increasingly in the United States of America, where twentieth-century Jewish artists thrived. The Jewish artistic response to the Nazi rise to power in the 1930s came quickly—artists and writers expressed their fears of expulsion and humiliation, and their premonition of the horrors to come.

Contemporary Jewish Art

After the systematic mass murder of six million European Jews, the philosopher Theodor Adorno thought it would be forever impossible to create poetry—and by extension, art—after Auschwitz. Yet, the Holocaust has become a major theme for modern Jewish artists as well as their non-Jewish counterparts. It has inspired architects to erect impressive monuments—in Europe, where the atrocities occurred, but also in Israel and the United States of America, where most Jews currently reside. The modern Jewish experience is shaped by the memory of the Holocaust and the creation of Israel, the two most influential events in the twentieth century—the former dealing with collective death, the latter with the rebirth of an ancient nation.

After 1945, American Jewish artists, many of European descent, were the first to reevaluate their assimilation into mainstream culture by responding to the atrocities and to the nascent Jewish state. Israeli artists, primarily occupied with shaping a national identity, integrated the Holocaust into the visual arts and compelling monuments while concurrently absorbing the effects of a swelling Palestinian nation-

The Pinkas synagogue (1535) at the edge of Prague's old Jewish cemetery was converted in the 1950s into a memorial for the 77,297 victims from Bohemia and Moravia—out of a community of 92,000 souls—deported via the "model camp" Theresienstadt, and murdered in concentration camps elsewhere. After having been closed for decades by the communist rulers of former Czechoslovakia, the building reopened in 1992. The names are arranged alphabetically according to community on the walls of the vestibule, the main nave, and the women's galleries.

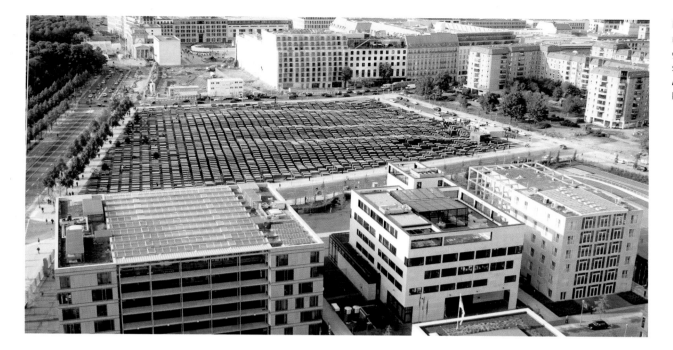

Hundreds of concrete steles near Berlin's Brandenburg gate create a most impressive *Memorial to the Murdered Jews of Europe*. Peter Eisenman, 2005

alism. The postwar generation, shaped by the memories of survivors, attempts to come to grips with the greatest trauma in Jewish history since the destruction of the Second Temple.

There is as little a Jewish artistic style as there is a Christian, Muslim, American, German, or Israeli style. Jewish artists play an integral part in all of the divergent artistic movements of modern pluralistic society. While some are inspired by traces of a now-lost world, others are attracted by the revival of Jewish mysticism. Amidst the resurging nationalism and fundamentalism of our times, the universalistic, prophetic dream of peace and justice remains, for many, enduringly vibrant.

Museums and Memorials, Synagogues and Art

For thousands of years and nearly until the present day, in Judaism, time—interpreted and actualized—prevailed over place. The Bible never specified exactly on which mountain in Sinai Moses received the *Torah* (the present monastery was founded in early Christian times), and the *Pentateuch* stresses the unknown location of the grave of Moses, the founding father of Judaism. The Temple Mount stands in Jerusalem, but exactly where the Temple stood is unknown. Before modern-day Israel's conquest of the eastern part of Jerusalem in 1967, its remaining outside western "wailing" wall, located in a narrow alley in Jerusalem's Old City, was a place visited only by pious Jewish pilgrims. The importance of the space itself, with its enormous square and an open-air synagogue with separation between men and women, is a rather recent phenomenon. That applies also to the tombs of Rachel in Bethlehem and of rabbinical scholars in Safed and Tiberias; the tombs of the patriarchs in Hebron have become a real bone of religious and political contention. From rabbinic times until well into the nineteenth century, rabbis have de-emphasized the significance of Israel in favor of Jewish life outside the biblical land. In other words, "home" could be virtually and actually realized in the Diaspora.

All of this would change under the influence of modernity, in which Jews started to construct a new orientation to their past history and culture to justify themselves and their place in society. A romantic nostalgia for the past became part of the Jewish conscience for both religion, as one imagined it used to be, and history. Beginning in the second half of the nineteenth century, Jewish exhibitions and museums presented Jewish religion, history, and material culture to a secularizing Jewish bourgeoisie. Jewish museums, soon present in most large European cities, emphasized the glorious past, like the Golden Age of Spanish Jewry before the expulsion or Spanish-Portuguese Jews in Amsterdam. Publications proudly presented Jewish ceremonial artifacts and newly discovered illuminated Jewish manuscripts from the Middle Ages. Jewish travelers began to visit places in Europe which reflected a glorious Jewish history, such as the Iberian Peninsula, where Jewish courtiers, poets, and politicians had lived; the romantic ghetto of Venice; Prague, home of the Golem; the Jewish quarter of Amsterdam, where Rembrandt once lived; or Budapest and Vienna, two cities close to the *Ostjuden* that, though negatively perceived as immediate neighbors, possessed the very religiosity lacking in emancipated Western Europe.

After the Holocaust, Jewish museums in Europe reopened, but their impact remained limited until the 1970s. In the United States, the Jewish Museum of New York (founded in 1904) opened new premises on Fifth Avenue in 1947 and quickly developed an innovative exhibition program. In the past decades, the number of Jewish museums multiplied in the United States and in Europe, where at times the abandoned synagogues of the cities where Jewish life had been almost completely destroyed were put to new use, such as in Krakow. A real change occurred in the late 1980s when Jews decided to take charge of their history themselves and, at the same time, national or local governments—for political reasons—chose to pay prominent attention to the fate of Jews in their society. Museums of an unsurpassed size, impressive museological quality, and located in prime locations opened their doors one after the other and soon attracted large crowds: Amsterdam (1987), Frankfurt

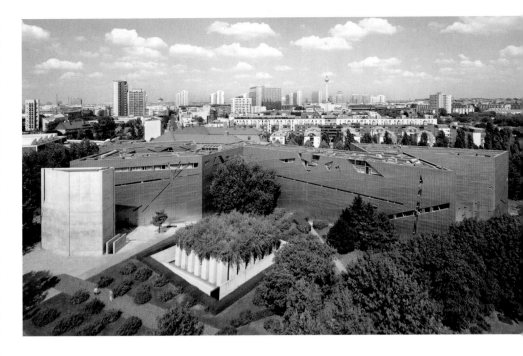

am Main (1988), Vienna (1993), Paris (1998), and, as a climax, Berlin (2001). The Jewish Museum, once a modest receptacle for the religious and historical remains of an almost extinct people, became a major tourist attraction and a Jewish pilgrimage destination. Most European capitals and major cities now possess Jewish Museums of the same size and importance as those in the United States.

Whereas in Europe, Holocaust-related sites like the former concentration camps increasingly became professional museums, in the United States and Israel, Holocaust museums and monuments arose for reasons more related to a Jewish need to connect to this dramatic phase of its history. The expansion of Israel's national Holocaust monument and museum Yad Vashem over the last decades into a vast and impressive area, and the establishment of the United States Holocaust Memorial Museum on an expansive site in the center of Washington, D.C., testify to the importance of this development.

After World War II, Jewish tourism expanded to the sites of destruction—pilgrimages to the concentration camps in Eastern Europe or to the Anne Frank House in Amsterdam, for example. Before, the glorious past had

Jewish Museum Berlin. Daniel Libeskind, 1989–99/2001

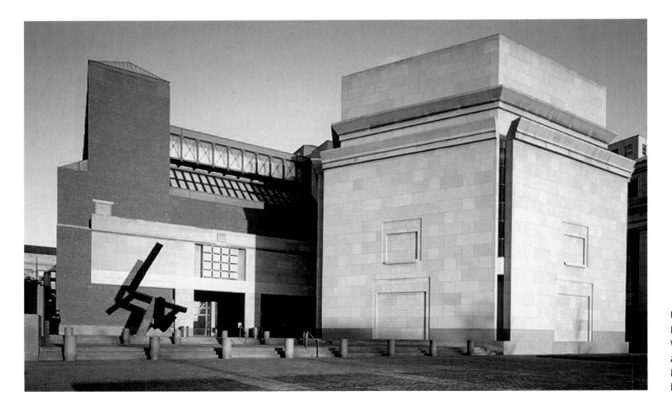

United States Holocaust Memorial Museum in Washington, D.C., is situated adjacent to the National Mall. Pei, Cobb, Freed and Partners, 1986–93

been the source of inspiration, often found with a visit by the pious to the tomb of a scholar. And although this is still the custom among traditional Jews, for modern Jews the focus has shifted. Now, visits to Europe's sites of persecution are coupled with hopeful, redemptory journeys to the Holy Land. Europe was literally a dead end; the course of European Jewish history—with its emancipation, integration, and assimilation—was perceived to lead directly to the extermination camps.

Jewish memory has become fully secularized; history is presented in chronological rather than cyclical order, as had been the tradition for centuries in the synagogues. Place has fully taken over from time, in the same way as history replaces religion. History rather than text has now become the arbiter, the point of reference for Jews, with physical space rather than the cycle of time serving as the vehicle for meaning. More Jews visit a museum, Jewish or otherwise, than a synagogue, even on Shabbat. Just as the museum has become the cathedral of the twentieth century for the Gentiles, Jews have equally made the museum their synagogue, where they relate to the past, meet socially, and celebrate secularized festivals and lifecycle events. Museums, memorials, and art remind them of their heroic or tragic past, and leave them with the determination of "never again," or to more positively assert a strong Israeli or Jewish identity.

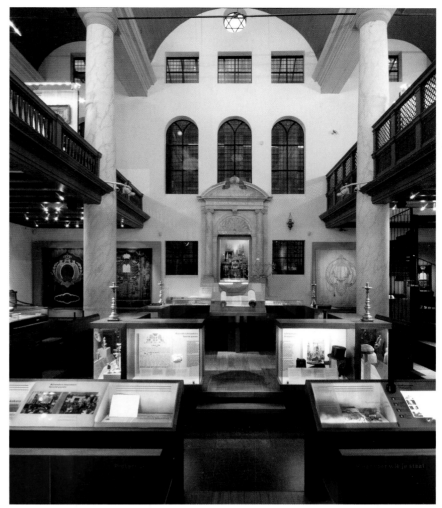

Lively presentation of Jewish religion in the new permanent display in the Great Synagogue (1671), part of the Jewish Historical Museum Amsterdam, 2004

Timeline

2000–1000 BCE

18th to 14th Century The patriarchs Abraham, Isaac, and Jacob, the matriarchs Sarah, Rebecca, Rachel, and Leah, and their extended families originate from Mesopotamia and migrate to Canaan before settling in Egypt, where Joseph becomes viceroy.

14th to 13th Century Sojourn of the twelve descendants of Jacob in Egypt.

1275–1250 Exodus of the twelve tribes from Egypt.

12th to 11th Century Forty years of wandering through the desert of Sinai, during which time Moses received *Torah*, the written — and according to the rabbis, also the oral — laws, amongst them the Ten Commandments; settlement in Canaan, the Promised Land. The traveling Tabernacle, containing the tablets of the law, serves as the spiritual center during the years of wandering in the wilderness and the time before the Temple is constructed.

1020 Saul becomes the first king of Israel, Samuel the first prophet.

1000–0 BCE

1000–450 Prophets criticize social injustice; their writings would later accompany weekly scriptural readings in the synagogue.

1000 King David unites the twelve tribes and chooses Jerusalem as the political capital.

961 David's son King Solomon builds the first Temple in Jerusalem. Priests are in charge of the sacrificial services.

922 Split between the northern kingdom, Israel, and the southern kingdom, Judah.

722 The fall of Samaria and the kingdom of Israel; Assyrian deportation of the ten northern tribes, the Lost Tribes of Israel.

586 Babylonians destroy the Temple in Jerusalem and send the Judeans into the Babylonian exile, during which time the first alternatives to sacrificial services develop.

538 The Persian King Cyrus permits the exiles to return home, but some stay behind. Jews settle in Egypt, and some merchants travel further still, perhaps as far as India and beyond. The prophet Jonah lived in Nineveh (late fifth century); Esther (fourth century) — the Jewish queen at the Persian court of Artaxerxes in Susan — successfully prevented a massacre of Jews, a feat still celebrated as the festival of Purim.

515 Completion of the Second Temple in Jerusalem.

450 The *Torah* (five books of Moses, *Pentateuch*) completed; the text is still read weekly in the synagogue.

333 Alexander the Great occupies the land of Israel.

300–200 Judea comes under the rule of the Ptolemies, a Hellenistic kingdom in Egypt; emergence of the Jewish community of Alexandria; the Bible is translated into Greek (*Septuagint*).

200 Judea passes under the rule of the Syrian Seleucid kingdom, which actively promotes Hellenization.

167 King Antiochus IV desecrates the Temple; the Maccabees revolt, remove the Greek idols, and rededicate the Temple in 164 — an event celebrated during Hanukkah.

140 Judea becomes independent under the Maccabees and their successors, the Hasmoneans.

Jewish sects claim authority over the interpretation of the Bible: the Sadducees, adherents of the priestly class, battle with the Pharisees, the precursors of the rabbis. The Essenes consider the priests tainted by foreign influences and withdraw into the dessert, the Zealots offer armed opposition, and others expect salvation from a messianic figure.

63 General Pompey brings Judea under Roman rule.

37–4 During the reign of King Herod, the Temple is renovated and expanded into what was considered one of the largest and most beautiful buildings of antiquity.

0–1000 CE

30 Crucifixion of the Jew Jesus of Nazareth under the rule of Roman governor Pontius Pilate.

66 Jewish revolt against Rome.

70 Destruction of the Second Temple by the Roman general Titus. Judea becomes a Roman province and Jewish refugees take refuge outside the biblical land, further strengthening the Diaspora.

70–80 The Sanhedrin, a rabbinic council, settles in Yavneh, and responds to the destruction of the religious center, Jerusalem, by finishing the codification of the Bible, restructuring the calendar, and beginning to commit into writing oral laws and interpretations of the Bible. Synagogues led by scholarly lay people, the rabbis, become the centers of prayer and study.

74 The fall of Massada: the last rebel stronghold against Rome falls after a dramatic mass suicide; sectarians hide their sacred texts in the caves of Qumran.

1st to 6th Century Synagogues are built all over Palestine and the Diaspora, some ornately decorated with paintings (Dura Europos, 245) or mosaics (Beth Alpha, 518).

132–135 Revolt in Judea by Simon bar Kokhba, followed by Roman persecutions and the martyrdom of Jewish scholars. Jews flee to all over the Roman Empire, from North Africa, to Spain, France, the Rhineland, Italy, Greece, Turkey, and Syria — some destinations had preexisting Jewish settlements.

136 Emperor Hadrian rebuilds Jerusalem but does not allow Jews to enter, renaming the province Palestine.

200 Judah the Patriarch, the recognized Jewish leader in the Roman Empire, makes the final redaction of the *Mishnah*, the basic code of Jewish law. Written in Hebrew, it has been studied and commentated upon up to the present day.

200–400 In Galilee, the first major commentary on the *Mishnah* is compiled and edited, the *Jerusalem Talmud*.

250–1000 Babylonia becomes the major center of Jewish learning outside Israel. Around 500, the *Babylonian Talmud* is edited, which becomes the foundation for all further interpretation of Jewish law and lore. For the following 500 years, Babylonian scholars were consulted on legal questions.

321 The first Christian Roman emperor Constantine forbids Jews to enter Jerusalem. He allows some Jews to settle in Cologne. German tribes invade the Roman Empire and gradually convert to Christianity. While the Popes and Church Fathers appreciate Jews as keepers of the true text of their "Old" Testament, they increasingly resent them for refusing to accept Jesus as the messiah, and begin to discriminate against them.

632 Death of Mohamed, the founder of Islam.

638 Jerusalem conquered by Arab Muslims, who characterize Jews as the "People of the Book." Their attitude to Jews, with whom they share a similar oral tradition and dietary laws, is less ambiguous than the Christians'. They rule Palestine until the Crusaders conquer the Holy Land in 1099.

691 Caliph Abd el-Malik builds the Dome of the Rock on the site where the Temple once stood.

712 Supported by Jews, Muslims overthrow Christian rule in Spain. Philosophy, literature, arts, and sciences develop to great heights in cities such as Cordoba, Granada, and Toledo, giving rise to a Golden Age of Sephardic Jews under Caliph Abd al-Rahman III (891–961), during which time the three monotheistic traditions would peacefully co-exist.

9ᵗʰ to 10ᵗʰ Century Under Charlemagne and his successors, the first Jews settle in France, the Rhineland, and Austria, giving rise to Ashkenazic Jewry, with Yiddish as its language.

1000–1500 CE

1000 German cities Speyer, Mainz, and Worms develop as centers of Jewish learning.

1066 Jews begin to settle in England after the Norman Conquest.

1070 Solomon ben Isaac (Rashi) starts an academy in France; his commentaries of the Bible and the Talmud remain today an indispensable accompaniment to these texts; his daughters and grandchildren develop and spread his ideas.

1085 Beginning of the Christian re-conquest of Spain.

1096 After Pope Urbanus II had called Christians to liberate the Holy land from Muslim rule, Crusaders murder Jews in the Rhineland. Amnon of Mainz, who was martyred, wrote a dirge still recited on Yom Kippur (the Day of Atonement).

1144 First blood libel in York, England, in which Jews are accused of using the blood of Christian children for their ceremonies; the same accusation surfaces periodically up until the early twentieth century.

1163 Jews in China build a synagogue in Kaifeng; the community endured until the nineteenth century.

1175–1250 Hasidei Ashkenaz: German pietists influence Jewish religious life.

1178 Moses ben Maimon (Rambam or Maimonides, 1135–1204) writes his *Mishneh Torah* in Hebrew, a comprehensive summary of Jewish law in 14 parts. This physician and leading rabbi of Sephardic Jewry also wrote *Guide of the Perplexed*, a philosophical work in Arabic, and summarized Jewish religion in thirteen articles of faith, still sung today in synagogue.

1178 Turkish sultan Saladin expels the crusaders from Jerusalem.

1190 About 150 Jews are massacred in York, England.

1204 Crusaders plunder Constantinople (Istanbul) and burn the Jewish quarter.

1215 The Fourth Lateran Council decides that Jews have to wear distinctive markings on their cloths.

1242 After a dispute between rabbis and Dominican Christians, French king "Saint" Louis IX orders the public burning of the *Talmud* and numerous other Jewish manuscripts.

1280 Moses de Leon (1250–1305) completes in Spain his *Zohar* (Book of Splendor), the main work of Kabbalah, Jewish mysticism.

1286 Rabbi Meir of Rothenburg, the "Light of Exile," angered about the high taxation of Jews, is taken prisoner, refuses acceptance of the ransom raised for him, and dies in jail in 1293. Ultimately, Alexander Wimpfen ransomed his body in 1307 for a large sum of money; their tombs, next to each other in Worms, still survive. At that time, German gangs killed thousands of Jews, wiping out 140 communities.

1290 Expulsion of the Jews from England; most fled to Spain and other parts of Europe.

1348–49 Jews are accused of poisoning wells and thus causing the pestilence known as the Black Death. Thousands are massacred and numerous Jewish communities are wiped out.

1364 Casimir the Great of Poland extends rights to Jews, attracting many refugees from Germany and elsewhere.

1391 Massacres and forced conversions in Spanish Christian Castile and Aragon.

1394 Expulsion of the Jews from France.

1421 Jews banned from Austria; Viennese Jews who refused to be baptized barricaded themselves in the synagogue and killed themselves by burning. Surviving Jews were burnt publicly. A monument in the center of Vienna commemorates this drama together with the equally horrendous murder of Viennese Jews during the Holocaust.

1462 Establishment of the Frankfurt ghetto; Jews expelled from many German cities and regions.

1473 Blood libel of Trent, Italy, and massacre of converted Jews in Cordoba, Spain.

1470s The first Hebrew printed books are published in Italy, the Iberian Peninsula, and Istanbul.

1481 King Ferdinand of Aragon and Queen Isabella of Castile establish the Inquisition to investigate *conversos* charged with secretly practicing Judaism. A year later, the first autos-da-fé, public burnings of Jews, were held (the last one occurred in 1826, and the Inquisition was abolished in 1834).

1492 Jews forced to convert or expelled from Spain. Some 150,000 Jews are estimated to have left Spain, mainly for North Africa, Italy, and Ottoman Turkey. The ban was officially revoked in 1968.

1497 Jews expelled from Portugal; the ban was revoked almost five hundred years later, in 1996.

1500 The most important centers of medieval Jewish life are either destroyed (England, France, Spain, Portugal) or severely diminished (Germany, Austria). In Eastern Europe, countries around the Mediterranean, and later in Northwestern Europe, Jewish life would resume and flourish.

1500–2000 CE

1516 Venice concentrates its Jews on a separate island, the Ghetto Nuovo, coining the term for a secluded area and inaugurating the era of ghettos in Italy, which would last until 1796.

1517 The Ottoman Empire conquers Palestine and rules this area until 1917 from Istanbul. Safed becomes a major center of Jewish learning, where Josef Caro would publish his four-part summary of the Jewish law, the *Shulhan Arukh* (Prepared Table, 1565) and Isaac Luria would develop a popular variety of Kabbalah (1570); the former creating a solid legal basis for exiles, the latter offering a new interpretation of the tragedy which shook all of Sephardic Jewry.

1553 Poland and Lithuania offer greater freedoms to Jews and become during the next centuries flourishing centers of Jewish learning and culture. During this period, Jews enjoyed more autonomy than they had ever before.

1570 Moses Isserles of Krakow adds, with his *Mappah* (Tablecloth), Ashkenazic customs to the Sephardic *Shulhan Arukh*, thus making the text the enduring code of Jewish law.

1600 The first Spanish-Portuguese Jews arrive in Amsterdam. The Northern Netherlands, converted to Protestantism and fighting for independence from Catholic Spain, became during the following centuries an attractive haven for both Spanish converts and Jews fleeing expulsion, war, and discrimination throughout Europe. Amsterdam soon became the world's center of trade and commerce; though the Dutch granted Jews autonomy and never imposed upon them a ghetto or clothing restrictions, they did exclude Jews from the craft guilds until 1796.

1622 Salamone de' Rossi, court musician of the Gonzaga rulers in Mantua, composed music for the synagogue.

1648–49 Ukrainian Cossack leader Bogdan Chmielnicki kills over 100,000 Jews in Poland and Lithuania, wiping out literally hundreds of communities.

1654 When the Portuguese conquer Dutch Brazil, Jews flee to New Amsterdam (New York), founding the first Jewish settlement in North America.

1656 Baruch Spinoza is excommunicated by the Jewish Portuguese community in Amsterdam for his unorthodox views on the Bible. Though he was forced to publish his rationalist works anonymously, he was in communication with the major European scholars of his time. Spinoza did not convert to another religion, however, as was then the custom; in this sense, he became the first modern Jew.

1666 The Turkish pseudo-messiah, Shabbetai Zevi, causes a stir amongst his many adherents in the Jewish world after he converts to Islam; the messianic fervor causes unrest in the following decades.

1670 Jews expelled from Vienna, families from which found the Jewish community of Berlin.

1700 Gluckl of Hameln, a successful Jewish businesswoman in Hamburg, begins to write her memoirs, providing insight into Jewish (business) life in Europe at that time.

1738 Joseph Suesskind Oppenheim (Jud Suess), successful German financer, is falsely accused of cheating and publicly executed.

1772 The most eminent scholar of the century, the Talmudist and Kabbalist Rabbi Elijah, Gaon of Vilna, bans Hassidism for undermining rabbinic authority. Israel ben Eliezer, called Ba'al Shem Tov (the master of the good Name), created this popular movement about ten years earlier, emphasizing spontaneity and charismatic leadership, and which spread quickly all over Eastern Europe. In 1791, Shne'ur Zalman of Lyady published his *Tanya*, to this day the most influential writing of the Lubavitcher stream of Hassidism.

1782 Joseph II of Austria issues an Edict of Tolerance, the first sign in Europe or America of a movement to accept Jews as equals in society.

1783 Moses Mendelssohn defends freedom of religion in the spirit of Spinoza. He translates the *Torah* to German, in Hebrew script, thus promoting the civil amelioration of the Jews and inaugurating the Jewish Enlightenment. He was a life-long friend of Lessing, the author of *Nathan the Wise* (1779) and proponent of a tolerant Germany.

1791 The Emancipation of all French Jews, two years after the French revolution and 15 years after the American constitution had granted religious freedom to all its citizens. In 1796, Holland followed suit, joined by Italy (1797, withdrawn in 1799, reintroduced in 1870), the German states (1800s, withdrawn in 1815, reintroduced in 1871), Denmark (1814), Sweden (1865), Great Britain (1866), Austria (1867), and Switzerland (1879).

1793 After the second partition of Poland, Russia inherits a large number of Jews, and forces them to relocate to the Pale of Settlement, extending from almost the East Sea until the Black Sea, but excluding Moscow and St. Petersburg. Successive Tsars introduced various discriminatory measures, repressing Hebrew and Yiddish, and Jewish religion and culture in general.

1804–23 German Liberal Jews (later called Reform in the United States) introduce the vernacular, sermons, and an organ into their services, until Prussian authorities put an end to the innovations.

1806 Napoleon calls a Great Sanhedrin to try to secure Jewish allegiance to the state.

1823 The poet and writer Heinrich Heine converts to Christianity, a "ticket of admission into European culture."

1836 Samson Raphael Hirsch publishes his *Nineteen Letters of Ben Uziel*, establishing himself as the founder of Modern Orthodox Judaism, which combines secular modernity with traditional Judaism.

1840 A blood libel in Damascus becomes a public scandal after European Jewish leaders such as Moses Montefiore intervene.

1844–46 Reform Rabbinic Conferences in Germany introduce various radical religious innovations, like the equality between men and women in the synagogue; a few years earlier, in 1838, Rebecca Gratz founded a Hebrew School in Philadelphia, as a first step to women's emancipation in America.

1848 Many Jews participate in revolutionary movements all over Europe.

1853 The first Modern Hebrew novel is published by Abraham Mapu from Lithuania.

1854 Zacharias Frankel opens the Jewish Theological Seminary in Breslau, the rabbinic school of the Conservative movement, which takes a middle position between Orthodox and Liberal (Reform) by promoting a more gradual change in Jewish law. In 1902, the Jewish Theological Seminary in New York (founded 1887), started to train Conservative rabbis for America.

1864 Mendele Moikher Sforim publishes the first modern Yiddish novel, starting a literary revival of the language spoken by East European Jews that lasted until World War II. The last great Yiddish writer, Isaac Bashevis Singer, won the Nobel Prize for Literature in 1978.

1872 Rabbi Abraham Geiger founds the Liberal Seminary for the Science of Judaism in Berlin; in 1873, the American Reform synagogues are united under one umbrella organization (UAHC, now Union of Reform Judaism), currently the largest Jewish denominational movement in the world; in 1875, the Reform Seminary, Hebrew Union College started training rabbis in Cincinnati, later with branches in New York, Los Angeles, and Jerusalem.

1880s Anti-Semitic movement in Germany; anti-Semitic pamphlets in France; Russian pogroms cause mass emigration to the United States.

1894–1906 Dreyfus affair in which a Jewish captain in the French army is accused of high treason; after big public outrage he is finally released from jail.

1896 Under the impact of the Dreyfus affair, the Viennese journalist Theodor Herzl writes his *Jewish State*, laying the foundation for political Zionism and calling for a sovereign Jewish nation; a year later, the first Zionist conference takes place in Basel.

1903 Pogrom in Kishinev (now the Ukraine) leads to international protests, and to further immigration of Jews to Palestine, who establish agricultural settlements and decide to adopt Hebrew as their vernacular language.

1905 The first publication of the anti-Semitic pamphlet *Protocols of Zion*, widely used by anti-Semites up until the present day.

1909 Tel Aviv is founded, a new city near Jaffa, expanded by Bauhaus architects in the 1930s.

1917 British foreign secretary Arthur Balfour "favors the establishment in Palestine of a national home for the Jewish people" in the territory which had recently come under British rule after 400 years of Ottoman control.

1917 In the wake of the Russian Revolution, Jews receive equal rights, which lasted but a few years until Communist repression of Jews and Jewish culture began.

1925 Opening of the Hebrew University in Jerusalem.

1928 Stalin gives the Jews an alternative to Zion: Birobidzjan in eastern Siberia.

1929 During Arab riots in response to Jewish immigration, Jews are killed in Palestinian cities including Jerusalem and Hebron.

1933 Hitler and the Nazis come to power in Germany, introducing a wide range of anti-Jewish measures from racial laws (1935) until the gradual revocation of German citizenship, excluding Jews from all professions and public life. Jews are harassed and openly humiliated.

1938 During the so-called Kristallnacht (November 9–10), synagogues and Jewish property are demolished, and German Jews murdered; others are sent to concentration camps.

1940 After the Nazis conquer much of Europe, ghettos are established in eastern Europe.

1942 In Wannsee, an idyllic suburb of Berlin, the Nazis decide to systematically murder all Jews.

1942–44 The Nazis murder six million Jews in German and Polish extermination camps like Auschwitz, Sobibor, Chelmno, Treblinka, Belzec, and Majdanek by gassing them and other "undesirable elements" such as homosexuals, the Sinti, and the Roma.

1945–47 Survivors wait in German, Austrian, and Italian camps for "Displaced Persons" for a new homeland in the USA or Palestine. British efforts to stop illegal immigration to Palestine results in Jewish terrorism against the British colonial authorities. In Poland, surviving Jews fall victim to pogroms.

1947 Discovery of the *Dead Sea Scrolls* near Qumran, with texts revealing the life of Jewish sects in the two centuries before the Common Era. Many of them are now exhibited in the Shrine of the Book next to the Israel Museum in Jerusalem.

1948 On May 14th, the British evacuate Palestine and the Arab armies invade; declaration of Independence of the State of Israel. A year earlier, the General Assembly of the United Nations voted in favor of the partition of Palestine. Mass migration of Jews from Europe and Arab lands during the following five years doubles the Jewish population to 1.3 million.

1949 Israel becomes a member of the United Nations.

1953 Foundation of Yad Vashem, the organization responsible to commemorate the victims of the Shoah (Holocaust) in Israel.

1956 Sinai (or Suez) Crisis

1960 The Israeli secret service captures Adolf Eichmann, the architect of the systematic mass murder of the Jews. He is sentenced to death at the conclusion of his trial in Jerusalem.

1967 Six-Day War

1973 Yom Kippur War

1979 Israel-Egypt peace agreement

1982 Lebanon War

1985 Claude Lanzmann's nine-hour documentary film *Shoah* makes a profound impression after Gerald Green's 1979 docudrama *Holocaust* received worldwide acclaim.

1987–1993 The first Palestinian Intifada begins, lasting until the signing of the Oslo Accords. The second Intifada would start in 2000 and last until 2005.

1993 Despite unprecedented optimism, the Oslo Peace Accords and other peace proposals do not lead to a permanent peace in the Middle East. The United States Holocaust Memorial Museum opens in Washington; the Jewish Museum New York (founded 1904) completes a major expansion, doubling its exhibition space.

2001 Daniel Libeskind's architecturally impressive Berlin Jewish Museum opens, preceded by other large Jewish museums in European cities such as Amsterdam (1987), Frankfurt (1988), Vienna (1993), and Paris (1998).

2005 The Memorial to the Murdered Jews of Europe, designed by Peter Eisenman in central Berlin, becomes Germany's most important Holocaust memorial site.

The Image
of Judaism

The Hebrew Bible — commonly known as the Old Testament — is the most precious legacy of the Jews. For over three thousand years, it has served as their portable sanctuary. Wherever Jews have lived, whether in biblical Israel or the Diaspora, they kept its stories and laws alive through commentaries that responded to perpetually new challenges. Jewish festivals combine universal themes with specific historical events, and remain relevant as each successive generation adds their experiences to the ancient lore. Jews decorate their sanctuaries, embellish their ceremonial objects, and illustrate their sacred texts with the intent to glorify their abstract God, who is never depicted.

The image of Judaism is as multifaceted as Jewish life, as the decorations in ancient synagogues and medieval Jewish manuscripts show. Centers like Toledo, Prague, and Amsterdam, which maintain their magical appeal to the present day, preserve traces of a golden age in which Jewish religion and culture flourished.

A Living Text

Hebrew Bible, Spain, 14th-Century Manuscript

Hebrew Bible, Printed in Amsterdam, 1724–27

Jews call the Bible *Tanakh*, an acronym formed by the first Hebrew letters of its three constituent parts: *Torah* (Instruction, which contains the five books of Moses: Genesis through Deuteronomy), followed by the *Nevi'im* (Prophets) and the *Ketuvim* (Writings). It is roughly equivalent to what Christians call the Old Testament.

For liturgical purposes, the *Torah* is still written by hand on a parchment scroll. The Hebrew text consists only of consonants, and is otherwise undecorated. Divided in 54 weekly sections, the whole *Torah* is recited annually in the synagogue on Sabbath. Each section is matched to chapters from the Prophets. The Writings are read on specific festivals: the *Book of Esther* on Purim, for example. Interestingly, as Esther is the only book that does not mention the name of God, the scroll from which it is read on Purim may be illustrated. For study, however, codices (bound volumes) replaced scrolls, and the first preserved complete Hebrew bibles date from the ninth century. In these manuscripts, vowels, interpunction, or cantillation marks are added to the consonantal text. Tradition stipulates that certain passages are written (and later printed) in a specific way, as with the example shown here, the poetic *Song of the Sea* (Exod. 15:1–18) celebrating the safe crossing of the Red Sea by the Jews liberated from Egypt. Writing the text in the shape of bricks is a subtle reference to the bricks with which the Jewish slaves were once forced to construct Egyptian cities. The detailed instructions for the accurate transmission of the Hebrew are written in a micrographic decorative pattern surrounding the actual biblical text. On the left page the tiny letters even form the strikingly realistic shape of a long arm, appropriately referring to the "mighty hand and outstretched arm" with which God freed the Jews from Egypt (Deut. 26:8).

According to Jewish tradition, the written Bible is incomplete without oral explanation; it remains a living text by virtue of interpretations answering numerous practical and theoretical issues with which Jews were faced during the past two thousand years. Transmitted, according to tradition, by God to Moses, in the rabbinic view the text needs interpretation in

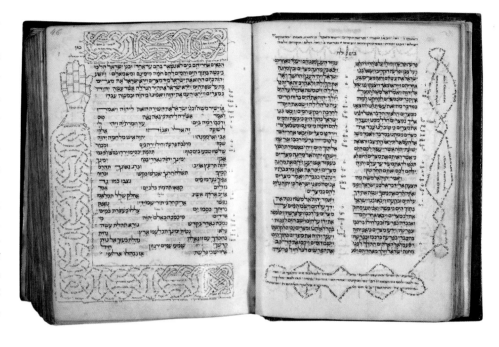

order to stay alive. Given to man, the revelation is "not in heaven" (Deut. 30:12) any more, and God is said to delight in man's autonomy to question the divine word and possession of the power of decision. Studying and questioning texts is the highest ideal in Jewish tradition—even God himself is said to enjoy it. The biblical scholar is said to enter a form of earthly paradise—in Hebrew, *PaRDeS*—by accessing the four types of exegesis: the literal meaning (*peshat*), veiled allusions (*remez*), homiletics (*derash*), and mystical, kabbalistic interpretations (*sod*). The printed bibles illustrate that these often-conflicting views exist, one next to the other, on the same page—views spanning many centuries and spreading across vast geographical regions. A contemporary student reads the bible through the eyes of the commentaries and is emboldened to contribute his or her perspective to those of previous generations, knowing full well that though he may be a dwarf standing on the shoulders of giants, he is nonetheless enabled to see further on.

Exodus 15 on the left page (fol. 46r) is written in layers, in the shape of bricks. In the form of an outstretched arm, tiny words instruct how to read and write the text.

Hebrew Bible, manuscript on parchment, Spain, 14th Century.

University Library Leiden (ms. Or. 1197), The Netherlands

In the middle, on the right, under a decorated panel with the initial word "These" are the first two verses of Deuteronomy: on the left, the second century Aramaic translation by Onkelos. The text is surrounded by commentaries: on the right, the most important and popular one by Rashi (France, 1040–1104), who gives both clear explanations and succinct homiletic interpretations based on his encyclopedic knowledge of all rabbinic literature before him; and on the opposite side, Abraham ibn Ezra (Spain, 1089–1164), concentrates on grammar and the plain meaning of the text. Below them, are the philosophical commentaries of Rabbi Levi ben Gershom, the Ralbag (Provence, 1288–1344), and the Hizkuni (France, mid-13th C.). In the column on the left, one finds Ba'al Haturim by Jacob ben Asher (Germany 1270–1340 Toledo) who plays with the numerical values of the words; Obadiah Sforno (1470–1550), who reflects the humanistic ideals of the Renaissance; and Imrei No'am by Jacob Illiscas (Spain, 14th C.) who explains difficulties in Rashi and Ibn Ezra. Moses Frankfurt printed this magnificent Rabbinic Bible, which received commendations from rabbis in Amsterdam, Prague, and Frankfurt.

Kehillot Moshe, Hebrew Bible, printed in Amsterdam, folio size, 1724–27.
University Library Amsterdam, Bibliotheca Rosenthaliana (ROF 18-21), The Netherlands

A Jewish Pompeii

Synagogue with Wall Paintings, Dura-Europos, Syria, 244–45 CE

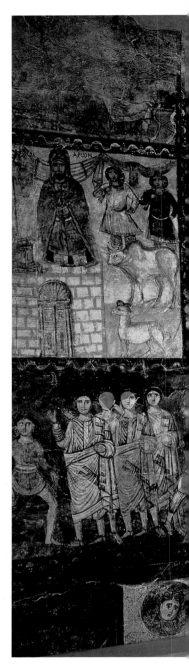

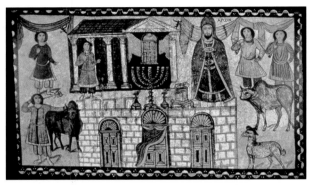

The Consecration of the Tabernacle as described in Exodus 40, is a quite static composition. Three monumental doors in a crenellated wall give access to the sacred sanctuary, represented in the form of a Classical temple, with the traditional implements of worship: the Ark, the menorah, and a rectangular altar flanked by two incense burners. To the right stands a priestly figure clearly identified with a Greek inscription as Aaron, dressed as a Persian monarch rather than a Biblical priest. On either side of the tabernacle are officiates holding trumpets and sacrificial animals, alluding to both the time of consecration in spring and a local lunar festival.
West wall, middle level, to the left of the niche

After some 1,700 years of oblivion, Dura-Europos, a strategically situated town on the right bank of the river Euphrates, was accidentally discovered in 1920 by a British army patrol. In November 1932, archaeologists uncovered in the excavation a remarkably well-preserved third-century synagogue, the walls of which contain a unique cycle of narrative paintings belying any Jewish resistance to figurative art.

The city, founded in 303 BCE in the wake of Alexander the Great's eastern conquests, was named Europos after the Greek birthplace of one of the generals. The Parthians, who ruled it from 113 BCE onwards, called it appropriately Dura (fortress), and in 165 CE, it passed to Roman hands. Although Roman measures to protect the city with extended fortifications against the Sassanian aggressors from the east proved to be in vain—it was conquered in 256 and subsequently deserted—they helped to preserve in perfect condition most of the synagogue.

Reflecting the multiethnic and religious culture of this border town between Roman Syria and the Persian Empire are also less elaborately decorated but equally spectacular Roman houses and baths as well as Greek Temples, a Mithraic sanctuary, and an early Christian house of worship.

The Jews at this outpost originated from those exiles who had not returned to Israel from Babylonia in 533 BCE. From the third century CE onward, Babylonian Jewry under the Persians formed a true center of learning and culture, quickly overshadowing Roman-occupied and war-ridden Jewish Palestine. Dura, this provincial town without Jewish scholars of note, would not appear at all in Jewish history were it not for its most astounding and absolutely unique decorated synagogue—unique not only for Dura, but also for the entire Ancient world.

The western wall with its Torah niche—according to tradition directed toward Jerusalem—is almost completely preserved, while the southern and northern walls only partially. Thanks to a dedicatory Aramaic inscription, we know that the sanctuary—meas-

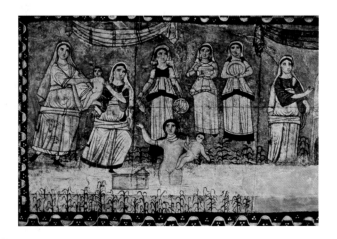

Moses drawn from the river by Pharaoh's daughter. According to a Jewish interpretation, the naked princess is descending into the water to save the child, whom she rightly presumes to be Hebrew. Behind her are three female servants in classical Hellenistic dress, each with a precious golden gift, representing the three nymphs of ancient art present at the birth of an important person. The princess raises her arm addressing the two midwives, Shifra and Puah—according to Jewish legend Moses' sister Miriam and their mother Yocheved assumed these roles to counteract the royal edict to kill all baby boys (Exod. 1–2).
West wall, lower level, to the right of the niche

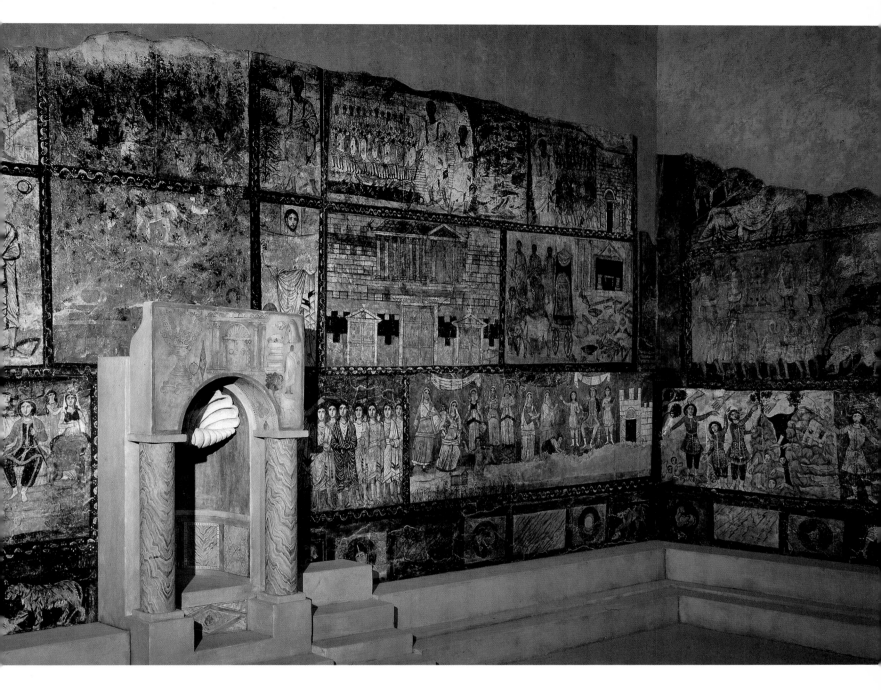

uring almost fourteen by eight meters and nearly seven meters high—can be dated to 244–45 CE, some 75 years after an earlier, smaller synagogue was founded on the same spot. About six years later the biblical scenes on the wall were finished. After another six years, the building was abandoned, covered, and saved by the earthen wall the Romans had put up in anticipation of the Sassanian siege of the town in 256 CE. As can be expected in a border town, the paintings absorb influences from both centers, combining regional Roman and Persian styles.

A total of twenty-eight separate panels with some fifty-eight different biblical episodes have survived, about 60 percent of the total. Most scenes can be easily identified, while others are subject to scholarly debate.

On three superimposed registers, the choice of scenes focuses on Tabernacle and Temple (the biblical forerunners of the synagogue), on messianic themes, and on the delivery of the Jews from Egypt under Moses and the triumph of Mordechai over his Persian persecutor. The episodes, without any specific chronological order, may have been chosen to stress God's ongoing commitment to the covenant with his people and their future redemption—relevant themes in the face of rivaling claims from nascent Christianity and other competing religious ideologies. Above the Torah niche this is further illustrated by a symbolic image of the Temple with, to the left, the menorah (seven-branched lamp stand) and, to the right, the sacrifice of Isaac on Mount Moriah, according to Jewish tradition the place on which the Salomonic temple would later be built.

Creation, Redemption, Revelation

Mosaic Floor
Beth Alpha Synagogue, Israel, 6th Century CE

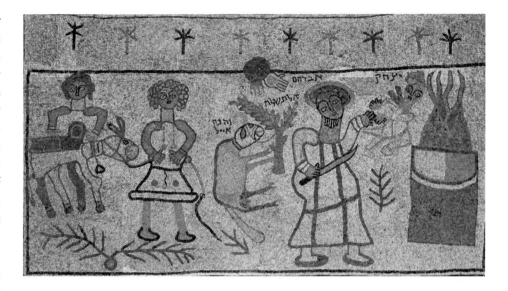

When the Romans destroyed the Temple in the year 70 CE, the synagogue became the central institution of Judaism. Sacrifices solely performed in Jerusalem by a hereditary caste of priests were replaced by prayers and text study under the guidance of scholars (rabbis), a form of worship subsequently adopted by Christianity and Islam. Synagogues can be built wherever Jews may gather, whether in Israel or the Diaspora. According to ancient sources and modern excavations, the presence of alternatives to a central place of worship slightly predates the destruction of the Temple, when modest gathering places served those living too far away from Jerusalem to make the required pilgrimage as well as those who had no sacrifice to offer.

The mosaic floor of the synagogue in Beth Alpha is an astounding example of figurative art that runs counter to the prohibition in the second commandment against making graven images (Exod. 20:4, Deut. 5:8). Yet, as the rabbis astutely pointed out, the verse ends with the admonition, "You shall not bow down to them or serve them," a clarification that permits the creation of images as long as they are not intended for worship. The rabbis may have frowned upon these depictions of human figures—a sun god and the signs of the zodiac—but they were forced to recognize that though statues of Greek and Roman gods decorated the public baths, the Romans did not generally worship their gods there. Times had changed; not even the Jews were suspected of idolatry—if the Romans hardly took the worship of their gods seriously anymore, there was even less of a reason to suspect the Jews of doing so. In a rabbinic treatise dealing with this theme—in biblical times, a serious matter—it is said that the rabbis did not prohibit "designs on pavements" precisely because they realized that such images posed no threat to monotheism.

At the Beth Alpha Synagogue, one would enter the actual hall of prayer via a square courtyard and a narrow vestibule, first coming across an inscription in Greek and Aramaic (a Semitic language similar to Hebrew) on the mosaic floor with the names of the responsible artists, Marianos and Ananias, who created this work in the early sixth century during the reign of the emperor Justin. The first rectangular pan-

el depicts the Binding of Isaac—this biblical story (Gen. 22) is read in Greek order (from left to right) rather than the Hebrew—the two servants are left behind with the ass on the left, and on the right, Abraham (with a nimbus) holds up his son Isaac in one hand and a knife in the other. Behind him, tied to a bush, is the ram that would ultimately take Isaac's place as a sacrifice.

According to the rabbinic interpretation of the story—part of the liturgy and read annually in the synagogue on Rosh Hashanah (Jewish New Year)—the abrogated sacrifice of Isaac is the foundation for the covenant between God and the Jewish people. The mountain on which they climbed was said to be none other than the Temple Mount, the altar the Temple altar. On that site, Jewish liturgy stresses, a new Temple will be built in future, messianic times. It is to this future that the panel in front of the apse with the Torah scrolls refers: a Holy Ark with birds (probably meant to depict cherubs, the winged celestial beings), surrounded by roaring lions, the seven-branched temple menorah, a shofar (rams horn), and other symbols.

Most astounding is the middle scene that depicts the sun god Helios surrounded by the twelve signs of the zodiac and the four seasons, a familiar theme in late Roman art following the third-century establishment of Sun-god worship as the state religion by the

The Binding of Isaac, Mosaic Floor, Beth Alpha Synagogue, Israel, 6th century

Right: The Sun god Helios surrounded by the twelve signs of the zodiac and the four seasons, Mosaic floor, Beth Alpha Synagogue

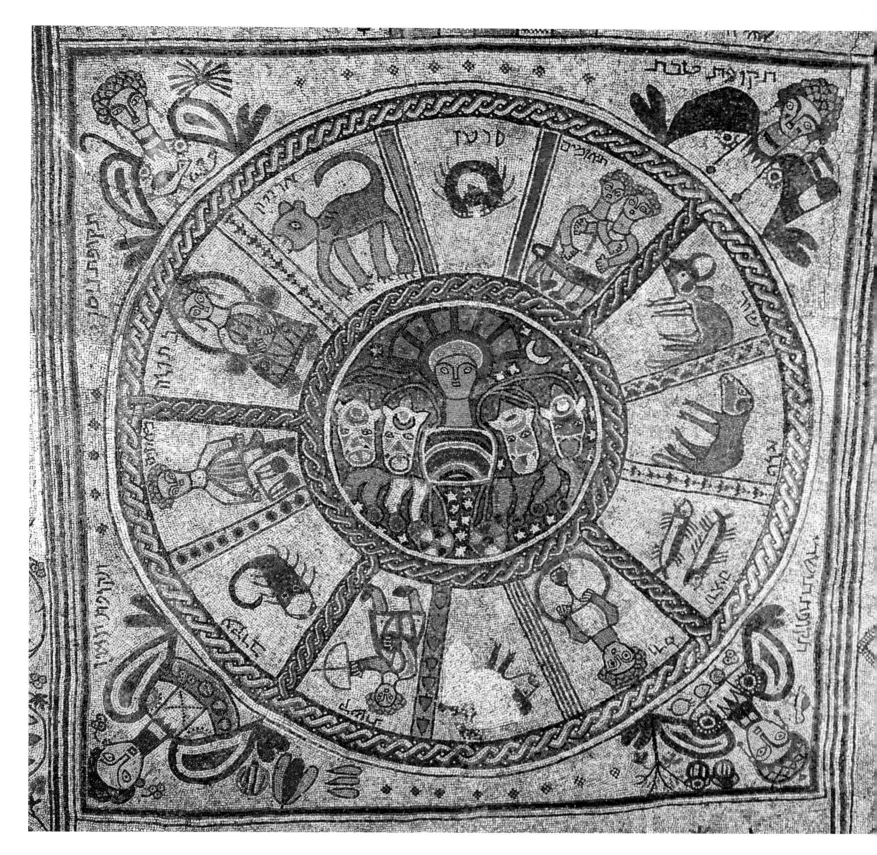

emperor Aurelian. The acculturated Jews who commissioned this mosaic may have justified this scene by referring to liturgical and mystical texts, in which God's cosmic power of creation, and rule over the months and the seasons, was celebrated. If this is indeed the case, then the mosaic has as its iconographic message the three central themes of rabbinic Judaism: Creation, future Redemption, and the divinely transmitted Revelation—celebrated by those Jews that gathered here twice a week on Shabbat and on holidays to read and interpret the Holy Book, the *Torah*. They may have marveled at the mosaics and their subtext as much as we do.

The Precious Legacy of a Glorious Past

The Jewish Quarter of Prague, since the 13th Century

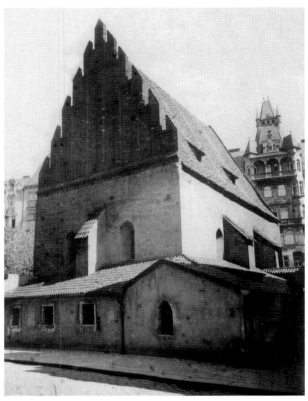

Old-New Synagogue

The thirteenth-century Old-New Synagogue, a free-standing building with a Gothic interior, is the oldest surviving European synagogue still in use. Here every year the victims of the devastating Eastern riots of 1389 are commemorated, massacred in this building when they sought refuge from the mobs. It owes its name to a legend, according to which the foundation stones were brought by angels from the destroyed Jerusalem Temple on condition (the Hebrew *al-tenai* becoming altneu) they would be returned when the temple would be rebuilt in messianic times. The building is said to be protected by the remains of the legendary Golem, that still lie, so the story goes, in the attic.
Together with the adjacent sixteenth-century Jewish Town Hall—note the Hebrew lettered clock—the Old-New Synagogue dominated the surrounding buildings (originally much lower) of the ghetto.

Prague represents the precious legacy of a glorious past: Europe's only preserved (and functioning) medieval synagogue; a romantically historic cemetery in the city center graced by fallen tombstones, narrow paths, and ancient trees; vestiges of the mysterious Golem; the footprints of Franz Kafka; a haunting Holocaust memorial; and an astounding collection of Judaica. Still intact, the former Jewish quarter of Prague is, like the impressive Kazimierz quarter of Krakow, flooded by tourists in search of a vanished world. But while in Krakow the dark shadow of nearby Auschwitz is an overwhelming presence (and left a Jewish quarter in name—and stone—only), in Prague Jewish life gradually resumed after the Velvet Revolution of 1989 (even though Theresienstadt lies not far away).

Prague was one of the many medieval cities with a ghetto, a walled and confined area reserved for Jews. The area, going back to the thirteenth century, roughly coincides with the present noble quarter of Josefov whose elegant middle-class houses are the result of an

Klausen Synagogue

The exceptional three-tiered Ark made from marbled wood in the Klausen Synagogue, dating from 1694, was donated by Samuel Oppenheimer, a wealthy court Jew and army purveyor. The synagogue was built on the site where the famous creator of the Golem, Rabbi Yehudah Loew, once had his Jewish Academy.

urban renewal project undertaken fifty years after the Jews were granted civil equality in 1848. Prior to that, as with most pre-modern Jewish communities, Prague Jews enjoyed autonomy in their social, political, legal, and religious affairs, in exchange for paying taxes to the suzerain, who promised but could not always guarantee protection. They are part of Ashkenazic Jewry, which includes northern Italy and northern France, the Germanic lands, England, and Eastern Europe. Ashkenazi Jews share common customs, a particular pronunciation of Hebrew, and use Yiddish (old German with Hebrew, French, and Slavic words)

as their vernacular. Often caught between conflicting interests of secular and religious rulers, and victims of discriminatory regulations (professional limitations, mandatory distinctive dress and headgear), Jews lived in proximity to their institutions: synagogue, school, ritual bath, bakery, slaughterhouse, town hall, hospital, and other charitable organizations.

From the sixteenth to the eighteenth century, the Jewish community of Prague, at one time numbering ten thousand, was among the largest in the world and the fame of their rabbis and scholars extended far beyond the confines of the ghetto.

Spanish Synagogue

The Spanish Synagogue derives its name from the exuberantly decorated "Moorish" style sanctuary, reminiscent of the fourteenth-century Alhambra. The last major synagogue to be built in the former ghetto was inaugurated in 1868 and offered room to the rapidly growing adherents of Reform practice.

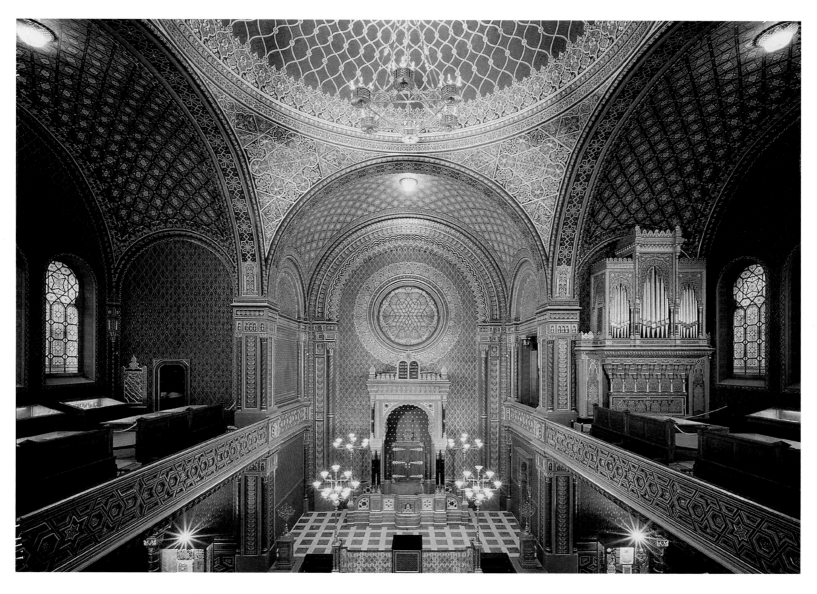

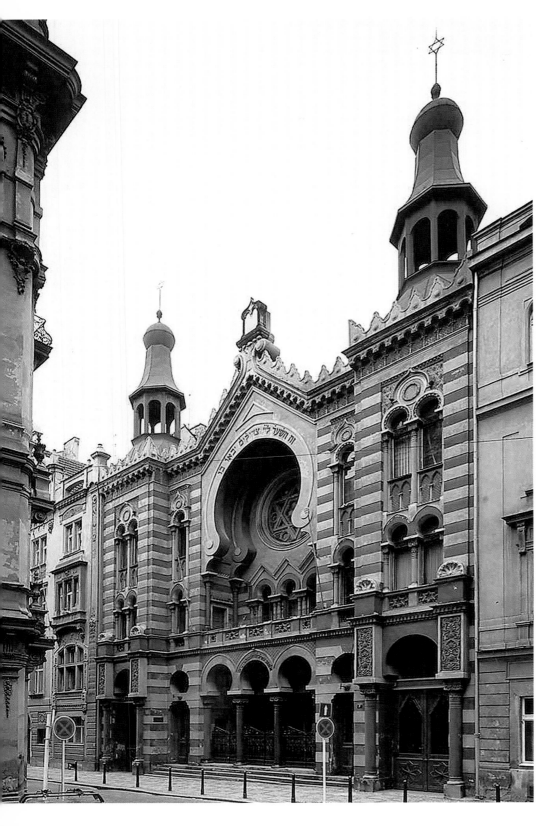

Synagogues, cemetery, and town hall—the remains of the former ghetto reflect the economic success of a few wealthy families who helped finance these buildings. Their religious and historical treasures became part of the public sphere when the Jewish Museum was founded in 1906, shortly after the transformation of the ghetto. Its current vast collection, spread amongst several buildings in the old Jewish quarter, is the result of a Nazi policy which turned the Maisel Synagogue into a warehouse for religious and personal objects assembled from over one hundred and fifty Jewish communities in Bohemia and Moravia: the inhabitants sent to death camps and their possessions registered by Jewish scholars, before their own turn came for deportation.

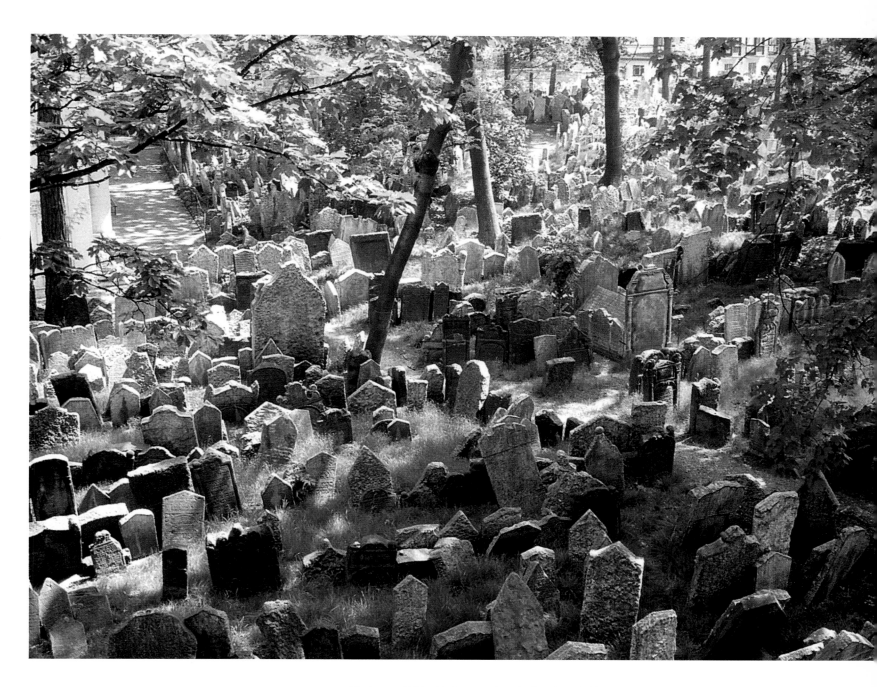

The famous Old Jewish Cemetery dates back to the early fifteenth century; its oldest tombstone dates from the year 1439. There are over 12,000 graves crowded together; space was limited and the dead were buried in twelve layers, accommodating an estimated 100,000 individuals.

According to Jewish tradition, visitors place pebbles on the graves of famous scholars and family members to honor the memory of the deceased. Among the more illustrious people buried here are Yehuda Loew (d. 1609), creator of the legendary Golem; David Gans (d. 1613), the mathematician, historian, and friend of Johannes Kepler; and Rabbi David Oppenheim (d. 1736), renowned collector of Hebrew manuscripts.

Spain's Golden Age

Synagogue "Santa Maria la Blanca," Toledo, Spain, 13ᵗʰ Century

Right: Synagogue "Santa Maria la Blanca", Toledo, Spain, 13ᵗʰ century

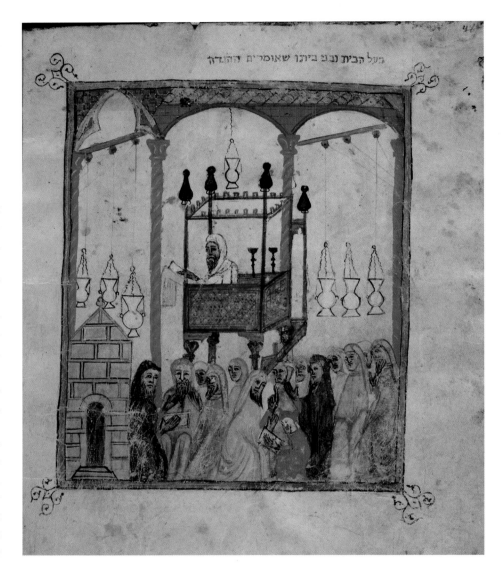

Toledo prides itself on being the oldest Jewish community in Spain. The origins of the Jews allegedly stretch back to the destruction of the first Temple in 586 BCE and the subsequent Diaspora, but their presence was actually documented in the early middle ages. The city, conquered by the Muslims in 712, built a reputation as a Jerusalem reborn, which lasted—under Muslim and, after 1085, Castilian Christian sovereignty—until the Inquisition seven centuries later.

The Jewish quarter was situated in the western part of town. In the fourteenth century, one-third of the approximately 40,000 inhabitants were Jewish and the city boasted of having no less than ten synagogues and five houses of study. Toledo was a center of Jewish scholarship, which included traditional Jewish learning and—under Arab influence—philosophy and sciences like astronomy and medicine. Jews wrote texts in Hebrew and Arabic, and served as translators into Latin. This favorable situation remained unchanged after the conquest of Alonso VI in 1085—Jews and Muslims initially retained their rights and the city kept its Moorish flavor. Beginning in the thirteenth century the situation gradually changed. First under the influence of anti-Jewish policies of the popes, then during the Black Death in 1348 when Jews were accused of having caused the pestilence by poisoning wells, and finally persecutions which swept Spain in 1391 and from which Jewish life would not recover: in 1492 many Jews, faced with the choice between conversion and expulsion, left Toledo and the Iberian peninsula altogether. Those "new Christian" converts who stayed behind, called *marranos* (pigs), were scrutinized by the Inquisition as insincere Christians, and burned at the stake (*auto-da-fé*) under accusation of secretly practicing Judaism.

In their own subsequent Diaspora—whether in Amsterdam, Hamburg, London, the Mediterranean, or the Americas—the Sephardic Jews, all those who once lived in and fled Spain (and shortly after Portugal) remained connected for centuries, proudly adhering to their Iberian heritage. Considering themselves a distinct group—with their own customs, pronunciation of Hebrew, language: ladino (Judeo-Spanish),

and a loyalty to the Spanish and Portuguese languages for literary purposes—they secretly yearned for the now inaccessible "idolatrous lands." The two remaining synagogues of Toledo were converted into churches in the fifteenth century: one founded by Joseph ibn Shoshan in 1203 is known since 1411 as Santa Maria la Blanca; the other, built by Don Samuel Halevi around 1357 is called El Transito, and since 1964 has served as a Jewish Museum.

The Golden Age of Spain would serve as a model for Jewish emancipation and integration in the nineteenth century and serves today as an ideal for contemporary pluralism.

Interior of a Spanish synagogue with Moorish lamps hanging from the ceiling. In the middle, the raised covered platform from which the service is lead (and the *Torah* is read); the congregation listening and praying attentively. The gabled structure on the left may be the Torah shrine.

Golden Haggadah, ca. 1350. British Library, London, United Kingdom

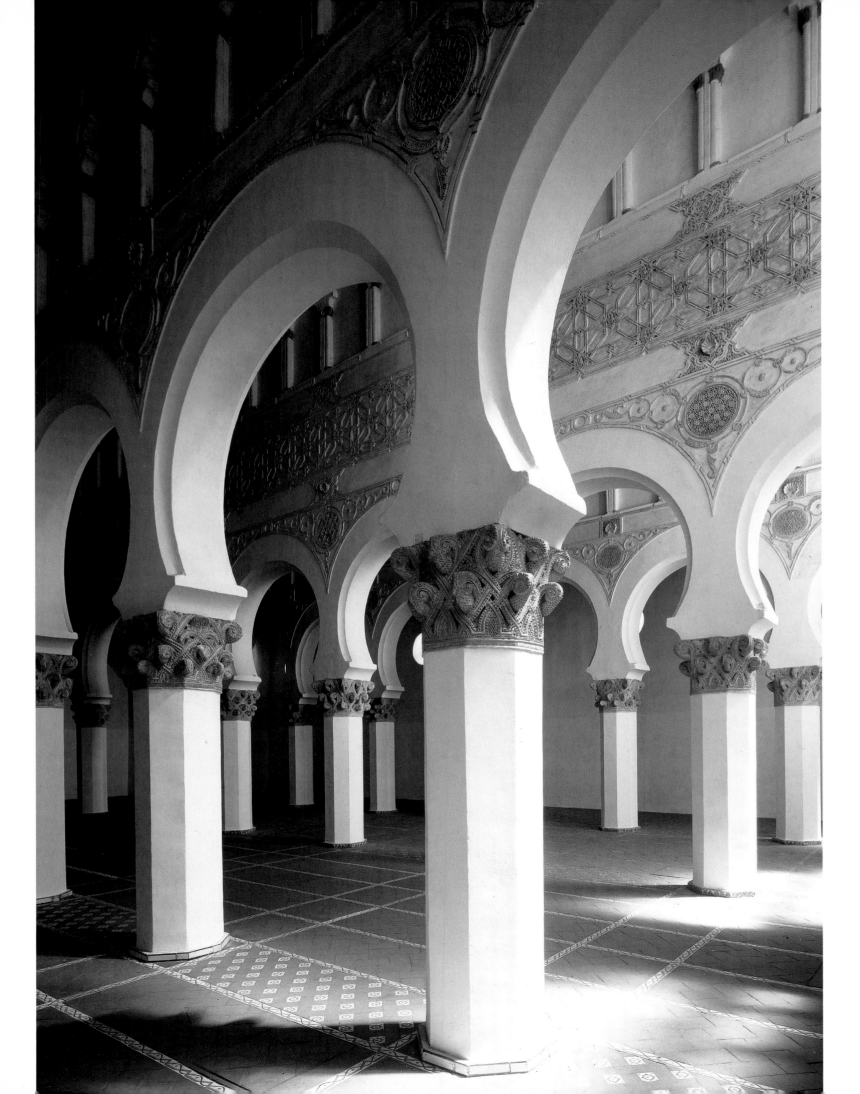

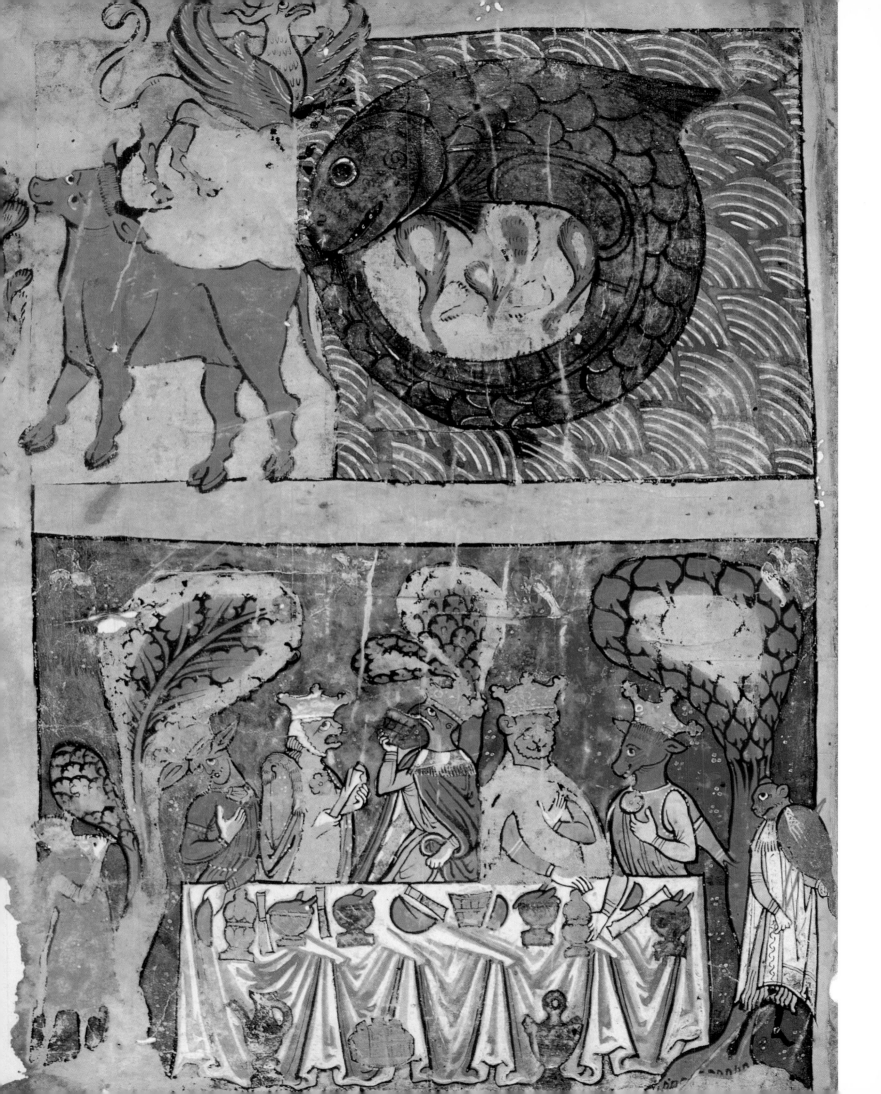

God's Favorite Fish

The Meal of the Righteous in Paradise, Ambrosian Bible
Ulm, Germany, 1236–38

Even more astounding than this full-page illustration at its very end—three large animals above a festive banquet enjoyed by animal-headed beings—is the fact that the name of the scribe of this giant three-volume medieval Hebrew Bible manuscript is known: Jacob son of Samuel. It is even known that he wrote the text in the years 1236–38 for a certain Joseph son of Moses, a wealthy patron of the southern German town of Ulm, which rose to prominence after receiving city rights from Emperor Frederick Barbarossa in 1181. In the thirteenth century, a synagogue existed and Jewish life flourished, but the town's prosperity was brought to an end in 1349 by a European-wide epidemic of pestilence.

At the top of the page are depicted a large fish with its fins and scales clearly marked, a red ox with split hooves, and a winged dragon-like bird; below, five crowned figures with animal heads enjoy food and drink, flanked by two musicians with features resembling lion cubs playing the flute and the vielle (a precursor to the violin), respectively. It is a unique combination of the banquet of the righteous in paradise and their food, consisting of the fish Leviathan, the wild ox Behemoth, and the mythical bird Ziz. In post-biblical times, the rabbis developed a variety of ideas about a hereafter, which they call the "world to come." Preceded by an apocalyptic battle between good and evil, the coming of a messiah, and a final judgment, the righteous would be resurrected and sit crowned, enjoying an eternal Sabbath, eating and studying in the presence of God. What they would study was clear: the Bible and rabbinic texts—works so open to interpretation and debate that there would not be a dull moment.

But what would they eat in the hereafter? Would the cumbersome and very detailed dietary laws still apply? As a reward for their strict adherence to the laws, the righteous would be permitted to eat the legendary beasts to which the Bible refers—kosher food for kosher lives. According to the Bible, kosher food includes fish with fins and scales, birds but not birds of prey, and animals with split hooves that chew the cud. Leviathan is identified as a big fish, so large in fact that it must roll itself up in the waters of creation

(see Pss. 74 and 104, Isa. 27, and Job 3, 40, and 41). The rabbis interpret an unfamiliar word, *magginim* (Job 41:7), as scales, and thus consider the Leviathan a kosher fish. In the illustration, its fins and scales are clearly accentuated, as well as its big eyes, which according to Jewish legend shed a splendor such that they frequently illuminate the sea. God's love for this fish is demonstrated in the rabbinic story about how God spends his twelve-hour day after creating the world—three hours he studies his own *Torah*, three hours he judges the world, three hours he provides for the needs of his creatures (some say matchmaking between men and women), and for three hours he plays with Leviathan. According to Jewish legend, at the end of days God will construct shelters for the righteous from the skin of his favorite animal so they may truly enjoy their fish dish.

As Leviathan is the ruler of the fish in the sea, so Ziz is the master of the birds in the air (Pss. 50 and 80), and his name originates from the variety of exquisite flavors of its flesh—*zeh* ("like this" in Hebrew) and *vezeh* ("and like that"). Ziz's flesh is such a delicacy that it will be served to the pious at the end of days to compensate for their abstention from eating unclean fowl. That his ankles rest on the earth and his head reaches the sky we clearly see in the illustration.

Behemoth (Pss. 50 and 80) is believed to be a wild ox, so large that it sits on a thousand mountains, and eats all kinds of different food and herbs. In the future world the righteous will enjoy the spectacular taste of this undoubtedly kosher animal; after all, it is split-hoofed. They will be compensated once more, this time for abstaining from all mammals that neither chew their cud nor have split hooves, (i.e. are not considered kosher by Jewish law).

The righteous all have animal heads (deer, lion, eagle, bear, and donkey). Animal- or bird-headed figures, or figures lacking facial features, are characteristic of southern German Jewish manuscripts from the thirteenth and fourteenth centuries. It should be noted, however, that in Christian art, the righteous, such as the evangelists, are also frequently depicted with animal heads.

The Meal of the Righteous in Paradise, Ambrosian Bible, Ulm, Germany, 1236–38.

Ink and gouache on parchment, 45.3 × 34.3 cm (17 13/16 × 13 1/2")
Biblioteca Ambrosiana, Milan, Italy

Wandering with a Promise

Sarajevo Haggadah, Barcelona, Spain, 14th Century

At Passover, Jews celebrate their liberation from slavery in Egypt. Each generation is called upon to identify with the fate of their suppressed ancestors in Egypt and enjoy their eventual liberation. The *Haggadah* (narrative), a book composed of biblical and rabbinical texts, serves as a manual and starting point for further debate during the Seder (the Passover meal). Stories, songs, symbolic foods, and the specific dishes of the meal dramatically evoke the liberation from past suffering and the promise of future redemption in messianic times. Young and old actively participate in the reciting, singing, drinking, and eating, while debating opposing views of slavery and freedom.

The *Haggadah* became the most popular Jewish text, illustrated with miniatures and later—after the invention of book printing around 1450—with prints, in literally thousands of editions.

In late medieval Europe, *Haggadah* manuscripts were embellished for the first time with illuminations, primarily text illustrations. About fifteen *Haggadot* from fourteenth-century Spanish Catalonia even contain whole narrative cycles preceding the text, recording the biblical story from creation until the exodus from Egypt or as far as Moses' death. Whereas in Christian manuscripts the selection of scenes is determined by typological considerations (i.e. the Old Testament foreshadowing the New Testament), these Jewish liturgical texts depict the stories in chronological order without any ideological distinction between theologically important events and simple narratives. Surprisingly, the biblical scenes in these *Haggadot* have no direct connection with the Passover ceremony, the Exodus of course excepted.

One of the most famous Jewish manuscripts is this *Haggadah*, which a Jewish child in 1894 brought to school in Sarajevo after the death of his father. The book was sold and ended up in the city museum. The *Sarajevo Haggadah* became instantly famous due to its facsimile and scholarly publication in 1898 by the Viennese art historian Julius von Schlosser and the Jewish scholar from Budapest David Kaufman; and it was to have a groundbreaking influence on the study of Jewish manuscripts just as the exhibition of Isaac

Strauss' Jewish ceremonial collection at the *World Exposition* in Paris (1878), the discovery of painted walls in the excavated synagogues of Dura, Syria (1932), and the floor mosaics in Galilean synagogues (the 1920s) had on the study of Jewish decorative arts. With these works, it was clear that despite negations by Jewish and non-Jewish scholars alike, there indeed existed something like Jewish art—art commissioned and sometimes even produced by Jews. These discoveries in turn contributed to the self-awareness of emerging Jewish artists and to the establishment of the first Jewish museums. For the first time, Jewish art could no longer be considered an aberration. Jews not only studied sacred texts, but also used illustration to elucidate the books of their ancestors.

The *Sarajevo Haggadah* was commissioned by a wealthy Jewish aristocrat with access to the court, probably from the city of Barcelona as the coat of arms and family crests on one of its pages seem to suggest. This precious manuscript probably left Spain together with the expelled Jews in 1492, most likely to Italy as a note by a Roman censor from 1609 suggests.

Text illustrations accompany the actual *Haggadah*. Whereas twenty-eight folios (double pages) at the end contain Hebrew poetry form the Golden Age of Jewish Arabic culture (from the tenth to the thirteenth century), the thirty-four folios preceding the liturgical text contain an unusually full cycle of some seventy biblical scenes from Genesis till the end of Deuteronomy—the most extensive of its kind in Christian Jewish Spain. It starts with almost abstract depictions of the creation and concludes with a summarized, full-page depiction of the Temple and its successors: the Jewish home in which Passover is prepared and an equally full-page synagogue interior.

"Why is this night different from all other nights?" the children ask during the ceremony. The answer takes us from the first Jews leaving home, Abraham, Jacob and Joseph, through biblical Egypt, to the rabbis of ancient Palestine, medieval Spain, Italy, Sarajevo, and beyond. The story of exile never seems to end; the promise of redemption lies in the future.

Sarajevo Haggadah, Barcelona, Spain, 14th century.

Illuminated manuscript on parchment, 142 pages, 22 × 16 cm (8 $^{11}/_{16}$ × 6 $^{5}/_{16}$")
Sarajevo National Museum, Sarajevo, Bosnia-Herzegovina

Folio 1 verso, folio 2 recto

The first three days of the creation of the world are depicted in four rectangles from right to left as in the order of the Hebrew text. (Above right) God's spirit moves over the face of the waters in the form of golden rays — in accordance with Jewish tradition, God is represented symbolically; (above left) God separates the light from the darkness; (below right) the second day — the separation of the waters is represented in a circle — followed by the third day, on which the waters are gathered together in one place, and the earth put forth vegetation.

Next to it, folio 2 recto shows (above right) the fourth day with the sun, moon, and stars, and the fifth day when birds, fish, and animals are created. (Below) The creation of man on the sixth day, and finally, (below left) Adam resting on Shabbat.

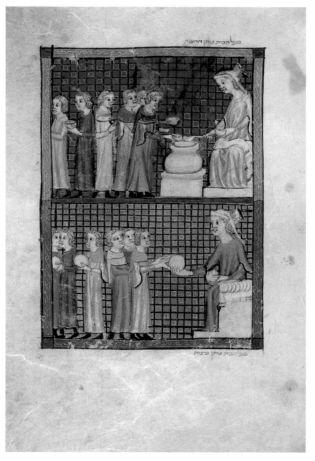

Folio 20 recto

This is the only known Jewish manuscript depicting Joseph's death. As the Hebrew bible only mentions Joseph's embalming and tells his coffin is placed in Egypt (Gen. 50:26), rabbinic interpretation asks where in Egypt? And their answer: in the Nile, so as to prevent the Egyptians from finding him and giving him, their revered viceroy, burial according to pharaonic customs. Below is the discovery of the infant Moses in a wooden cradle similar to Moses' casket, also in the Nile (Exod. 2:5–8) — a reminder of the oath the Israelites had sworn to Joseph that they would bring the coffin with Joseph's bones with them upon leaving the land of Egypt.

Folio 33 verso

A medieval Passover celebration: Above, the host serves *haroset* (one of the special dishes of the Seder, the Passover meal) to members of the household; Below, he serves enough round *matzot* (unleavened bread) to each person to last the Seder.

The Dutch Golden Age

17th-Century Synagogues in Amsterdam, The Netherlands

There has always been something unique about Amsterdam's Jewish quarter, clustered around the seventeenth and eighteenth century synagogues that still stand on Jonas Daniël Meijer Square. Initially, the Jewish immigrants who fled the Inquisition on the Iberian Peninsula were regarded with some suspicion, a product of traditional Christian prejudice. Yet, during the Eighty Years War for Dutch independence from Roman Catholic Spain (1568–1648), the Protestant burgomasters did not lose sight of the commercial importance of the Sephardim (Spanish and Portuguese Jews) whose international connections and knowledge of languages was an additional impetus for the city's economic growth. As a consequence, a blind eye was turned to the influx of impoverished Ashkenazi Jews, fleeing from persecution in Central and Eastern Europe.

Not just a question of economics, civil tolerance and religious freedom were important principles for Holland in general, and Amsterdam in particular, as a Dutch law of 1579 prohibiting persecution on the basis of faith attests to. For centuries, the commercial city of Amsterdam served as a haven for refugees of many persuasions as Jews, Protestant dissenters, and Catholics all benefited from the city's climate of tolerance. Without the constraints of a ghetto or distinguishing dress that were common elsewhere in Europe, Jews lived in the same neighborhoods amongst the non-Jewish majority. Professionally, though, Jews were barred from most guilds and, as a consequence, the majority was forced to earn a living as street traders, peddlers, used clothing dealers, diamond polishers, or printers of Hebrew books. Although their freedom was not unlimited, Amsterdam's Jews enjoyed a remarkable position during the Dutch Golden Age of the seventeenth century—certainly when compared to that of Jews living elsewhere in Europe.

Like other religious minorities, Jews held their first prayer services in converted houses. By 1674, the 5,000 Ashkenazi Jews in Amsterdam already outnumbered Sephardim two to one. Small wonder that both communities needed new synagogues. The large Portuguese Esnoga was solemnly opened in August 1675

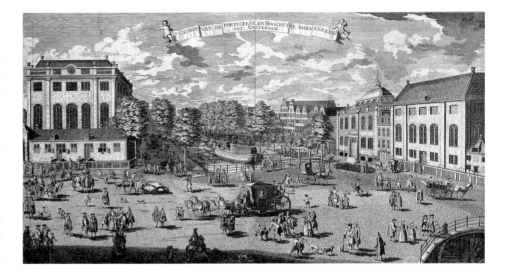

during an eight-day celebration, echoing the inauguration of the Jerusalem Temple, whose layout also served as inspiration for the tall central synagogue situated in a courtyard surrounded by low buildings. It was built by Elias Bouman (1636–1686), the same architect responsible for the Great Synagogue standing opposite, dedicated four years earlier on March 25, 1671. These were the first outwardly recognizable monumental synagogues built in Europe and formed an integral part of Amsterdam's cityscape.

The Portuguese synagogue and its community were quite literally "in the picture" for contemporary visitors and artists alike, from both Holland and abroad. The most famous visitors, albeit to an earlier sanctuary, were Henrietta Maria, Queen of England and Stadholder Frederick Henry of Orange, who were welcomed in 1642 by the teacher and book printer Rabbi Menasseh ben Israel—the first of many visits of the still ruling royal house of Orange to synagogues.

Artists were particularly fond of the Portuguese synagogue, no less so than the mansions of the wealthy Portuguese Jews that lined the canals. Dutch rabbis were amongst the first rabbis ever to be portrayed, one of them, Menasseh ben Israel, presumably even by Rembrandt, whose younger contemporary Jacob van Ruysdael, the great landscape painter, was fascinated by the Portuguese Jewish cemetery in nearby Ouderkerk on Amstel. Emanuel de Witte, the most

Today the restored Great Synagogue is part of a complex of four synagogues; the others are the Obbene Shul (1685–86), the Dritt Shul (ca. 1700), and the Neie Shul (1750–52), with its magnificent dome designed by Frederik Maybaum (d. 1768). The Holocaust left these buildings without congregations. Since 1987, they have housed the Jewish Historical Museum of Amsterdam.

Adolf van der Laan, *The Synagogues of Amsterdam*, c. 1752.

Engraving.
Bibliotheca Rosenthaliana, Amsterdam, The Netherlands

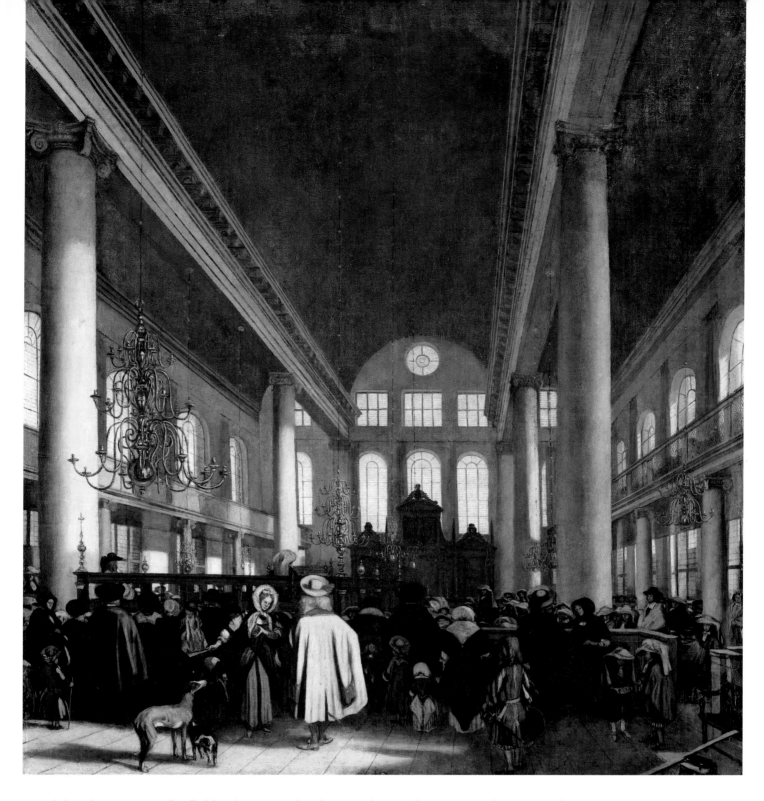

famous painter of church interiors in the Golden Age, depicted the splendid interior of the Portuguese synagogue no less than three times: one version is known to have been in the possession of, and perhaps commissioned by, David de Abraham Cardozo, a wealthy Jewish merchant and shareholder in the Dutch East India and West India Companies.

In January 1795, French troops occupied the Dutch republic, and "liberty, equality, and fraternity" found their way to the Netherlands. On September 2, 1796, following a stormy debate, the National Assembly resolved unanimously to grant Jews full civil rights. In around 1900 almost 60,000 Jews, more than half the Jewish population of the Netherlands, lived in Amsterdam. The Nazi invasion on May 10, 1940 took the Netherlands by surprise and for Dutch Jews, a tolerated and never-persecuted minority, it came as a crushing blow. Of the nearly 80,000 Jews living in Amsterdam in 1941, barely 15,000 survived the war, either in hiding or in concentration camps. Jewish life resumed after the war and, despite its small size, the Portuguese community of five hundred still holds services at the Esnoga and prides itself on its famous library Ets Haim.

Emanuel de Witte, *Interior of the Portuguese Synagogue in Amsterdam*, 1680.

Oil on canvas, 100 × 99 cm (39 3/8 × 39").
Rijksmuseum, Amsterdam,
The Netherlands

Hanukkah: A Political Story

Pieter Robol II

Hanukkah Lamp, Amsterdam, The Netherlands, 1753

During the month of December, when the days are shortest, the Jewish people light candles on eight consecutive nights. The festival Hanukkah (Hebrew for dedication) celebrates the liberation in the second century BCE of the Temple in Jerusalem by the Maccabees, who led a revolt against their Syrian rulers for desecrating the central sanctuary and established a short-lived, independent Jewish state.

Jewish tradition, however, didn't preserve this heroic story; the books bearing the Maccabee name were not included in the canon of the Hebrew Bible, but survived in Greek and were preserved by Christians as apocryphal texts added to the Christian Bible but lacking rabbinic authority. Apparently, the rabbis who served as the final editors of the sacred text of the Bible in around 100 CE were concerned about the violent nature of the story; bothered by the military aspects of a tale glorifying a dynasty that became corrupt and would ultimately, in the first century CE, contribute to the loss of independence and the destruction of the Temple. As a result, whereas all other Jewish festivals have a solid biblical foundation, Hanukkah is nowhere mentioned in the Hebrew Bible. What does Hanukkah really celebrate, the rabbis pondered centuries later. They came to emphasize a miracle as the source of the festival: a small lamp containing enough oil to keep the seven-branched Temple candelabrum lit for one day miraculously lasted for eight! Throughout Jewish history, Hanukkah was considered a minor Jewish festival and not extensively discussed by the rabbis. Modernity would change that.

In the late nineteenth century, Zionists happily reclaimed the Maccabees as forerunners in the fight for renewed political independence, and in present-day Israel, this aspect is accentuated, and the Maccabiade became the Jewish equivalent of the Olympic games. At the same time, the Maccabees who fought against Jews collaborating with the Hellenized Syrians became the heroes of Orthodox Jews in their battle against Reform Judaism in particular and modern assimilation in general.

Conversely, many modern religious and secular Jews are encouraged by the story of a minority fighting for (religious) pluralism. For them, not all outside influences are negative. On the contrary, they point out: We owe our synagogue to the Greeks! Looking at modern sermons and songs, Hanukkah became the festival with the most ideological overtones. Even Jews who neglect their religion celebrate Hanukkah, which is now no longer considered only a minor festival. The Jewish refusal to assimilate into Greek majority culture has ironically given Hanukkah the status of a major Jewish holiday because of its proximity to Christmas. While in cities of the Diaspora with significant Jewish populations Hanukkah is the festival of competing lights, in Israel it is the celebration of victorious fights. In a clear polemic against exuberance and physical might, the prophetic text the rabbis once had chosen for reading in the synagogue, now sounds as a warning: "not by might, nor by power, but by My spirit, says the Lord of Hosts" (Zech. 4:6).

This precious, large-scale silver lamp was designed and crafted in 1753 by the fine Amsterdam silversmith Pieter Robol II (1733–1769) for the monumental Great Synagogue of Amsterdam (built in 1671). Today, it still stands in its original place before the Torah ark in this building, now part of the Jewish Historical Museum. The setting of the lamp alludes to the seven-branched lamp that once stood in the Temple in Jerusalem and the shape bears the same origin, dating back to a medieval tradition when European synagogues possessed a large, nine-branched standing lamp enabling travelers away from home to celebrate Hanukkah. Sarah Rintel (ca. 1690–1761) donated this particular lamp on the first day of Hannukah in 1753 on behalf of herself and her late husband, with the stipulation that the widow would annually donate candles (a total of forty-four) to last the eight days of the festival.

Politically and culturally, this lamp and its donation mark a time when Jews of German descent began to supersede their brethren from Spain and Portugal in prominence and influence in the Dutch capital.

Pieter Robol II, Hanukkah Lamp, Amsterdam,
The Netherlands, 1753.

Silver, 102 × 131 × 44.5 cm (40 1/8 × 51 9/16 × 17 1/2").
Hebrew inscription: "This lamp is a gift of the late trustee Haim, son
of trustee Jozef Levi, and his wife Sarah, daughter of trustee Itsik Rintel,
on the first day of Hanukkah (5)514 (December 21, 1753)."
Joods Historisch Museum, on loan from NIHS Amsterdam,
The Netherlands

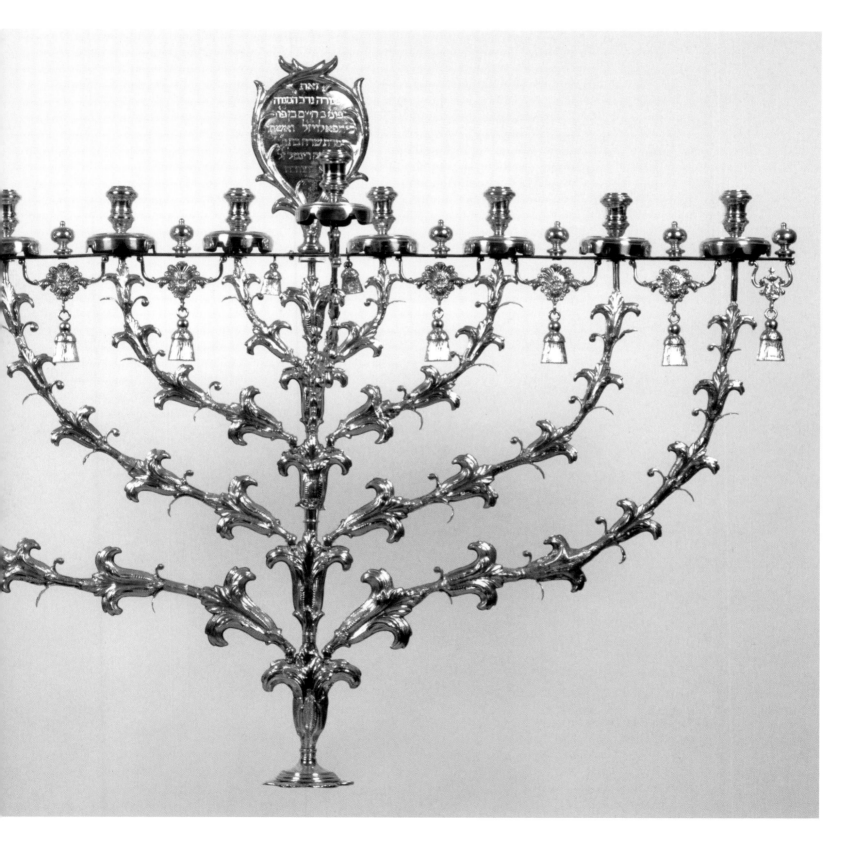

Jewish Emancipation and Jewish Art

Before 1800, Jewish communities enjoyed autonomy: they could live, to a large extent, according to their own laws and regulations. Christian society, and to a lesser degree Islam as well, imposed restrictions on Jews, limiting them professionally and sometimes forcing them into separate areas. Yet, Jews never lived completely separate from society at large — even while in the ghetto there was exchange with the outside.

Equality before the civil law — granted to the Jews first in the United States of America and France, in 1789 and 1791, respectively, and later in other countries — did not guarantee equal opportunity in society, as Jews were quick to discover. The emancipation of the Jewish religious and cultural minority turned out to be a slow process, in which the Jews tried to integrate into society at large — sometimes successfully, but often stumbling over Christian religious or modern racial prejudices.

Wherever possible, synagogues were turned into landmarks in the cityscape and outward symbols of a new self-consciousness. For the first time, Jewish artists successfully presented Judaism to the outside world, or alluded to their background more indirectly. Others explored traces of past Jewish material culture and contributed to a modern renaissance of Jewish art, or to innovations in the arts in general. Despite setbacks, the spirit of optimism prevailed—in Europe, in America, and in Israel where the first pioneers had settled.

Loyalty to Faith and Fatherland

Moritz Daniel Oppenheim
Return of the Jewish Volunteer from the Wars of Liberation to His Family Still Living in Accordance with Old Customs, 1833–34

Moritz Daniel Oppenheim (1800–1882), the Rothschild of painters—thus called because of his early success and later wealth—was born in the ghetto of Hanau near Frankfurt. From early childhood, his parents stimulated him to pursue his artistic talents and, after studying in Munich—and travels to Paris and Italy—he moved to Frankfurt. There he became the painter of the Rothschilds and, at the same time, as an art dealer helped them acquire an impressive collection.

The *Return* is a painting with a message. It was commissioned by the Jewish community of Baden and donated to Gabriel Riesser in gratitude for his help securing their equal rights. The principles of Oppenheim, Germany's first renowned Jewish painter, and Riesser (1806–1863), the political spokesman of German Jewry, coincided: "yes" to emancipation but "no" to religious surrender in the form of conversion or assimilation, and the steadfast belief that loyalty to both the Jewish faith and the German fatherland need not be in conflict.

The setting of the painting is a traditional Jewish home on the Sabbath, the weekly day of rest. A soldier in military uniform returns safely to his family after contributing to the defeat of Napoleon and the liberation of Germany in 1813. Lovingly embraced by his elder sister, his mother and the two youngest children look at him in admiration, his father turns away from a book to stare bewildered at the Iron Cross his son received for bravery, and his helmet and sword enthrall another brother. The home is traditional indeed: all men except the returned volunteer wear skullcaps, and the mother's head is covered, as tradition prescribes for married women. The ceremonial wine cup over which the Sabbath is sanctified and the *challah* (braided bread) are on the table, above which hangs a brass Sabbath lamp. Next to a bookcase with heavy Hebrew volumes hangs a *mizrach* (plaque) indicating the direction of prayer, and on the bottom shelf in the corner stands a spice tower used to mark the end of the Sabbath. On the left wall hangs, as a significant reference to the family's allegiance to Germany, an equestrian portrait of Fredrick the Great of Prussia, the eighteenth-century soldier-king who pro-moted religious tolerance. Other details subtly point to the modernity of the family as well: under the Hebrew book the father was reading (a *Bible* or a *Talmud* with rabbinic commentaries) is a copy of a German newspaper, the *Vossische Zeitung*.

The *Return* became an immediate success, and in gratitude Riesser praised the work as "pairing enthusiastic love of the fatherland with deep devotion to religious family life." A lithograph was produced in 1838 and eventually the painting would become, in a slightly different version, part of one of Germany's most popular Jewish books: *Scenes from Traditional Jewish Family Life*, accompanied by texts from the moderate Reform rabbi Dr. Leopold Stein (1810–1882). Rather than reflecting a nostalgic yearning for the past, the *Return* is, despite its old fashioned garb, a political statement. The period in which it was painted, the 1830s, marked the years in which the French revolutionary ideas of "liberty, equality, and fraternity," which greatly influenced Germany, were threatened by restoration and reaction. The period after the *Return* first appeared in print in the 1860s, witnessed a new dawn of these ideas and the first fulfillment of their promise: Jews were for the first time granted equal rights in the united Germany (1871).

Oppenheim illustrates how a family combines religious observance and Jewish learning with secular, political involvement. He emphasizes that Jews successfully acquired (German) middle-class values by placing the fancily dressed mother, the guardian of Jewishness, in the center of his composition. Indeed, nowhere in this work does Oppenheim link tradition to the negative aspects of the recently abolished ghetto. He sanctifies Jewish family life in the synagogue, but primarily at home. His new Jewish quarter is the sheltered bourgeois living room in which timeless ancient rites are meaningful models for the present, and in which a honorable past serves as a guarantee for self-assurance.

Religion redefined and integrated into modern life did not contradict with Jewish allegiance to the new nation, and Jews considered themselves as German citizens, though of the Mosaic persuasion.

Moritz Daniel Oppenheim, *Return of the Jewish Volunteer from the Wars of Liberation to His Family Still Living in Accordance with Old Customs*, 1833–34.

Oil on canvas, 86.4 × 91.4 cm (34 × 36").
The Jewish Museum, New York, USA. Gift of Mr. and Mrs. Richard D. Levy

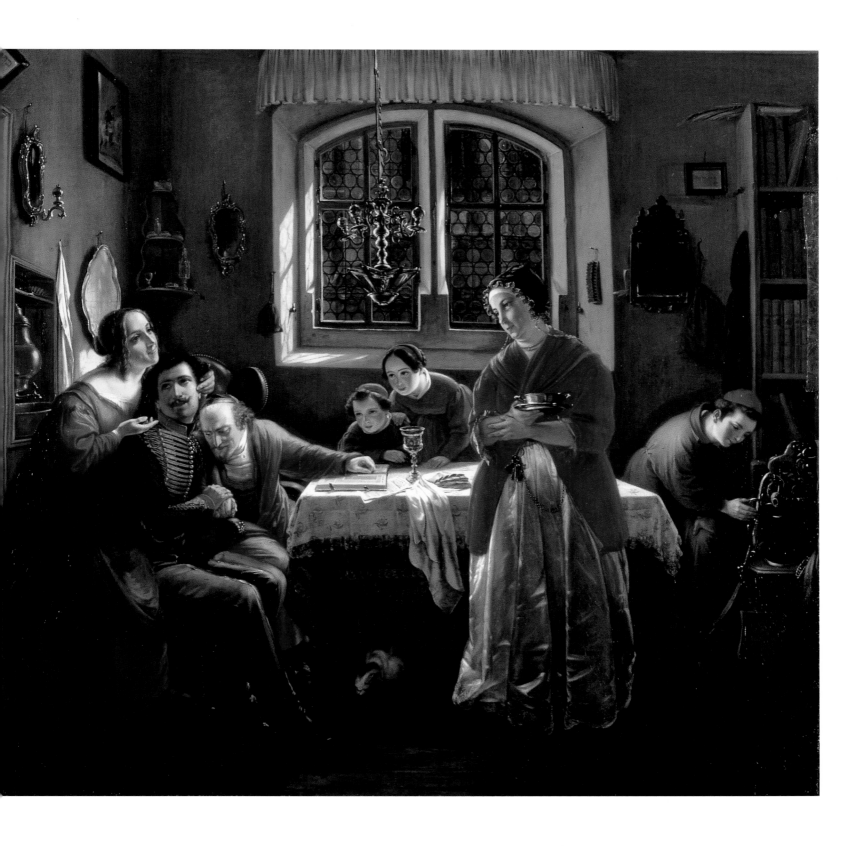

An Oriental Wedding Feast

Eugène Delacroix
Jewish Wedding in Morocco, ca. 1839

When first exhibited at the Paris salon of 1841, the canvas created a sensation and was immediately acquired by the Louvre. *The Jewish Wedding in Morocco*, completed a few years before, was based on sketches and written notes Eugène Delacroix (1798–1863) made when he was invited to join a diplomatic mission to Morocco in 1832. He was fascinated with the exotic street life in the cities, but due to the traditional seclusion of Muslim women who cover their faces, his attention was diverted to Jewish women, who he found "at once beautiful and pleasing, their habits having a certain dignity that excludes neither grace nor coquetry." His guide, interpreter, and host, Abraham Benchimol, who worked for the French consulate in Tangier, introduced him to the private world of Moroccan Jews and even invited Delacroix to attend his daughter's wedding.

Yet, the scene Delacroix chose to represent is unusual, as it does not depict a traditional wedding ceremony—bride and groom standing under a wedding canopy, surrounded by parents and guests, addressed by the rabbi speaking the blessings over a glass of wine and reading the marriage contract, the groom placing the wedding ring on his bride's finger and breaking a glass, triggering a wave of shouts by the celebrants, "mazal tov!" (good luck). Instead, Delacroix became enamored with the festivities right after the ceremony, which among Moroccan Jews lasts for up to a week. He was enthralled by its liveliness: the singing, dancing, and eating.

In the brightly lit courtyard, he depicts the women guests on the right side and the men on the left, separated from each other according to Jewish tradition. The beautifully dressed women are seated on pillows, low stools, and rugs; a bearded man stands in the gateway (could it be the bride's father, Benchimol?). Judging by their clothing, the group of men also includes Arab guests—in lively conversation, offering coins, or admiring the barefooted dancer slightly to the left of center. Encouraged by the man on the left foreground, she forms the real center of attention, elegantly dressed, but not as fancy as the bride would be (we know as Delacroix painted a separate watercolor) and dancing to the rhythms of the three musicians next to her, playing the *rebab*, the *oud* and the tambourine, respectively. Hanging over the balconies are curious youngsters and neighbors. In the right foreground sits the scribe of the calligraphed and undoubtedly elaborately decorated marriage contract; on his low desk, we detect his ink bottle and quill.

The "Orient," with its exotic customs and beautiful costumes, possessed a magical attraction for artists and the general public alike. The Romantic spirit of the early nineteenth century inspired many a traveler and artist to visit North Africa and the Middle East, but hardly anyone depicted the region in a so lively and respectful manner as did Delacroix.

Eugène Delacroix,
Jewish Wedding in Morocco,
ca. 1839.

Oil on canvas, 105 × 140.5 cm
(41 5/16 × 55 5/16").
Louvre, Paris, France

Eugène Delacroix,
Jewish Wedding in Morocco,
detail

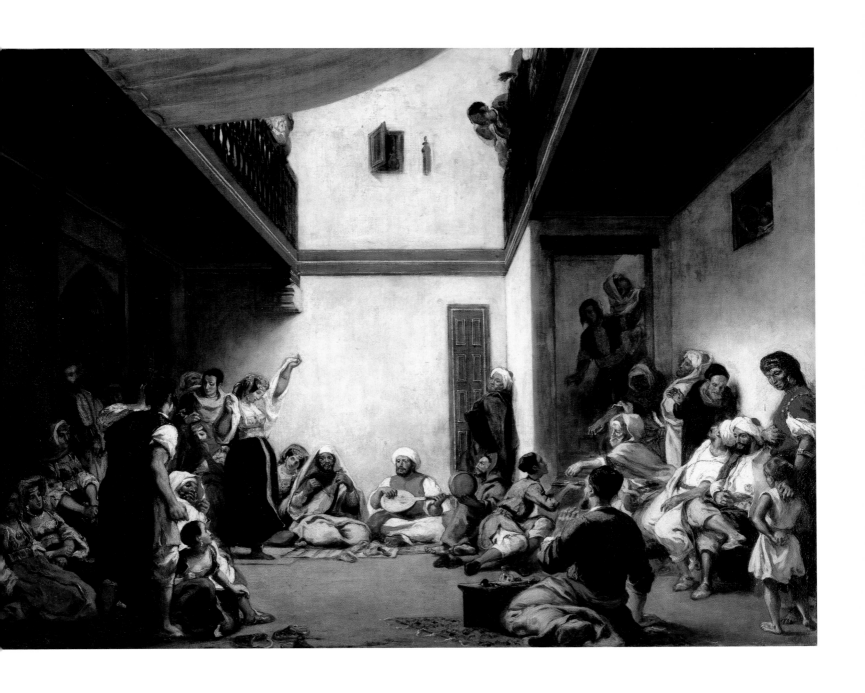

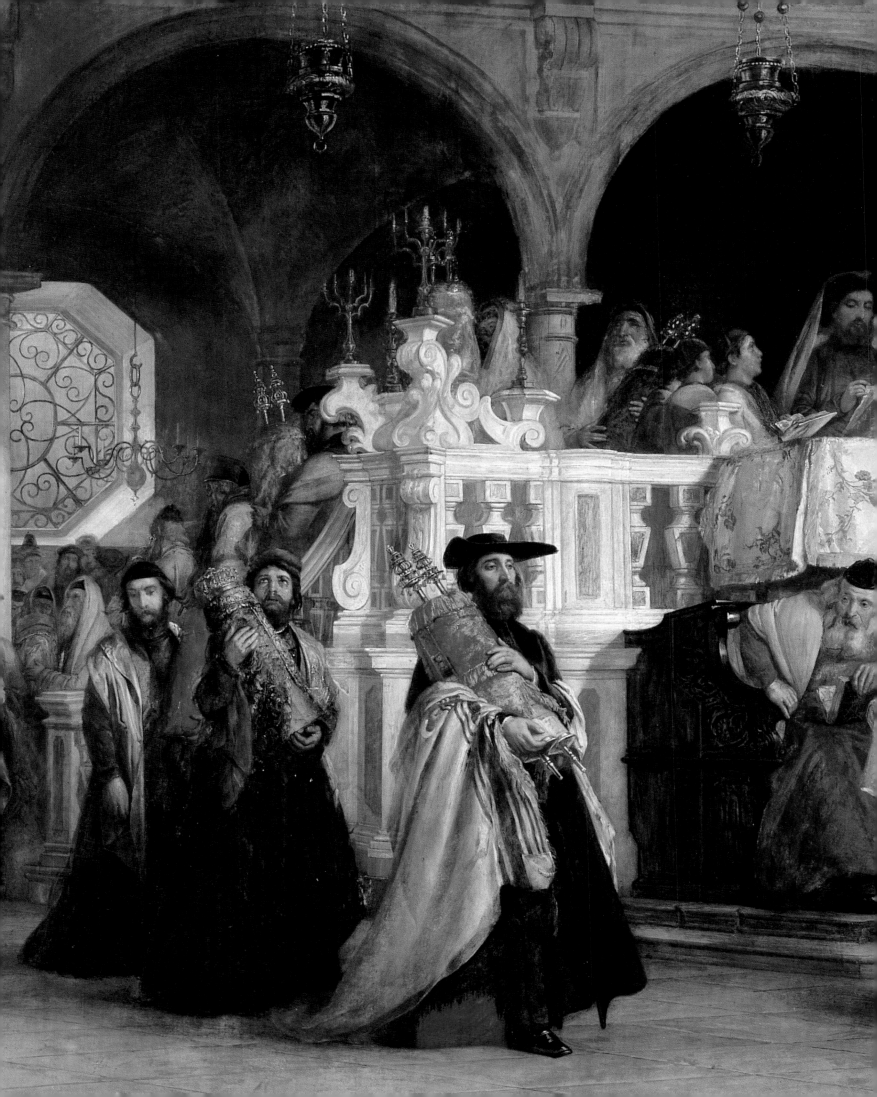

Rejoicing in Splendor

Solomon Alexander Hart

The Feast of Rejoicing of the Law at the Synagogue of Leghorn (Livorno), Italy, 1850

Joy vibrates when the Jewish community celebrates Simhat Torah (Rejoicing in the *Torah*). This festival forms the conclusion of Tabernacles, a final coda at the end of nearly a whole month of festivals that begins with the solemn Rosh Hashanah (New Year) and Yom Kippur (Day of Atonement). It marks the end of the annual cycle of Torah readings. In the synagogue, the cantor stands on the *bimah* (an elevated marble platform) leading the congregation in song as the Torah scrolls are removed from the ark to become the focus of rejoicing. Young and old parade around and look in reverence at the sacred text.

During the Simhat Torah service, all those present, even children, receive the honor of being called up to the *bimah* for an *aliyah* (reciting the blessing over the Torah reading). They are showered with blessings and in more recent times candy. At the close of the ceremony, two people are honored with reading, respectively, the last verses from Deuteronomy 34 (the last book of the *Pentateuch*, the five books of Moses), and immediately thereafter the first chapter of Genesis. These honorees are called bridegrooms, evoking the symbols of marriage and covenant, specifically between Jews and the *Torah*. Duly impressed, they form the center of the composition.

The setting is equally impressive. The procession takes place in one of Europe's largest and most beautifully decorated synagogues, that of Livorno. This main port of Tuscany owed its prominence and its Jewish community to the magnanimity of Ferdinand de Medici, who developed the town and in 1593 granted liberty to the Jewish refugees from Spain. Centuries later, their turbans and exotic dress reflect the family ties and commercial contacts with other Mediterranean towns in North Africa and Turkey.

In 1716, a visiting priest recorded how women dressed after the latest French fashion and wore pearls and jewels to the synagogue, men wore mostly black in the style of Florence, and the rabbi led the services wearing a red robe. Not much had changed by 1850, as we see the rabbi is still in his red robe rising from his seat under the *bimah*. The synagogue itself, in size and grandeur only comparable to the equally magnificent Spanish-Portuguese sanctuary in Amsterdam,

was built in 1693 and embellished during the following decades. The beautiful polychrome marble platform and balustrade, prominently featured in the painting, was designed by the community's vice-chancellor, David Nunes, and installed in 1745. The building reached its most glorious phase in 1789 with an even further enlarged *bimah*, arches supporting two galleries for the women, and a truly monumental marble ark. The Jewish population of over 4,000 represented one-eighth of Livorno's inhabitants, who justifiably prided themselves on being the only Italian town without a ghetto.

When Solomon Alexander Hart (1806–1881), the first Jew to become a member of London's prestigious Royal Academy, visited Italy in 1840–41, he surely was witness to these and similar celebrations in this self-assured community. The painting he later made reflects the then current glorification of Spanish Jewry and its descendants in an age when Jews were looking for positive identification with their past to counter the view that the Jewish religion was primitive and Jewish history had been one of suffering alone.

Solomon Alexander Hart, *The Feast of Rejoicing of the Law at the Synagogue of Leghorn (Livorno), Italy*, 1850.

Oil on canvas, 141.3 × 174.6 cm (55 5/8 × 68 1/4").
The Jewish Museum, New York, USA. Gift of Mr. and Mrs. Oscar Gruss

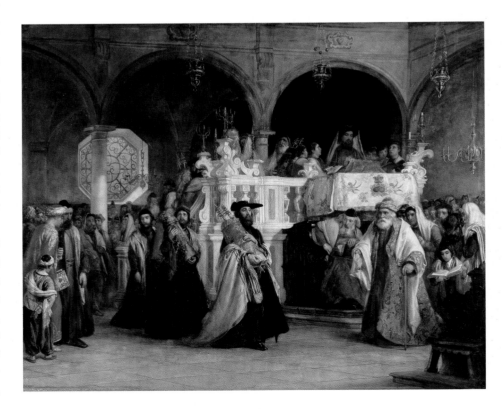

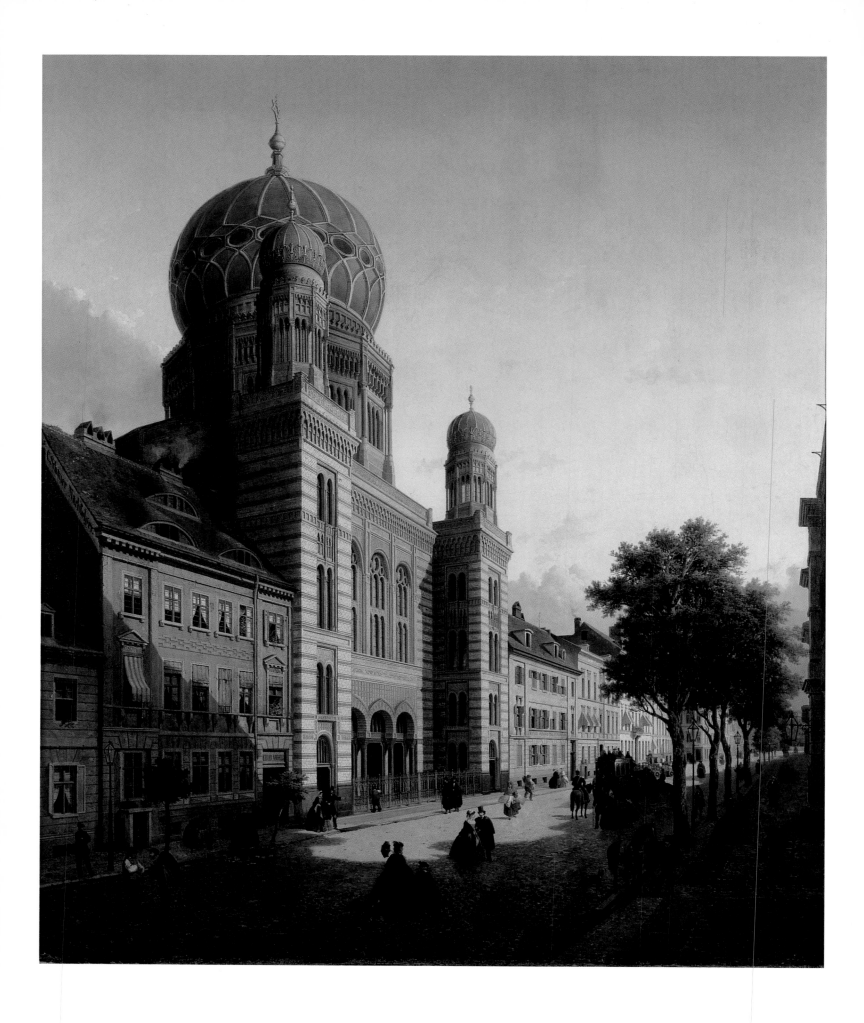

The Self and the Exotic

Eduard Knoblauch, Friedrich August Stüler

New Synagogue, Oranienburgerstrasse, Berlin, Germany, 1859–66

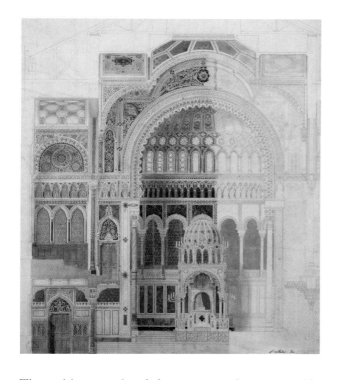

The golden cupola of the entrance dome is visible from afar and still dominates the Berlin skyline. It was designed as a Reform synagogue by two Protestant architects, Eduard Knoblauch (1801–1865) and Friedrich August Stüler (1800–1865). The 3,200-seat Oranienburgerstrasse synagogue in the center of Jewish Berlin was the largest and most beautiful synagogue ever built in Germany and reflects the short period in which Jews enjoyed increasing social acceptance.

The synagogue was festively dedicated on September 5, 1866, just a few years before equal rights were granted to the Jews of Prussia in 1869, and to German Jewry as a whole in 1871. Exactly two centuries earlier, in 1671, a few families had been permitted to settle in Berlin, and by 1871 the Jewish population of the capital of the German Empire numbered some 34,000. As entrepreneurs, merchants, and bankers, Jews played an important role as Berlin became a rapidly expanding metropolis—this New Synagogue reflected their self-assurance.

For both the interior and exterior designs, the architects used the Oriental or Moorish style (as it was then called). The synagogue's interior was widely admired for its marble, mosaics, colored tiles, and stained glass windows. The gas lighting, then a novelty, gave it a fairy-tale quality. Despite the classic separation between men in the main sanctuary and women in the upstairs galleries, the New Synagogue was a typical Reform synagogue: the lectern stood near the Ark, rather than in the middle of the prayer hall. Characteristically it featured a gigantic organ. Cantor Louis Lewandowski (1821–1894) thrived as choir director and composer of liturgical music. His compositions are still performed in Orthodox and Reform synagogues all over the world.

Reform Judaism, with its belief in the progression and adaptation of ancient beliefs and practices became the Jewish religious movement with the most adherents in Germany. Its main advocate Abraham Geiger (1810–1874) was appointed to the New Synagogue as a rabbi.

Synagogues continued to be built in Berlin up until 1933, but due to the insecure political climate of the era, primarily in courtyards and out of sight. The New Synagogue was untouched during the pogrom known as Kristallnacht ("The Night of Broken Glass"), but the sanctuary was severely damaged during the Allied aerial bombardments of Berlin. The empty space is marked, and visible from one of the upstairs rooms where, since 1995, Reform services are once again held. The front part of the New Synagogue now houses a beautiful museum, the Centrum Judaicum.

Left page:
Emile de Cauwer, *House Number 32, the New Synagogue and Houses Number 29–26 of the Oranienburgerstrasse in Berlin*, 1865.

Oil on canvas, 125.5 × 108 cm (49 3/8 × 42 1/2"). Stadtmuseum, Berlin, Germany

Left:
Friedrich August Stüler, Draft for the Painting of the Eastern Wall, 1865

University Library, Technical University, Berlin, Germany

Below:
Longitudinal Section, 1866

Landesarchiv, Berlin, Germany

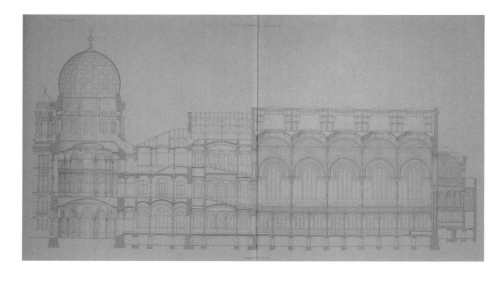

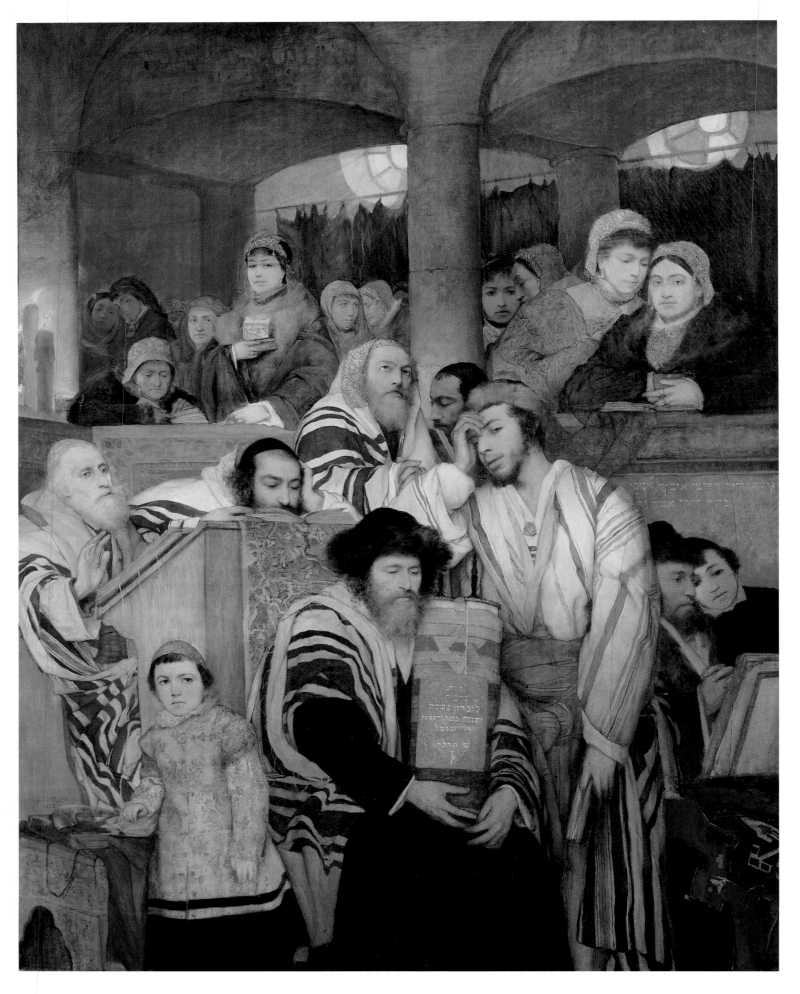

A Day of Penitence and Repentance

Maurycy Gottlieb

Jews Praying in the Synagogue on Yom Kippur, 1878

Yom Kippur (the Day of Atonement), a Jewish holiday with no exact equivalent in either the Christian or Muslim calendars, is a full day of fasting, praying, and penitence, which starts at sundown and ends twenty-five hours later when it is completely dark. Repentance is the major theme of this holiest of days in the Jewish calendar, set apart in dedication to the return of men to his fellow human beings, and ultimately to God.

Painted at the end of his brief career as an artist at the threshold of Jewish modernity, Gottlieb shows an intimate picture of the interior of a Central European synagogue. The women are separated in an elevated gallery—immersed in prayer, looking around, or talking amongst themselves. The men are wrapped in traditional striped prayer shawls. In the middle, the young artist depicts himself with his head covered by a fur hat. Strikingly, the old man seated next to him carries a Torah scroll with a Hebrew text commemorating Gottlieb as if he already died (which he would a year later). Refraining from food and drink, from work, and from sex, every Jew retreats back to him or herself on this festival; and this sense of floating between life and death is further accentuated by a commemoration of past martyrs and the recently deceased. Aware of the conflicts between Jewish and general culture, Gottlieb identifies himself with the age-old chain of Jewish tradition.

The synagogue in which Gottlieb stands is not an actual building, but reconstructed from the memories of his birthplace, Drohobycz in Galicia—at that time part of the Austro-Hungarian Empire, later Poland, and presently in the Ukraine. Pious Hassidic Jews and enlightened German-speaking Jews lived side by side in this provincial town, where little less than half of the population was Jewish. Gottlieb's upbringing was not particularly religious, and he received a liberal education. Although German-speaking, he was a fierce Polish nationalist, and at the same time fascinated by his Jewish roots.

At thirteen, this child prodigy was sent to study art in Lemberg (now Lvov, Ukraine), then later at art academies in Vienna, Krakow, and Munich. In Munich he visited the Pinakothek, discovered Rem-brandt, and read Gotthold Ephraim Lessing's *Nathan the Wise* and Heinrich Graetz's multi-volume *History of the Jews* (1853–75), the first major modern synthesis of Jewish academic learning. Gottlieb was touched by Graetz's moving descriptions of the courageous Jewish struggle for survival and their sufferings in Exile, particularly under Christianity. Graetz's negative view of Christianity, the primary sources of which—the Gospels and the Epistles—he subjected to radical criticism, undoubtedly struck a chord with the young Gottlieb.

Based on his artistic success in Munich, Gottlieb was commissioned to illustrate Lessing's famous plea for religious tolerance. His interpretation of historical themes like *Shylock and Jessica* and *Christ before His Judges* is revolutionary. Shylock is no longer the despicable figure as Christian artists had portrayed him for so many centuries; Jesus is a sympathetic contemporary Jew—counter-images in the spirit of the new Jewish historians.

During Yom Kippur, even the most assimilated Jew feels compelled to maintain ties with ancestral traditions, and this unique day of observance has become a touchstone for Jewish identity. Particularly beloved is *Kol Nidre* with its haunting melody traditionally sung three times during the evening. Composers such as Max Bruch (actually a non-Jew) in 1880, and Arnold Schoenberg, over fifty years later, used this melody as a motif in their compositions. The philosopher Franz Rosenzweig, who in 1913 was on the brink of converting to Christianity, reexamined his decision after attending a *Kol Nidre* service in a small synagogue in Berlin. Yom Kippur was to inspire many artists, but Gottlieb was the first Jewish artist to directly portray the intimacy of this most solemn Jewish festival, daringly presenting himself as part of the Jewish people when they feel closest to God.

Maurycy Gottlieb, *Jews Praying in the Synagogue on Yom Kippur*, 1878.

Oil on canvas, 245 × 192 cm (96 1/2 × 75 1/2").
Tel Aviv Museum of Art, Tel Aviv, Israel. Gift of Sidney Lamon, New York

Of Pots and Pans: Keeping Kosher

Max Liebermann
Self-portrait with Kitchen Still-life, 1873

Max Liebermann (1847–1935) is one of Germany's most famous artists. This *Self-portrait with Kitchen Still-life* dates from 1873, and betrays his love for the Dutch masters of the sixteenth and seventeenth centuries, the kitchen still lifes of Joachim de Beuckelaer, and the portraits of Frans Hals. In 1881, his older contemporary and long-time friend Jozef Israëls (1824–1911) would introduce him to Holland and to Amsterdam's Jewish quarter.

Max Liebermann grew up in a traditional Jewish home. He belonged to the Jewish upper class in Berlin, economically as well as culturally. From his father Liebermann inherited the monumental home on Pariser Platz next to Brandenburger Tor, where he and his wife would live until his death, surrounded by an art collection that included French Impressionist paintings. This French art was the inspiration for the realistic style that brought him such great recognition as a painter and also as co-founder and founding president of the Berliner Secession, the German impressionist alternative to the then current academic style of painting.

The Liebermann family was actively involved in Jewish life in Berlin, religiously as well as socially. They regularly contributed financially to the community and donated ceremonial objects to the synagogue. Max Liebermann's father was the founder of a private synagogue and his uncles served on the board of the Jewish community. Max Liebermann himself belonged to the Jewish Society of Friends, which supported needy Jews regardless of their denominational affiliation.

With this background, it comes as no surprise he would be familiar with the Jewish dietary laws, which determine so much of daily life. Kosher, meaning fit or proper, refers primarily to food. The origins of these laws can be found in the Bible (Lev. 11 and Deut. 14): permitted are mammals with cloven (or split) hooves which chew their cud, such as cows and goats; certain fowl; and fish with both fins and scales. Pigs and hare are forbidden because they don't chew their cud, and camels forbidden because they don't have cloven hooves. Prohibited are crustaceans and mussels. Vultures are not considered kosher birds but turkey, goose, duck, and chicken are. In order to secure the animal or bird dies instantly and without pain, they must be slaughtered kosher (a split-second cutting of the throat). Based on the biblical verse, "You shall not boil a kid in its mother's milk" (Exod. 34:26), Jewish dietary law requires a strict separation of milk and meat-based products. A meal is either *fleischig* (meat-based) or *milchig* (milk-based). They are prepared and served separately, from specially reserved pots and pans. After eating a meat meal, observant Jews must wait three to six hours before eating dairy, whereas eating dairy first shortens the wait.

The *Self-portrait with Kitchen Still-life* from 1873 possesses an interesting detail which the graphic artist Hermann Struck pointed out at the opening of the Liebermann commemorative exhibition in the Tel Aviv Museum in 1935: "In order to please his pious mother, Liebermann painted on the foreground a kosher slaughtered chicken with a kosher seal." Here a son honors his mother and the Jewish kitchen with all its ingredients, including the kosher chicken for the much-praised chicken soup. As the "Jewish penicillin," it became the touchstone of Jewish adherence and sentiment, even at times when other tokens of religious observance were on the decline.

This realistically painted *Self-portrait with Kitchen Still-life* turns out to be a testimony of Jewish love for food. It was probably painted for his parents. The painting remained in the family, who lent it to Tel Aviv. In 1936, the painting was included in the Max Liebermann commemorative exhibition at the Jewish Museum Berlin, at a time when his work was elsewhere considered degenerate.

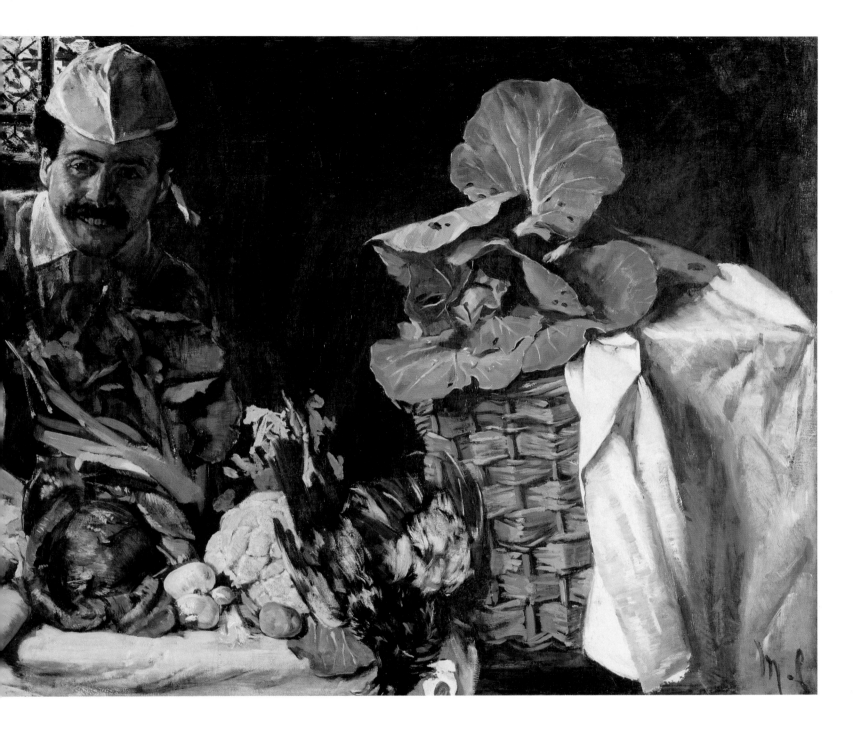

Kosher as a concept is extended in popular speech beyond dietary laws to refer to behavior and people, and as such it can be said that Liebermann wasn't exactly treated kosher during his long and successful career. He, "the Jew incarnate," for whom Judaism was a private matter of home and family, continually faced anti-Semitism though he "had felt himself a German all his life." In 1933, his world fell apart. Before it was too late, this once celebrated painter and honorary citizen of Berlin resigned from the Prussian Academy of Arts, which he served as president for many years. His paintings were confiscated and removed from public collections. Very few of his colleagues stood by his side, just as few attended his funeral at Berlin's

Jewish cemetery on Schönhauser Allee in 1935. His widow, forced out of the elegant family home upon his death, poisoned herself in 1943 after receiving the order for deportation to Theresienstadt.

Exactly sixty years after he had finished his flamboyantly optimistic *Self-portrait with Kitchen Still-life*, when the Nazi's marched through Brandenburger Tor in 1933 past his house, Liebermann responded in a appropriately culinary fashion: "I cannot eat as much as I can throw up."

Max Liebermann, *Self-portrait with Kitchen Still-life*, 1873.

Oil on canvas, 85.3 × 139 cm (33 9/16 × 54 3/4"). Städtisches Museum Gelsenkirchen, Germany

A Rembrandt Reborn

Jozef Israëls

Son of the Ancient People, 1889

"He sits there, staring in front of him, his hands emaciated, bony, resting in his lap. Misery and despair have dulled his eye, consumed his strength. And day after day [...] Jacob sits outside his shop, dazed..." This reaction that first appeared in an 1896 newspaper is one of many evoked by the painting. Jacob Stedel is the name Jozef Israëls (1824–1911) gave to the merchant in one of his best-known Jewish works—*Son of the Ancient People.*

During his lifetime, and especially in its final decades, contemporaries were fascinated as much by Israëls' attempts to emulate his idol Rembrandt as his identity as a Jew, even though paintings with overt Jewish themes comprise just a fraction of his entire œuvre. Apart from *Son of the Ancient People*, he created *The Jewish Scribe* (1902), *The Jewish Wedding* (1903), and a number of etchings of Jewish figures, all towards the end of his life. Even including his bible-themed work, his *Self-Portrait Before Saul and David* (1908), and portraits of Jewish relatives, friends, and prominent Jews, the list is still relatively small. It is therefore remarkable that he made his name not just as a celebrated representative of the impressionist Hague School or as the "Rembrandt of the nineteenth century," but as a Jewish painter. Beginning in the twentieth century, surveys of Jewish art finally recognized Israëls in the vanguard alongside such luminaries as Camille Pissarro (1830–1903), Max Liebermann (1847–1935), and Amedeo Modigliani (1884–1920). It was the Jewish identity of this Rembrandt reborn that drew the particular attention of his admirers.

Israëls was raised in a traditional Jewish home in Groningen, and the portion of the *Pentateuch* that he read on his bar mitzvah (Jewish rite of religious initiation at the age of 13) became a sort of personal motto, to be later inscribed, at his own request, on his tombstone: "I am sending an angel before you to guard you on the way and to bring you to the place that I have made ready."" (Exod. 23:20).

Israëls dates his love for Rembrandt to the 1840's when he moved to Amsterdam, "I lived at a distance of a few houses from the famous one where Rembrandt had worked for so many years. I viewed the picturesque masses, the bustle, the warm blooded faces of the Jewish men with their grey beards; the women with their reddish hair, the carts full of fish and fruits and other wares, the air—everything was Rembrandt, everything Rembrandtesque."

Israëls appears to have taken the seated man with arms folded in *Son of the Ancient People* from Rembrandt's *Portrait of an Old Man* of 1654 (The Hermitage, St. Petersburg). Certainly familiar with second-hand dealers from the Amsterdam and Hague Jewish quarters, he saw them through the eyes of his artistic inspiration Rembrandt. His *Saul and David* of 1899 suggests Rembrandtesque aspirations; Rembrandt's painting of the same title had in fact been purchased by the Mauritshuis in The Hague the year before. Israëls' *Jewish Wedding* of 1903 is clearly a Jewish painting, yet here again, Rembrandt emerges as the source of inspiration: the theme is borrowed from the painting long known as *The Jewish Bride* (Rijksmuseum, Amsterdam).

Despite the relatively few Jewish themes in Israëls' œuvre, his work struck a chord among Jews. Only some Zionists, in an attempt to distance themselves from the negative image of the ghetto Jew, initially had difficulty with the work: "Should we be grateful to Jozef Israëls for seeing this old clothing-merchant-*cum*-rag-and-bone-man as typifying the son of the ancient people? Were we not entitled to expect another, proud, powerful young Jew instead of this hunched-up, insignificant, decrepit man?" However, Jews were among the earliest collectors of his paintings and Israëls made a few smaller copies of his *Son of the Ancient People* for the American art market. Etchings and engravings further contributed to the popularity of this work. Once his name had been established, Israëls became a source of pride for Jews. His popularity goes hand in hand with the Jewish fascination for Rembrandt, the painter who after all had lived in the Amsterdam Jewish quarter and who expressed his love for the daughters and sons of the ancient people in numerous Old Testament paintings and in portraits, which up until only very recently were described by art historians as Rabbis, Jewish faces, or Jewish Jesuses.

Jozef Israëls, *Son of the Ancient People*, 1889.

Oil on canvas, 178.5 × 137.5 cm (70 1/4 × 54 1/8"). Stedelijk Museum, Amsterdam, The Netherlands

A Secular Jewish Painter

Camille Pissarro
La Place du Théâtre Français, 1898

Camille Pissarro is celebrated as a founding member of the French Impressionists, and he is the only member to have participated in all eight of their exhibitions held between 1874 and 1886. Pissarro (1830–1903) was a decidedly modern artist whose importance was increasingly overshadowed by his friend and colleague Paul Cézanne, and by younger artists like Gauguin and van Gogh, to whom he was a mentor and fatherly advisor. His role in the first modern art movement, originally diminished by the destruction of an estimated 1,500 of his earlier works during the German invasion of France in 1870 (he escaped to London), has recently been reevaluated.

Though his Caribbean extraction is widely known, his Jewish descent is not. Born Jacob Pizarro on the West Indies island of St. Thomas, son of a successful businessman originally from Bordeaux, a Sephardic Jew of Portuguese descent, he studied in Paris from 1841 to 1847, and moved to France permanently in 1855.

Around 1900, when Jewish thinkers began to promote Jewish art as a distinct category, his Jewish ancestry became relevant. Though included in Jewish art exhibitions in Basel, Berlin, and London, Pissarro never depicted (nor actively participated in) Jewish life, and consequently was not perceived by scholars in the same way as, for example, Jozef Israëls, "the Jewish Rembrandt," or Moritz Daniel Oppenheim, "the first Jewish painter" of Germany.

Pissarro was fascinated with pure observation, the depiction of visual sensation, and empirical rather than religious experience, including Judaism, which he considered contrary to "our modern philosophy which is absolutely social, anti-authoritarian, and anti-mystical." Much like Pissarro, acculturated French Jews were hardly interested in religious art, and preferred subjects of universal interest. Though Pissarro was not religious, and married a Catholic woman, he never denied his Jewish identity—on the contrary, he enjoyed being affectionately described as "Jew," or greeted as Moses, which with his long, flowing white beard, was no surprise. Though Pissarro felt that "race is a fiction," he too was affected by anti-Semitic sentiments endemic to all social classes in France in the 1860's, and increasingly in the 1890's during the Dreyfus affair, when a French Jewish artillery officer was arrested for treason (he was later pardoned and exonerated in 1906). Even his avant-garde artist colleagues were tinged by prejudice; his old friends Renoir and Degas did not want to be associated with the "Israelite Pissarro." Impressionists in general and Pissarro in particular were accused by some critics of being color blind, a disease believed to particularly afflict Jews.

Pissarro increasingly turned to the depiction of complex cityscapes—life in the modern metropolis of Paris with its traffic and people on the newly designed grand boulevards and squares. Pissarro, celebrated for his observation of light, color, and atmosphere, became the precursor of the secular and modern painter for whom artistic success overrules, but does not discard, ethnic descent.

Camille Pissarro, *La Place du Théâtre Français*, 1898.

Oil on canvas, 72.4 × 92.7 cm (28 1/2 × 36 1/2).
Los Angeles County Museum of Art, Los Angeles, USA

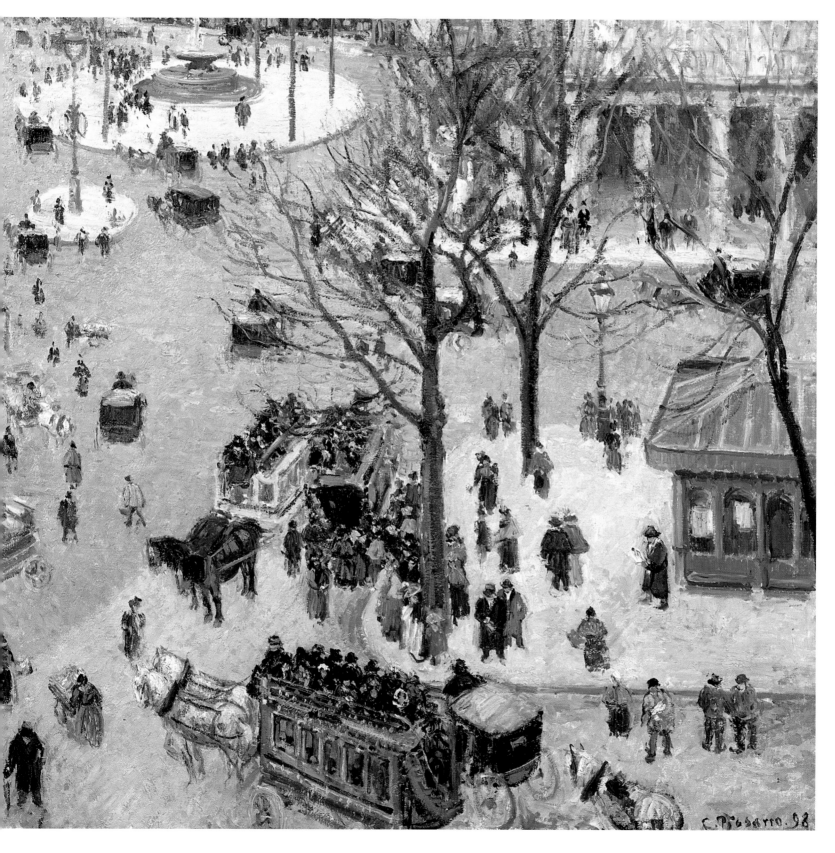

Contemporary Jewish Portraits

Samuel Hirszenberg
Portrait of a Jewish Writer, 1903

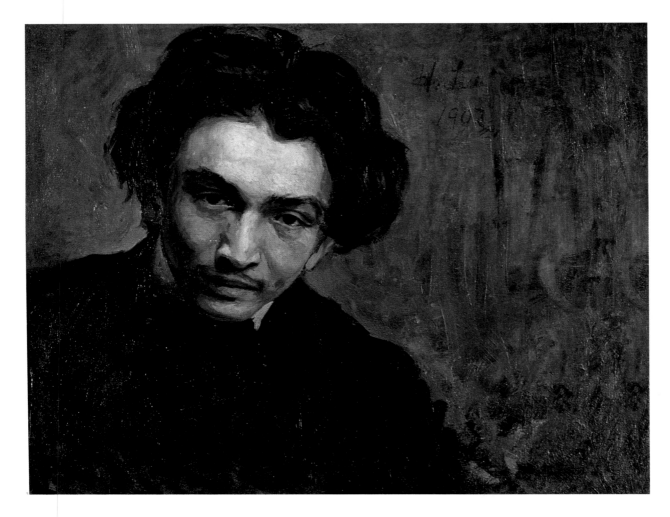

Since the early nineteenth century, traditional Judaism has been challenged from the inside by religious reformers and secular intellectuals. Well-versed in the study of classical Jewish texts, these scholars looked for new ways to define Jewish identity, while at the same time seeking recognition from the outside academic world. The critical study of texts and modern Jewish history were born. In the wake of the emergence of European nationalism, Jewish political ideologists also tried to raise Jewish national self-consciousness. At the same time, Jewish writers revived Yiddish and Hebrew as languages for secular literature. Sholem Aleichem (1859–1916, the author of *Tevye*, on which the musical *Fiddler on the Roof* was based) and Isaac Bashevis Singer (1904–1991) became household names with their often humoristic Yiddish stories; Achad Ha'am (1856–1927) and Haim Bialik (1873–1934) modernized Hebrew literature.

The Polish artist Samuel Hirszenberg (1865–1908), who so powerfully focused on contemporary Jewish struggles, was mourned on his death by Hebrew writers as the pioneer of Jewish artistic revival. Which writer he had portrayed here we unfortunately do not know.

Amedeo Modigliani
The Jewess (La Juive), 1907–08

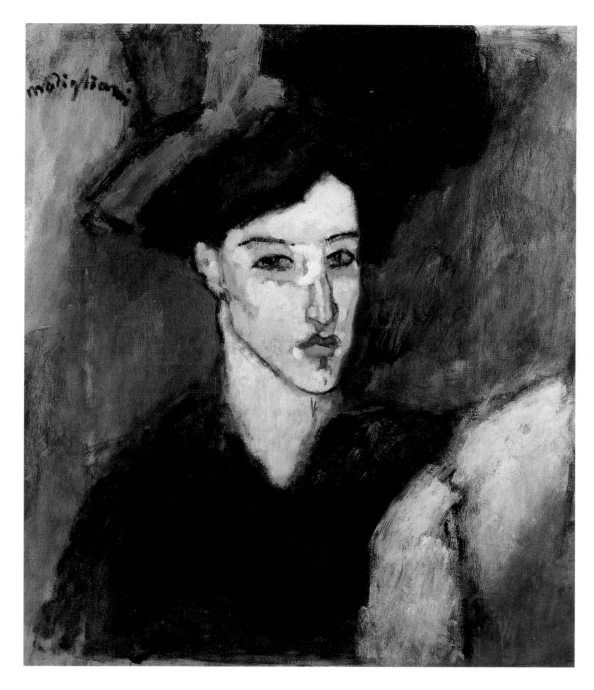

Amedeo Modigliani, *The Jewess (La Juive)*, 1907–08.

Oil on canvas, 55 × 46 cm (21⅝ × 18⅛").
Re Cove Hakone Museum, Kanagawa, Japan

Amedeo Modigliani (1884–1920), the well-educated but sickly son of a respected Italian Jewish family, settled in Paris in 1906, where he met Pablo Picasso and became friendly with Chaim Soutine. Paul Alexandre, his patron and admirer, encouraged Modigliani to exhibit one of his first works, *La Juive (The Jewess)* at the *Salon des Indépendents* (1908), and subsequently bought the painting. It clearly betrays the influence of the Fauves and the blue period of Picasso. Later portraits included some of his fellow Jewish artists like Jacques Lipchitz. He became famous for his paintings and sculptures of sensuous, seductive women—their presumed Jewish carnality being as much a part of Jewish self-consciousness as of Parisian modernity.

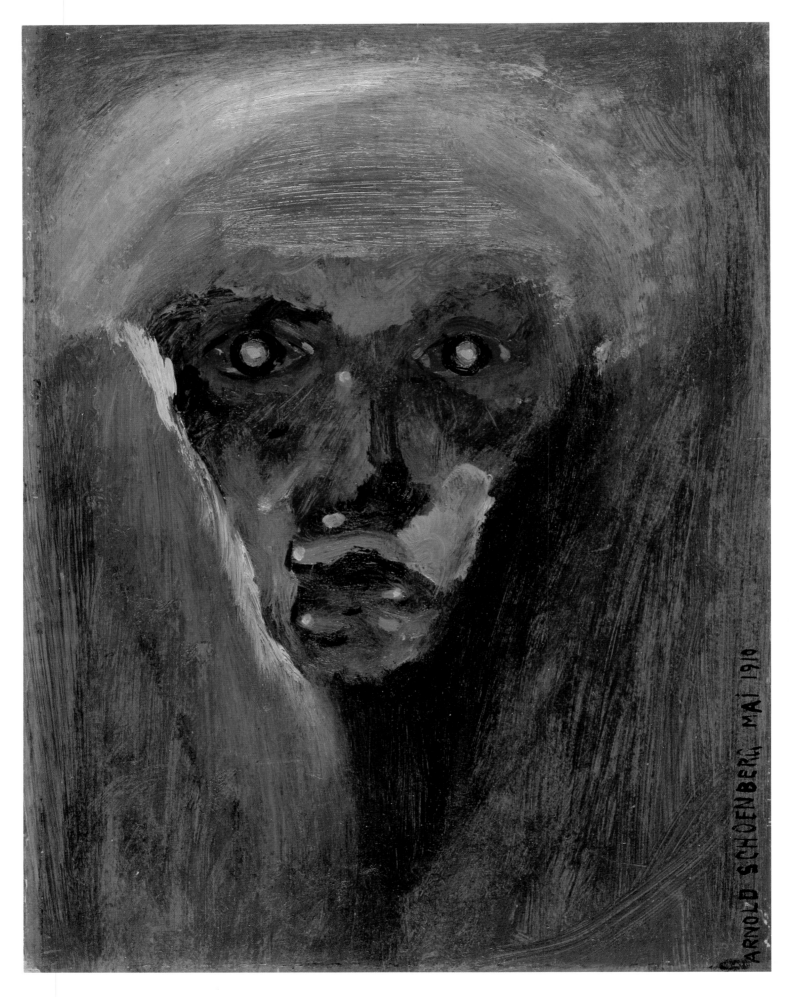

Musical Visions

Arnold Schoenberg
Red Gaze, 1910

At the start of the twentieth century, abstract art was in the air, as were experiments in music. The composer and painter Arnold Schoenberg (1874–1951) was involved in both. Echoing the recent psychological theories of his fellow Viennese Sigmund Freud, the composer-painter wrote to the painter and music lover Wassily Kandinsky, "Art belongs to the unconscious." Even before they actually met in 1911, Kandinsky's road to abstraction, inspired by Schoenberg's music, ran parallel to Schoenberg's revolutionary compositions. Only a short time before, in 1908, after finishing *Gurrelieder* and *Transfigured Night*, Schoenberg had taken up painting, the rudiments of which he learned from a talented young artist, Richard Gerstl. It was also at this time he took his first steps towards atonal composition. The hostility from both music critics and the public towards this revolutionary break from tonality nearly convinced Schoenberg to devote himself entirely to the visual arts.

Red Gaze is an astounding almost abstract painting—a frontal icon-like portrait, intensely concentrated on the face, with a haunting stare in the angst-ridden, red-rimmed eyes.

Who is the artist? Schoenberg was born in Vienna to Bohemian Jewish immigrants. Though his circumcision was registered with the Jewish community, he did not receive much formal religious education as his family belonged to the assimilated Jewish middle class. And while raised in Austria and taught music by his future brother-in-law Alexander von Zemlinsky, Schoenberg admired German composers such as Johannes Brahms and Richard Wagner. He must have sympathized with his friend and colleague Gustav Mahler who once said, "I am thrice homeless: a native of Bohemia in Austria, an Austrian amongst Germans and Jew throughout the world: always an intruder, never welcomed." While Mahler converted to Catholicism in 1897 to gain access to the Viennese musical scene, Schoenberg was baptized a Lutheran one year later, a minority in catholic Vienna.

His new religion wouldn't protect him however from the prejudice he experienced in 1921 when he and his family, as "non-Aryans," were refused permission to stay in the holiday town of Mattsee near Salzburg, or when in 1923 he learned of anti-Semitic tendencies at the Bauhaus which included his friend Kandinsky (who in 1911 included *Red Gaze* in the famous first *Blaue Reiter* exhibition in Munich's Thannhauser Galerie). Anti-Semitism pursued Schoenberg—just as it did the emancipated German and Austrian Jews after receiving legal rights in the nineteenth century (Austria in 1867)—and in 1933 he fled Austria for France where, in a Reform synagogue of Paris, he reconverted to Judaism (though he would reject all official forms of it, religious or national). He reached the United States in the same year on a Czech passport and in 1944 became an American citizen, ultimately changing the history of music in the New World just as he had in the Old.

In his unfinished opera, *Moses und Aron*, dating from the period just before his return to Judaism, Schoenberg struggled with the dichotomy between Moses, who received divinely-inspired ideas yet could not speak, and his brother Aaron, who didn't understand those ideas but was a gifted orator. For Schoenberg this dichotomy represented two equally valid approaches in dealing with the Jewish people's fate. He dealt with this question from ever changing perspectives but, just as the composition was never finished, the problem remained unresolved.

Despite offers to return to Vienna or immigrate to Israel, Schoenberg decided to remain in exile, at home in "wasteland" America. Many people change and choose new identities—voluntarily or not. As Freud once commented about the Jews, one has to be both an insider and an outsider to develop new visions. *Red Gaze*—and Schoenberg's personal history—shows this sometimes hurts.

Arnold Schoenberg,
Red Gaze, 1910.

Oil on cardboard, 32 × 25 cm (12 1/2 × 10").
Arnold Schoenberg Center,
Vienna, Austria

75

Escape to a Better Future?

Maurycy Minkowski

After the Pogrom, ca. 1910

The harsh reality of persecution and pogroms—the subject of a long chain of Jewish religious and secular texts—began to influence the visual arts only around 1900, when pogroms in Russia and Poland shook the confidence of Jewish artists who witnessed an increase of violent anti-Semitism, crushing earlier optimism over the gradual improvement of the legal position of Jews in many European countries.

Over the centuries, Jews had regularly been the victim of hatred and enmity, as both Jewish and non-Jewish sources amply testify. Already in pagan antiquity, the Jews, a monotheistic minority adhering to its own customs and festivals, were confronted with resentment because of their refusal to assimilate, intermarry, eat, or drink with the Gentiles. Christianity, though recognizing the Jews as keepers of the authentic Hebrew text of the Old Testament, resented the obstinate refusal of Jews to recognize Jesus as their messiah. They not only accused the Jews of the murder of Jesus, but also considered the New Testa-ment as the fulfillment of the Old, making Jews super-fluous, rejected by God, and condemned to eternal wandering. Medieval Christianity exacerbated these theological prejudices by accusing Jews of poisoning wells, defiling the host, and the ritual murderer of Christian children (blood libel). For every natural or economic disaster, the Jews were to blame.

Although the eighteenth-century Enlightenment promoted equality for all humanity and ultimately led to the emancipation of the Jews, its vitriolic critique of religion, especially the supposedly backward and particularistic Judaism, created the roots for secular anti-Semitism. In the 1870s, the traditional hatred of Jews, envy about the success of a few Jewish entrepre-neurs, and revulsion with the poor Jewish masses unable or unwilling to assimilate, culminated in racial anti-Semitism, directed against the Jews as a whole, religious or not. Jews were considered racially inferi-or, capitalist or socialist conspirators striving to rule the world—in short, a threat to civilization.

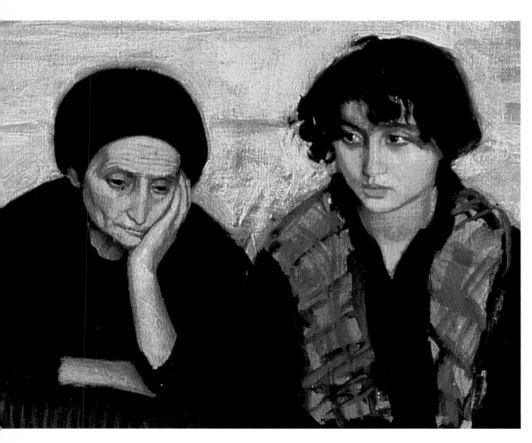

Maurycy Minkowski,
After the Pogrom, detail

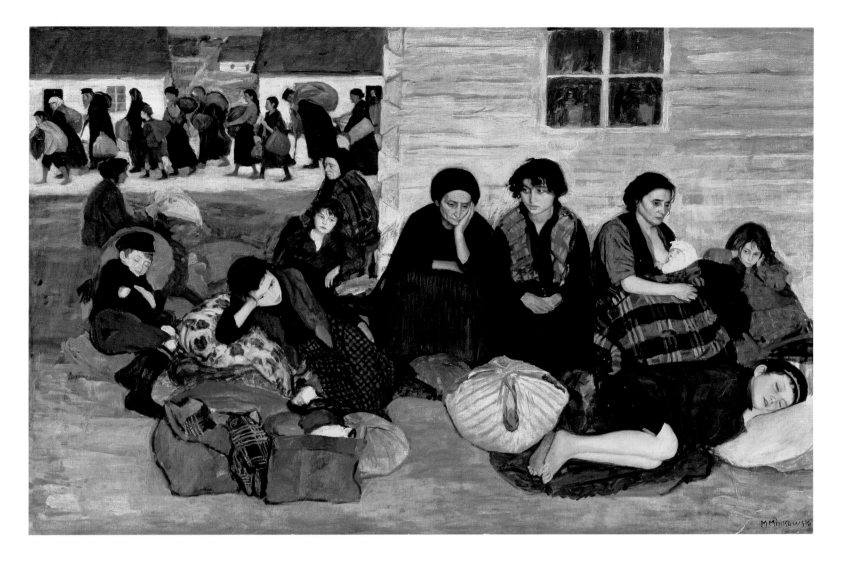

Jews received the blame for the imbalances caused by rapid economic changes in late-nineteenth-century France, Germany, and Austria, but the main threat was posed by Czarist Russia, where millions of Jews were caught in the Pale of Settlement. State-sponsored discriminatory measures—limiting the Jews to pursue certain professions, censuring Jewish culture, and military conscription to enforce assimilation—created a climate in which the resentment of the farmers against the Jewish middlemen, of the clergy against the Jewish religion, and of the nationalists against the Jews as a people, culminated in pogroms, a Russian word for massacre and destruction. The bloodiest and most infamous pogroms took place after Czar Alexander II was killed in 1881, which spread to other Eastern European countries and went on beyond the fall of the czarist regime, during the White Terror in the years immediately following the Communist Revolution of 1917. In these popular riots aimed at the Jews, property was destroyed, women raped, and hundreds of thousands of people were brutally killed or forced to flee. The result was a mass exodus of Jews, primarily to the United States, where over one and a half million Eastern European Jews found refuge. Others emigrated to the "Promised Land," then Ottoman Palestine, or fled elsewhere, to Western Europe or South Africa. However hard life was in their new homes, most refugees did not want to be reminded of life in the old country.

Maurycy Minkowski (1881–1930), son of an educated bourgeois Jewish family, was familiar with Russian pogrom refugees in his hometown Warsaw, and had witnessed firsthand the pogroms following the aborted Russian revolution of 1905, when pogroms in Bialystok and elsewhere broke out. Reminded of the vulnerability of Polish Jewry, he vividly documents the desperation of the victims—the women, probably widowed, taking care of exhausted children near the few material remains rapidly packed in bags or bundles. In the background, the survivors are taking flight to safer destinations. As history has shown, it was not always possible to escape.

Maurycy Minkowski,
After the Pogrom, ca. 1910.

Oil on canvas, 103.9 × 152.4 cm
(40⁷/₈ × 60").
The Jewish Museum New York,
USA. Gift of Lester S. Klein

The Lost World of the Shtetl

Issachar Ryback
The Old Synagogue, 1917

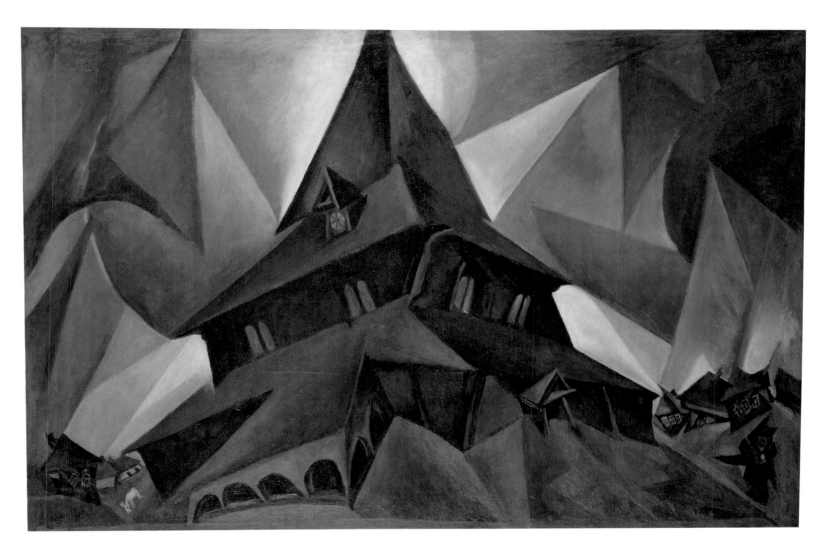

Issachar Ryback, *The Old Synagogue*, 1917.

Oil on canvas, 97 × 146 cm
(38 3/16 × 57 1/2").
The Tel Aviv Museum of Art,
Tel Aviv, Israel

Not many synagogues in Eastern Europe have survived the vicissitudes of time: the pogroms of the Cossacks in the seventeenth century, the many wars, the forced neglect during the communist era, and the systematic destruction by the Nazis. This applies to stone synagogues, those imposing fortress-like buildings providing refuge during times of persecution, but more so to wooden synagogues. These distinctive structures with their two- or three-tiered roofs could be found in the small towns and villages of Poland, Ukraine, Lithuania, and even in southern Germany. In contrast to their austere exterior, the interiors were often lavishly decorated with Hebrew texts, signs of the Zodiac, Jewish symbols, and at times entire illustrated biblical stories.

Even before their photographic documentation in the 1930's, Russian-Jewish artists in search of a style at the beginning of the twentieth century were the first to pay systematic attention to these buildings and their decoration. In the wake of their ethnographic expeditions (led by S. Ansky), they even brought to light names of forgotten Jewish decorators such as Israel Lisnicki, who painted the ceilings of the Ukrainian synagogue of Chodorow in 1714 (a reconstruction is preserved in the Diaspora Museum in Tel Aviv); Eliezer Sussmann, who went to Unterlimpurg to paint the synagogue's interior in 1738–39 (now in a museum in Schwaebisch Hall); and Chaim Segal, the legendary ancestor of Marc Chagall (born Moissej Segal), whose now-lost, luxuriously decorated synagogue at Mohilev (1710) in present-day Belarus Lissitzky had discovered and documented.

Issachar Ryback (1897–1935) tirelessly copied these scenes from old painted synagogues during an ethnographic exhibition in 1917, and subsequently published them. His *Old Synagogue* actually depicts Dobrowna, near Mohilev, one of the shtetls (small village) where Jewish religion and culture had flourished for centuries, and a source of inspiration for artists and writers alike. The style of the painting betrays Ryback's contemporary approach to the traditional Jewish life he so cherished. Indeed, together with Chagall, Altman, and Lissitzky, he brought modernism to Jewish art—first in Berlin where he moved in 1921,

and later in Paris, where he lived from 1926 until his death. In an album including 30 lithographs, he copied this painting to commemorate the shtetl, which was damaged beyond repair in the aftermath of the Russian revolution.

Wooden Synagogue of Wolpa, Belarus.

This building destroyed by the Nazis and dating back to the first half of the seventeenth century had a monumental *bimah* (platform where the Torah was read) supporting the vaulted ceiling, as well as an elaborately decorated Torah shrine.

Singing Jewish History

El Lissitzky

"and then came the fire and burnt the stick," Had Gadya, 1919

Had Gadya ("the only kid") is one of the favorite ditties included in the *Haggadah*, the book which serves as a companion during the Seder meal on Passover. The central theme of the festival is that of oppression and liberation, with which all participants are expected to identify.

Had Gadya, resembling medieval German children's songs, lends itself to illustration. This enchanting ten-verse litany tickles the fancy of adults as much as children: a little goat is bought for two silver coins, is devoured by a cat, who is gobbled up by a dog, who is beaten by a stick, which is burnt by a fire, which is quenched by water, which is drunk by an ox, who is slaughtered by a butcher, who is killed by the angel of death, who is, finally, slain by God himself. Jewish tradition identifies the kid as the Jewish people, who were acquired by God with the two tablets of the Law and subsequently victim to a long line of persecutors, beginning in the distant past and continuing till contemporary times. Ultimately, God will save His only kid.

Eliezer Lissitzky, his full Jewish name, knew *Had Gadya* from childhood. Born in a small town near Smolensk, he was raised religiously in what is now the Belarusian city of Vitebsk, then part of the so-called Pale of Settlement in the western part of tsarist Russia between the Baltic Sea and the Black Sea, an area in which Jewish settlement was permitted from the late eighteenth century until 1917. Forced assimilation, discrimination, and pogroms regularly shook the foundations of Jewish life.

After Russian reforms in 1905, Jews as well as other national and cultural minorities openly revived their own native traditions in art, music, and literature. Discrimination continued however and, as a Jew, Lissitzky was denied admission to the St. Petersburg Academy of Arts, instead studying architecture in Darmstadt, Germany. In 1914, with the outbreak of the First World War, he returned to Russia.

For the next few years, Lissitzky became involved in the renaissance of Jewish art and culture: he illustrated Yiddish stories and children's books, *Had Gadya* being one of them. In 1916, he took part in a Jewish ethnographic expedition organized by folklorist and

writer S. Ansky during which he vividly documented synagogues. In May 1919, Chagall invited him to teach art and architecture in his newly founded Vitebsk Art Academy. When Chagall left the school later that year, Lissitzky became increasingly involved with the abstract avant-garde, and would earn international fame as an experimental artist, photographer, and exhibition designer, developing close contacts with the De Stijl movement in the Netherlands and the Bauhaus in Germany. Increasing discrimination of Jews and the prohibition of Jewish themes in the Soviet Union very nearly relegated his early Jewish work to oblivion, and yet it is in these works that his enthusiasm for revolutionary changes in style and content are clearly discernable for the first time.

Lissitzky's decision to illustrate *Had Gadya* as a separate booklet rather than as part of a *Haggadah* may reflect his particular interest in the story as a metaphor of the liberation of the Jews from tsarist oppression. Instead of the original Aramaic, he used the vernacular Yiddish for the captions in the architectural frames above each stanza so as to make the song and its message fully accessible to his fellow Jews

Frank Stella, *Then Came a Stick and Beat the Dog.* Illustration after El Lissitzky's *Had Gadya*, 1982–84.

Lithograph, linoleum block, and silkscreen on paper, hand colored, 134.5 × 134 cm (53 × 52 ³/₄").
Waddington Graphics, London, United Kingdom

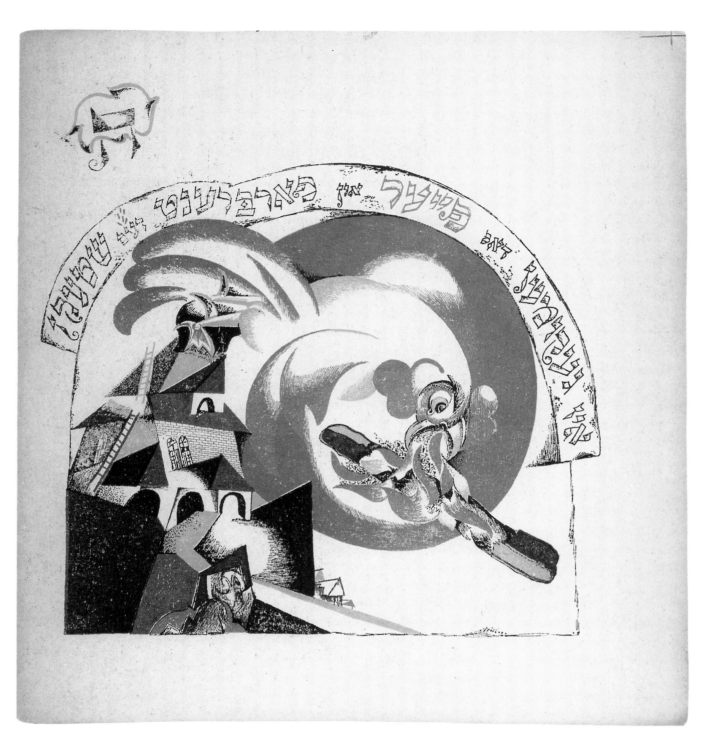

in Eastern Europe. The years 1917 (when he had start-ed work on it) and 1919 (the year of publication) marked sweeping changes: the Russian Revolution of 1917 meant the end of the Pale of Settlement and the tsarist regime, and the dawn of a new era of hope—however short lived it turned out to be.

The illustration of the fifth stanza, when fire burns the stick, is appropriately dominated by the color red, even in the Yiddish word for fire in the caption. Fire is symbolized by a red, semi-abstract, fire-breathing rooster that consumes the stick and an equally abstract building on the left side of the composition that resembles the synagogues Lissitzky documented during the ethnographic expedition. His audience would immediately understand the red rooster in this context, since it refers to the Yiddish phrase for arson (*royter henn*). Lissitzky clearly alludes to pogroms and the burning of synagogues—which had occurred all too often under the Tsars—and in this way set the tra-ditional interpretation of the song, the nations of the world persecuting the Jews, in a contemporary con-text. For Lissitzky, the promise of a successful Russian Revolution was the ultimate triumph over the evils of arson and destruction, and thus for him and his fellow Jews—children and adults alike—this traditional children's song remains relevant.

El Lissitzky, *"and then came the fire and burnt the stick,"* a verse from the Passover song *Had Gadya* (the only kid), published in a small edition of 75 by the Jewish Cultural League in Kiev, 1919.

Color lithograph on paper, 27.3 × 25.4 cm (10 3/4 × 10"). The Jewish Museum, New York, USA. Donated by Leonard and Phyllis Greenberg

Jewish Life in the Theatre

Marc Chagall
Introduction to the Jewish Theatre, 1920

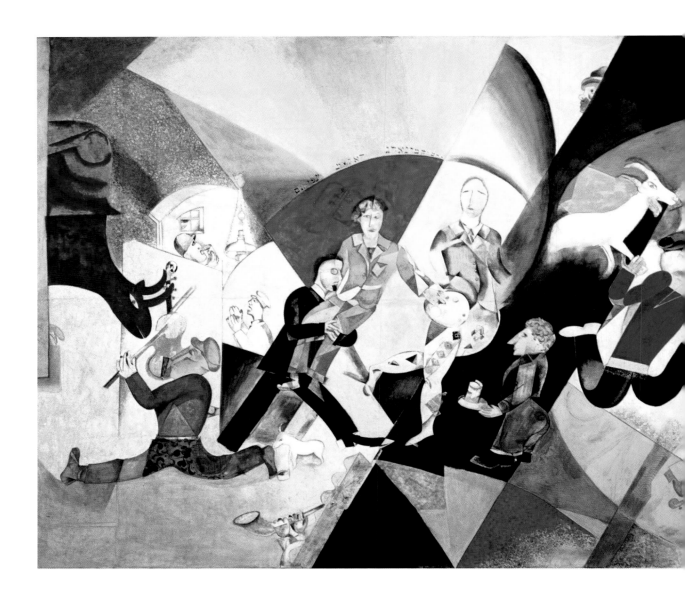

Marc Chagall (1887–1985) painted this *Introduction* as part of seven huge murals for the Jewish Theatre in Moscow during a period of Jewish cultural renaissance shortly after the Russian Revolution of 1917.

Under the Russian tsarist regime, Jewish culture and religion were suppressed. In the period 1835–1917, most of the five million Jews of the Russian Empire were obliged to live within a restricted area, the so-called Pale of Settlement, which included Poland, Lithuania, Belarus, the Ukraine, Bessarabia and the Crimea. In cities such as Moscow or St. Petersburg, Jews were only allowed to settle once they had a special permit from the tsar—a privilege reserved for the wealthy.

Chagall's birthplace of Vitebsk lies in the northeast of the Pale of Settlement, in present-day Belarus. The *Introduction to the Jewish Theatre* celebrates, like many of Chagall's paintings, life in the shtetl—towns much smaller than Vitebsk, where most of the inhabitants were Jewish. Oppressed and marginalized, the majority of the Jews lived in poverty. A multifaceted religious life and a rich Jewish folk culture characterized the Pale, despite discrimination and censorship. Literature and theatre performances in Yiddish, the

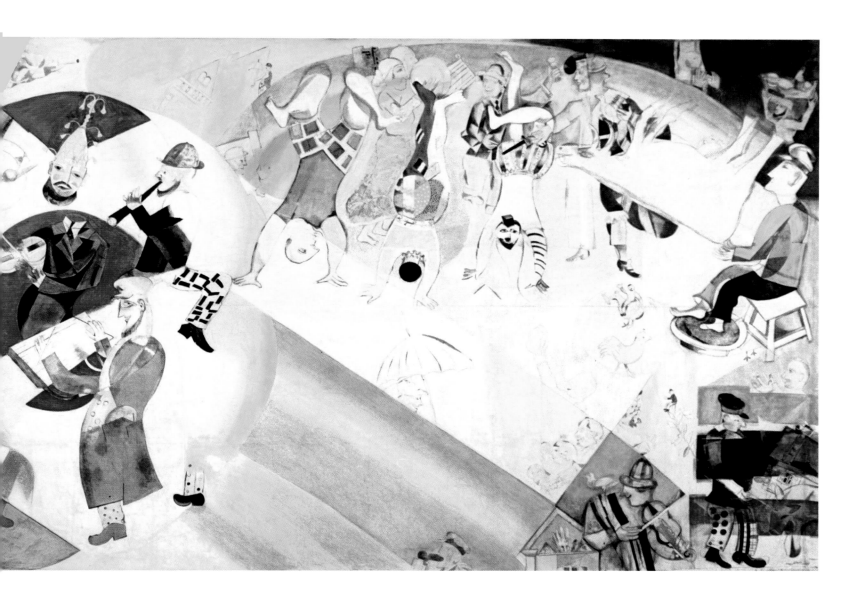

language of the East European Jews, were usually forbidden.

As part of the revival of nationalism and the search for a national art amongst the Russians, Jewish ethnographers and artists organized several ethnographical expeditions within the Pale of Settlement between 1911 and 1915. Led by the outstanding ethnographer, S. Ansky (1863–1920), they traveled around documenting Jewish folk culture. Their documentation of Jewish manuscripts, synagogue paintings, decorated tombstones, klezmer and synagogue music, as well as folk tales, stimulated many Jewish artists to reappraise

their own culture. Thanks to these efforts, Jewish culture experienced a brief renaissance during the early years of Communist rule. Art, literature, music, and theatre then flourished both in Yiddish and Hebrew.

Chagall, too, was keenly interested in Jewish folk art and it clearly influenced his *Introduction to the Jewish Theatre*. But Chagall equally found inspiration in avant-garde art. During the years he spent in Paris (1910–14), he became good friends with Robert Delaunay and his Russian wife Sonja Delaunay-Terk. Chagall's use of large areas of vivid color in his mural *Introduction* betrays the influence of a group of

Marc Chagall, *Introduction to the Jewish Theatre*, 1920.

Tempera and gouache on canvas, 284 × 787 cm (112 × 310"). The State Tretyakov Gallery, Moscow, Russia

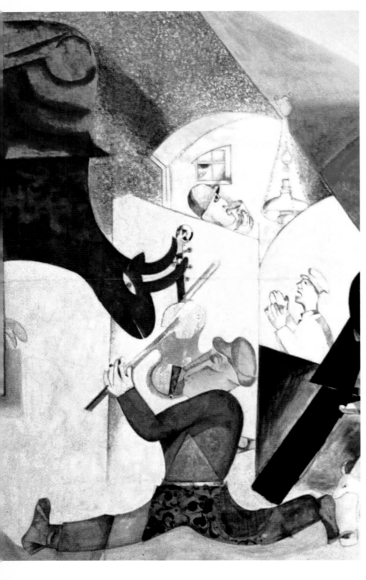

painters nicknamed Les Fauves (meaning wild beasts). Chagall also encountered cubism in Paris, a movement initiated by artists such as Braque and Picasso. Its free geometric forms and varying points of view suggested simultaneously can also be recognized in Chagall's *Jewish Theatre*. On his return to Russia in 1914, Chagall would encounter completely abstract art with geometric shapes no longer bearing any relation to seen reality. This type of non-realistic painting meant little to him. In his murals for the *Jewish Theatre*, he often makes critical references to the work of two of the heroes of abstract art, El Lissitzky and Kasimir Malevich. Both were on the teaching staff of Chagall's Art Academy in Vitebsk, in 1919 and 1920. When the students chose the way of abstract art, Chagall felt that his friend Lissitzky had betrayed him. Bitter and frustrated, he departed for Moscow.

On November 20, 1920, Chagall was asked to design the decor and costumes for the opening performance of the recently founded Jewish Theatre, the chief Yiddish-speaking theatre in Russia, which had moved to new premises on Great Chernyshevsky

Details from Marc Chagall, *Introduction to the Jewish Theatre*, 1920

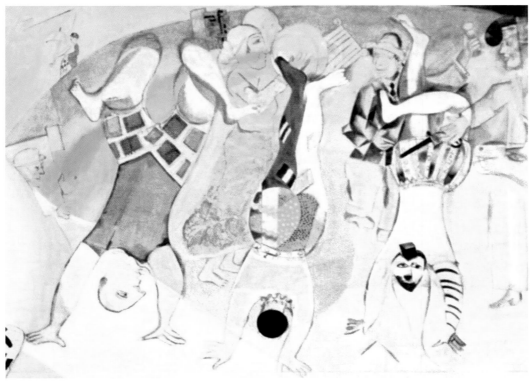

Street. On his own initiative, Chagall decided to paint the whole interior. Within a small space, Chagall created a total work of art: he designed the ceiling, the stage curtain, and seven large canvasses that completely covered the walls. (The ceiling and stage curtain are apparently lost; only a sketch remains of the curtain.) The largest canvas, titled *Introduction to the Jewish Theatre*, hung on the left-hand wall. On the wall beside the entrance could be seen *Love on the Stage*. On the window side, on the right, hung the Four Arts—*Literature, Drama, Dance,* and *Music*—and above, the long narrow painting titled *The Wedding Table*. When the curtain rose for the first time on January 1, 1921, it appeared as if the small theatre and the stage formed a visual whole. The ninety spectators stepped into the world of Chagall to become part of it themselves, completely absorbed into the ambiance of a theatre which, not surprisingly, was referred to as "Chagall's box."

Chagall's murals are lavish and ebullient, a feast to behold. They combine the abstract shapes and vivid colors of modern art with motifs borrowed from traditional Eastern European Jewish folk art. Furthermore, the artist has combined traditions from Jewish drama with the new revolutionary notions about the theatre. The murals are counted among the highlights of Chagall's extensive œuvre.

After leaving Russia in 1922, Chagall's canvases moved to the foyer of the Jewish Theatre's new home in 1924, but because of the anti-Jewish climate that developed in the Soviet Union, the paintings were removed in 1937 and hidden. In 1950, they turned up in the depots of The State Tretyakov Gallery in Moscow. Chagall's work remained inaccessible for the public until the Soviet Union fell apart in 1989, and since 1991, the murals have been widely exhibited.

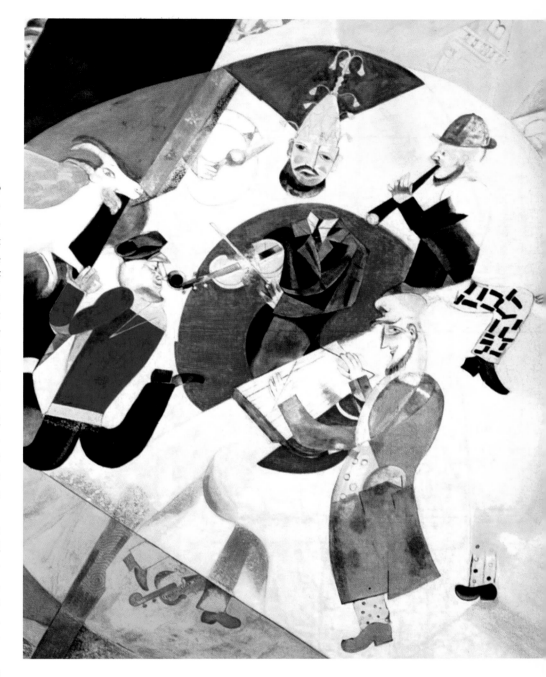

What is in a Name?

Man Ray
The Enigma of Isidore Ducasse, 1920–71

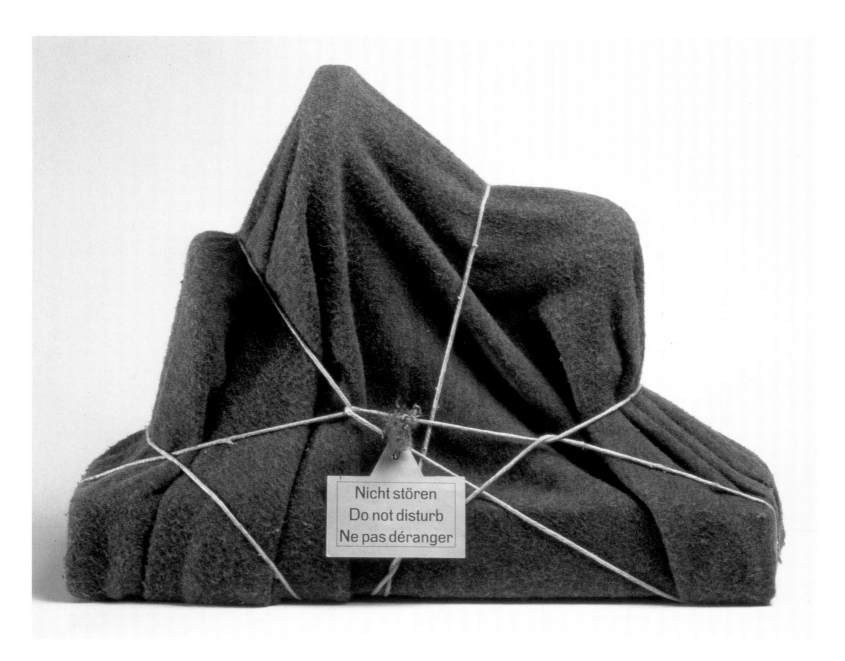

What unites Man Ray with Fred Astaire, Kirk Douglas, Al Jolson, Harry Houdini, Yves Montand, and Leon Trotsky? All of them changed the names that may have sounded "too Jewish" to serve their careers as dancer (Friedrich Austerlitz), actor (Issar Demsky), jazz musician (Asa Yoelson), magician (Erich Weisz), singer (Ivo Livi), and revolutionary (Lev Bronstein).

The Enigma of Isidore Ducasse is the enigma of the American-born Man Ray (1890–1976), or rather Emmanuel Radnitsky, who once said, "I am mysterious," and did everything possible to hide his Jewish name and background to avoid being pigeonholed. The title of this work refers to the legendary Comte de Lautréamont's (alias Isidore Ducasse) saying: "Beautiful as the chance meeting of a sewing machine and an umbrella on a dissecting table." A coarse piece of fabric covers a vaguely anthropomorphic form, firmly tied by a rope (with a warning: "Do Not Disturb").

Man Ray, *The Enigma of Isidore Ducasse*, 1920 (Reconstructed 1971).

Assemblage: sewing machine, blanket, strings, and wooden base, 45 × 58 × 23 cm (17 3/4 × 22 3/4 × 9"). Museum Boijmans van Beuningen, Rotterdam, The Netherlands

Man Ray kept as a closely guarded secret his Jewish heritage and social milieu, a fact confirmed by his biographers and friends. His parents were Russian-born Jews; his father worked as a tailor in a factory and also at home—a house cluttered with scraps of fabric from which young Emmanuel made deliveries by pushcart. The sweatshop experience is common to many Jewish immigrants in America—the families of artist Barnett Newman and architect Louis Kahn included—but Man Ray carefully tied these stories under a blanket. He created this intriguing work in New York, shortly before leaving for Paris in 1921, where he would replace his biological family with a family of avant-garde artists who created their own identities, like fellow Dadaist, poet Tristan Tzara (born Samuel Rosenstock). Yet, the clothes irons (with nails), fabrics, and coat hangers—however trivial and witty—are a constant reminder of Man Ray's repressed and (for him) shameful background as the son of Jewish textile workers, and as such the camera with which he photographed high fashion can be seen as an upgrade on the sewing machine of his youth.

Man Ray remained silent about the Holocaust on his return to Paris in 1951 from his native America, to which he fled in 1940. His 1952 painting *Rue Férou*—the Paris street where he lived and worked—depicts a tiny figure pulling a loaded cart on an otherwise deserted street. The heavy load strikingly resembles *The Enigma of Isidore Ducasse*. Man Ray may have once claimed that "Race and class, like styles, then become irrelevant," but he too had to carry the burden of his past and acknowledge (however indirectly) his social background and his Jewishness when he reentered the world of art and fashion after fleeing Europe: "With my bundle in a black cloth under my arm I felt like a delivery boy"—perhaps like young Emmanuel transporting his father's wares as did so many Jewish peddlers before him, wandering from town to town in search of clients.

In antiquity, the rabbis were critical of Jews adopting Greek and Roman first names, just as later they would frown upon such names as Morris (Moshe) and Sigmund (Solomon), or the refashioning of an ancient

Hebrew name with messianic overtones, Emmanuel (God is with us) as Man (human in general). The rabbis couldn't prevent Jews from changing their names, but—as Man Ray's life and work tell us—there is more to Jewish identity than just a name.

Man Ray, *Rue Férou*, 1952.

Oil on canvas, 80 × 60 cm (31 1/2 × 23 5/8").
Man Ray Trust, Paris, France

Jewish Pioneers in Palestine

Reuven Rubin
First Fruits, 1923

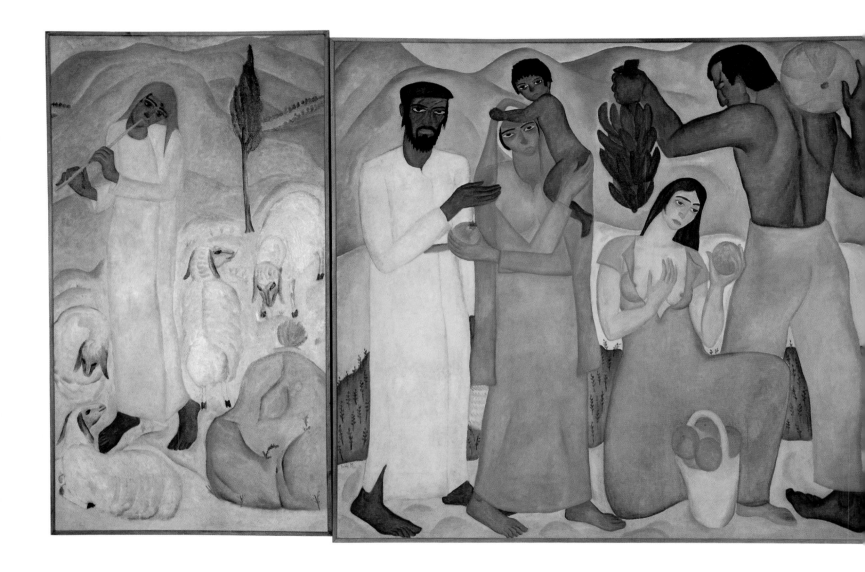

Although rooted in the Hebrew Bible, Jewish tradition, and liturgy, Zionism as a political movement for a national homeland is a product of the Diaspora. "In Basel I founded the Jewish state," said Theodor Herzl (1860–1904), summarizing the First Zionist Congress in 1897. This assimilated Austro-Hungarian Jew, a newspaper correspondent in Paris, was as appalled as were his fellow Jews (and many French) by the anti-Semitism which surfaced during the Dreyfus affair in France, in which an assimilated Jewish military officer was unjustly accused and condemned for treason, primarily as a result of his being Jewish. Ignoring religious reservations about what many perceived as an

irresponsible messianic adventure, Herzl managed to convince Jewish representatives of his dream of a Jewish return to the Promised Land. In his eyes, European nationalism invited only one response: a Jewish national solution to the endemic problem of anti-Semitism, which plagued backward and absolutist Russia as well as modern and democratic France.

But how do you turn Jewish European traders into Middle Eastern farmers, as their biblical ancestors were? Before it became the independent state of Israel in 1948, Ottoman (and later British) Palestine was colonized by Eastern European settlers. Supported by various philanthropic organizations in the Diaspora,

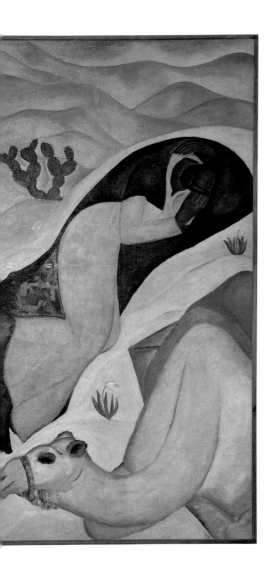

Natalia Goncharova, who like so many of her contemporaries (including Marc Chagall and Wassily Kandinsky), revealed the influence of Russian iconography. Rubin's *First Fruits* can well be compared to her *The Jewish Family* (1911–12); it possesses the same expressive iconic style and ritualistic monumentality that reaches far beyond the simplistic narration of a genre scene.

First Fruits impresses by its solemnity. The title refers to the biblical harvest festival, described in Deuteronomy 26, in which each individual settler in the "land of milk and honey" brings to a specially designated place a basket with the first fruits of the soil God had given him, whilst reciting a prayer which briefly summarizes his origin as a fugitive Aramean who was oppressed in Egypt but now delivered to the Promised Land. In the earliest Zionist settlements, the villages, and *kibbutzim*, these ritual observances of the harvest festival were revived. The words of the prayer, part of Passover, the festival which celebrates the Exodus, are brought to life, depicted in a style resembling social realism. Whether traditionally dressed with their heads and bodies almost fully covered, or modern and secular with naked breast and chest, these Jews celebrate their first fruits—of the land and the womb. They are in unison with the land, celebrating it musically with the animals, or being as one with it, relaxed after wandering so many millennia over the earth. Arabs serve as a role model of strength and belonging for these new Israelites. The desert starts to flourish; a dream is being fulfilled.

The harsh awakening comes after the Arab attacks and riots in 1929. From then on, naïve forms of Zionism need revision: Palestinian inhabitants also start to develop national thoughts.

Reuven Rubin, *First Fruits*, 1923.

Oil on canvas, triptych, 188 × 397 cm (74 × 156 1/4"), From left to right: *The Shepherd, First Fruits, The Bedouin.* Collection of the Rubin Museum Foundation, Tel Aviv, Israel

they founded agricultural colonies on available, uncultivated land, which was in general either too arid or too swampy.

The back-to-the-land movement predominated in many romantic and nationalist European ideologies of the late nineteenth and early twentieth centuries, and artists were particularly sensitive to such tendencies. Before he definitively settled in Palestine in 1920, Reuven Rubin (1893–1974) had been influenced by the large neo-Byzantine murals in his Rumanian homeland, as well as by the naive realism of Henri Rousseau and the African art he saw while studying in Paris. He may have also been inspired by the work of

Blood and Tears: Non-Jewish Jewish Art?

Chaim Soutine
Carcass of Beef, ca. 1925

At first sight, there is nothing Jewish about the art of Chaim Soutine (1894–1943); in fact, he never painted a Jewish subject. Still, Soutine identified himself and was perceived by others as a Jew. He never changed his Hebrew first name and spoke with a Yiddish accent that betrayed his Eastern European background (he was born near Minsk in White Russia, and studied art in Lithuanian Vilna). Like Chagall, he married Jewish (in 1925), but unlike him, he never painted his shtetl, Smilovitchi, where he was once beaten up for drawing an elderly Jewish man. Among traditional Jews, art is considered a waste of study time, and portraying people is forbidden. Once installed in Paris in 1913, he made portraits of himself, a cook, and a communicant, but never of a rabbi as did Chagall. He preferred Chartres cathedral to synagogues, painted landscapes in southern France, and still lifes of simple provisions. Food was among his favorite subjects, a choice that may originate in his own humble background, and remained as such even after he achieved financial success from acquisitions by French and especially American collectors.

His personality and his art have always fascinated his critics and admirers. They labeled it as expressionist and intense, but also as primitive and instinctive. They derogatorily considered his work as "art based on the Jewish spirit," art incapable of incarnating ideas and hostile to formal beauty. However much he differed from painters like Chagall and Modigliani, or sculptors like Lipchitz, they and some of their non-Jewish colleagues shared one feature: they were foreigners, grouped together under the School of Paris label, excluded from the prestigious French School.

Soutine became most noted for his paintings of dead animals, about which a critic at the time wrote: "bloody heaps ... flesh more flesh than flesh itself." Though perhaps inspired by reminiscences of slaughtered animals from his youth, Rembrandt's *The Slaughtered Ox* (1655) in the Louvre is a more obvious influence. Though an ox chews the cud and has split hooves and is therefore kosher, the majority of animals depicted by Soutine—such as skate, hare, and game—are not. Soutine purchased his carcasses from a nearby slaughterhouse, hung them, and started painting as an assistant fanned away the flies. As soon as the carcass dried, he would get a fresh pail of blood, which he applied to the carcass to revive the color of fresh meat. The story goes that when neighbors complained to the authorities about the stench of decaying flesh, Soutine was able to convince the police of the artistic importance of his work.

In Judaism, blood equals life. Its consumption is absolutely forbidden and in the Bible punished with death. When an animal is slaughtered—for sacrifice as well as for consumption—all blood must be drained. Soutine does the opposite: he replenishes the drained flesh and paints the carcass as if it were dripping blood.

Was France, with its abundant street market and its exquisite cuisine, the counter-image to the poor Lithuanian shtetl of his birth? Does this painting symbolize the fatal attraction of France and the still lifes of western art in general versus the dietary restrictions and perceived lack of art in Judaism? Is the slaughtered ox a tragic Jewish counter-image to sun-intoxicated France, foreshadowing the future drip-paintings of abstract expressionism in the United States or the end of all flesh in general, a "memento mori" like any real still life? Soutine, the outsider inside, exploring borders, died of a perforated ulcer in 1943, before the Nazis could catch him in occupied France, and kill him back in Eastern Europe.

Chaim Soutine, *Carcass of Beef*, ca. 1925.

Oil on canvas, 166.1 × 114.9 cm (65 3/8 × 45 1/4").
Stedelijk Museum, Amsterdam, The Netherlands

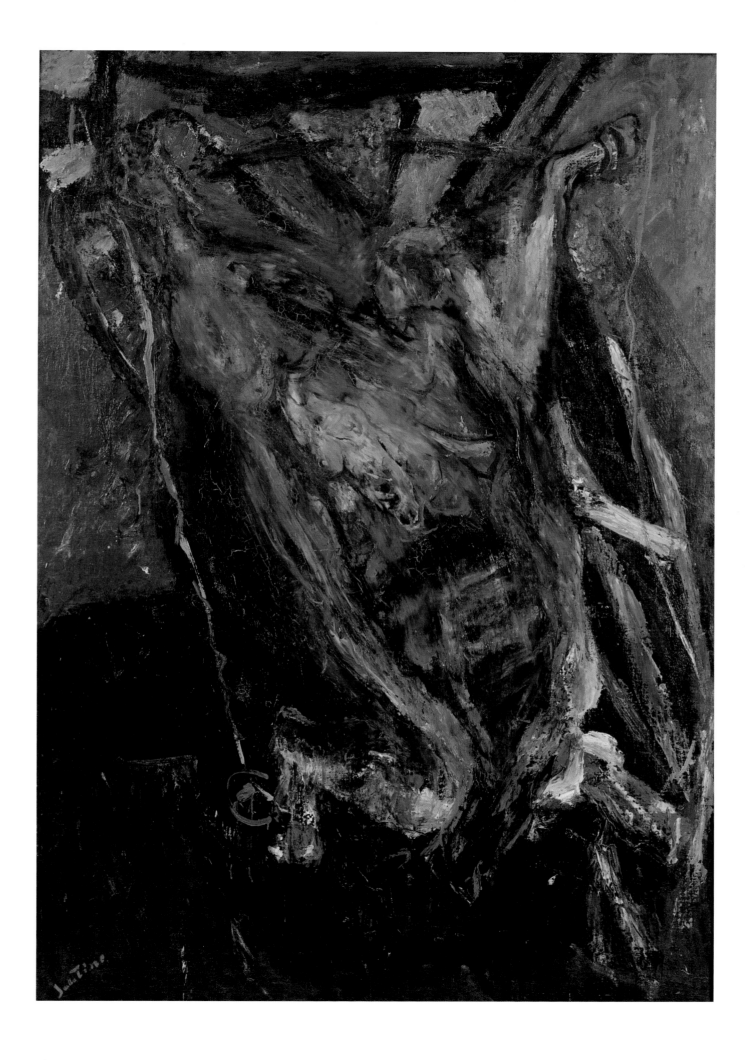

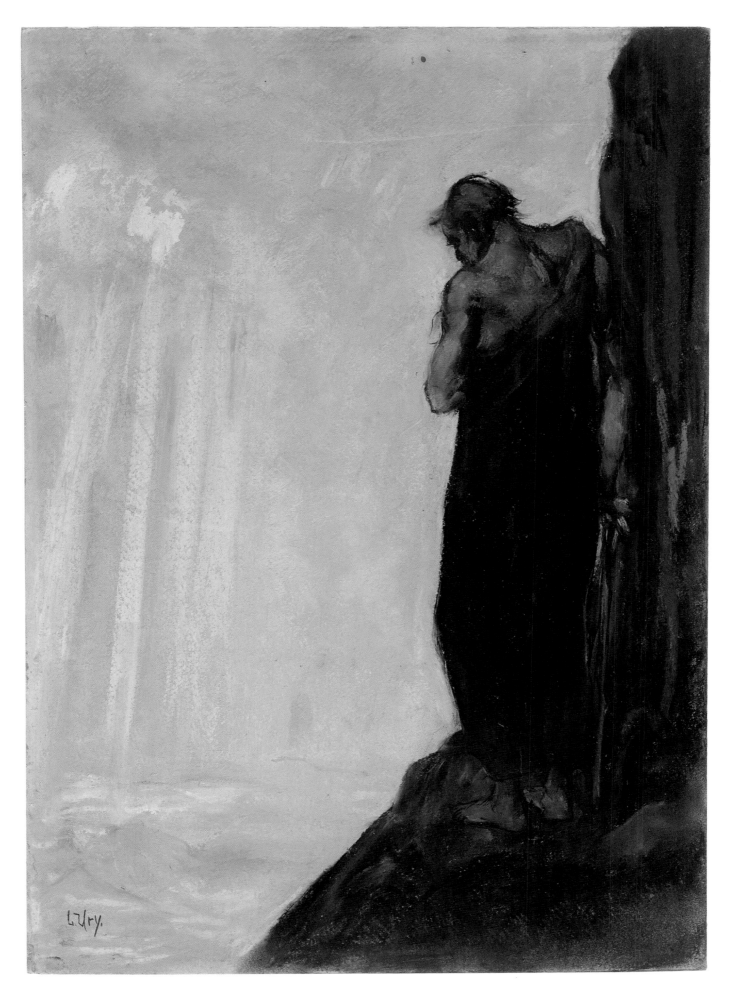

Dreams of Emancipation

Lesser Ury

Moses Sees the Promised Land before his Death, 1927–28

Moses, the most powerful hero of the Bible, stands alone on the steep peak of Mount Nebo, overlooking the land God had promised to his ancestors: "I will let you see it with your own eyes, but you shall not cross the Jordan" (Deut. 3:23–7 and 34:1–5). Jewish legend elaborates how Moses' desperate plea to enter the Promised Land was angrily refused by God—not even 515 prayers, or the five books that bear his name, helped him. Instead, Moses, passionately leading his people into freedom, will have to die before his mission is fulfilled.

The preliminary sketch by Lesser Ury (1861–1931), made in preparation of a now-lost painting, very well summarizes this most tragic moment in Moses' life. He was not allowed to bring the people he had liberated out of Egyptian slavery into the Promised Land, the people he led for forty years through a hazardous desert, that he condemned impatiently but also lovingly blessed. Bent over, he stares gloomily down; yet he is unbroken, strong as the rock of which he seems to be a part.

Lesser Ury, the first artist who celebrated Berlin's vibrant metropolitan life in his cityscapes, was praised in Jewish circles for his monumental treatment of Old Testament figures. His *Moses* is at the same time both authentic and modern, and as such characteristic of Jewish culture during the Weimar Republic. Anti-Semitism in the wake of the First World War created a renewed sense of community amongst German Jews, a Jewish Renaissance of learning and culture then taking root. Zionist philosopher and writer Martin Buber (1878–1965) had been one of its major initiators: he had not only revived interest in the stories of Eastern European rabbis, but also emphasized the relevance of Biblical leaders like Moses to modern Jewish self-awareness. Contemporary writers and artists were particularly struck with Moses' historical alter ego: Theodor Herzl (1860–1904), whom Ephraim Moses Lilien (1874–1925) photographed in 1903 as the visionary of a Jewish state overlooking the Rhine from the balcony of his Basel hotel. That photo was to become an icon of Zionism: Lesser Ury paints Moses in the same position as Herzl, and like the latter, Moses gazes towards an unknown future.

Lesser Ury's paintings were, together with the works of Jewish artists like Jozef Israëls and Isidor Kaufmann, included in an exhibition of Jewish artists which Buber and graphic artist Ephraim Moses Lilien organized in connection with the Fifth Zionist Congress in Basel (1901).

In 1933, when the original Berlin Jewish Museum opened its doors one week before Hitler took power, its entrance hall illustrated how German Jewry then defined itself. The busts of two prominent German Jews, Moses Mendelssohn (1729–1786) and Abraham Geiger (1810–1874), celebrated the advocate of civil rights and the pioneer of Liberal Judaism, respectively. Four biblical-themed works emphasized the new Jewish self-esteem: a sculpture of the young and naked David with his sling ready to kill Goliath, and three paintings—two tormented Prophets seeking to bring justice to an already threatened world, and Lesser Ury's *Moses*. Just as Moses was not allowed to enter the Promised Land, Jews in Germany began to realize that they would not see their dream fulfilled: to live as equal citizens in a country to which they had contributed so much—as soldiers and scholars, workers and entrepreneurs—a fatherland they loved. With the rise of Nazism, Germany no longer looked for visions of justice and compassion anymore, and as a result, Moses became the biblical model for Jewish leaders looking to solve the historical dilemma of a homeland for their people. Sigmund Freud (1856–1939) explored this subject from another angle in his famous study *Moses and Monotheism*, which, tellingly, he was forced to publish during his London exile in 1939.

The Jewish hopes placed in Germany were eclipsed, just as Moses and other Jewish visionaries had passed on. And yet, the vision of a just society portrayed by Lesser Ury in his *Moses*, a vision shared by so many pioneers of moral values in the twentieth century, remained alive.

Lesser Ury, *Moses Sees the Promised Land before his Death*, 1927–28.

Gouache, 50.5 × 35.5 cm (19 $^{11}/_{16}$ × 14").
Jewish Museum, Berlin, Germany

An Israeli stamp, issued on the centenary of Theodor Herzl's birth in 1960, uses the photograph of Herzl taken in 1903, which has become one of the most popular icons of Zionist imagery, and which also inspired Lesser Ury.

Tracing Genealogy

Frida Kahlo

My Grandparents, My Parents, and I (Family Tree), 1936

Beginning with the Bible and continuing up to the present day, genealogy and descent play an important role in Judaism. Lists of ancestors serve as an introduction to all major biblical figures—patriarchs, prophets, and kings—and the importance of these listings can be measured by the fact that in Hebrew the word for generations (*toldot*) became the word for history. Purity of descent played a major role for the priests (*kohanim*) of the Temple, and even after the Second Temple's destruction in the year 70 CE Jews pride themselves upon being descendants of those Biblical priests or their servants, the Levites, while others trace their lineage back to King David. In later Jewish history considerable importance was attached to descent when marriages were arranged; being the son or daughter of a famous Jewish scholar made one a particularly attractive mate. The current interest in tracing and documenting family records has very old roots indeed.

In *My Grandparents, My Parents, and I*, Magdalena Carmen Frieda Kahlo Calderón (1907–1954), as she figures on her birth certificate, deals with her genealogy and her divided loyalties, the indigenous Mexican culture of her Catholic mother and the European background of her Jewish father. Raised Catholic and an ardent communist as an adult, Kahlo explored her mixed background throughout her artistic career. Her father, Guillermo (Wilhelm) Kahlo, was an immigrant Jew of German-Hungarian descent, her mother Matilde Calderón y Gonzáles, a woman of mixed indigenous Mexican and Spanish origin.

My Grandparents, My Parents, and I shows Frida as a small child, standing naked in the courtyard of the house her father had built just outside Mexico City where she lived most of her life (now the Frida Kahlo Museum). On top of the house are her father and mother in their wedding dress; Frida depicts herself as a young girl in front of her father, and again as an embryo attached by an umbilical cord to her mother. A ribbon flows to her grandparents in the clouds, just as in Henri Rousseau's painting *The Present and the Past* (1899) she so admired. Her paternal grandparents are depicted on the right coming from overseas, and her maternal grandparents above Mexican soil on the left.

Since her mother was not Jewish, Kahlo would not be Jewish according to the strict sense of Jewish law. Yet, she occasionally spoke about herself as "half-Jewish" and was deeply concerned about the consequences of the 1935 Nuremberg racial laws for her German relatives still residing near Baden-Baden, realizing of course that she himself would have been affected by the Nazi dictates. In 1945, the year the Second World War ended, she painted *Without Hope*, depicting herself in bed, fantasizing about her own persecution by the Spanish Inquisition.

Celebrated since her death as a cult figure in exhibitions, films, and books, this bohemian artist and proto-feminist battled her whole adult life with her health as the result of a bus accident. Having taken up painting in 1925 while convalescing, in 1928 she started her stormy relationship with the celebrated painter Diego Rivera, famous for his politically charged murals. Her work is a fanciful and sophisticated blend of her native Mexican culture and European modernism.

Frida Kahlo, *My Grandparents, My Parents, and I (Family Tree)*, 1936.

Oil and tempera on metal panel, 30.7 × 34.5 cm (12 1/8 × 13 5/8"). The Museum of Modern Art, New York, USA. Gift of Allan Roos, M. D., and Matheu Roos

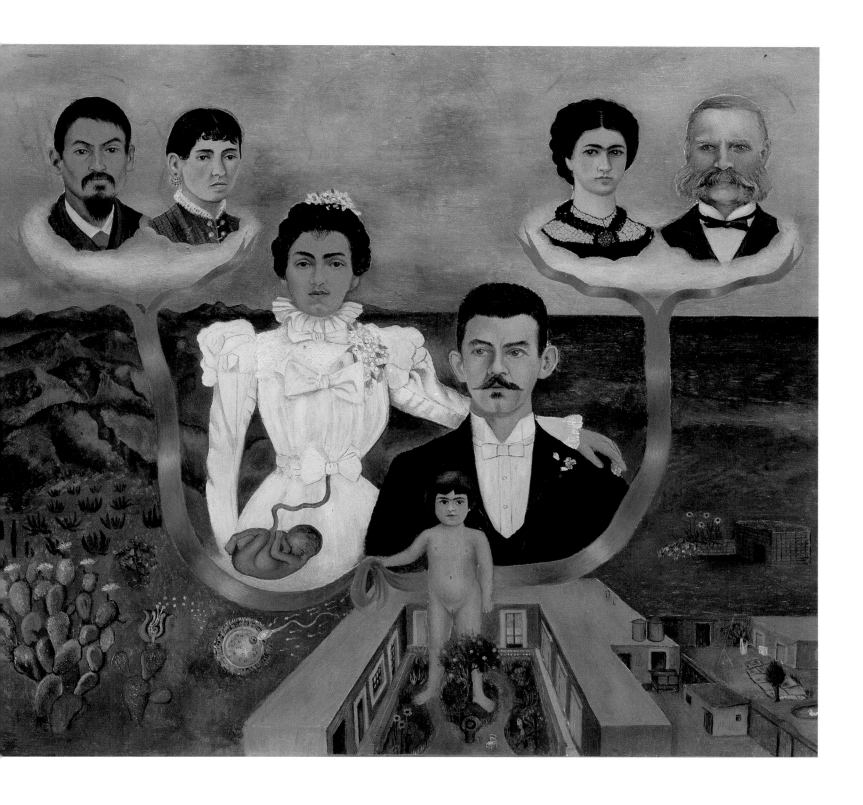

Human Dignity

Jankel Adler
Two Rabbis, 1942

Two bearded rabbis with troubled looks in their eyes stare us pleadingly in the face. They make an appeal by showing us a small scroll on which a single word is written, *Misericordia*—compassion. It is 1942 and they have every right to our compassion; the rough stripes across their heads and the background indicate they are behind the barbed wire of a concentration camp somewhere in Germany or Eastern Europe. The bandage beneath the headgear of the rabbi on the left indicates they have been injured, the red of their scarves suggesting the gravity of their wounds.

In other paintings with Jewish subjects, or in his *Self-portrait*, Adler used Hebrew letters. Why the Latin *misericordia* and not the Hebrew equivalent, *Rahamim*, one of the biblical attributes of God (Exod. 34:6)? The two rabbis are fully aware that according to Jewish tradition God has given man the choice between good and evil and consequently do not blame God, but implore us, human beings, to take responsibility and combat evil. They do not pray to God, but appeal to the conscience of men, more specifically to those of the Christian faith.

Jankel Adler (1895–1949) traveled in 1912 from his native Poland to study art in Germany where, in close contact with Otto Dix and Max Ernst, he became one of the more prominent innovators in the visual arts. From 1931 until his forced retirement in 1933, he taught at the Art Academy in Düsseldorf where he became friendly with Paul Klee, whose lyrical abstraction and color clearly influenced Adler, as can be seen in the *Two Rabbis*. He fled Germany and wandered around, spending two years in Warsaw before going to France in 1937. When the war broke out, he joined the Polish army as a volunteer in 1940; after his discharge a year later, he settled in Great Britain—first in Glasgow and later in Aldbourne near London, where he tried to keep in contact with his native Poland.

Classically dressed in their monumental headgear, these serious, tight-lipped rabbis with their carefully combed beards—the very antithesis of Nazi propaganda—are icons of Jewish wisdom and human dignity, even in the most barbaric circumstances.

Jankel Adler, *Two Rabbis*,
1942.

Oil on canvas, 85 5 × 112 cm
(33 $^7/_8$ × 44 $^1/_8$").
The Museum of Modern Art,
New York, USA, Gift of Sam Salz

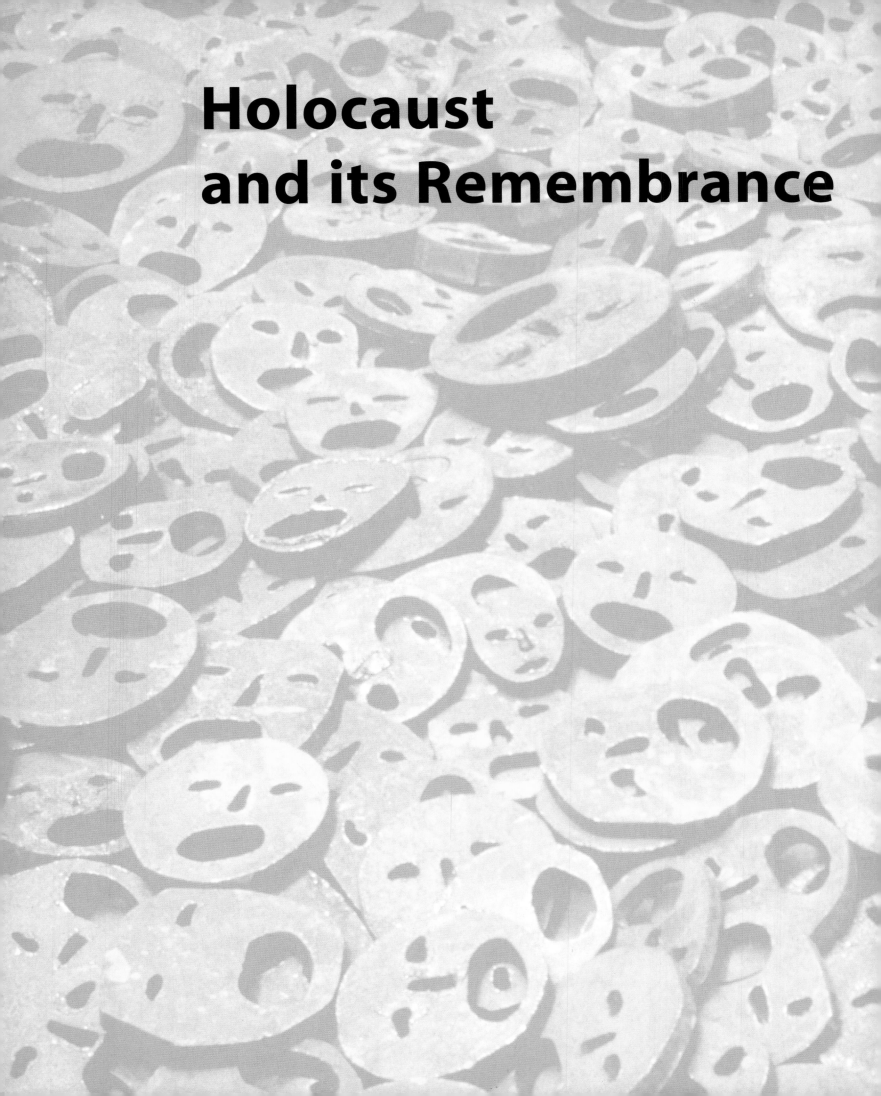

Holocaust
and its Remembrance

The Jewish artistic response to the Nazi rise to power in the 1930s came quickly: artists and writers expressed their fears of expulsion and humiliation, and their premonition of horrors to come. After the systematic mass murder of six million European Jews, the philosopher Theodor Adorno thought it would be forever impossible to create poetry — and by extension, art — after Auschwitz. Yet, the Holocaust has become one of the major themes for modern Jewish artists, as well as their non-Jewish counterparts. It has inspired architects to erect impressive monuments — in Europe, where the atrocities occurred, but also in Israel and the United States of America, where most Jews currently reside. The memory of the Shoah remains alive in numerous ways, but is perhaps most evident in the visual arts and powerfully moving monuments.

"This monster, which we try to kill ..."

Jacques Lipchitz
David and Goliath, 1933

The biblical David is a truly extraordinary figure, a warrior and statesman who united the Israelite tribes in establishing Jerusalem as its capital, but also a poet and musician—the author of psalms. Although his life is not without personal contradictions and conflicts, missteps and misbehavior, he remains celebrated in Jewish tradition as the founder of the House of David, expected to rule again in messianic times. David, the small shepherd boy, the unlikely hero, earned his fame with his victory over the Philistine giant Goliath, killing him with a stone from a slingshot and then cutting off his head (1 Sam. 27:49–51). The story's message struck a chord with Jews throughout the ages: a tiny people able to defeat greater adversaries.

This image of the Jew as a hero attracted Lipchitz. Shortly after Hitler became chancellor on January 30, 1933, he began making sketches for *David and Goliath*. The way he depicts them in his sculpture is unusual, eschewing the scenes most commonly illustrated of David with his slingshot or cutting off Goliath's head with a sword. Instead, David strangles the giant with a rope, killing the enemy with his own hands. In this way, Lipchitz, not wanting to interpret the text too literally, expresses his personal anger with the violent world around him. He chose to represent not just this specific historical slaying, but the defeat of evil in general. To make this meaning clear, he carved a swastika on Goliath's chest, having little David defeat the Nazi giant, strangling him in an attempt to exorcize impending evil: "I reacted purely instinctively as a Jew on behalf of my dispersed and persecuted brethren. But this monster, which we try to kill, is not only just anti-Semitism, it represents in fact everything which keeps man from advancing."

Lithuanian-born Chaim Jacob Lipchitz (1891–1973), immigrated to Paris in 1909 to study art. There, in Montparnasse, he became acquainted with artists like Constantin Brancusi, Chaim Soutine, and Amedeo Modigliani; through Diego Rivera, he met Picasso; and Juan Gris became a close friend. Lipchitz quickly became a celebrated cubist sculptor, whose work was widely admired; as early as 1922, the American collector Albert Barnes bought a number of his

sculptures. After the German invasion of France in May 1940, Lipchitz fled first to the unoccupied southern part of the country and from there, with the help of the American Emergency Rescue Committee, to New York, where he was to spend the rest of his life. Adjusting to yet another language and culture, difficult for any exile, was ultimately a propitious turn of events for the sculptor.

Lipchitz's response to fascism, the impending war, and the Holocaust started with *David and Goliath* in 1933, and he continued to address the theme in other monumental sculptures with mythological themes such as *Prometheus Strangling the Vulture* (1936), *The Rape of Europe* (1938), and *Theseus Slaying the Minotaur* (1942), in each case representing civilization in battle against barbarism. Works like *Mother and Child* (1941–45) and *Flight* (1940) relate to his own narrow escape from Europe, though the joy of his own rescue remained overshadowed by his despair over the fate of those left behind.

In accordance with the Biblical adage not to oppress the stranger in your midst, "for you were strangers in the land of Egypt" (Exod. 22:20 and elsewhere), Lipchitz responded to Israel's War of Independence in 1948 with the creation of *Hagar* (1948 and 1969). Abraham's first wife and their son Ishmael, considered the ancestor of the Arabs, were sent into the desert, exiled from the land that had been promised to Abraham and Sarah's son Isaac. Lipchitz's life-long involvement with the vicissitudes of the Jewish people and injustice throughout the world culminates in his anguish about those new refugees, the Palestinians; having been a refugee himself, Lipchitz identifies with their cause. And yet, Lipchitz recognized Israel as his spiritual home, and was ultimately buried there. He had turned his justified anger, expressed in *David and Goliath*, into apprehension about new injustices, but also into hope for a peaceful coexistence between two peoples.

Jacques Lipchitz, *David and Goliath*, 1933.

Bronze, height 99.7 cm (39 1/4"). Estate of Jacques Lipchitz. Courtesy Marlborough Gallery, New York, USA

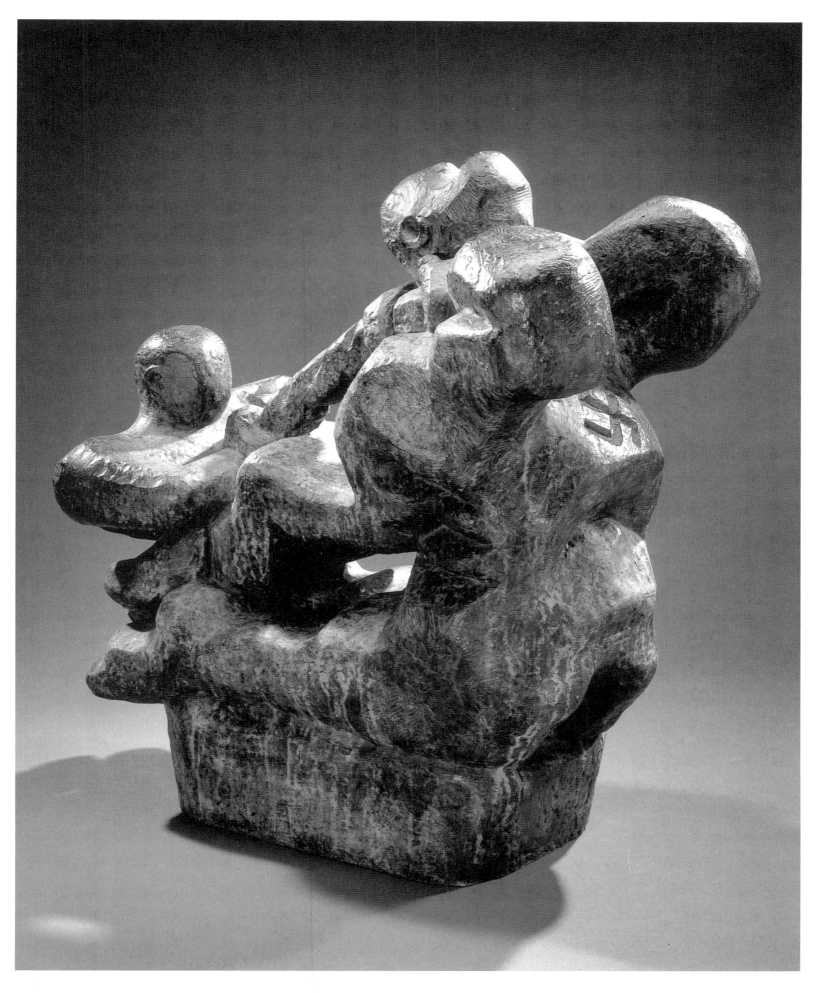

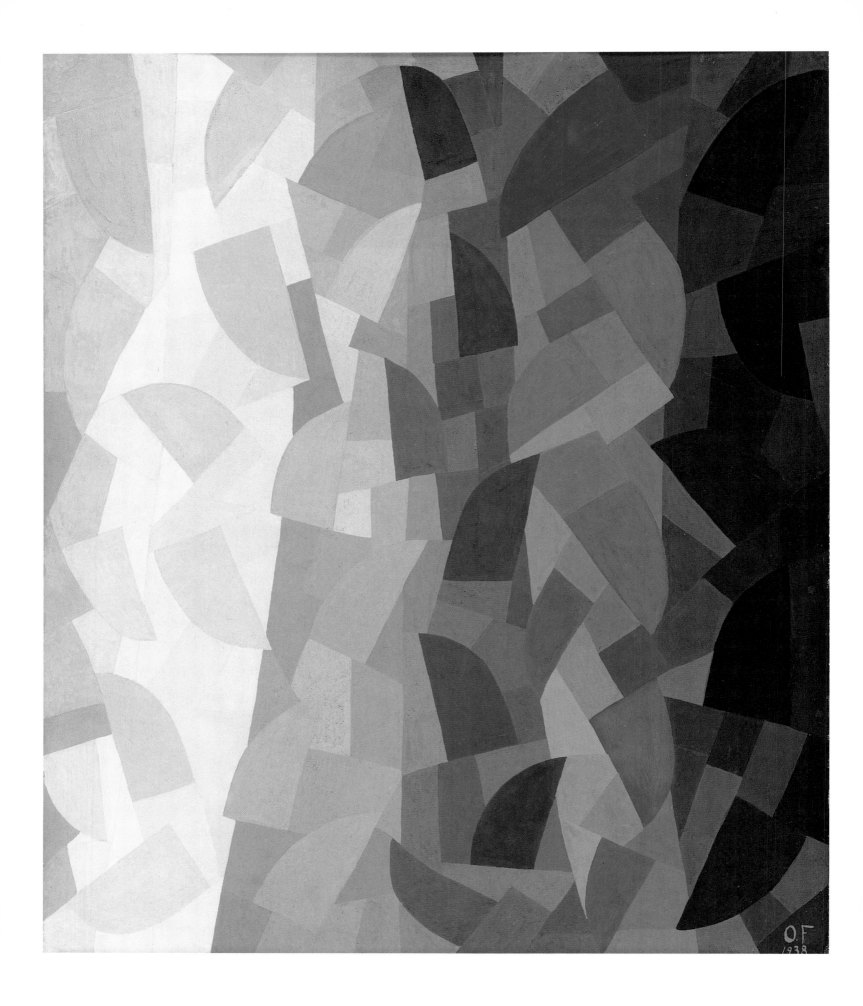

Defamed Art

Otto Freundlich
Composition, 1938

Otto Freundlich (1878–1943) studied in Berlin and Munich before moving to Paris in 1909 where he became friendly with the avant-garde artists of Montmartre, and participated in groundbreaking exhibitions in Berlin, Munich, and Paris.

Influenced as much by the colorful, lyrically abstract compositions of Robert Delaunay as the magnificent stained-glass windows of Chartres Cathedral which he greatly admired, Freundlich created his first purely abstract works in 1911. His rigorously organized abstract *Composition* dated 1938 shows his ability to reach great optical and lyrical intensity with a vibrant patchwork of color. In this same year his works were being exhibited together with Kandinsky and other moderns in Paris, and included in the international show *Abstract Art* in Amsterdam. By that time it was clear he couldn't return to Germany, not for visits and certainly not for exhibitions; modern art was increasingly and openly put under sharp criticism by the Nazis, causing a veritable exodus of artists, architects, writers, and scholars.

In 1937, Freundlich had the dubious honor of being included in the *Degenerate Art* exhibition in Munich's Archeological Institute on Galeriestrasse. His sculpture *Der neue Mensch* (The New Man) was positioned in a foyer opposite a wooden sculpture by Ernst Ludwig Kirchner. Then described as "fantasized by the Jew Freundlich, the anarcho-fascist," the sculpture, created in 1912, was in the possession of the Hamburg Museum of Arts and Crafts from 1930 until 1937, when it was confiscated by the Nazis as part of a nationwide cleansing policy in which over 12,000 printed works and 5,000 paintings and sculptures were seized.

The *Degenerate Art* exhibition displayed some 600 works by 110 artists in a deliberately chaotic fashion, the pieces placed one above the other in crowded, narrow rooms. This stands in stark contrast to the orderly *German Art* exhibition, personally opened by Adolf Hitler in the recently-inaugurated House of German Art in Munich. The exhibition opened on July 19, 1937—a day after the opening of *German Art*—and lasted until the end of November, attracting over two million visitors. The subsequent showings in Berlin, Hamburg, and Düsseldorf achieved similar results.

The heavily shadowed lighting for the cover image of *Der neue Mensch* on the exhibition brochure, *Degenerate "Art"*, accentuated the "racial" features of the figure. The work, conceived as the embodiment of a new humanity, was denounced by Nazi art critics as "primitive," "Negroid," "sick," and "Jewish." After the exhibition closed, the sculpture disappeared.

When France was occupied in 1939, the French authorities arrested Freundlich as a German national. He was imprisoned but managed to escape, fleeing to the Pyrenees. He was betrayed and deported via Paris to Majdanek, an extermination camp outside Lublin where he was murdered on March 9, 1943, shortly after arrival. Today, Freundlich's name may be less familiar than the image of his sculpture, *The New Man*, which became a symbol for the Nazi persecution of modern art and its creators, both Jews and non-Jews.

Otto Freundlich, *Composition*, 1938.

Tempera on cardboard, 54.5 × 45 cm (21 ¹/₂ × 17 ³/₄"). Jewish Museum, Berlin, Germany

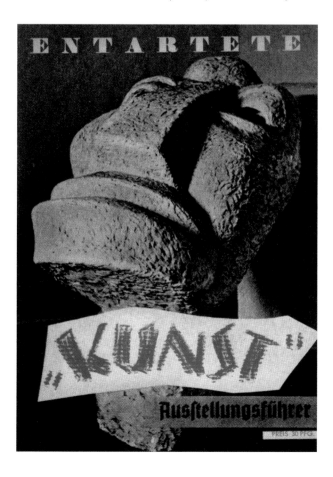

Exhibition brochure *Entartete "Kunst"* (Degenerate "Art"), Munich 1937, with the sculpture *Der neue Mensch* (The New Man) by Otto Freundlich.

A Holocaust of Books

Micha Ullman
Library, Berlin, 1993–94

Even though modern Berlin is reunited, rebuilt, and restored, its ghosts remain ubiquitous—memories of the topography of the Nazi terror and the destruction of the Jews surface everywhere. Government offices are housed in Nazi buildings, the former concentration camp Sachsenhausen is just a stone's throw away from the center, as is the villa on the idyllic Wannsee Lake where the annihilation of the Jews was planned. In spite of the forward-looking, modern glass cupola that crowns it, the German Reichstag preserves the traces of arson and attack and can be as little ignored as the hundreds of steles next to Brandenburg gate which symbolize the mass murder of European Jews, initiated and carried out from Berlin.

More numerous in the city are those "stumbling stones" with the name of an individual victim in the pavement, the rail tracks, street signs, plaques on a wall, or empty spots between houses that bear witness to personal tragedies, mainly of Jews, but also of artists and intellectuals whose views and lives were despised by the Nazis. To this latter category of less monumental—but no less impressive—memorials belongs the work of the Israeli artist Micha Ullman (b. 1939).

The square is empty: no statue, no fountain, not even a bench. Barely visible in the middle of Bebelplatz lies Ullman's subterranean installation, surrounded by the ponderous symbols of German cultural, religious, and intellectual life—the Royal Opera House, St. Hedwig's Cathedral, the former Royal Library and, on the other side of Unter den Linden, Humboldt University. Securely locked off by thick glass, a rectangular white room with white shelves theoretically offers space for some twenty thousand books. It is difficult to get insight into its layout and structure; one has to search hard for a position from which to look inside, one must bend or kneel down, only to struggle with the reflection of the clouds, or the dizzying abyss of the infinite sky. Inserted in the pavement, the installation is best seen at night. Lit solely from within, the illuminated work appears as an eternal memorial light on an ominously dark square.

One of Germany's most inconspicuous and impressive monuments to the victims of the Holo-caust, Ullman's installation commemorates the book burnings in Berlin and seventeen other German university towns on May 10, 1933. The action, organized by the German Student Association and attended in Berlin by some five thousand students and a crowd of eighty thousand spectators, resulted in the burning of about twenty-five thousand books, in the majority works by Jewish authors and scientists.

Jews are the People of the Book, and in 1933, a holocaust of books took place. Although nobody died

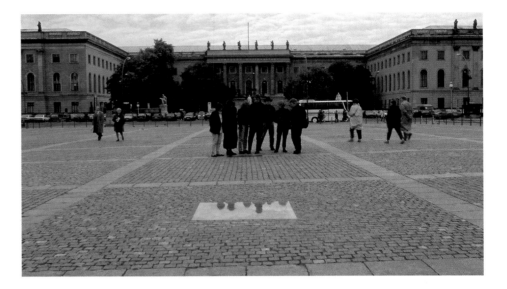

Micha Ullman, *Library*, Berlin, 1993–94.

Subterranean Space: 7.06 × 7.06 × 5.29 m (23 $\frac{1}{6}$ × 23 $\frac{1}{6}$ × 17 $\frac{1}{3}$'); Glass viewing cover: 1.20 × 1.20 m (3 $\frac{11}{12}$ × 3 $\frac{11}{12}$'). Bebelplatz, Berlin, Germany

Book burning, Berlin, May 10, 1933

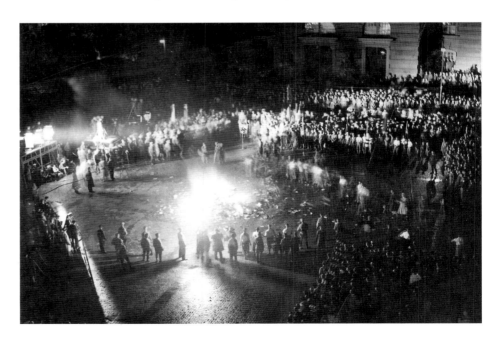

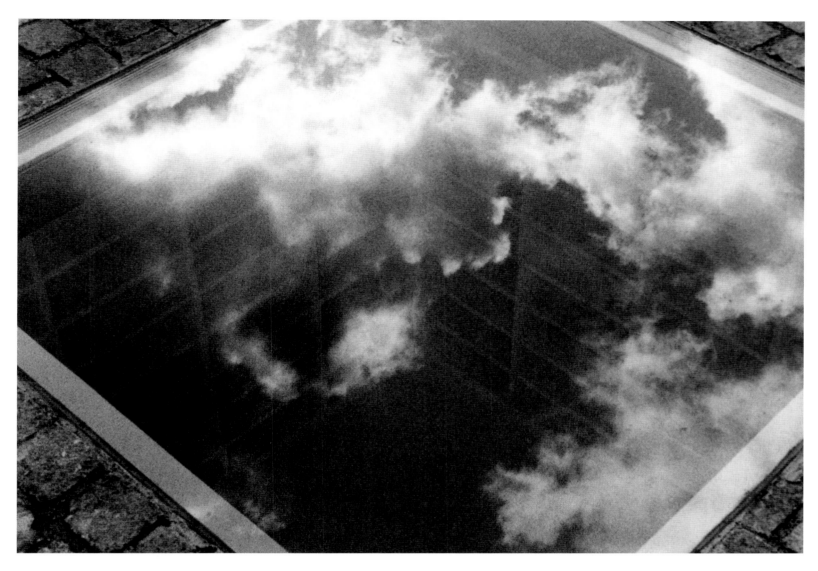

at the time, the modern-day visitor clearly senses what we know in hindsight, as Heinrich Heine wrote over a century before: "This was only a prelude; wherever they burn books they will also, in the end, burn human beings" (*Almansor*, 1820–21).

Trying to look into the empty *Library*, we realize how hard it still is to fill the inaccessible void with new life, wisdom, and insight.

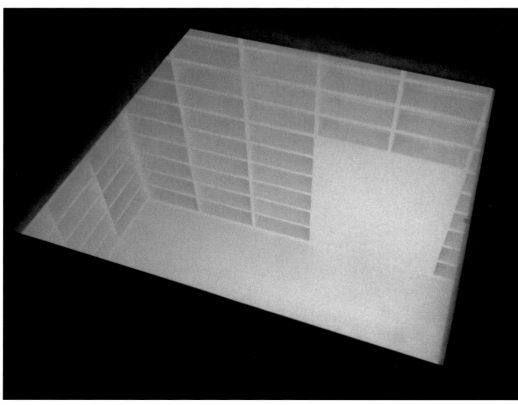

Departure into Exile

Charlotte Salomon
Life? Or Theatre?, 1940–42

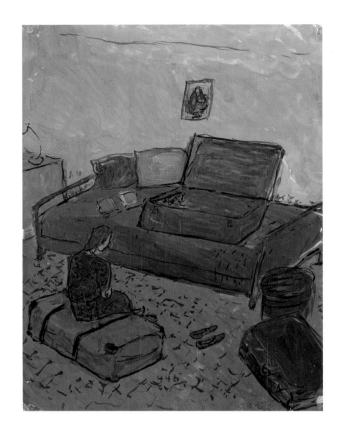

Charlotte Salomon, *Life? Or Theatre?*, 1940–42.

Gouaches on paper, 32.5 × 25 cm (12 ³/₄ × 10"). Charlotte Salomon Foundation, Joods Historisch Museum, Amsterdam, The Netherlands

Discriminatory laws and later the threat of annihilation in the 1930s and early 40s forced hundreds of thousands of Jews in Germany and Nazi-occupied Europe into exile. Success depended, amongst other factors, upon being granted asylum elsewhere and on obtaining an exit visa; most countries kept their borders virtually closed and Germany levied prohibitory taxes and confiscated property. Non-Jewish artists, intellectuals, and political dissidents also decided to go into exile.

In January 1939, Charlotte Salomon, a not yet twenty-two-year-old woman, left her ancestral home, the city she was born and raised in: Berlin, and her fatherland: Germany. As the repercussions of Hitler's rise to power became increasingly evident—the boycott of Jewish stores and professionals (her father Albert was a doctor), the exclusion of Jews from cultural life (her stepmother Paulinka was a Lieder singer), the labeling of art created by Jews as degenerate (Charlotte had to leave the Art Academy), and particularly after the pogrom night of November 9–10, 1938, when Jewish property was plundered and synagogues burnt—the family decided to send Charlotte, their only child, to safety in the South of France. All she carried was a small suitcase and a record with Bizet's *Carmen* sung by Paulinka, enough for "a weekend visit" to her maternal grandparents' home, who had fled the country four years earlier. Her father and stepmother accompanied Charlotte to the railway station along with her friend and muse, the music pedagogue Alfred Wolfsohn (nicknamed Daberlohn), to send her off.

With the exception of documentary photographs of the children's transports—organized by Jewish relief organizations to save Jewish youth from Nazi Germany—very few if any representations of departure scenes exist in contemporary art. Yet departure is a recurrent theme of Jewish history that began in biblical times with the divine call to Abraham in Mesopotamia to leave, in an ascending order of difficulty (as the rabbis point out): his country, his place of birth, and his father's house—lines which appear in Hebrew in the painting *Jew in Red* of that other refugee artist, Marc Chagall.

While in France, Charlotte's grandmother, depressed by the outbreak of the war, committed suicide, prompting her grandfather to reveal a family secret: suicide ran in the family and her mother, whom Charlotte had been told died of influenza, also took her own life. "You are next in line," her grandfather told her, compelling Charlotte to do "something really extravagantly crazy." In a cathartic outburst of creative energy, she painted her life's story. *Life? Or Theatre?*, consisting of 1,325 gouaches and transparencies, 769 numbered and all of the same size, was produced over a period of eighteen months.

This work, later handed over to her parents who had survived in Holland, is a unique personal testimony in images accompanied by text and music. Its full power and artistic authenticity bring to mind her contemporaries Edvard Munch and Max Beckmann, and seems to anticipate modern artists such as Markus Lüpertz, Joerg Immendorff, and William Kentridge. We will never know in what direction she would develop artistically, because Charlotte Salomon—recently married—was betrayed, arrested, and, together with her husband, deported to Auschwitz, where she was murdered in 1943, five months pregnant.

A Passage into Death

Dani Karavan

Passages, Homage to Walter Benjamin, Portbou, Spain, 1989–94

Portbou, a small village at the steep foothills where the Pyrenees extend into the sea on the French-Spanish border, has become one of Europe's most impressive *lieux de mémoire*. It was here that numerous refugees tried to cross the border to safety. In this truly dramatic landscape, the Israeli sculptor and environment artist Dani Karavan (b. 1930) created a monumental environment in memory of Walter Benjamin (b. 1892), at the place where, on September 27,1940, the celebrated German Jewish philosopher, critic, and pioneer of new ideas committed suicide out of fear of being handed over to the Gestapo (German secret police). Aware of impending catastrophe, he immigrated to Paris in 1933 and, after the German occupation of France, tried to escape to the United States via Spain, which reluctantly granted transit visas to Jews. The monument documents his final abortive journey across the mountains from Banyuls-sur-Mer in France to Portbou in Spain.

Karavan's *Homage to Walter Benjamin* is a large-scale site-specific environmental sculpture consisting of several separate parts. The work integrates the sound of the nearby border railway station that indirectly recalls the cattle cars on their way to the concentration camps; the roaring waves of the sea below, the sky above, the old olive tree struggling to live, and the fence of the old cemetery, all become loaded with meaning. A square metal platform with a seat overlooks the cemetery where the remains of Benjamin lie buried, pointing towards the mountains, the sea, the sky, freedom.

The largest section is an underground stairway made out of thick, 2.35-meter-high steel plates and cut into the slope. Eighty-seven steps project steeply downward towards the sea; more than two-thirds down, a transparent glass wall prevents further descent. Engraved on the glass is a quotation, "It is more difficult to honor the memory of the nameless than of the renowned. Historical construction is devoted to the memory of the nameless." This leitmotif for the monument comes from *Passages* (1935), the famous but unfinished fragmental text by Benjamin in praise of the Parisian arcades as models for the exuberant and sensuous attractions of modernity. Karavan's installation concentrates on hope and despair, and is as much a discourse with Benjamin as it is part of an ongoing discourse about memory.

The memorial honors all those intellectuals and artists, famous and anonymous people, who because of their birth or political stand had to leave Nazi-occupied countries. Many were killed, others survived in exile often under great privation, but none were ever thanked for upholding the German humanistic tradition, nor were the survivors ever invited back to their homeland. Instead, they were forgotten for decades. Thanks to this memorial, these often-nameless exiles have at long last received a truly breathtaking monument. Portbou has become a special place for contemplating the fate of those who did not manage to escape, deciding instead to take fate in their own hands rather than wait for worse things to come.

Left: View of Portbou with the cemetery on the left side and with the memorial below.

Right: View of the memorial

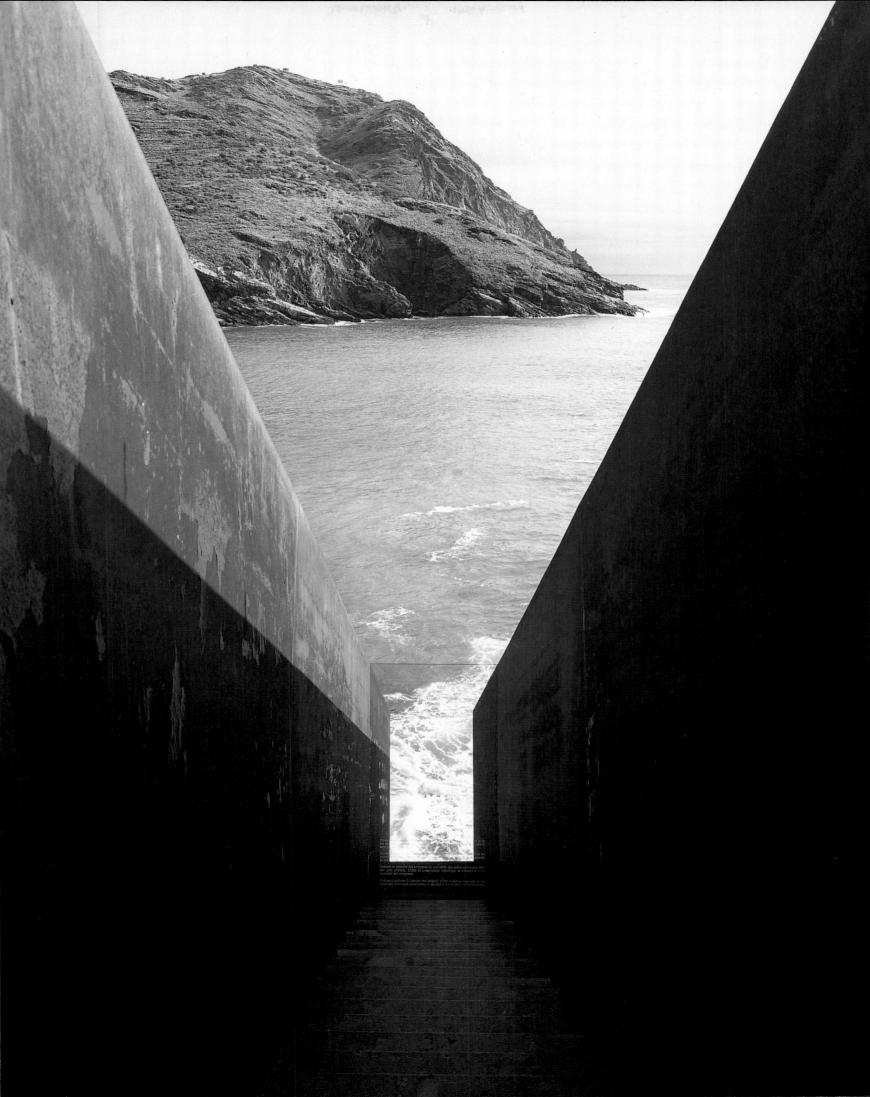

Facing Disaster

Felix Nussbaum
Self-Portrait in Death Shroud (Group Portrait), 1942

Even before he was killed in Auschwitz, Felix Nussbaum (1904–1944) had looked death in the face. With a pictorial language often recalling Giorgio de Chirico and James Ensor, Nussbaum's melancholic mood and macabre subjects characterize most of his paintings, and for good reason. A number of events brought harbingers of a darker future; after he moved to Berlin Anti-Semites vandalized the synagogue and cemetery of his hometown Osnabrück, and in 1932, while in Rome studying at the Prussian Academy of Art, his Berlin studio caught fire. Returning to Germany became impossible after the Nazi's rise to power in 1933: Hitler had been appointed chancellor, Jewish businesses were boycotted (including his family's ironware business), and book burnings staged. Nussbaum and his Polish-born, Jewish partner Felka Platek (they married in 1937), also an artist, decided to go to Belgium: first to Ostend and later to Brussels on renewable visas for resident aliens.

His œuvre is a direct reflection of his personal life and an illustration of the uncertainties of exile and flight, of exclusion and loneliness, and ultimately of death and destruction. Upon the German invasion of Belgium in May 1940, Nussbaum was arrested and deported to St. Cyprien, an internment camp in southern France. He managed to escape and return to Brussels where he would live in hiding. Nussbaum often reflected on his fate in self-portraits, in which he expressed a wide range of moods.

In his *Self-portrait in Death Shroud*, Nussbaum, turned apart from three other more abstracted figures, looks away despairingly, dressed in a shroud, with a fatal rope behind his head and a broken-off branch of leaves in his hand. The faces and hand gestures behind him reflect, in turn, an introverted, mute acquiescence; a blinded cry of despair before the rope is fitted around the neck; and sadness of the person raising a hand in accusation. Nussbaum is trapped with his conflicting moods in a reddish-brown room, the only window offering a pitch-black view of an inaccessible outside world.

From this point on, all of his previous intimations of doom paled in comparison with the horrors he was to experience in his final years. Astutely aware of the destructive powers of war and concerned about his own fate and that of his wife and relatives (trapped in German-occupied Holland), fear and anxiety became a palpable reality for Nussbaum, culminating in the creation of apocalyptic works in the months before his arrest in June 1944.

In the last transport from the Belgian transition camp Mechelen, Felix Nussbaum and his wife were deported to Auschwitz and killed upon arrival on August 2, 1944. They shared the fate of numerous

Felix Nussbaum, *Self-Portrait in Death Shroud (Group Portrait)*, 1942.

Oil on canvas, 50.5 × 80 cm (20 × 31 5/8").
Berlinische Galerie, Berlin, Germany

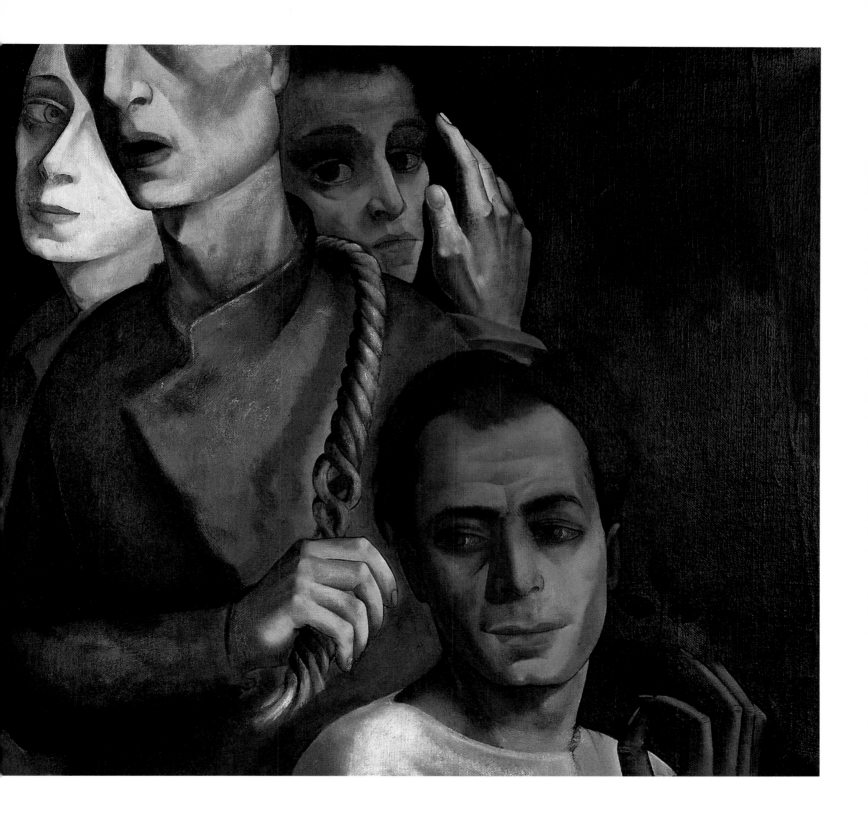

Jewish artists, both young and old, from all over Nazi-occupied Europe, who were caught in exile or at home, and perished during the Holocaust. Yet, hardly any other painter expressed his prescience of those horrors so strongly and consistently as Nussbaum did in the years preceding his death.

War and Destruction

Ossip Zadkine
The Destroyed City, Rotterdam, The Netherlands, 1948–51

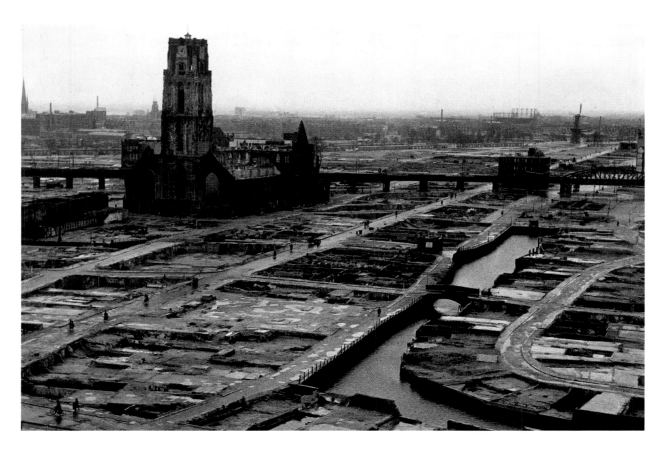

Ossip Zadkine, *The Destroyed City, Monument for Rotterdam*, 1948–51.

Bronze, 650 cm high (21' 2").
Leuvehaven, Rotterdam,
The Netherlands

Left: The destroyed city of Rotterdam after the German air raid. Photograph, 1941

Rotterdam was destroyed during a German air raid on May 14, 1940; the Netherlands, neutral until invaded on May 10, capitulated a day later. The destruction was truly dramatic: the old city was completely wiped out, approximately 900 people were killed, 25,000 houses burned to the ground, and 78,000 people were left homeless.

When in 1948 he received the commission to commemorate the destruction of Holland's second largest city, Ossip Zadkine (1890–1967) stood face to face with the ruined city and was deeply affected. A Jew from Smolensk, he had experienced the disastrous consequences of war and destruction in his own life. Born in Russia, he moved to London as a fifteen-year-old boy, before settling in Paris in 1911, where he soon became part of the circle around the painter Pablo Picasso, the painter-sculptor Amedeo Modigliani, and the sculptor Alexander Archipenko, a fellow Russian. In World War I, he served as a soldier until suffering gas poisoning. When the Nazis invaded the country, he fled France for New York and returned to Paris in 1945.

The Destroyed City is his most important monumental work of the post-war period. Located at the Rotterdam harbor, the sculpture can be looked at from all sides, a pain-ridden giant, its torso disemboweled, its arms stretching to heaven in a desperate gesture of lament, yearning to be restored. Zadkine combined the best of the two modern artistic movements in which he excelled—cubism and expressionism. Initially, the plaque's inscription read simply "May 1940," though it was a public secret the statue was donated by De Bijenkorf, a formerly Jewish-owned department store. Only in 1978 did a new inscription reveal the name of the sponsor, adding that the store wished to honor its 737 murdered Jewish employees. This sculpture is one of the most powerful modern monuments to commemorate the human suffering and material destruction of World War II.

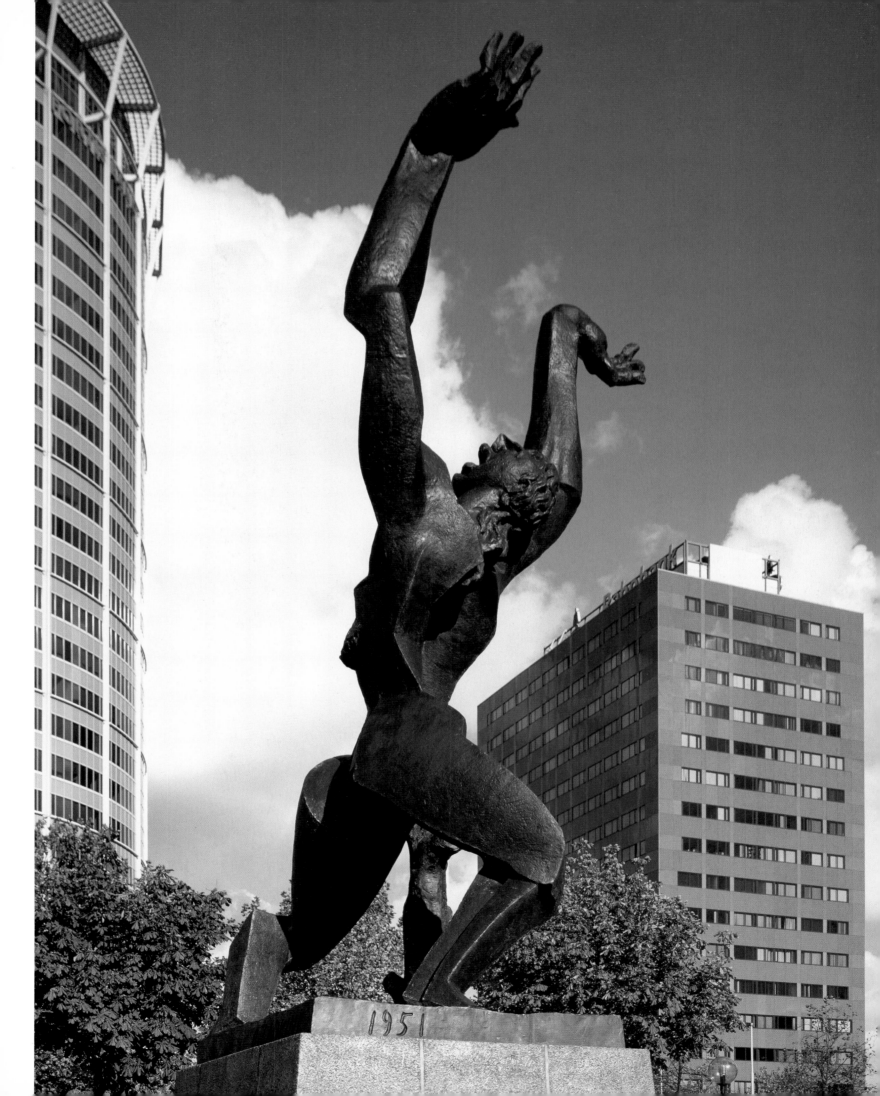

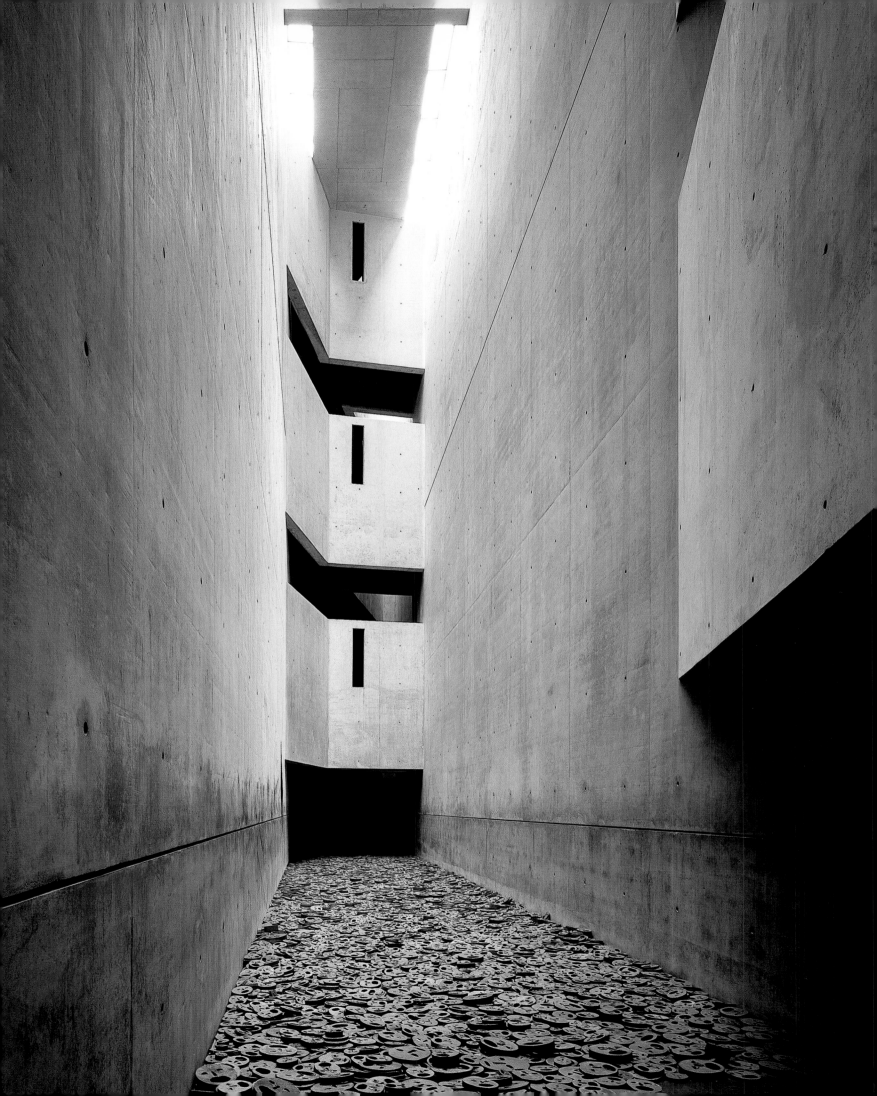

Remembering the Holocaust in Germany

Menashe Kadishman
Fallen Leaves, 1997–99

The commemoration of Jewish victims in Nazi-occupied countries has become a litmus test for modern multicultural democracies: how long was this dark chapter in history repressed and when and why did it become part of public consciousness? In the former Communist countries the debate about rights and restitution is just getting started, often in competition with an equally-needed consideration of the victims of Stalinist repression. Remembering the Holocaust in the land of its perpetrators has been notoriously difficult, and the debates surrounding it have been universally scrutinized. The former East Germany claimed innocence; for them Hitler was the product of (West) Germany's bourgeois capitalism, and East German—and East European—camps commemorated the victims of fascism without even mentioning that most of them were Jews.

Despite occasional political setbacks and serious, public slips of the tongue, Germany has gradually come to terms with its "unmanaged past," writing about, debating, and observing the extermination of its own Jews and those in the neighboring countries. This now occupies a central and strategic place in the German conscience; be it, since 1996, Holocaust Memorial Day on January 27, marking the liberation of Auschwitz by the Soviet army in 1945, or the Memorial to the Murdered Jews of Europe, centrally located near Brandenburg Gate and opened in 2005 in the presence of many government officials.

Nevertheless, no eyewitness report, no photograph, no documentary film can ever do justice in conveying the horrors of the systematic, technological mass destruction of six million Jews; at best, one can hope to approximate the atrocity. The same is true for art and poetry.

With this limitation in mind, the inclusion of Menashe Kadishman's (b. 1932) installation *Fallen Leaves* in one of the voids of Daniel Libeskind's Berlin Jewish Museum was an enlightened decision, strengthening the visitor's almost visceral, chilling experience of death and destruction in one of the deliberately empty spaces of the building. The space is covered by thousands of intentionally schematic oval head shapes, about half the size of an adult face:

nose, staring eyes, and open mouth. Cut from steel, they are heavy and yet look incredibly vulnerable.

Although a sign invites visitors to enter the space and walk over the installation, most hesitate to tread over the faces. When one finally does, the passive observer feels he becomes an active culprit, the squeaking metal transformed into screaming faces. The silence is broken and a dialogue commences between the living and the dead. When passing over the installation, each visitor becomes a witness to the awful death of a human victim of the Holocaust. With each step the visitor begins to discern what seem to be individual faces, each with a personal voice, whispering or screaming in immeasurable suffering.

However successful it is in transmitting to the visitor the horror of genocide, Kadishman's installation contains a spark of hope—the title *Fallen Leaves* refers to the natural cycle of autumn and winter followed by the rejuvenated green of spring. The dead belong to the past as much as they are part of the present, forcing us to become either silent voices from the hereafter or screaming forces for a more humane world.

Menashe Kadishman,
Shalechet (Fallen Leaves),
1997–99.

Installation of approximately 10,000 individual sculptures, cut with a mixture of gas and oxygen from sheet steel; thickness: 1.5 to 8 cm (5/8 to 3 1/8"), height: 8 to 17 cm (3 1/8 to 6 3/4"), width: 7 to 16 cm (2 3/$_4$ × 6 5/$_{16}$"). Jewish Museum, Berlin, Germany

Menashe Kadishman,
Shalechet (Fallen Leaves),
detail

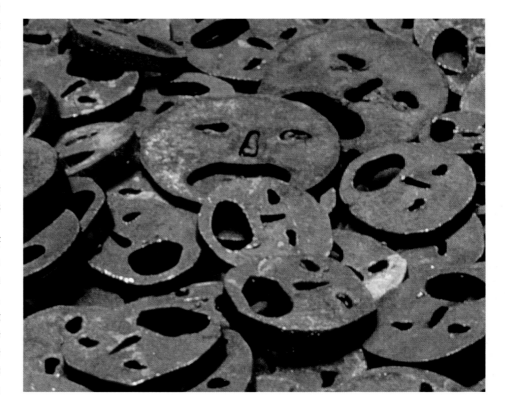

National Memory and Identity

Moshe Safdie

Yad Vashem Holocaust Museum, Jerusalem, Israel, 1997–2005

The history of the Jews plays a major role in defining Israel's national identity. While archaeological sites provide a vital ideological link between the modern State and its biblical roots, and museums stress the longevity of Jewish involvement in the arts or are dedicated to life in the Diaspora, the role of the Holocaust had long been ambivalent in Israel. Classical Zionist ideology and the first political leaders of the country considered the Holocaust the ultimate result of Jewish life in the Diaspora—proof of Jewish vulnerability without the power to defend themselves, without a state of their own. Yet despite their negative attitude towards the Diaspora, the founders of the young state could hardly ignore the importance of the Shoah (Hebrew for total destruction) since one half of the new state's population were survivors.

Once the full dimension of the mass destruction of European Jewry became known, plans developed for a memorial in then British-occupied Palestine. In 1951, a law was passed in the young Jewish state establishing an official day to commemorate the victims and the heroes of the Holocaust, *Yom ha-Shoah Ve-Hagevurah* (Catastrophe and Heroism Day), as it is officially called. The commemoration is set on the 27th of the month of Nissan, between the start of the Warsaw Ghetto Uprising on the eve of Passover, the 15th of Nissan (April 19) in 1943, and Israel's Independence Day eight days later, on the 5th of Iyyar. In the national narrative, a connection was created between the preceding celebration of the liberation from Egypt (Passover), and the following Independence Day, on the eve of which the Israel's fallen soldiers are remembered. Both new celebrations fall in a seven-week period of religious mourning for the Jewish victims of the European crusades. Thus a full circle of Jewish history is created in the calendar: from Biblical national liberation, medieval persecution, and modern annihilation up until heroism in the camps and ghettos, and ultimately the survivors' return to and redemption in the land of Israel. Just as the Holocaust became integrated in the long view of Jewish history, so too it literally received a place in Israel, with a monumental site on which the Shoah is commemorated but also deliberately redeemed, now by the landscape of the Jewish state.

In 1953, by decision of the Israeli parliament, the Holocaust Martyrs' and Heroes' Remembrance Authority was established. Its Hebrew name, Yad Vashem, is derived from Isaiah 56:5, "… and to them I (God) will give in My house and within My walls an everlasting memorial and name (*yad vashem*)." Symbolically located on a hill site outside Jerusalem—next to Mount Herzl, where Israel's ideological founder Theodor Herzl, national leaders, and soldiers fallen in defense of the Jewish state are buried—Yad Vashem has, since its foundation, received millions of visitors, including numerous foreign dignitaries. Over time, the Holocaust (Greek for whole-burnt offering) came

From left to right:
The Hall of Remembrance (1957–61) designed by Aryeh Elhanani, Aryeh Sharon, and Benjamin Idelson is the official site for commemorative ceremonies.

The interior is barely lit via the opening at the top, through which the smoke of the eternal flame and the sound of prayers escape; on a black tile floor, one sees the white lettered names of twenty-two concentration camps. In the center, the ashes of tens of thousands of Jews are interred.

The Valley of the Destroyed Communities (1992), designed by Lipa Yahalom and Dan Zur, located further outside, is designed as a huge 6,000-square-meter maze excavated from the rocks, with the names of thousands of annihilated towns and villages.

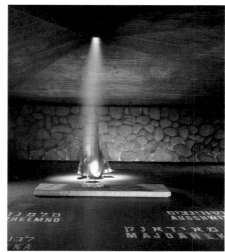

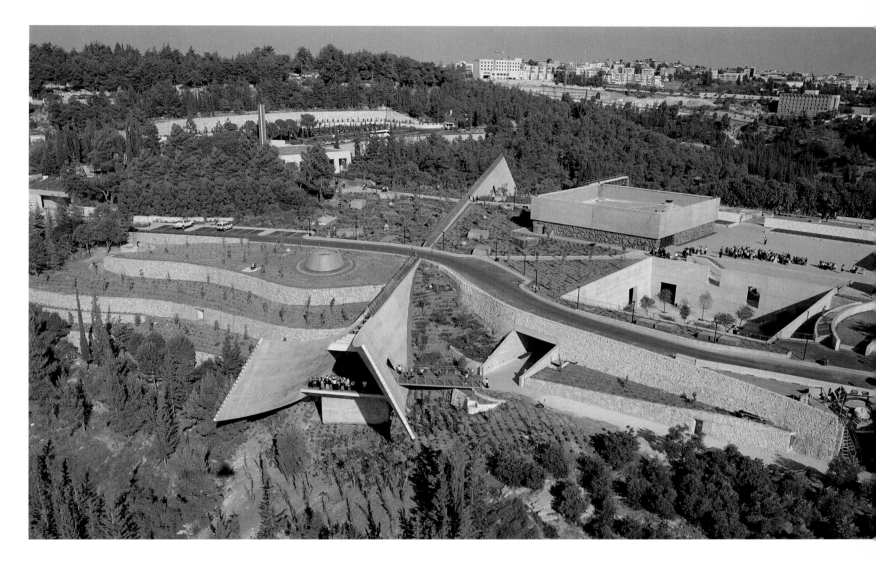

to be perceived as a raison d'être for the state: "never again."

There was a notable lack of coherence between the various buildings created over the years until Moshe Safdie (b. 1938) was commissioned to design a master plan in 1997. The architect achieved renown for his Habitat residential project for Expo '67 in Montreal, and the Skirball Museum and Cultural Center in Los Angeles (1986–95). His new Holocaust History Museum, penetrating the Mount of Remembrance and largely buried within it, preserves the beautiful landscape and occupies a central place in the complex, connecting its various elements. These include the monumental Hall of Remembrance

(1961), the Avenue of the Righteous Among the Nations (1962) with trees planted in memory of righteous gentiles who saved Jews during the war, the Children's Holocaust Memorial (1987, also by Safdie), and the Valley of the Destroyed Communities (1992). One enters the area via Safdie's new Visitors' Center before arriving at his overwhelming Holocaust History Museum, a 175-meter-long and 16-meter-high triangular wedge. Safdie felt that a traditional museum environment would be an inappropriate place to tell the story of the Holocaust. Inside, it is almost entirely dark; light penetrates only from the extremities of the wedge and from above.

Aerial view of Yad Vashem with the new Holocaust Museum (the exit is in the foreground).

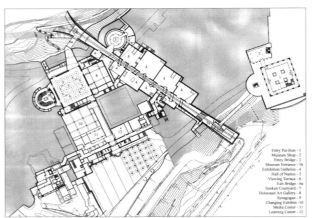

Design sketch for the Holocaust Museum by Moshe Safdie, showing the wedge cutting through the hill.

Site plan with, on the right, the new Visitors Information Center, leading to the Holocaust Museum, with the round Hall of Names on the right and the Hall of Remembrance and older exhibition pavilions on the left.

Entry Pavilion - 1
Museum Shop - 2
Entry Bridge - 3
Museum Entrance - 3b
Exhibition Galleries - 4
Hall of Names - 5
Viewing Terrace - 6
Exit Bridge - 6a
Sunken Courtyard - 7
Holocaust Art Gallery - 8
Synagogue - 9
Changing Exhibits - 10
Media Center - 11
Learning Center - 12

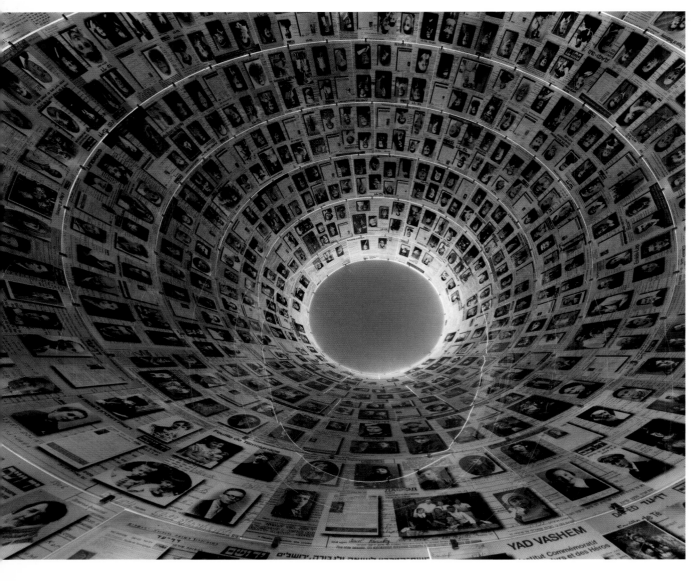

The newly designed cone-shaped Hall of Names with the faces of individual victims is located next to the Holocaust Museum.

Interior view of the museum. The strip of light at the top of the triangle above recalls the divine light of Creation with which evil — as well as good — entered the world. The gradual convergence of the floor and ceiling increases the dramatic effect.

At the exit, the museum opens like a funnel onto the surrounding landscape, which had been deliberately incorporated into the overall plan.

Entrance to the Holocaust Museum.

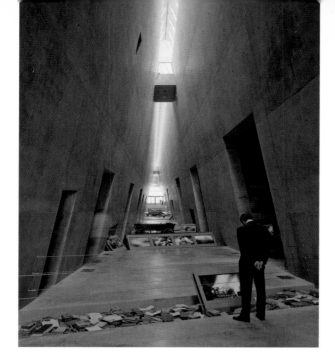

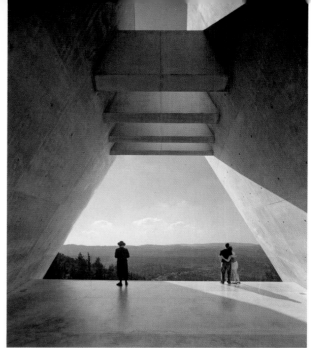

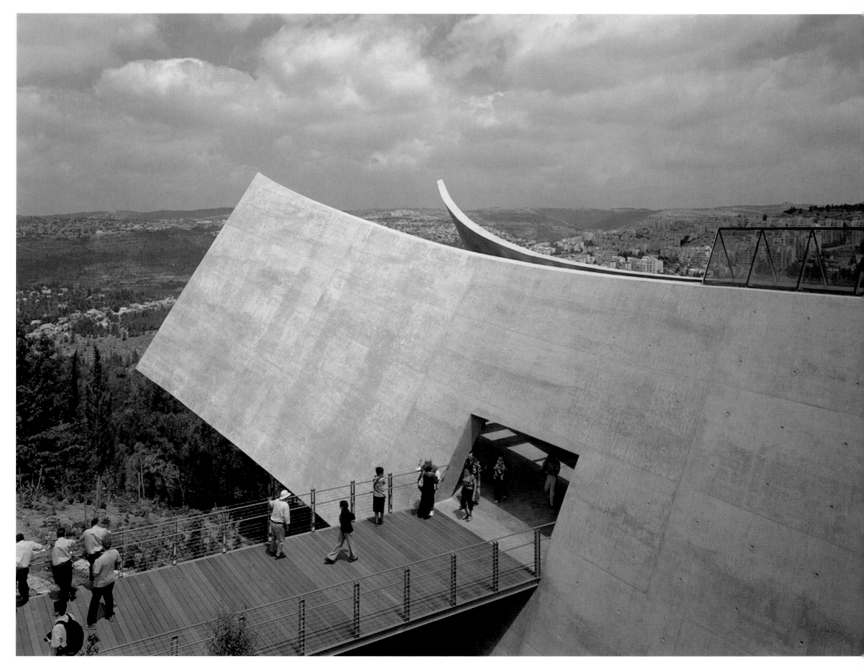

Jewish Art
in the Modern World

The modern Jewish experience is shaped by the memory of the Holocaust and the creation of Israel, the two most influential events in the twentieth century—the former dealing with collective death, the latter with the rebirth of a nation.

After 1945, American Jewish artists, many of European descent, were the first to re-evaluate their assimilation in mainstream culture by responding to the atrocities and to the nascent Jewish state. Israeli artists, primarily occupied with shaping a national identity, integrated the Holocaust into the visual arts and compelling monuments while concurrently absorbing the effects of a swelling Palestinian nationalism. The postwar generation, shaped by the memories of survivors, attempts to come to grips with the greatest trauma in Jewish history since the destruction of the Second Temple.

There is as little a Jewish artistic style as there is a Christian, Muslim, American, German, or Israeli style. Jewish artists play an integral part in all of the divergent artistic movements of modern pluralistic society. While some are inspired by traces of a now lost world, others are attracted by the revival of Jewish mysticism. Amidst the resurging nationalism and fundamentalism of our times, the universalistic, prophetic dream of peace and justice remains, for many, enduringly vibrant.

Questions of Justice

Ben Shahn
Sound in the Mulberry Tree, 1948

Lithuanian-born Ben Shahn (1898–1969) belongs to a group of Jewish painters and photographers who successfully integrated into the American art scene. Like many American Jews shaped by the immigrant experience, the labor struggle, and the Great Depression of the 1930s and 1940s (during which he documented its effects on the rural population alongside photographers Walker Evans and Dorothea Lange), Shahn adopted left-wing politics as his secular religion. His identification with social issues, his defense of minorities and the poor, and his abhorrence of injustice is a running theme throughout his body of social realist work.

Shahn, who long denied his religious background while trying to integrate into secular Christian America, was familiar with prejudice form his youth. Brought up in a Jewish household, he was familiar with the stories of the Bible and the biblical emphasis on social justice, as well as Jewish history. When painting *The Passion of Sacco and Vanzetti* (1931–32), a work about the much-publicized conviction and execution of two anarchist workers, Shahn perceived parallels with the victimization of Alfred Dreyfus, an assimilated French-Jewish army officer. He was inspired by the movie *The Dreyfus Case* (1930), and may have had childhood memories of the affair.

During the thirties and forties, Shahn became increasingly aware of the danger of the United States' isolationism in the face of the emerging threat of anti-Semitism in Nazi Germany. His works testify to his familiarity with both the catastrophic fate of the Jews in the Nazi ghettos and the horrific death of civilians in Hiroshima. Having read the biblical prophets, Shahn was familiar with the tension in Judaism between universal concern for the needs of the world at large and the impulse to work for the particular needs of one's own community. The prophetic call to be "a light amongst the nations" had triggered Jewish involvement in such diverse universal nineteenth-century movements as liberalism, socialism, communism, and Esperanto. For most Jews, both reform and orthodox, and certainly for socialists like Shahn, Jewish nationalism in the form of Zionism was an anomaly. Yet, in the 1940s, American Jews came to realize the catastrophic impact of the Nazi Holocaust in Europe—for most, their place of origin. The proclamation of the state of Israel on May 14, 1948, seemed an appropriate response to the acute need to find a home for the survivors.

It is no coincidence that Shahn returns in that same year to the use of Hebrew letters when painting *Sound in the Mulberry Tree.* In the wake of the Holocaust, he feels a renewed sense of Jewish identity. On the stoop of a New York City tenement sits a boy blowing bubble gum, resembling both the emaciated children in the Warsaw ghetto and the poor children in New York's Greenwich Village that Shahn had photographed in the thirties. Next to the boy stands a girl reading a Hebrew text: "And when you hear the sound of marching in the tops of the mulberry trees, then go into action, for the Lord will be going in front of you to attack the Philistine forces" (II Sam. 5:24). The final biblical victory of King David over the Philistines is thus connected to the Independence War of the recently founded Jewish state. Why does Shahn choose this obscure quote? Following this tale is the story of the seemingly unjust death of Uzza for touching the Ark that David was planning to bring to Jerusalem—and Shahn remembered this incident from his youth as another example of inexplicable divine injustice, a recurring theme in the Bible.

Shahn employed the Hebrew alphabet primarily in prints and book illustrations, in works focusing on the universal aspects of the Bible and Jewish tradition. He never visited Israel however, or wrote about it in his many books and articles. Yet, in his predominantly Jewish hometown of Roosevelt, New Jersey, he must have been aware of the heated debates between religious and socialist Jews about whether or not to support the state, about chauvinism and dual loyalty, and about the need for a homeland for both Jews and Palestinians. For Shahn, questions of justice remained.

Ben Shahn, *Sound in the Mulberry Tree*, 1948.

Tempera on canvas, mounted on panel, 122 × 91.5 cm (48 × 36"). Smith College Museum of Art, Northampton, Massachusetts, USA

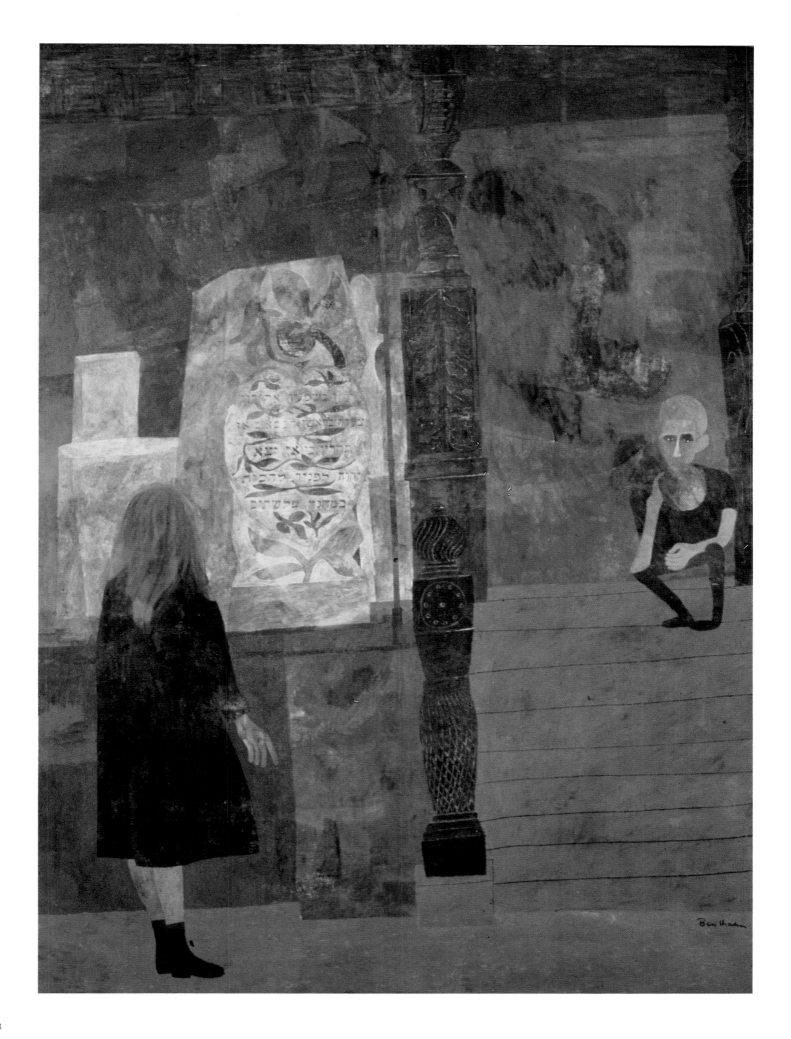

Abstract Monotheism

Barnett Newman
The Name I, 1949 / Zim Zum II, 1985

Jewish monotheism prides itself on being abstract: the Ten Commandments explicitly prohibit the depiction of God. In addition, the unity of God proclaimed in the Biblical verse "Hear, O Israel! The Lord is our God, the Lord is One" (Deut. 6:4), forms the center of the Jewish prayer book. Considered the handbook of practical theology, the prayer book also includes Moses Maimonides' thirteen tenets of faith, which stress God's oneness.

Throughout his career, the now celebrated New York abstract expressionist artist Barnett Newman (1905–1970) used titles such as *Onement*, *The Name*, and *Zim Zum*, which all refer to Jewish (mystical) tradition. Next to one of the five versions of *Onement* he created between 1948 and 1953, he once wrote "Atonement," a play on words but also a reference to the most solemn day of the Jewish calendar, the Day of Atonement (Yom Kippur), on which each Jew atones for his sins and tries to become at-one with himself and with the one God. Atonement/at-one-ment marks the beginning of a new year, inaugurated

and celebrated ten days earlier, and the start of a new creative process for each individual. Newman, though not himself religious, attended Hebrew school and was raised in the Jewish tradition by his parents, immigrants from Russian Poland.

In his painting with the title *The Name I*, Newman may very well mean the four-letter Hebrew name of God, YHWH, which is commonly referred to as *ha-Shem* ("the Name") and is not pronounced by Jews except once a year, on Yom Kippur, by the high priest in the Jerusalem Temple. When reading the painting from right to left as in Hebrew, the four zips (as Newman called the vertical lines) correspond to the four letters: a pencil-thin zip on the right stands for the tiny letter *yod*; followed by a wider zip, the broad *he*; a narrow zip corresponds to the stick-like form of the *waw*; and the fourth zip on the left is the same as the second, also a *he*. Newman's painting with these four vertical lines is as abstract as the Jewish God.

This abstract nature of God led to a logical and conceptual problem for rabbis: If God is completely

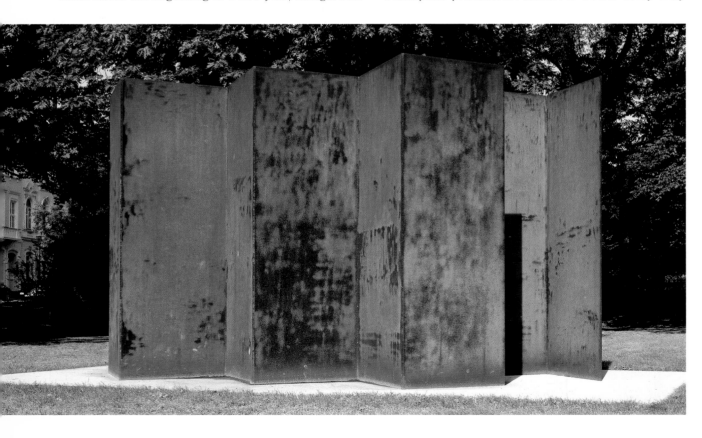

Barnett Newman,
Zim Zum II, 1985.

Cor-Ten steel,
361 × 520 × 250 cm
(142 $^1/_8$ × 204 $^3/_4$ × 99 $^7/_{16}$).
Kunstsammlung Nordrhein-Westfalen, Düsseldorf, Germany

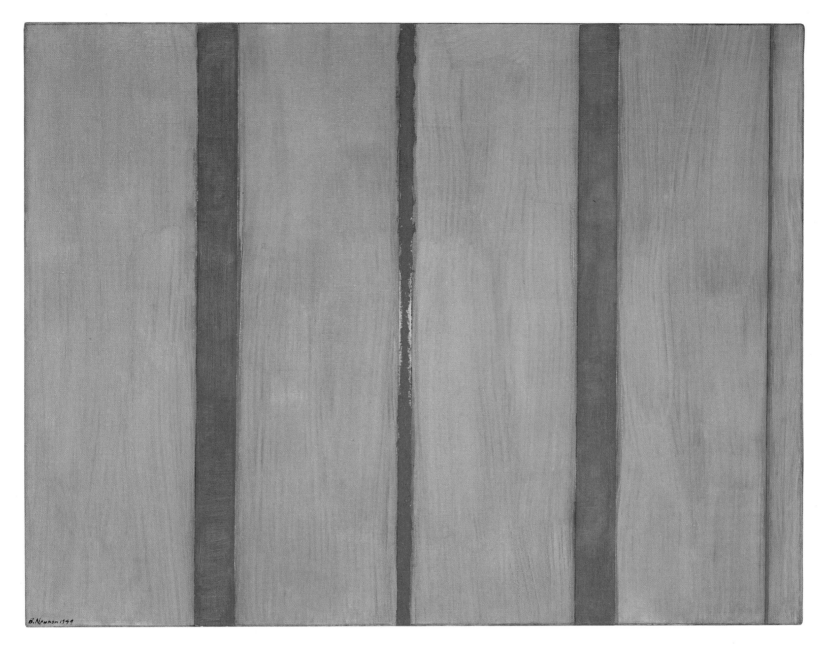

abstract, how can he create and be involved with creation? To this question, Jewish mysticism gives an answer. According to sixteenth-century Kabbalah, the world and humanity are not the result of a positive creative act by God as described in the book of Genesis, but a negative step of withdrawal (*zimzum*), in which the infinite God broke his wholeness to make room for a descending order of ten divine spheres. The sixth of them, a male aspect, created the world, whereas the tenth, its female counterpart, accompanies mankind in it and enables man to ascend again to higher levels. This ongoing human creative process is called *tikkun*, literally meaning the completion of an unfinished world and repair (of the original unity of God). Every human being tries to repair and complete the world through his or her creative actions. Interestingly, this concept gained great prominence in the Jewish world during the last decades.

For Newman, the way an artist works parallels God's creative process, as demonstrated by his two sculptures with the title *Zim Zum*, and his design for a synagogue in which he wrote a Hebrew quotation from Isaiah and the word *zimzum* next to zigzagging windows. Newman was familiar with the Kabbalistic notion of *zimzum* (withdrawal, contraction), which became widely popular through Eastern European Hassidism. He translated the concept in zigzagging lines of his sculpture, making space for creation.

In this context it doesn't come as a surprise that Newman used titles referring to both creation myths and origins from Greek mythology (*Euclid and Prometheus*), the Hebrew Bible (*Day before One, Genesis, The Word, The Command, Covenant, Adam,* and *Eve*), and the New Testament (*Stations of the Cross*).

Barnett Newman,
The Name I, 1949.

Oil on canvas, 121.9 × 152.4 cm
(48 × 60").
Daros Collection, Zürich,
Switzerland

Secret Signs

Lee Krasner
Composition, 1949

For a long time she was referred to as Mrs. Pollock; Lee Krasner (1908–1984) and Jackson Pollock (1912–1956) formed the most famous artist couple in New York. But this slight illustrates the problem she faced: her work was underappreciated for being that of a woman and, after 1945, the wife of the most famous representative of Abstract Expressionism. Just like Elaine de Kooning (née Fried) and Sophie Arp (née Taeuber), Lee Krasner had trouble with traditional ideas about the role of the female.

Lee Krasner, who had studied with the inspiring painter and theorist Hans Hofmann, regularly exhibited in New York as part of a group of painters the critics coined Abstract Expressionists, roughly divided into "action painters" like Pollock and "color field painters" like Clyfford Still. This first true American artistic movement ironically consisted of many European immigrants, such as Willem De Kooning, Mark Rothko, Barnett Newman, and Lee Krasner (Lena Krassner). Quite a few of them were also Jewish.

Between 1946 and 1950 she created her first important abstract paintings, which she herself called hieroglyphs, geometrically patterned works with small scribbles. In *Composition*, Krasner, who had no problem referring to her Jewish background, combines her personal, painterly handwriting with allusions to ancient indecipherable sign systems. Language played an important role in her life: she grew up in a household where Russian, Yiddish, and, of course, English were spoken. Krasner, always interested in calligraphy, revealed that she usually started her canvases in the upper right corner, like the Hebrew she learned to write as a child.

The fact that her mysterious signs resemble somehow archaic looking languages, like wedge-shaped cuneiform letters, may not be a coincidence. The discovery of the *Ras Shamra* tables in 1930—with text very similar to, but predating, the Biblical Psalms—created as much a public storm as did the *Dead Sea Scrolls* in 1947, when these biblical texts, one thousand years older than the oldest known manuscript, were unearthed.

After years of American isolationism, interspersed with anti-Jewish sentiments, and the catastrophe of the Holocaust, even unaffiliated Jews like Krasner were deeply impressed by the many examples of Jewish continuity—its language, its alphabet, its texts, and the resurrection of its nationhood: "I am never free of the past. I believe in continuity. The past is part of the present." She was as moved by Jewish continuity as she was part of American artistic modernity, in which she is now recognized, in her own right, as being one of the most important representatives of Abstract Expressionism.

Lee Krasner, *Composition*, 1949.

Oil on canvas, 96.5 × 71.1 cm (38 × 28").
Philadelphia Museum of Art, Philadelphia, USA. Gift of the Aaron E. Norman Fund

Flying Letters

Morris Louis
Charred Journal, 1951

This series of black canvases with white symbols and scribbles vaguely resembling ancient script strongly contrast with the abstract Color Field style for which Morris Louis would later become famous. Though largely ignored in later exhibitions, Louis included this series in his first solo show in Washington in 1953. Louis (1912–1962), who used his father's first name in place of the family name Bernstein, explained the absence of color by citing *Guernica* (1937), Picasso's protest to the destruction of the city of that name and whose shock and force lies in the black, gray, and white tones.

In the title of his own more abstract work, and in the use of black pigments, Louis evokes the burning of books and ultimately of the Jews in the European crematoria, about which Americans were by then fully informed. In *Charred Journal* as well as in related paintings and drawings of the same period, a six-pointed Star of David and agitated swirls seem to be escaping from the pages of a book or the columns of a Torah scroll.

The series represents a break for Louis from his earlier social realist style in favor of an abstraction deemed the only appropriate medium to express the haunting un-representable reality of the Holocaust. Like many artists of his generation, he felt something completely new had to be created in response to the enormity of war and human destruction. Hardly religious in the common sense, Louis attended High Holiday services and was proud of his Jewish heritage. As such, he must have been familiar with such liberal and Jewish values as the sanctity of life and the equality of all humans being created in the divine image. His *Charred Journal* recalls the legendary story of the martyrdom of Rabbi Hananyah ben Teradyon commonly read during Yom Kippur service, a scene which is sculpted on the menorah (installed in 1956) in front of the Israeli parliament. As part of a group of pupils of Rabbi Akiva, Hananyah defied the decrees of the Roman emperor Hadrian and continued to teach Judaism in public. He was arrested and burnt at the stake, wrapped in a Torah scroll. Surrounded by flames, he told his pupils what he saw, "I see the parchment burning, but the letters are flying to heaven."

Louis' letters and signs rising from the charred journal symbolize defiance and the will to survive in even the darkest of times. The barely recognizable yet imperishable Hebrew letters can be read as an allusion to the Phoenix-like rise of the decimated Jewish people in the independent state of Israel. Yet, the mostly unintelligible script largely avoids any such ethnic specificity, in accordance with the optimism of so many people for a new era—artistically and in the world at large.

Morris Louis, *Charred Journal: Firewritten A*, 1951.

Acrylic on canvas, 91.4 × 76.3 cm (36 × 30").
Louisiana Museum of Modern Art, Humlebaek, Denmark

Morris Louis, *Charred Journal: Firewritten B*, 1951.

Acrylic on canvas, 91.8 × 76.2 cm (36 1/8 × 30").
Louisiana Museum of Modern Art, Humlebaek, Denmark

Modernizing the Synagogue

Erich Mendelsohn

Park Synagogue, Cleveland, Ohio, USA, 1946–52

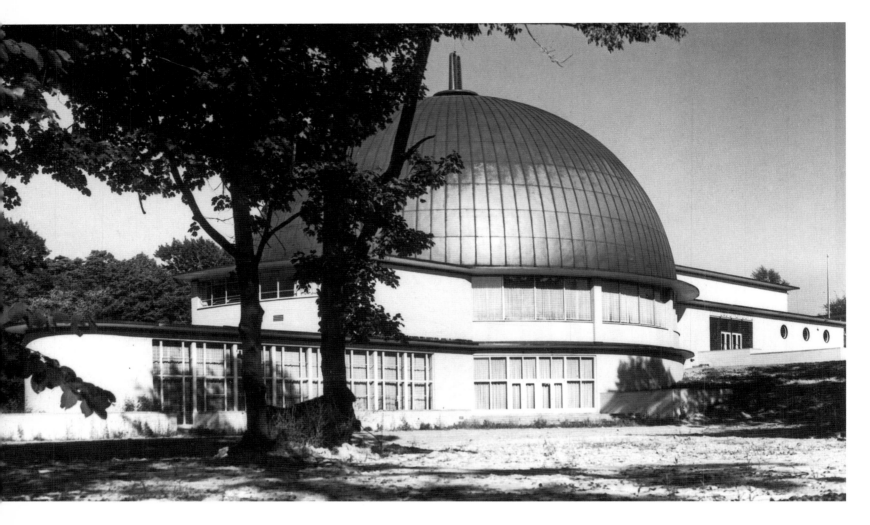

The synagogues of postwar American Jews reflect a thus far unsurpassed self-confidence. No longer just sanctuaries, they are large and lively community centers—including social halls, classrooms, and libraries—accommodating middle-class Jews recently settled in suburbia. They distanced themselves from the city synagogues built in historical styles, preferring modern architecture in which to educate the baby boom generation as forward-looking Americans. They engaged prominent architects to realize their ideals in the 1950s: the prolific Percival Goodman, Philip Johnson, Frank Lloyd Wright, and Walter Gropius.

The first modern, truly revolutionary synagogue designs in America were the work, however, of a German-born architect, Erich Mendelsohn (1887–1953).

When he arrived to the country in 1941, he had already achieved international renown for his organic-looking expressionistic Einstein Tower in Potsdam (1921), offices for the publisher Mosse, and his sensational department stores in most major German cities, primarily for Schocken. Along with his established reputation, American Jews were familiar with his name as builder of the Hadassah University Hospital on Mount Scopus in Jerusalem (1934–39), to which many had contributed financially.

Park Synagogue, created for a Conservative congregation, is laid out as a long wedge, a kind of spiritual ship, dominated by the massive dome of the main sanctuary near the tip. The entrance to the complex is on the opposite side: a courtyard surrounded by administrative facilities and classrooms. At the very

Erich Mendelsohn, Park Synagogue, Cleveland, Ohio, USA, 1946–52

tip a small, weekday chapel is located. On the High Holidays (New Year and the Day of Atonement), sliding walls allow the 1,000-seat capacity of the main sanctuary to expand to 3,000, with additional seating in the adjacent foyer and assembly hall.

The design clearly conforms to ideas Mendelsohn had formulated in 1947; a contemporary synagogue needed to organically integrate its three traditional functions: spiritual, educational, and social. His general layout—sanctuary, courtyard, and ancillary rooms—as well as his insistence on flexible use of space would remain a great influence on future synagogue architecture. Apart from a Jewish hospital and a private home, Mendelsohn built three more synagogues in the United States, and designed four others that, like his Holocaust memorial for New York, were never realized.

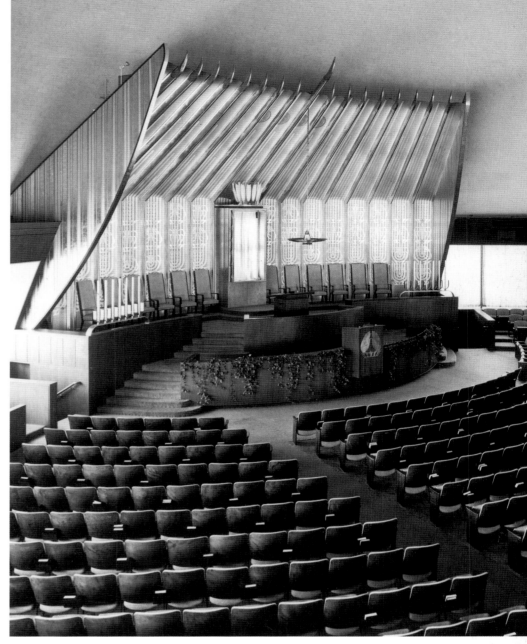

Interior of the Park Synagogue

The interior of the main sanctuary is truly impressive—large and yet somehow intimate—and shows Mendelsohn's mastery of light and drama. The focal point is a tent-like structure—like a baroque altar integrated into the wall and the cupola—with a crowned ark for the Torah scrolls in the middle, surrounded by twelve chairs above which Jewish symbols can be seen.

Groundplan of the Park Synagogue

Forging Israeli Art

Mordecai Ardon
Train of Numbers, 1962

Mordecai Ardon (b. Max Bronstein, 1896–1992), son of a Polish Orthodox Jewish watchmaker, studied at the Bauhaus between 1920 and 1925 and was influenced by such luminaries as Feininger, Itten, Klee, and Kandinsky, as his later work would testify. He taught and exhibited in Berlin before political events forced him to leave in 1933 for Palestine, where he immersed himself in Jewish mysticism and history.

In his work, the bright light of the land of Israel became imbued by a spirituality reminiscent of his teacher Paul Klee, and darkened by the shadows of the Holocaust. From his only surviving brother he learned in 1945 that his Polish relatives had all perished, and, from this point on, the Holocaust increasing influenced his work. Returning from a visit to his birthplace Tuchow in 1959, he tells about his anger with the Nazi killers and with a God who remained silent. Art cannot really depict the atrocities, but only allude to it using abstraction and symbolism. The dark lines in *Train of Numbers* refer to the trains that transported Jews to the destruction camps, riding full speed through a deserted landscape under a blood-red sky. The wheels of the cattle cars already seem to crush the victims, their bodies symbolized by the numbers in the painting—numbers that would be tattooed on those selected for labor at the camps, while the others were sent directly to the gas chambers.

Ardon's seemingly rational and natural landscape grows apocalyptic and loaded with wheels, colors, signs, and childlike scribbles (in his other works appear Kabbalistic symbols, Hebrew letters, torn parchment), which seem to be engaged in a desperate search for meaning, a search for the artist far more consequential than that of his mentors. Ardon, who oscillated between figurative and abstract styles, remained so engaged with Jewish history and Israeli reality that it prevented him from reaching the complete abstraction of so many of his contemporaries. Instead, this gifted storyteller and talented artist became renowned in the first decades of Israel's existence for his contribution in forging a national art—modern, invested with Jewish symbolism, and haunted by the memory of the Holocaust.

Mordecai Ardon, *Train of Numbers*, 1962.

Oil on canvas, 74 × 145 cm
(29 1/8 × 57").
Collection of the Mishkan
Le'Omanut, Museum of Art,
Ein Harod, Israel

The Realm of Shadows

Louise Nevelson
Homage to 6,000,000 (I), 1964

Without knowledge of its title or subject, the mere dimensions of this enormous room-filling black installation instill it with a magical aura, inviting the viewer into an enchanting yet threatening world.

Louise Nevelson, née Berliawsky (1899–1988), emigrated from Kiev to the United States as a six-year-old child. She traveled widely and discovered the arts in all its forms: painting in Munich where Hans Hofmann had been her teacher, mural painting in New York working with Diego Rivera, dance—she was a close friend of Martha Graham, theatre, and music. All these elements were to influence her large and dramatic sculptural environments, which brought her international renown from the 1950s onward.

Wood became her primary material—found crates and discarded wood, bits and pieces, profiles and fragments, ornaments: each and every one carrying their own associations and meaning. Painted in a single color—pure white, sacral gold, or mysterious black—they become anonymous, their specific pedigree dis-

appearing in further oblivion. Yet, though frozen, these mixtures of ornament and decay paradoxically seem to somehow come alive, regaining some of their individuality in the ensemble.

Many of her architectonic fantasies, particularly those in black, possess a commemorative aspect and an association with a netherworld, the limbo between life and death. Her large pieces are especially effective in conquering the space in which they stand, creating a truly mysterious environment.

Homage to 6,000,000 impressively conveys this association with death and destruction. The austere and repetitive size of the crates seem to recall the mechanic massiveness of the destruction; the individual shapes seem to evoke persons or parts of their plundered property.

In the sculpture's presence, one is immersed in a realm of shadows, forced to reflect on the essence of life and death.

Louise Nevelson, *Homage to 6,000,000 (I)*, 1964.

Black painted wood, 274 × 548.6 × 25.4 cm (108 × 216 × 10").
Present whereabouts unknown.
Courtesy The Pace Gallery, New York, USA

A second smaller work with the same title was donated in 1965 to the Israel Museum in Jerusalem.

The Presence of the Divine

Mark Rothko

Rothko Chapel, Houston, Texas, USA, 1965–67/1971

In 1965, at the height of his fame, Mark Rothko (b. Marcus Rothkowitz, 1903–1970) received an invitation from the Houston art collectors John and Dominique de Menil to create what many rightly consider to be his most important artistic statement: several large paintings for the chapel these wealthy benefactors planned to donate to the Institute of Religion and Human Development at the St. Thomas University in Houston. The couple had been duly impressed with his *Harvard Murals* (1962) and the paintings intended for the Four Seasons restaurant in New York's Seagram Building (1958, never installed; nine of them are now at the Tate Modern, London).

Following Rothko's proposal, the architects realized an octagonal chapel, similar to Christian baptisteries, so as to completely envelop the visitor with his paintings, fourteen in total—three triptychs and five individual canvasses. As in his studio, the light was to come from above.

Their colors are maroon and opaque black, more sumptuous and hermetic than any of his previous work. Like the curtain separating the Holy of Holiest in the desert Tabernacle or the Jerusalem Temple from the rest of the sacred spaces, these mysteriously dark paintings create a sense of awe, hinting to a divine presence, perhaps even to the invisible abstract God of Judaism.

In 1969, the de Menils acquired Barnett Newman's *Broken Obelisk* to be installed in the reflecting water of the pond in front of the chapel. Their gift was made in commemoration of the recently assassinated civil rights leader, Martin Luther King, Jr. Reflecting the new spirit of openness initiated by the Vatican Council in 1965, the chapel, originally conceived as an exclusively Catholic space, was dedicated in truly ecumenical spirit, in the presence of Catholic, Protestant, Jewish, Muslim, Buddhist and Greek Orthodox clergy. The ceremony took place in February 1971, exactly a year after Rothko's tragic death by suicide and Newman's passing of a heart attack.

What remains is one of the most important works of painting, sculpture, and architecture dedicated to religion in modernity—a true Gesamtkunstwerk.

Mark Rothko, *Rothko Chapel*, Ecumenical Chapel, Houston, USA, 1965–67, opening 1971.

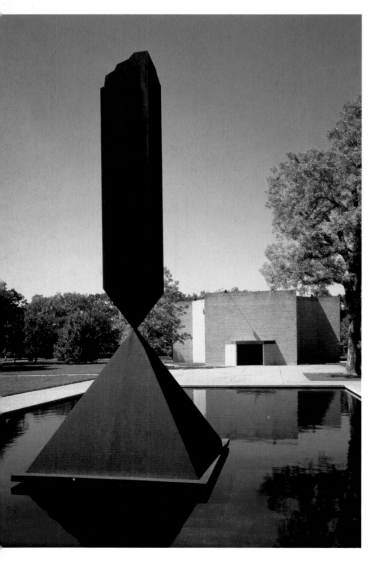

Barnett Newman's *Broken Obelisk* (1967, Cor-Ten steel, 774.5 × 306 × 306 cm (25' 5" × 10' 6" × 10' 6")) is, according to the artist, "concerned with life and hope," and as such a fitting tribute to Martin Luther King, Jr. Newman combined the tragic content of the obelisk, a frequently used symbol to commemorate the dead and the victims of man's inhumanity to man, with the pyramid, associated with eternal life after death, a "glimpse of the sublime." The sculpture stands in front of the Ecumenical Chapel, built by Howard Barnstone and Eugene Aubry in 1965.

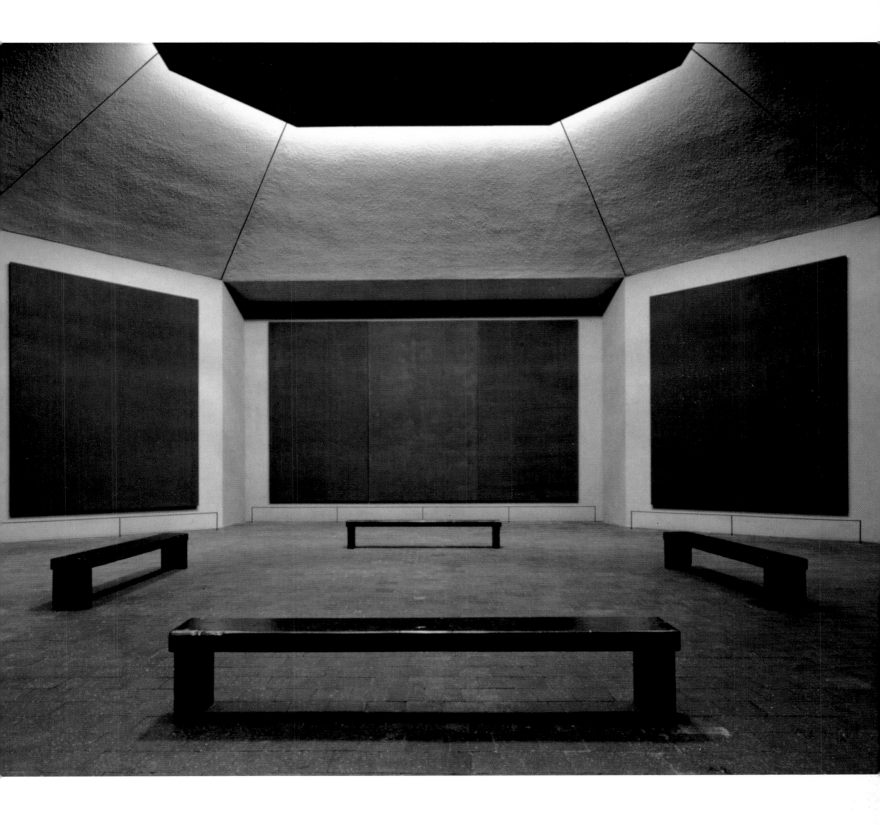

An Unbuilt Synagogue, An Unfulfilled Dream

Louis I. Kahn

Hurva Synagogue, Jerusalem, Israel, 1967–74 (Unbuilt)

Jerusalem is a holy city for Jews, Christians, and Muslims alike, a city that for over three thousands years attracted the devout who filled it with sacred places to consolidate the memory of prophets and priests, the pious, saints and saviors. Since the destruction of their central sanctuary, the Temple, and their loss of independence in the year 70 CE, Jews have been, at least until 1948, a minority in this city, mourning the ancient destruction and defending holy places like the Western Wall, the only remaining part of the Temple precinct. Apart from this "Wailing Wall," and the tombs of patriarchs and rabbinic scholars, few visual reminders were preserved, and only particularly devout pilgrims hazarded the arduous journey required to visit the holy places. The seventh-century Muslim Dome of the Rock, constructed on the site where the Temple once stood, long dominated the idyllic image of the city. Still, Jerusalem holds a place of primary importance in the liturgy, guaranteeing no Jew would forget the Holy City in his prayers.

Not until the completion of the monumental Hurva synagogue in 1864, did Jerusalem have, after eighteen centuries, a Jewish icon in addition to the Western Wall. The first domed synagogue in Israel, depicted on many prints and early souvenirs, and visited by many foreign Jewish dignitaries, Hurva became a source of inspiration for numerous synagogues in Israel and abroad. Its predecessor had been founded by pious Jewish immigrants from Poland in the eighteenth century, but was burned down by unsatisfied creditors and hence became known as Hurva (ruin in Hebrew). Jerusalem's skyline was then complete, dominated by three domed sanctuaries symbolizing the central role this city fulfills for the three monotheistic religions: the Dome of the Rock, the medieval Church of the Holy Sepulcher dating to the fourth century, and the Hurva synagogue.

The synagogue remained in the popular imagination of Israelis even after it was destroyed by the Jordanian military while occupying the historic Old City of Jerusalem during Israel's war of Independence in 1948. After Israel reunited Jerusalem during the Six-Day War in 1967, the city authorities approached Louis Kahn—by then recognized as one of the world's most important architects—to design a synagogue on this history-loaded site in the center of the redeveloping Jewish Quarter.

The Estonian-born architect Kahn (1901–1974), who immigrated with his family to Philadelphia in 1906, was strongly interested in halls of assembly, whether for secular or religious use. In the 1950s and 60s he received commissions for synagogues and churches, and the central assembly hall of the parliament in Dhaka, the new capital of Bangladesh. His preference for centralized spaces (either rectangular or circular), where "inspired rituals" could take place is clearly shown is his never-realized design for the illustrious Hurva synagogue. It would have restored the presence of the oldest of the monotheistic religions to Jerusalem's skyline through a truly monumental building, a "world synagogue" as then Mayor Teddy Kollek announced. To absorb the light of the sun, the outside was to consist of sixteen massive pylons eighteen meters tall (sixty feet), reminiscent of an Egyptian temple. Via entrances at the four corners, one accesses an ambulatory space surrounding the actual sanctuary that is intimate and yet immense (9.5 meters squared), but "designed so that four people or 200 people may feel comfortable while praying there." From within, the sky and the city would be visible between the pylons, light mysteriously filtering into the interior, recalling a nineteenth-century reconstruction of the holiest of holies—Solomon's Temple with its square four-columned floor plan and thick double walls.

Strongly aware of the historic urban context, Kahn planned to use massive blocks of the warm, gold-colored Jerusalem stone characteristic of the city's architecture, of a size similar to the largest stones in the Western Wall. To emphasize the importance of these two Jewish landmarks, he planned a new connecting street to join the two and a square to replace the narrow street in front of the Western Wall. After Kahn's death, another architect realized the square, but the synagogue was never built.

Jerusalem is perceived in rabbinic and later Jewish mystical tradition as the center of the world, where creation started, where heaven and earth meet, and

Louis I. Kahn, Hurva Synagogue, Jerusalem, Israel, 1967–74 (Unbuilt). Section (above) and plan studies (below), third scheme, 1973

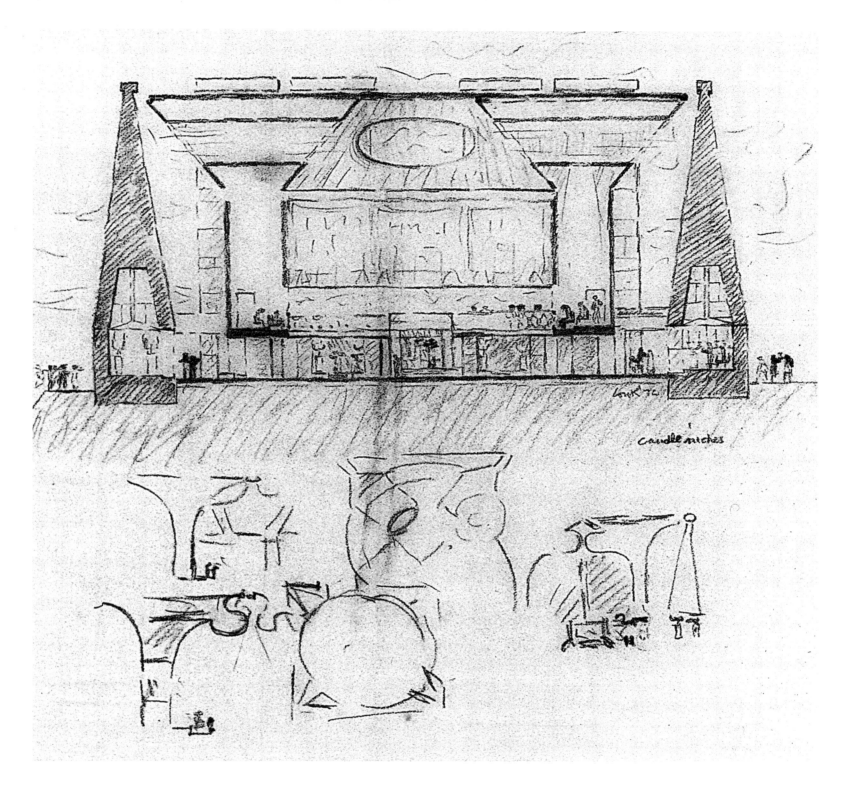

where the messianic era would start for all humankind. Jerusalem is regarded as a city of peace (*ir shalom* in Hebrew)—paradoxically, as no other city has seen so many foreign rulers and bloody battles. Just as the prophet Isaiah's vision—"My house shall be called a house of prayer for all peoples" (Isa. 56:7) —remains unfulfilled, so Kahn's aspirations for creating a sacred spiritual space for the city where the Temple once stood remain unrealized.

Still, no city needs dreams more than Jerusalem, symbol of the as yet unfulfilled vision of universal peace. Modern Jerusalem is about building and rebuilding, but also about working to realize a better world.

Fragility

Eva Hesse
Untitled (Rope Piece), 1970

Eva Hesse, *Untitled (Rope Piece)*, 1970.

Latex, rope, string, and wire, 244 × 549 × 92 cm (96 × 216 × 36"), Dimensions vary depending on the mounting. Whitney Museum of American Art, New York, USA, purchased with funds from Eli and Edythe L. Broad, the Mrs. Percy Uris Purchase Fund, and the Painting and Sculpture Committee, April 1988. Copyright The Estate of Eva Hesse, Hauser & Wirth, Zürich and London

In 1964–65, New York artist Eva Hesse (1936–1970) spent an extended period of time in Germany on a stipend. Her German stay marked a turning point in her life and in her work; it represented her transition from two-dimensional abstract expressionist drawings to three-dimensional works in soft, fragile, highly unorthodox materials, her colors gradually receding toward monochromatic white, grey, or black. She started to experiment with gravity—hanging and balancing her sensual, corporal, individual, funny, and somewhat disturbing pieces—and using ephemeral materials, such as latex, in her works, that she knew would deteriorate with time.

Early in her life, Hesse experienced two traumatic events. Born in Hamburg, she and her older sister were taken on a children's transport to Holland in 1938 to escape the Nazis. The next year their parents took them to England and, thereafter, to New York. In what was supposed to be a safe environment, the next tragedy occurred. Shortly after her parents divorced—Eva was ten years old—her mother, who suffered from serious depression, committed suicide. The death of her mother contributed to the insecurity produced by her forced exile. The diaries she kept after 1954 helped her search for stability and self-assurance, as a woman and, increasingly, as an artist.

Apart from visiting exhibitions, meeting artists, and reading, in Germany she had tried to retrace her own past, as she wrote, "It's a weird experience. Like a secretive mission, a new generation seeking the past. I knew next to nothing of my family or my grandparents... Never knowing them, their lives, they never knowing me or mine. I never had the grandpa, the grandma...the encouragements, proudnesses, my mother, where she was from and grew, even then distortedly grew."

Untitled (Rope Piece) was created the year Eva Hesse died after a long illness. The complex network of chaotic ropes and strings are her handwriting, searching to securely tie knots and to untie remaining riddles, to find a thread to the past that playfully hangs in suspense, evading answers and posing ever more questions.

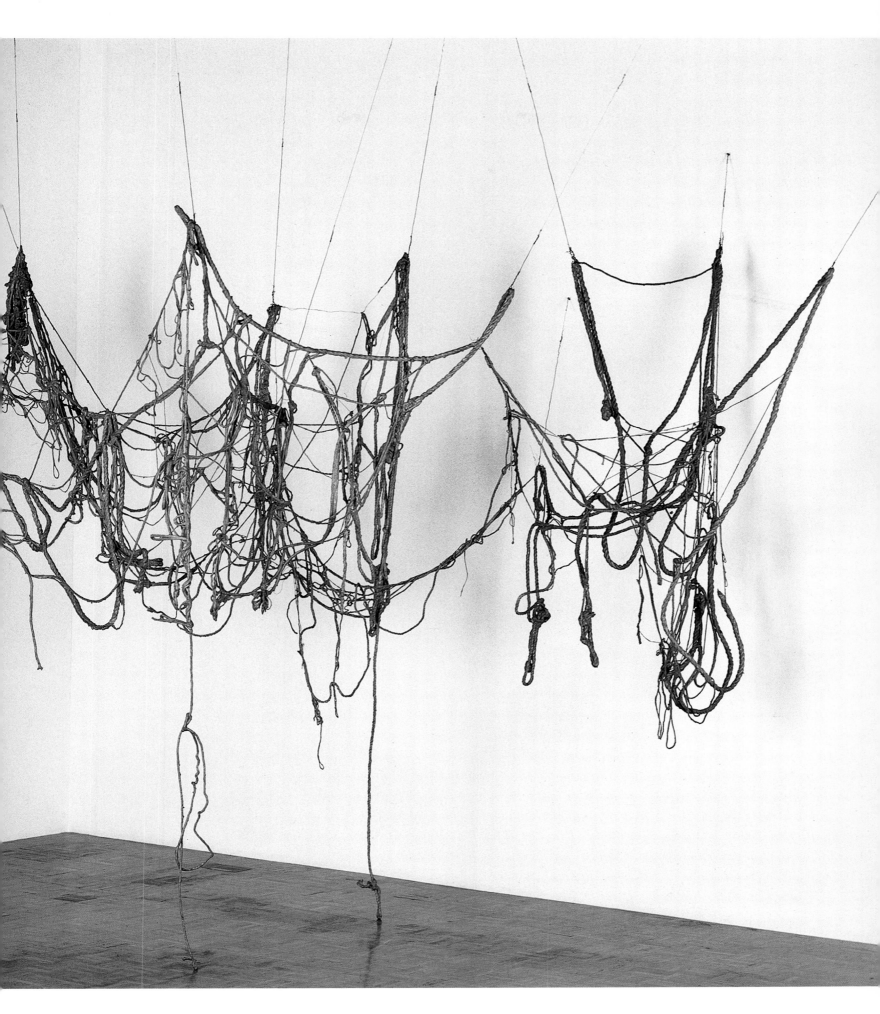

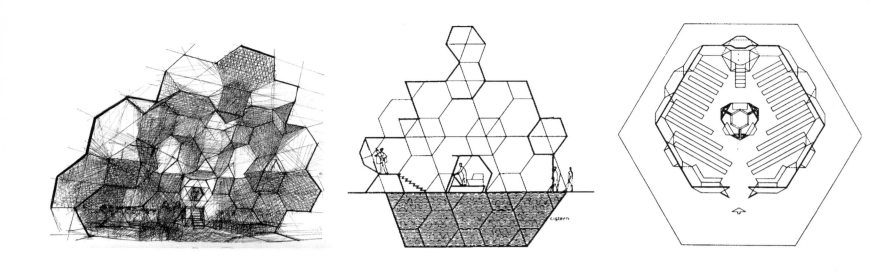

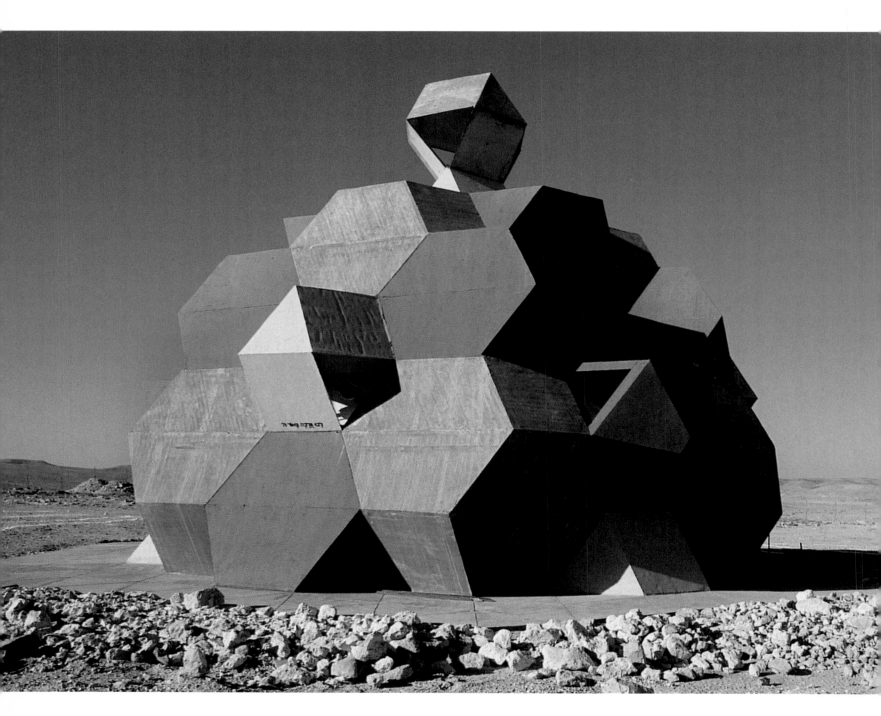

Sacred Space in the Desert

Zvi Hecker

Synagogue at the Military Academy Campus, Mitzpeh Ramon, Negev Desert, Israel, 1969–71

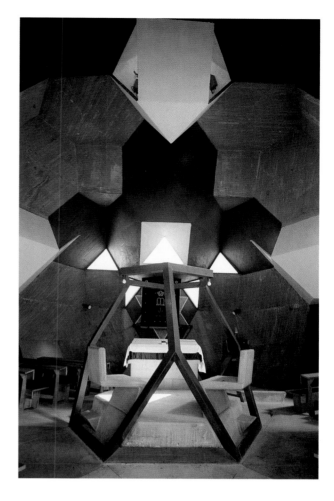

Zvi Hecker, Synagogue at the Military Academy Campus, Mitzpeh Ramon, Negev Desert, Israel, 1969–71

It is a truly astounding building that one would never suspect to be a synagogue. But what is a synagogue? The requirements for a synagogue are actually rather simple: almost any decent space will do, it only needs to have an Ark, the cupboard placed in the direction of Jerusalem to safely store the precious hand-written parchment scroll with the Hebrew text of the *Torah*; and a *bimah* (raised platform), from which the scroll can be read amidst a group of people. The synagogue's sanctity is defined by the presence of the scroll; the structure itself has no inherent sanctity— emotionally maybe, but not according to Jewish law—and a synagogue may be sold to guarantee Jewish life continues elsewhere.

With rare exceptions, Jews in the past were discouraged or forbidden to make distinctive buildings for themselves; only with the Emancipation were they allowed to represent themselves more prominently. And yet, there was hardly anything explicitly Jewish about the synagogues—built in as many architectural styles as one could imagine—which revealed themselves through oblique references to the Temple or the use of Jewish symbols like the Decalogue or the six-pointed Star of David.

The interwar period did away with synagogues built in neo-classical or Moorish revival style and modern synagogue architecture gradually accepted the challenge to experiment with contemporary styles, primarily in the Netherlands, Germany, and the United States.

Although most Israeli synagogues are inconspicuous—being Jewish, after all, is commonplace—modernism took root in synagogue architecture, particularly at the university campuses of Jerusalem, Haifa, and Tel Aviv, where representative and innovative constructions were realized.

The desert synagogue of Zvi Hecker (b. 1931) is one of the more unusual buildings in religious architecture. This Polish-born architect was raised in Israel where, in 1969–71, he built this small synagogue on the campus of a military academy in Mitzpeh Ramon, in the Negev Desert. The synagogue is a result of special research carried out by Hecker on the combination of geometrical cells. It is a concrete building geo-metrically faceted like a crystal, its hexagons vaguely recalling the six-pointed Star of David. The interior sanctuary of about 100 square meters seats approximately 100 people. Air and, more indirectly, light penetrate through the triangles to create a religious space surprisingly harmonious with the concrete material, offering an enveloping embrace focused on the two spiritual foci: Ark and *bimah*.

In spite of the harsh realities of military life, here one is reminded of the first meetings in the desert between God and Moses at Sinai—the desert as a truly spiritual place, romantically celebrated by the prophet Jeremiah: "I account to your favor the devotion of your youth, how you followed Me in the wilderness" (Jer. 2:2).

Hecker wandered further as well; in Germany, he built a Jewish school in Berlin (1995) and a synagogue in Duisburg (1999), both symbolically charged and geometrically challenging buildings.

The Golem's Dream of Power

R.B. Kitaj

The Jewish School (Drawing a Golem), 1980

Ronald Brooks Kitaj (1932, Cleveland) took the name of his stepfather Walter Kitaj, a Holocaust refugee from Vienna, whom his mother of Russian Jewish descent had married in 1941. After a few years of traveling and studying art, primarily in Vienna, he moved to Great Britain in 1957, where he formed, along with Francis Bacon and Lucian Freud, part of the London art establishment.

The Jewish School seems far removed from that revered traditional center of Jewish learning; the teacher seems to have lost all control over the boys as ink spills over one of them. The boy in the middle is engaged in his own world and reads, whereas the boy on the right draws a figure on the blackboard. Yet the scene is not as innocent as it looks; Kitaj gives a particularly Jewish response to European art and to some hostile imagery in European history.

As Kitaj explained, his composition is based upon an anti-Semitic drawing by a nineteenth-century German caricaturist, found in a book published in 1974 by the Israeli art historian Isaiah Shachar for the Warburg Institute in London, which specializes in the study of images and their relation to civilization. That drawing showed a school classroom in which one of the boys draws a bearded Jew kneeling behind a pig. This so-called *Judensau* (Jew's sow—the title of Shachar's book) was a recurring image in Germany from the middle ages onward, with sculptures and numerous prints depicting Jews suckling the teats of a sow, riding atop it, and eating its excrement—an obscene visual abuse of Jews, which also became the subject of folksongs. "*Judensau*" was often chanted by anti-Semites at Germany's Jewish Foreign Minister Walther Rathenau before he was assassinated in 1922. The original drawing, as Kitaj points out, illustrated the accusations of propagating chaos Nazi propaganda would later use to depict the "degenerate" Jews.

Kitaj responds to the image of degradation by having the boy draw a Golem instead of the *Judensau*. The Golem refers to an ancient legend, the best known version of which tells how the renowned scholar and mystic Rabbi Yehudah Loew created an artificial man out of clay, animated by the divine name, in order to protect the Jews of sixteenth-century Prague who were falsely accused of using the blood of Christian children when baking matzot (the oft-mentioned blood libel). The Golem was successful, but took his orders so literally that he became an uncontrollable danger himself; when asked to bring water from the well, he brought so many pails that Rabbi Loew's house was flooded. He proved so difficult to "program" that Rabbi Loeb had to erase from his clay forehead the first letter of the Hebrew word *emet* (truth), which afterwards read *met* (death). According to legend, the Golem's remains are hidden in the attic of the still existing Old-New Synagogue in Prague.

The story of a powerful monster (the Golem was the inspiration for Frankenstein), an out-of-control robot, or a computer threatening human existence became the subject of immensely popular novels and films in the twentieth century. The creation of an artificial being is the touchstone of human creative power and is unquestionably the reason artists like Kitaj feel attracted to the topic. The Golem legend may also be understood as a survival myth, a dream of power for oppressed Jews at the mercy of whimsical rulers or violent mobs. Kitaj's golem is drawn on the blackboard by the "emancipated" child (the artist), but remains unfinished and arrives too late—blood is already flowing. The child on the left tries to escape by running towards a wall, a gesture in vain as the teacher is unable to prevent the ink (blood) from spilling over him. The middle boy represents Jewish learning, which will survive even if the boy does not.

Kitaj is a self-proclaimed Diaspora artist, who gives a post-Holocaust twist to his Jewish identity. His Jewishness is tied to the image of a European survivor (like his stepfather) and, on the other hand, he is a "rooted" American/British Jew, in which Jewish means "being different"—both an insider outside and an outsider inside. Kitaj shares with his friend the writer Philip Roth the guilt of post-war Anglo-Saxon Jews—they "survived" without ever being in danger. As a "Diasporist" artist Kitaj tries to place himself between the nostalgic Russian Jewish world of the "only real Jewish artist" Chagall (and his own maternal grandparents) and the acculturated world of his intel-

R.B. Kitaj, *The Jewish School (Drawing a Golem)*, 1980.

Oil on canvas, 152.4 × 152.4 cm (60 × 60").
Private collection, courtesy Marlborough Fine Art, London, United Kingdom

lectual stepfather (a Viennese chemist). Kitaj's work is in the tradition of figurative artists like Picasso, Cézanne, or Beckmann and he feels connected to "precursors in the painters of the great schools of Paris, New York and London, half of whom were not born in their host-countries—a Diaspora of Yiddish and doomed café freedoms which ended in transition camps and the eastern railheads." Kitaj is aware that no classroom, no image, is innocent after Auschwitz.

The Shield of David

Jim Dine
Painting (Cruising) (La Chasse), 1981

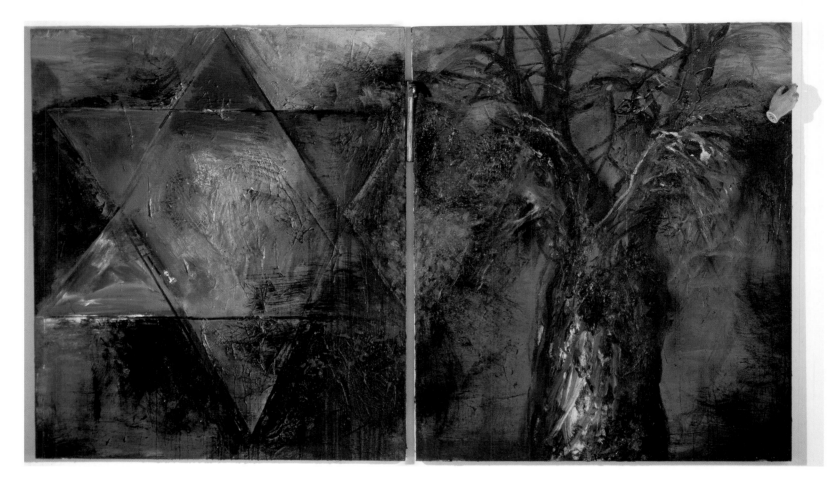

Jim Dine (b. 1935) is primarily associated with Happenings and the Pop Art of the 1960s in New York. He himself described his *Painting (Cruising) (La Chasse)* as "cruising my themes and cruising as a painter ... taking chances with unknown things and literally, physically, taking chances in the painting. This was a sort of random search for that sensation." Four poetically painted yet potent symbols are the result of his intuitive search: a six-pointed star, a tree, a heart, and a gate. Of these four, the inclusion of the Star of David, a specifically Jewish symbol, is most surprising—a rare allusion to his Jewish background. And yet the Star of David, now universally recognized as a Jewish symbol or a symbol of Judaism, wasn't always known as such. This ancient decorative motif was to be found among different civilizations of Oriental Antiquity—and in Christianity and Islam—as a symbol without meaning.

Despite its association with King David, the hexagram, two interlocking equilateral triangles, plays no role in either the Bible or rabbinic literature. As Gershom Scholem, the famous scholar of Jewish mysticism has pointed out, no Jew, learned or lay, thought of detecting any, even secret, Jewish meaning in it. Six- (and five-) pointed stars do occasionally appear on ancient Jewish monuments, but compared to the Menorah (seven-branched candelabrum) or the two lions flanking a Tree of Life or Torah niche, the Shield of David (Hebrew: *Magen David*) was a "foreign shoot in the vineyard of Israel." Beginning around 1500, Jews used the six-pointed star as a printer's mark, especially in Prague, which is probably where we have to look for the origin of the Jewish connection. From there, it spread in the seventeenth century to other Jewish communities in Bohemia and Moravia, to Austria and Amsterdam, and to the rest of Europe.

Jim Dine, *Painting (Cruising) (La Chasse)*, 1981.

Acrylic, hammer and mannequin's hand on canvas, four panels, 182.8 × 612.2 cm (72 × 243″).
Private Collection, courtesy of Pace Wildenstein, New York, USA

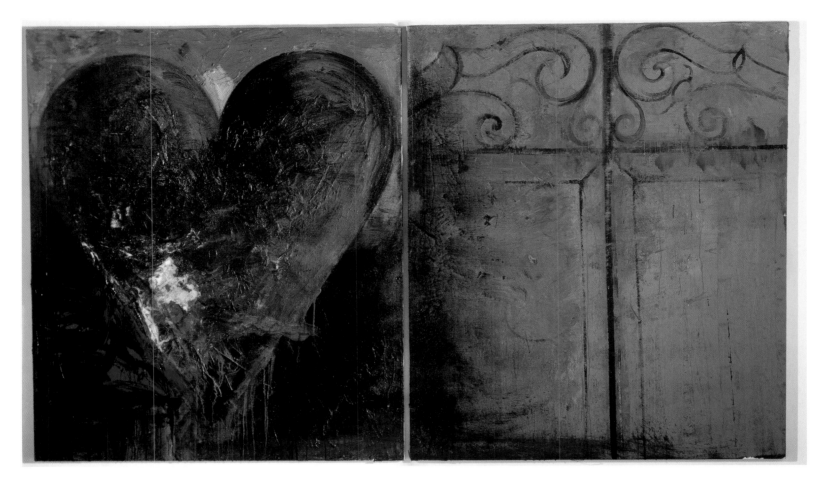

With the emancipation of the Jews in the middle of the nineteenth century, and in its wake the possibility to build new and more flamboyant synagogues outside the former ghetto, the need arose for a striking and simple visual symbol as a counterpart to the Christian cross. The choice for the Star of David was obvious; it owed its popularity to its already being familiar, while for the pious it did not have the charged religious associations of the much older Menorah. For the same reason, the Zionists, primarily secular in orientation, subsequently chose it as their official insignia at the Basel congress in 1897, the founding year of the movement. By that time, the sign was already widely used as a popular Jewish symbol on every new synagogue built, and for nearly every Jewish organization.

The yellow six-pointed star the Germans imposed on Jews during the Holocaust was intentionally meant as a sign of degradation and humiliation, marking the Jews for extermination—yellow is traditionally the color of shame. Yet, the symbol survived in the dark blue color the Zionists had chosen, an allusion to the legendary dye color used to make the tassels of the striped Jewish prayer shawl; the blue star and stripes are prominent on the Israeli flag.

Dine may not have realized at the time that, originally, the Star of David was not a specifically Jewish symbol. Now it is, however, and the color he chose for it, dark blue, is appropriate. It just may cruise the mind of the viewer that perhaps the red stains on the canvas refer to a more painful recent past, symbolically outweighed by the tree of life, the heart, and the gate. The Shield of David does after all have a strong and protective connotation: a royal insignia, a sign of pride.

Little Isaac, where are you going?

Moshe Gershuni

Isaac! Isaac!, 1982

In the 1960s, the biblical story of the binding of Isaac became a dominant theme in Israeli culture, replacing the naïve pastoral orientalism of the early pioneers, and the imagery of the *sabra*—the blond, blue-eyed, virile, and native-born Israeli, the hero during the first decades of the Jewish state's existence. Holocaust survivors, scarred and traumatized, felt displaced in an ideological climate that blamed them for being "brought like lambs to the slaughter," passive victims bracketed out of the Zionist concept of history which ceased in 70 CE with the destruction of the Second Temple (and subsequent exile), only to resume again in 1948. The survivor's voice wasn't heard until the nationally broadcast trial of Adolf Eichmann in 1960–62, when an Israeli court prosecuted, on behalf of the victims and the survivors, the architect of the system of mass extermination of European Jewry, and through him Nazi Germany in general. The impact was enormous; the Holocaust moved to the center of Israeli cultural and political consciousness.

In the book of Genesis, Abraham was prepared to sacrifice his only, beloved son Isaac, bending—both father and son—to God's will. Thanks to His last minute intervention—seeing their commitment and accepting as a whole burnt offering (holocaust in the Greek translation) a lamb in the child's place—God spared the life of Isaac. Modern Israeli literature and art began to take up the medieval Jewish tradition, expressed in haunting liturgical poetry, in which Isaac was actually sacrificed. *Isaac! Isaac!* is not the surviving son, but a prey bound for slaughter conjuring up the victims of the medieval Crusades, the pogroms, and the Holocaust, in which not just the lamb but also the son and the father are killed—together.

Born to Polish parents in Tel Aviv in 1936, Gershuni uses Hebrew as well as Yiddish writing in his artwork; Hebrew religious texts were disdainfully associated with backward religiosity by secular Israelis, and Yiddish was despised in Israel as the "jargon" of the "cowardly" Diaspora Jews. His quotations and wordplays serve to comment bitterly and ironically upon the euphoria of Israeli military victories and accentuate the dark fears of the soldiers (*Soldier! Soldier!*), to express anger about the Shoah (*meyne teyere yiddishe kinder*—my precious Jewish children), and to vent his fury about an absent God (God full of mercy who dwells in bitterness—in the Hebrew, the word *bamerorim* (in bitterness) replaces the customary word *bameromim* (on high)).

The predominant colors in Gershuni's palette are yellow—related to the Jewish yellow star during the Nazi era, black—associated with death, and red—a reference to the blood of the victims of both the Holocaust and the Israeli wars, a reference to Gershuni's wish to downplay the differences between Israel and the Diaspora, and an acknowledgement of the continued presence of those anxieties that Israelis believed they had left behind in the Diaspora. Gershuni's oftentimes-radical work—possessing allusions to the Bible, Jewish liturgy, and Modern Hebrew and Yiddish poetry—is a crude awakening from the Zionist dream of a peaceful, normal existence.

Moshe Gershuni, *Isaac!
Isaac!*, 1982.

Mixed media on paper,
140 × 200 cm (55 ¹/₈ × 78 ³/₄").
Tel Aviv Museum of Art,
Tel Aviv, Israel

Ghosts of the Past

Jonathan Borofsky
Berlin Dream, 1982

For the generations of Jews born after the Second World War, the Holocaust remains an issue of vital importance—though not victimized personally, a great many were raised by survivors of the Nazi terror. Whether the tragic family history was concealed or in turn formed an integral part of their upbringing, the children and grandchildren of the survivors oftentimes seek to confront the topic themselves, breaking through what for many is a well-meaning conspiracy of silence. The descendents go off to find "their roots," to visit the sites of destruction. They look to identify with the fate of their parents or grandparents—the anger and humiliation—and allow themselves to express their own feelings of pain and anxiety while guiltily admitting that nothing could ever compare to the pain of what their ancestors had themselves experienced.

Jonathan Borofsky (b. 1942) grew up in the large Jewish community of Boston and certainly absorbed his first impressions of the Holocaust as a child. After studying art in France, Italy, and the United States, he settled in New York in 1966, turning to conceptual art. Beginning in about 1969, Borofsky frequently used numbers in works like his *Self-portrait* of 1979, striking the viewer as a modern confrontation to the Nazi practice of tattooing concentration camp inmates. In addition, he created a whole series of works with numbers starting with 1,933,000, undoubtedly referring to the year that Hitler was elected chancellor of Germany.

In 1976, he visited Germany for the first time, and started to make his first open references to the Holocaust in *Hitler Dream*: "I dreamt that some Hitler-type person was not allowing everyone to roller-skate in public places. I decided to assassinate him, but I was informed by my friend that Hitler was dead a long time…" Borofsky tells how he is like *the running man* himself, "looking over my shoulder to see who's chasing me—a person, my past, Hitler, whatever." Borofsky relates how he is born in the year that Hitler was in his prime, and already as a child became fascinated by, angry with, and afraid of the ultimate "evil-doer" of the twentieth century. In 1982, he clandestinely painted a *Running Man* on the Berlin Wall while working on his installation for the exhibition *Zeitgeist*. The figure of the running man is common in Borofsky's work as escape is altogether a central theme for him.

In *Berlin Dream*, he dreamt of "a dog that got into a garden of birds—the fence was broken." This visceral image can be interpreted alternately with the Jews, represented by the vulnerable birds, attacked by the ferocious Nazi dogs in the concentration camps; as the East Germans trapped behind the Berlin Wall; or even the West Berliners living in a walled-in enclave in a totalitarian, communist country. The context of this installation (shown subsequently in New York, the Israel Museum in Jerusalem, and elsewhere) is the violent world of oppression and terror, and the fear of defenselessness.

For Borofsky, as for so many Jews, it was difficult to visit, work, and exhibit in Germany, particularly in Berlin, where the ghosts of the recent past are so much alive, having been the capital of militaristic Prussia and of Hitler's Third Reich, and where, during the Cold War, the East and West played their dangerous game of cat and mouse. *Zeitgeist* was held in the Gropius-Bau, a pompous building located between the Berlin Wall and the former Gestapo torture cellars that had then been recently excavated, an area haunted by a terrible history and, at the time, a threatening present certainly capable of inducing the nightmares Borofsky had had. Even so many decades after the war, the fears of being subjected to a barbaric system remain. The generation that was victimized is dying out; it is the successive generations that must deal with the fears and anxieties created by such a horrific legacy.

Jonathan Borofsky, *Berlin Dream*, 1982.

Acrylic on two canvases split, left: 361 × 227 cm (142 × 89 1/4"); right: 288 × 178 cm (113 1/4 × 70 1/4") overall: 361 × 405 × 117 cm (142 × 159 1/2 × 46"). Installation, Paula Cooper Gallery, New York, USA

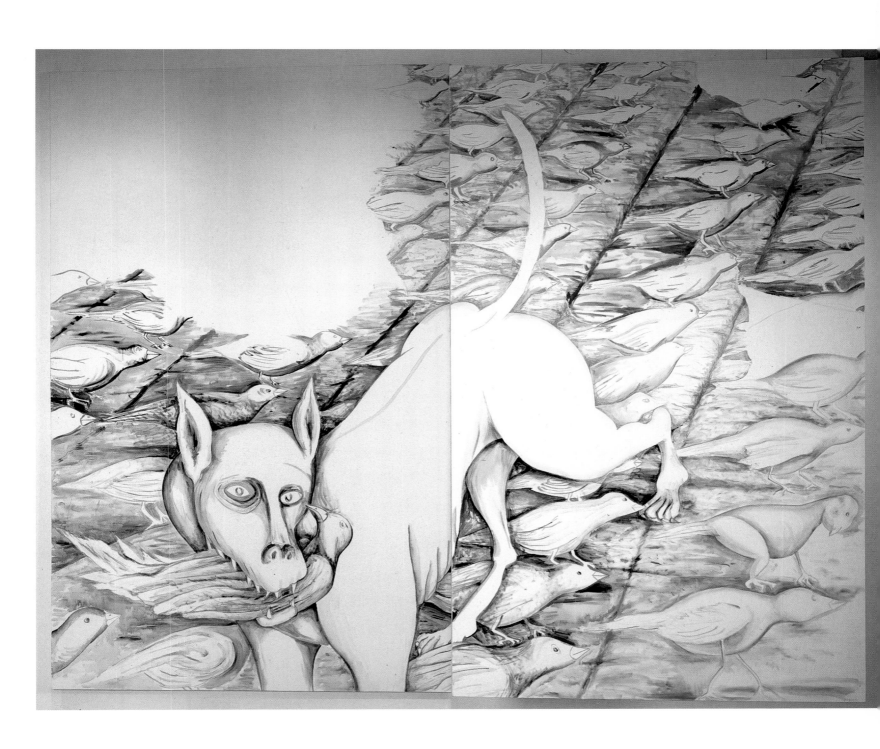

A Breakable Image of History

Larry Rivers

History of Matzah: The Story of the Jews, 1982–84

Larry Rivers, *History of Matzah: The Story of the Jews*, 1982–84.

Acrylic on canvas, triptych: 295 × 422 cm, 295 × 427 cm, 295 × 457 cm (116 × 166", 116 × 168", 116 × 180"). Private Collection, New York, USA

Matzah, the brittle unleavened bread that accompanied the Jews in their deliverance from Egypt, is the principal symbolic fare during the celebration of Passover. Surrounded by stories, songs, and food, the Jews commemorate the constitutive event in biblical history and dedicate time to discuss related episodes in the story of the Jewish people.

Children ask why this night differs from all other nights. One might answer that Passover—in an almost playful manner—develops the Jewish consciousness of history. Bondage in Egypt and Pharaoh's order to kill all first born males serve as triggers for comparison by the rabbis to events such as Laban's much earlier attempt to kill his future son-in-law, the patriarch Jacob (representing all Jews), or the second-century revolt against the Roman oppressors in Israel. These reflections culminate in fundamental discussions about the essence of slavery—physical, such as in Egypt, or spiritual, as when Abraham was an idolater in ancient Babylonia.

This celebration of history by association prevailed for thousands of years, as festivals served as the primary vehicles of Jewish memory. Chronological accounts and histories in the modern sense appeared only occasionally during the Renaissance and became more common in the nineteenth and twentieth centuries when the works of such luminaries as Heinrich Graetz, Simon Dubnov, and Salo Baron were commonplace Jewish household items. Jewish history was secularized when presented in chronological rather than in a cyclical order, as it was for centuries in the synagogue and during traditional celebrations. As the historian, Yosef H. Yerushalmi, pointed out in his classic study *Zakhor* (remember), history has become the arbiter and point of reference for Jews, supplanting the traditional study of sacred texts.

History of Matzah uses a chronological story line as the vehicle for Jewish memory. Contemporary and easily accessible one-volume historical accounts by writers such as Chaim Potok (*Wanderings*) and Irving Howe (*World of our Fathers*), slides from the New York Jewish Museum, and the immensely popular *Pictorial History of the Jewish People* (1953) by Nathan Ausubel served as principal sources for the artist Larry Rivers

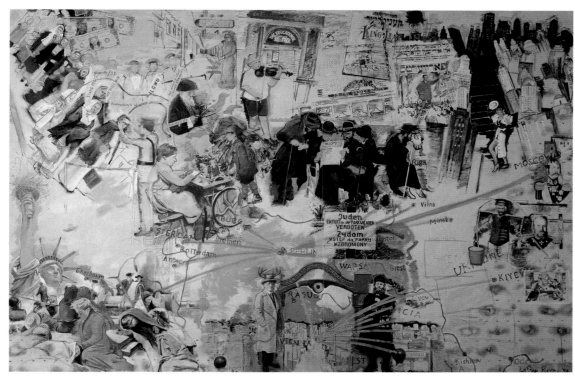

(1923–2002). Born Yitzroch Loiza (Irving) Grossberg in New York, Rivers began a career as a jazz saxophonist before taking up painting in 1945.

The triptych is held together by the color and texture of the matzah, symbol of physical and spiritual liberation throughout the ages. The first panel, *Before the Diaspora*, relates the story of the Jews up to the destruction of the temple and early Christianity. Beginning with a towering Moses (Rivers' cousin) in an Egyptian milieu, through David, the Maccabean victory culminating in the miracle of Hanukkah in the second century BCE and the destruction of Massada in 73 CE, the panel concludes with the last supper of Jesus interpreted as a Passover seder with matzoth. The second panel, *European Jewry*, deals with the European Diaspora beginning with the Assyrian exile in the ninth century BCE and Titus carrying to Rome the seven-branched Temple candelabrum removed from the razed Jerusalem in 70 CE. Granada symbolizes the convivencia of Jews, Christians, and Muslims in Spain, while details from manuscripts and yellow badges on dresses illustrate the vicissitudes of

medieval life leading to the expulsion from the Iberian Peninsula in 1492 and the attack on Frankfurt's ghetto in 1614. A representation of Spinoza—expelled from the Dutch Jewish community in 1656 and prefiguring modern individual thought—is juxtaposed with images of pogroms and persecutors. The panel ends with Theodor Herzl's Zionist solution. The third canvas, *Immigration to America*, covers America, with the Statue of Liberty as a uniting symbol for Russian Jewish immigrants and Jews fleeing from Nazi Europe, illustrating the famous lines by American Jewish author Emma Lazarus: "Give me your tired, your poor, / Your huddled masses yearning to breath free."

As with previous historical cycles such as *The History of the Russian Revolution* (1965), Rivers utilized a variety of visual quotations in his *History of Matzah*— Egyptian hieroglyphs, Rembrandt's *Moses*, Michelangelo's *David*, Leonardo's *Last Supper*, depictions of Polish synagogues, and a painting by Gottlieb all serve to illustrate his three-part visual history of the Jewish people. Breakable, yet full of hope.

Minimal Form and Maximal Meaning

Sol LeWitt

White Pyramid / Black Form (Dedicated to the Missing Jews),
Münster, Germany, 1987
Black Form: Memorial to the Missing Jews, Hamburg-Altona, Germany, 1989
Beth Shalom Synagogue, Chester, Connecticut, USA, 1999

Since the 1960's, minimal artists have concentrated on geometric forms and primary colors, more inclined towards an abstract concept and the visual impact of their work than a concrete narrative. Yet, sometimes the rather detached primary structures of minimal and conceptual artist Sol LeWitt (b. 1928 Hartford) are the carriers of a very specific, even political meaning. In a few related projects, LeWitt refers to his Jewish background.

The *White Pyramid* and *Black Form (Dedicated to the Missing Jews)*, commissioned by the Westphalian Museum in Münster for its 1987 *Sculpture Projects* exhibition was a deliberately political work, both in its title and locale. The *White Pyramid* was situated in the castle garden, in a visual relation with the *Black Form* located in the castle's court. The *Black Form* was installed at the place where until World War II an equestrian statue in honor of German emperor William I had stood. In both sculptures, LeWitt uses his characteristic geometrical and architectonic shapes, and his customary color, white, is interestingly paired with the black that LeWitt is using for the first time since 1966. With the addition, "Dedicated to the Missing Jews," LeWitt occupied this monumental spot with an explicit reference to the emptiness and silence left behind after the extinction of Münster's Jews during the Shoah, and, as he explained in a letter, to all those unborn and the lack of Jewish life in today's German society. The black sculpture is a clear allusion to death, with its shape reminding one of an enlarged sarcophagus; white is traditionally associated with purity and innocence. The shape of the *White Pyramid* seems a deliberate association with the pharaonic funerary monuments—symbolizing

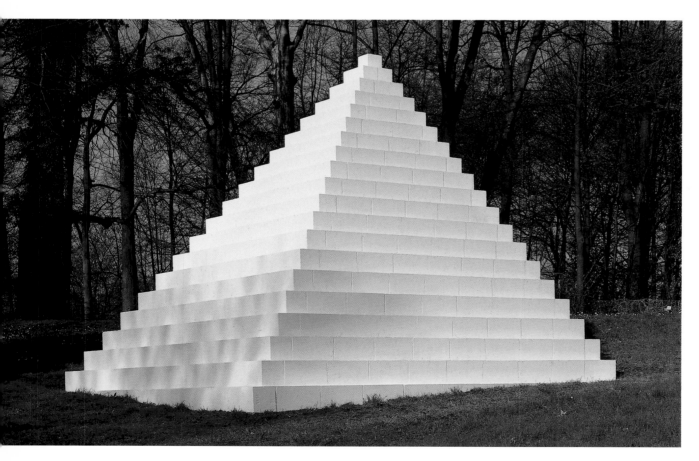

Sol LeWitt, *White Pyramid*, 1987.

White painted concrete block: 510 × 510 × 510 cm (200 × 200 × 200"). Westfälisches Landesmuseum für Kunst und Kulturgeschichte, Münster, Germany.

The *White Pyramid* as a silent witness to the absence of the Münster Jews—before it was removed from the Palace Garden—was abstract and mysterious in form but explicitly political in content: "I owed it to the Germans—and the Jews—to make one comment", LeWitt said.

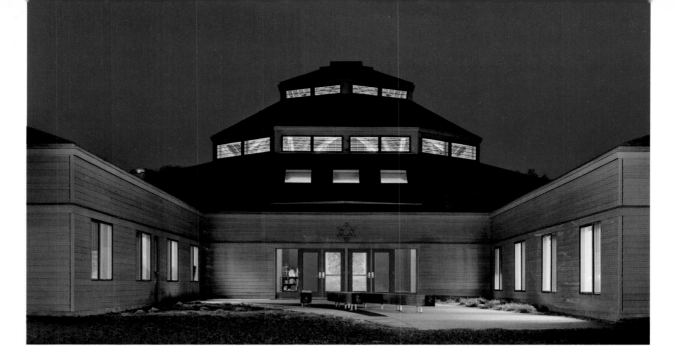

the connection between earth and heaven—which enable the king to enter the divine realm, whereas its specific form, the succession of receding stories, reminds one of the ziggurat, the dwelling place of the ancient Mesopotamian and Persian gods. Thus, *White Pyramid* and *Black Form* express death and elation.

The project was ill fated. The dedicatory inscription and *Black Form* itself were vandalized so regularly the city saw itself forced to remove the installation after a few months in early 1988; *White Pyramid* ceded way to the University's botanical garden. Yet, both survived, in Hamburg and in Chester, respectively. In Hamburg, the *Black Form*, slightly enlarged, stands in front of the town hall of Hamburg-Altona, and now serves as a Memorial to the Missing Jews of Altona,

who trace their illustrious history from the seventeenth century until the community's annihilation by the Nazis. The bricked surface not only refers to a sarcophagus as it did in Münster, but also to a building which is not accessible, a house in which Jews no longer reside. Dedicated on the fifty-first anniversary of Kristallnacht in November 1989, this solid black block, isolated in front of the government building, evades in its abstraction any heroic personification or personified heroism. Yet, without its dedication, it would simply be another minimalist sculpture.

The shape of the *White Pyramid*, with its more religious associations, Sol LeWitt reuses in his proposal for the now realized synagogue in Chester, of which he is himself a member.

Sol LeWitt, Stephen Lloyd, Beth Shalom Synagogue, Chester, Connecticut, USA, 1999.

The Beth Shalom Synagogue in Chester, Connecticut, was realized by Stephen Lloyd based on a proposal by LeWitt, who had worked early in his artistic career as a graphic designer in the studio of architect I. M. Pei. The central pyramidal form was, in the final design, ultimately softened by a sloping roof reminiscent of Polish wooden synagogues. LeWitt designed the Ark for the Torah scrolls in the form of an exuberantly colored Shield of David.

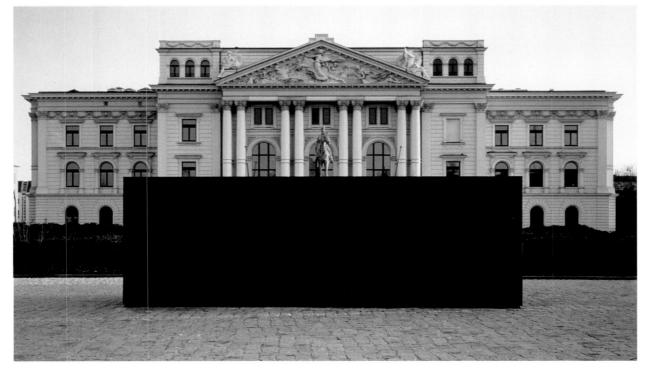

Sol LeWitt, Black Form: Memorial to the Missing Jews, 1989.

Painted concrete block, 200 × 550 × 200 cm (79 × 217 × 79"). Platz der Republik, Hamburg-Altona, Germany. Collection Kulturbehörde der Freien und Hansestadt Hamburg, Germany.

Black Form: Memorial to the Missing Jews stands like an empty house in front of the local government building—albeit separated by a road and an equestrian statue.

A Jewish Lexicon

Grisha Bruskin
Alefbet Lexicon, 1987–88

Jewish history in Russia has been marked by ambivalence—before the revolution, during the existence of the Soviet Union, and no less today. In spite of Tsarist pogroms, Bolshevik repression, mass murder during the German occupation, and anti-communist, anti-Zionist campaigns in post-war decades, Russia possessed the world's largest Jewish population up until the mass emigration of the past twenty years. It was here that modern Hebrew and Yiddish emerged at the same time that Zionism was searching for an outside political solution, and the League (Bund) of Jewish Workingmen pursued national cultural autonomy at home—assimilation was nearly impossible and anti-Semitism apparently endemic, as it remains to the present day.

Grisha Bruskin (b. 1945, Moscow) grew up at a time when Jews gradually began to project a sense of pride and affirmation. In the wake of the Six-Day War (1967) Jews emerged from the shadows. When Chagall inaugurated a small show of lithographs in Moscow's Tretyakov Gallery in 1973, Bruskin became aware of the vanished world of the shtetl which he only knew from books, and began to dream of exhibiting his own Jewish-themed work. His first solo exhibitions a few years later in Moscow (1976) and Vilna (1983), however, were denounced and forced to close for "promoting Zionism." With the ultimate success of his work—celebrated as Glasnost Art by western critics—at a Sotheby's Russian art auction in Moscow in 1988 (in which his pieces brought record prices), Bruskin relocated to New York.

From 1983 on, he worked on two series of paintings: the *Fundamental Lexicon*, reflecting the world of monumental social realist art, and the *Alefbet-Lexicon* (the Hebrew word for alphabet, 1983–90), which explores archetypical Jewish figures. Against a background of cursive Hebrew script, the *Alefbet-Lexicon* consists of patriarchal figures in traditional garb (prayer shawls, phylacteries, and skullcaps) depicted in positions proclaiming—almost provocatively—their Jewish faith. He paints mysteriously-dressed, gesticulating Jews carrying symbols like matzot (unleavened bread was hardly available in the Soviet Union), candlesticks, and other ritual objects rare at the time (Torah scrolls, prayer books, fruits and plants featured during Jewish festivals), as well as winged angels, pious mystics, and possessed souls.

Dissected and isolated like saints on Russian icons (similar to the way Bruskin depicts the pseudo-religious heroes of the former Soviet system), the Jewish figures in *Alefbet-Lexicon* seem to reflect the contemporary nostalgia in both east and west for a religious world that no longer exists. Painted on a background with Hebrew script which look like the pages of a book, the collection of figures do not appear to interact with each other, but rather seem to wait endlessly to be continued into an ever extending greater whole in which each person, each attribute, is calling for more questions and reactions from the reader of this illustrated lexicon. From it, a larger structure, a whole system could emerge—a new Jewish "text," an encyclopedia of images and ideas. In this sense Bruskin is truly one of the "People of the Book," for whom a seemingly endless list of commandments (613 in total) attempt to structure life and determine a set of beliefs. Bruskin's figures appear to be pleading to come alive, as the separate blocks of commentary surrounding classic Jewish text are waiting to be revived through debate with the modern reader.

Grisha Bruskin, *Alefbet-Lexicon no. 1 and no. 2*, 1987.

Oil on canvas, each 116 × 88 cm (45 $^2/_3$ × 34 $^2/_3$"). Museum Ludwig, Cologne, Germany. Donation Ludwig

Grisha Bruskin, *Alefbet-Lexicon no. 3 and no. 4*, 1988.

Oil on canvas, each 116 × 88 cm (45 $^2/_3$ × 34 $^2/_3$"). Collection Henri Nannen, Kunsthalle Emden, Germany

"Let there be light"

Zelig Segal
"In memory of the destruction of the Temple,"
Sabbath Candlesticks, 1988

The association of light with religious ceremonies is a universal phenomenon. In Jewish tradition, light is of primary importance; according to the Biblical account in the book of Genesis the words "let there be light" mark the first act of creation and light was created on the first day, after heaven and earth. It is no wonder Jewish tradition prescribes that the celebration of the finishing of creation, marked by the weekly day of rest, the Shabbat, should be inaugurated at sunset on Friday evening with the kindling of light. It became tradition to light two Shabbat candles, symbolizing the two versions of the Ten Commandments, in which one is ordained to "remember" and one to "observe" the Sabbath day to keep it holy (Exod. 20:8 and Deut. 5:12, respectively). The earliest types were undoubtedly simple oil cruses; later, since the Middle Ages, hanging oil lamps were used, simple star-shaped forms in Central Europe and more elaborate six-piece pendant lamps in Western Europe. Wax candles became customary since the eighteenth century.

Light accompanies Jewish ceremonies to impart holiness on special moments, and candles are lit before the start of all festivals. During the eight days of Hanukkah (at the darkest time of year), Jews light candles at sundown; during Passover in the Spring, remnants of matzah (unleavened bread) are searched for with a light: both festivals commemorate the Jewish people's struggle for freedom. The eternal light in the synagogue is a reminder of the destroyed temple lamp; light sanctifies the alliance between man and woman at weddings; and the memorial light serves in remembrance of the departed.

Only after the emancipation, when Jews were no longer excluded from the guilds, did Jewish artisans become involved in designing ritual objects to beautify the acts of fulfilling the Commandments. Early Zionists stimulated Jewish craftsmanship when they founded a design school in Jerusalem, named after the legendary first Jewish artist, Bezalel, who executed the ceremonial objects for the Tabernacle according to the blueprints Moses received from God, but that he himself could not read.

After graduating form the Bezalel Academy of Arts and Design in Jerusalem, Zelig Segal (b. 1933) became one of Israel's most creative designers of ceremonial objects. Though raised religiously, his approach is unconventional and practical; his forms are innovative and free of the familiar language of Jewish ceremonial objects.

With these candlesticks, Segal combines the function of the traditional two candlesticks with a memorial light, alluding to the destruction of the Temple. Once destroyed, the Temple—symbol of harmony between the human and the divine—became the symbol of an incomplete world. A small piece in the wall of a building is left unfinished, just as a glass is broken at the height of joy during a wedding ceremony to remind Jews that the world is incomplete since the destruction of the Temple: "If I forget you Jerusalem, let my tongue stick to my palate, if I don't keep Jerusalem in memory even at my happiest hour" (Ps. 137:6). Segal extends this now to the Sabbath, that most joyful weekly festival which starts with the kindling of lights, and ends when three stars appear in the sky and flames of a braided candle are extinguished to mark the separation between sacred and secular, light and darkness.

With his candlesticks, Segal seems to suggest that light and darkness are never completely separated, that even at joyous moments one may feel loss: historical, in memory of the destruction of the Temple, or personal, as a light burning in memory of loved ones.

Zelig Segal, *"In memory of the destruction of the Temple," Sabbath Candlesticks*, 1988.

Silver, 17.5 × 3.8 cm ($6^7/_8$ × $1^1/_2$"). The Israel Museum, Jerusalem, Israel. Purchased through the Eric Estoric Fund

Lessons of Darkness

Christian Boltanski
The Festival of Purim, 1988

The title refers to the Jewish festival of Purim (lots) based on the Biblical book of Esther, in which a beautiful Jewish woman of that name averts the destruction of her people by marrying king Ahasuerus of Persia. His councilor Haman, described as a rabid Jew-hater, had cast lots to determine the date for the extermination of the Jews—the 13th of the month Adar, in the Spring. With the help of her uncle Mordecai, queen Esther thwarts Haman's evil plans.

Since that time, the festival is celebrated in a way reminiscent of carnival; Jews dress up like the characters in the story, behave riotously in synagogue, use noisemakers, give mock sermons, and drink until they are unable to distinguish between Haman and Mordecai. In the synagogue, the reading of the Esther scroll is met with cheering whenever Mordecai's name is pronounced. In contrast, whenever Haman appears in the text, so much noise is made that one cannot hear his name—the memory of this evildoer is supposed to be blotted out. On the preceding Sabbath, called the "Shabbat of Remembrance," Jews are called to erase the memory of Amalek, Haman's ancestor who attacked the Israelites from the rear as they were leaving Egypt. Here is the prime example of a ritualized call to erase the memory of an evil person, a "damnatio memoriae," when Jews pronounce the name of their destructors only with the addition, "may his name be wiped out." The call to remember is repeated numerous times in the Bible, memory and remembrance being central concepts in Judaism and at the core of most Jewish festivals; remember the Sabbath to keep it holy, remember the exodus from Egypt to recall the oppression of slavery, and remember the destruction of the Temple as a symbol of our broken human existence.

On Purim, Jews remember their narrow escape and are once more reminded of the numerous occasions on which Haman (or his successors) did prevail. The story seems to defeat biblical theology: a God who does not save his people as he did in Egypt! The name Esther is related with the Hebrew word for hiding (*haster*), alluding to the hidden ways of God, whose name is not even mentioned in this biblical text.

In *The Festival of Purim*, Christian Boltanski deals with the darker aspects of this festival. The faces are based upon a photograph of children at a Purim party held at a Jewish school in Paris in 1939, with the suggestion that it was taken shortly before most of them were murdered. Their festive costumes bestow on them an individual identity that would be taken away from them not long after. For Boltanski, photographs, like the cloths he uses in other installations, can possess the connotation of death: "they have in common that they are simultaneously presence and absence"—reminiscent of the still-preserved clothing that Jews removed before entering the gas chambers.

The character of the photographs as a souvenir, a memorial, is stressed by the lights, which can be associated with the memorial lights Jews and Gentiles burn to commemorate the dead. During memorial services in the synagogue, the names of deceased family members and victims of persecutions are read, long after their individual faces and fates are forgotten. Boltanski's photographs are blurred, the faces anonymous: converted into symbols of the Holocaust and of death in general.

Born in 1944 in Paris on the day it was liberated, Boltanski is acutely aware of the narrow line between death and life. As the son of a Jewish father who came out of hiding to register his birth, and a non-Jewish mother who had hidden his father, he chose to be Jewish—a choice he observes, most Jews did not have the luxury to make.

Christian Boltanski,
The Festival of Purim, 1988.

10 black & white and color photographs, 41 lights, 1 tin box, 210 × 120 cm (82 11/16 × 47 1/4").
The Israel Museum, Jerusalem, Israel. Gift of the artist in memory of Jacques Ohayon

Purim celebration at a Jewish school in France, 1939

A Whisper of Angels

Anish Kapoor

It Is Man / Installation with Angels, 1989–90

According to Jewish tradition, angels have always existed: "In the beginning He created angels," it says, according to one interpretation of the first three Hebrew words of the Bible (reading the word *Elohim* as angels instead of God). And when it says: "let us make man" (Gen. 1:26), to whom does God address himself? To the angels of course! Divine messengers assume a prominent role in Jewish legend and folklore, frequently appearing in the Bible and Jewish liturgy. Ancient rabbis and mystics tell stories of how these supernatural beings foretell the future, influence rain, control human health and fate, and may appear in various forms, human or animal, as fire or water. They are good or evil and have as many names as they have functions, these intermediaries between the human and divine worlds. They accompany each Jew when going home from the synagogue on Friday night and are greeted in a popular Shabbat song. Angels may not be formally worshipped, but they can be invoked against evil and disease, and can aid in childbirth or bless a venture. Magic texts and amulets ward off spells and the evil eye. Negative reactions of more rational rabbis—from the middle ages to modernity—could not prevent the popular belief in angels, which persists today well beyond the worlds of Oriental and Hassidic Jews.

Anish Kapoor (b. 1954), the son of an Indian father and a Jewish mother, was born and raised in Bombay before moving to London in 1973. His installations all possess a mysterious almost mythical quality and deal to a large extent with archetypes, with creation, life, and death. On an architectural scale or on a more intimate size, on paper, Kapoor pulls the spectator into an energizing, enigmatic world. As a priestly consecrator, he freely arranges his *Angels*—slabs of slate covered in blue pigment—over the floor; the stones seem to flow in space. The transcendence Newman and Rothko realized in painting, Kapoor achieves decades later in sculpture.

The rough, masculine stone of *It Is Man* draws us into a smooth, seemingly endless dark blue womb-like depth, a birth channel, hiding the mythical powers of the androgynous creation of man—"male and female He created them" (Gen. 1:27). Darkness is a dominant theme in Kapoor's work. The creation story may state that God's first words were, "let there be light" (Gen. 1:3), but darkness preceded light, as the previous verse says, "the earth being unformed and void, with darkness over the surface of the deep" (Gen. 1:2). Therefore, according to Jewish legend, darkness protested against God, fearing that if it were lit, it would become the slave of light. And that is why in the End of Days, darkness and its angels will support his claim in having played a role in creation, but God and his angels will defeat them, since God's angels were part and parcel of creation itself, as it says, "and heaven and earth were finished, and all their array" (Gen. 2:1); that is, God's angels.

It Is Man affirms the dualism between dark and light, good and evil, male and female. *It Is Man / Installation with Angels* as a whole juxtaposes and unites these opposites, immersing us in the mysterious world of darkness and allowing us to come back to the light again, in which angels ultimately float freely.

Anish Kapoor, *It Is Man / Installation with Angels*, 1989–90.

Angels, 11 elements: slate, blue pigment, variable dimensions, approximately 60 × 260 × 115 cm (23 1/2 × 102 5/16 × 45 1/4"). Installation, Le Magasin, Centre National d'Art Contemporain, Grenoble, France

It Is Man, sandstone, pigment, 241 × 127 × 114 cm (94 7/8 × 50 × 44 7/8"). Museo National Centro de Arte Reina Sofia, Madrid, Spain

Anish Kapoor's *It Is Man / Installation with Angels*, is an excellent example of his "interest as an artist in how one can somehow look at that very first moment of creativity in which everything is possible and nothing actually happened. It's a space of becoming."

What Words May Mean

Lawrence Weiner

Licht = (Licht), 1990

Word and image have struggled with each other for prominence in the transmission of culture from the beginning of human recollection. Art for art's sake is a modern idea. Until relatively recently, the word was victorious. The image served to support and illustrate the word's message, it conveyed religious content and secular-political ideologies but never replaced the word. Most word-dominated systems depend on the image. In the contemporary postmodern world, however, these systems have lost their preeminence—visual impulses, television, and new media now determine the agenda and demand our attention.

How important is the word? Language? Writing? Is it confined merely to a small reading minority, or does it still demonstrate its strength by calling for our attention in wall writings, comics, graffiti, and commercial billboards?

For Lawrence Weiner (b. 1942) the word is art. Like other conceptual and minimalist artists, he reduces the object of art, in his case into the realm of language. Setting is important for him, as are his personal associations. A work of Weiner consists of a single line or a short statement, a quote on a wall or in a town square, in an exhibition space or projected on a window or screen. The language he uses is carefully constructed and his sentences usually have universal meaning: he pretends to state facts rather than opinions or personal beliefs. Utilitarian typescript—capitals without punctuation—underscore the sense of objectivity as much as typographic elements like brackets and equation marks provide a sense of algebraic precision.

Only once in his work has Weiner referred to his Jewish background, using Hebrew and Yiddish alongside the English, French, and Dutch (or German) he most frequently employs. As with most of his installations, this work for the Amsterdam Jewish Historical Museum is site- and (in this instance) time-specific, and was created to coincide with the winter festival of Hanukkah, the celebration of the Maccabean victory over the Greeks when they rededicated the Temple in Jerusalem. "Light = (Light)" in Hebrew and Dutch and "& vers les étoiles" (and towards the stars), screened on the windows of the museum, refer to the miracle in

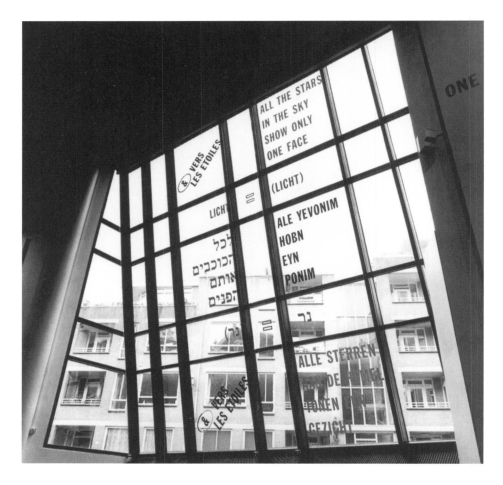

which the Temple candelabrum burned eight days on a day's worth of oil at the darkest time of year. During the day light shines through the window, which reflects the stars at night. It radiates warmth and hope for the future.

Words, as with celebrations and art, always carry more than one association, which is why Weiner also deals with the opposite of light: darkness, the symbol of evil and oppression. Weiner grew up in the South Bronx amongst Eastern European Yiddish-speaking Jewish immigrants for whom discrimination and pogroms had been a reality. From them Weiner learned the expression *ale yevonim hobn eyn ponim*, which literally means all Greeks have one face. He heard it when people warned him not to mix with non-Jews (Greeks). Based on their negative experience in the Diaspora, many Jews considered all non-

Lawrence Weiner, *Licht=(Licht)*, 1990.

Installation.
Joods Historisch Museum,
Amsterdam, The Netherlands

לכל הכוכבים אותם הפנים

LiCHT = (LiCHT)

ALL THE STARS iN THE SKY SHOW ONLY ONE FACE

ALLE STERREN AAN DE HEMEL TONEN EEN GEZiCHT

Jews as anti-Semites and potential persecutors. "& vers les étoiles" holds a more specific meaning for Weiner. Many Eastern European Jews arrived at New York's Ellis Island unable to write, and yet they refused to sign their names with a cross (the symbol of Christianity) and used a circle or a little star instead. The hopeful light of a renewed identity in a new country is linked to darker fears—the apprehension of continued belonging to a minority.

Reading one of Weiner's multilayered messages is not so different from the way Jews traditionally study their literature, in which often one single line or word forms the point of departure for several questions. The Hebrew Bible for instance sets out with the following line, "In the beginning God created heaven and earth…," whereupon the rabbis ask immediately: with what did he create them? One story recounts that he created the world by his word; so the twenty-two letters of the Hebrew alphabet descended from Gods crown (on which they were engraved with a pen of flaming fire), each entreating him to create the world through a word beginning with a specific letter. Eventually the second letter, *bet*, triumphed, claiming all inhabitants of the world would "bless" (*baruch*) him daily. For that reason God created the world through the letter *bet* of "beginning" (*bereshit*). The first letter of the alphabet refrained out of modesty, and was rewarded by becoming the first letter of the Ten Commandments.

Viewed through the prism of Jewish tradition, Weiner's words are (re)contextualized and carry multiple meanings.

The Thin Line of Survival

Richard Serra
The Drowned and the Saved, 1991–92, Synagogue Stommeln, Germany

The title of this work refers to two texts by the Italian Jewish author Primo Levi (1919–1987), a chapter in his book *Se questo è un uomo* (originally published in 1947 and translated in English as *Survival in Auschwitz* in 1960 and as *If This Is A Man* in 1965), and shortly before his tragic death, in a book entitled *The Drowned and the Saved* (1986, English translation: 1988). Levi had been arrested as a member of an anti-Nazi resistance group and deported to Auschwitz in 1944. He survived, but remained haunted by what he had witnessed there.

In his early description of the conditions at the concentration camp in Auschwitz, Levi makes a harsh distinction between two categories of prisoners: those who have given up everything and can only follow orders, and others who battle at all costs for their own survival. Those who don't manage to gain prominence as, for instance, a doctor, musician, or cook, quickly

become mentally and physically exhausted human wrecks, ready to be gassed. In normal life, Levi claims, nuances exist between categories like good and evil, cowardice and courage, happy and unhappy, but no such possibilities exist in extreme circumstances. Two worlds clash here. On the one hand, "...the drowned form the backbone of the camp, an anonymous mass continually renewed and always identical, of non-men who march and labor in silence, the divine spark dead within them, already too empty to really suffer. One hesitates to call them living; one hesitates to call their death death..." On the other hand, there are "the saved" as Levi calls them: "They, the Jewish prominent, form a sad and notable human phenomenon.... They are the typical product of the structure of the German Lager.... [Their] capacity for hatred, unfulfilled in the direction of the oppressors, will double back, beyond reason, on the oppressed."

In his later publication, Levi nuanced his views about the survivors. They survived at high costs. He expresses his feeling of shame of belonging to the minority of survivors who had luck, "I might be alive in the place of another, at the expense of another." Then he comes to the flowing observation, "We, the survivors are those who by their prevarications or abilities or good luck did not touch bottom. Those who did so, those who saw the Gorgon, have not returned to tell about it, or have returned mute.... They are the rule, we are the exception." In 1986, he no longer claims a contrast between the drowned and the saved as he did earlier, but admits they are inextricably linked to one another.

In his sculpture, *The Drowned and the Saved*, the American artist Richard Serra (b. 1939) does precisely this, he makes the two angled, mirroring shapes subtly support or rather "clash" with each other in the middle. Separately, each element would collapse. Neither the drowned nor the saved can stand on their own—the living cannot exist without the dead; they need each other.

As with the majority of his sculptures, Serra created *The Drowned and the Saved* for a specific location, in this case the former synagogue of Stommeln, which regularly features installations by prominent artists.

Richard Serra, *The Drowned and the Saved*, 1991–92.

Wrought steel, two pieces, each 143 × 155 × 35 cm (56 $^5/_{16}$ × 61 × 13 $^3/_4$"). Designed and realized for the Synagogue Stommeln, Germany. Present location: Diözesanmuseum, Cologne, Germany

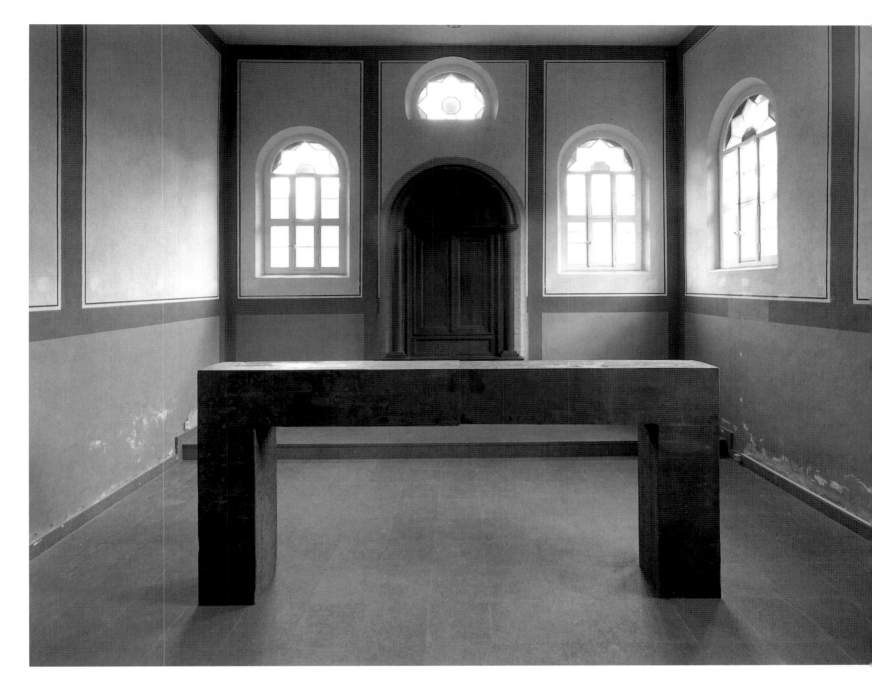

The building survived Kristallnacht in November 1938 only because the Jewish community of Stommeln had already been forced into exile or murdered. The former sanctuary, meticulously restored but totally empty, attests to the devastation—the title, size, and abstract nature of this specific installation invite the viewer to reflect upon its meaning. The sculpture's stark presence confronts the visitor, preventing him or her from comfortably walking around or drawing too near to it: the sculpture seems to point to the building's now-lost sanctity as much as seeming to refer to those who once inhabited it.

The work evokes the very questions Serra, at the time of creating this sculpture, remembers asking his Jewish mother, Gladys Feinberg, at age five, "What are we, who are we, where are we from? One day she answered me: if I tell you, you must promise never to tell anyone, never. We are Jewish. Jewish people are burned alive for being Jewish. I was raised in fear, in deceit, in embarrassment, in denial. I was told not to admit who I was, not to admit what I was." His mother, born in Los Angeles into a Russian Jewish family originally from Odessa and familiar with prejudice and persecution, raised Serra, like so many of his generation, in silence and denial, believing that in this way she could protect him. Serra's work expresses the awareness of this silence and of the burden of history, as he represents in his black drawings and the choice of heavy metal for his sculptures. As Serra said about *Gravity*, the sculpture he created for the United States Holocaust Museum in Washington, "we face the fear of unbearable weight…the weight of history."

Divine Creativity

Michal Na'aman
Lord of Colors (in white), 1998

Contemporary Israeli art is fundamentally modern, yet at the same time rooted in traditional Judaism. As with Israeli society at large, it is primarily secular art that plays with, challenges, and provokes the traditions of a culture thousands of years old. It is this tension with which kibbutz-born Michal Na'aman (b. 1951) deals in her *Lord of Colors* (*Hashem tzva'im*), words written in white Hebrew letters over an abstract colored background. The title is a pun on "Lord of Hosts" (*Hashem tsva'ot*), a biblical title for God used in connection to his bellicose activities. In her painting she turns the male military God into a female life-sustaining God who created the colorful rainbow to conclude the covenant with all living creatures on earth, which was never again to be destroyed by a massive flood (Gen. 9:12–17). The title and content of this work subtly refers to another gender-related irony; in the Hebrew, *tzva'im* (colors) has a masculine form, whereas *tzva'ot* (hosts) has a feminine plural ending. She plays with the attributes of God's name while at the same time abbreviating the name itself respectfully with one letter, in conformance with the tradition of not spelling out God's four-letter Hebrew name.

God of colors? The *Zohar*, the bible of Jewish mysticism originating in thirteenth-century Spain, asks what it means when the text says that God "appeared" to the patriarchs instead of speaking to them (Exod. 6:3), and explains that he reveals his true nature not in an anthropomorphic form, but in colors—each letter having a different color. The military Lord of Hosts is transformed into a mystical God of colors when Na'aman connects God's creative powers with her own impulse to make a colorful painting as an expression of the human impulse to create art. She is aware of the power of the word as one of the secrets and charms of Hebrew, which she now extends to secular art, no longer limiting it to the rabbis or the exclusive circle of the mystics of old. She is seizing control of a power that had previously been denied to her as a woman and as a secular person.

Hebrew, the mother tongue of modern secular Israelis, is the sacred language of the Bible, spoken three thousand years ago by Jews in ancient Israel, and since the loss of statehood after the destruction of Jerusalem in 70 CE, used mainly passively for religious and liturgical purposes. The square so-called Aramaic script Na'aman uses is the same scribes used for two thousand years to copy the text of the Bible on parchment scrolls, its shape being the basis for the letters used in Hebrew printed books since the late fifteenth century.

Hebrew is a Semitic language, and its alphabet of 22 consonants (vowels being written under and above them) was also used for writing the spoken languages of Jews in the Diaspora: Yiddish in Eastern Europe and Ladino in the Mediterranean area. Literary Hebrew was revived during the *Haskalah* (Jewish Enlightenment) in the late eighteenth century, and became the spoken language of Jewish immigrants in Palestine thanks to the efforts of Eliezer ben Yehudah (1858–1922), who himself had settled there in 1881. Extreme Orthodox Jews still prefer to speak Yiddish rather than use the holy tongue for secular use.

In the cycle to which this painting belongs, Na'aman plays with biblical words and images, making Hebrew puns, referring to the male and female aspects of the abstract God of Jewish mysticism; she literally explores its specter, without any fear to explore its limits and tensions within the time-honored traditions of the Jewish religion and the holy language.

Michal Na'aman, *Lord of Colors (in white)*, 1998.

Oil paint and masking tape, 200 × 170 cm (78 3/4 × 66 15/16"). Tel Aviv Museum of Art, Tel Aviv, Israel

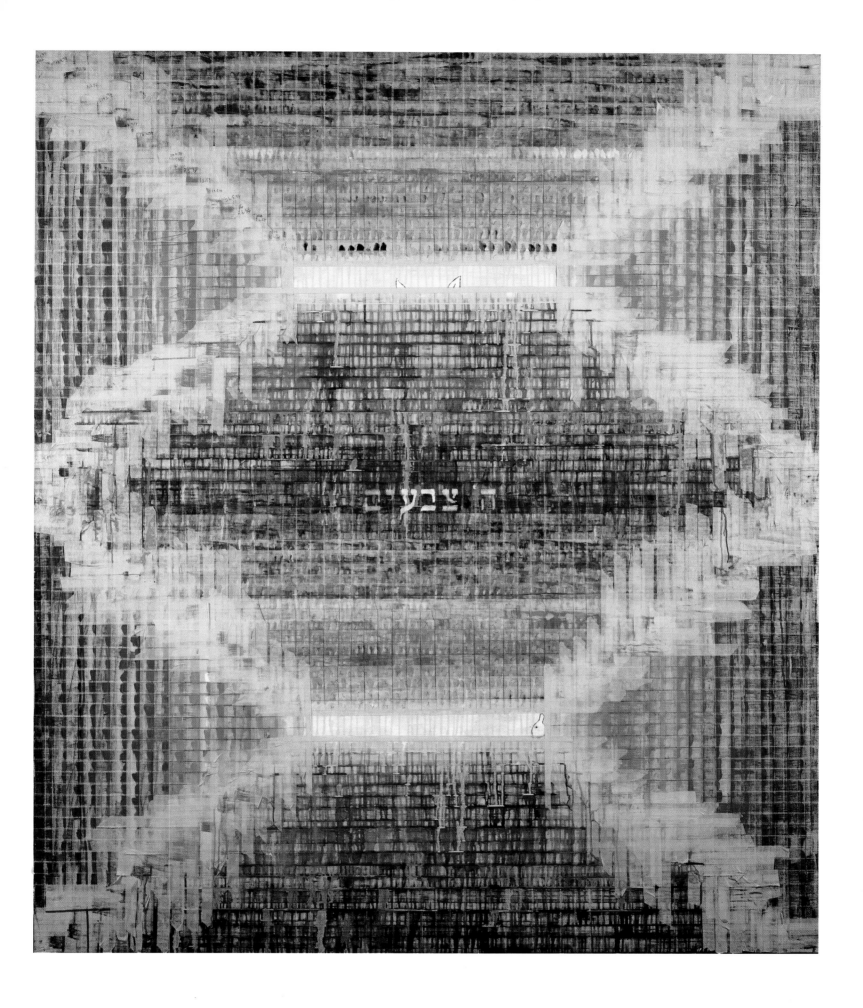

"The drumming's now at its height"

Nancy Spero

The Ballad of Marie Sanders, the Jew's Whore III (Brecht), 1998

Nancy Spero's (b. 1926) art is political and feminist; her art deals with mythological and martyred women, heroines and victims, sexuality and vulnerability. Her concerns are universal, but recently she also took interest in those human victims of the Nazis who were Jewish or had consorted with Jews.

The Ballad of Marie Sanders, the Jew's Whore is based on a disturbing 1935 poem by Bertolt Brecht recounting the brutal story of humiliation of a non-Jewish woman who had slept with a Jew—an act forbidden under the Nuremberg racial laws of that year. After earlier installations for a museum in Wuppertal, Germany (1991) and the Jewish Museum in New York (1993), in 1998 she created a truly impressive site-specific installation for the Festival Hall at Hellerau near Dresden. This modernist building of 1911, desolate and deserted, carried the traces of two totalitarian systems—of the Nazis who in 1936 turned it into a police academy, and the Soviets who converted it into a military hospital in 1945. Here, amid frescoes of past heroes, remains of old furniture, peeling plaster and old wallpaper, Spero's stamped images and the poem of Brecht, quoted in its original German, functioned as an act of recuperation or, as one of her assistants remarked, "it was as if the figures and symbols had always been there, as if we had simply uncovered

them." The image of a naked and chained woman, which Spero used in previous installations, took on a new and more intense meaning in this particular building. The installation was an outcry against Nazi sexual sadism, a powerful tribute to Marie Sanders surrounded by Spero's favorite heroines: the awe-inspiring Medusa of Greek mythology and Lilith, her Jewish equivalent, the sea monster Scylla and female athletes—a memorial to all women humiliated, both past and present.

In earlier works, Spero commemorated the atrocities against the Jews in *Warsaw Ghetto* (1997), and paid homage to un unknown partisan woman, *Masha Bruskina* (1993), the first woman to be executed by the Nazis in Soviet Russia and who many years later was discovered to have been a Jewish girl from the ghetto of Minsk.

Nancy Spero, *The Ballad of Marie Sanders, the Jew's Whore III (Brecht)*, 1998.

Wall painting installation. Festspielhaus Hellerau, Dresden, Germany

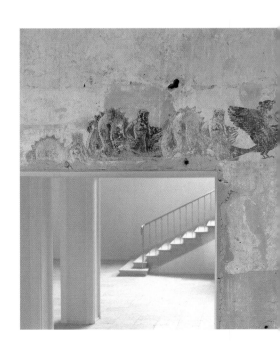

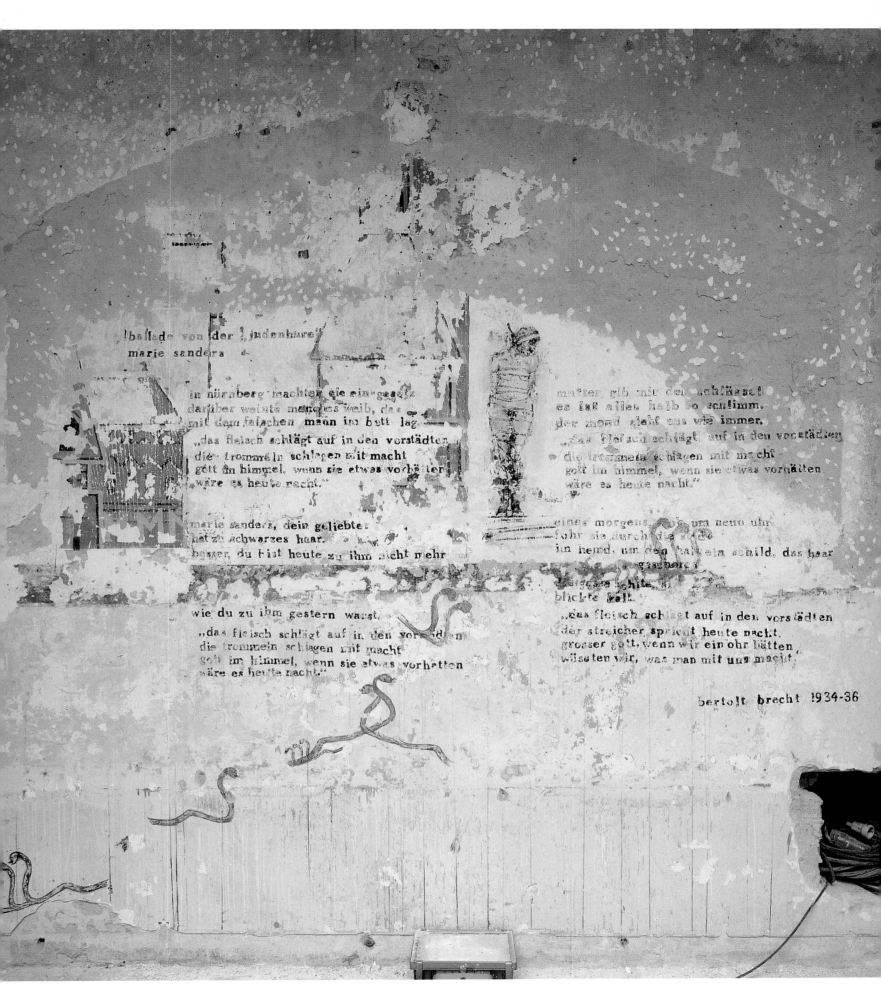

A Shrine of Absence Filled With Life

Daniel Libeskind

Jewish Museum Berlin, Berlin, Germany 1989–99/2001

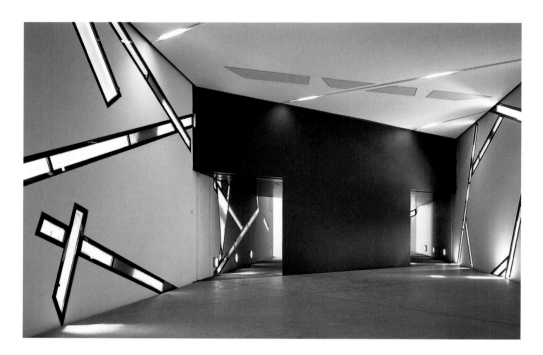

Joining the historic Brandenburg Gate and the restored Reichstag building—once again the seat of the German parliament—the Jewish Museum has become a Berlin landmark and one of Germany's most popular museums. The museum marks a change: for the first time international public attention is focused upon architecture whose external form and inner structure is a clear expression of the memory of almost two thousand years of Jewish life in Germany, its dramatic extinction during the Nazi era, and its modest new beginnings in the postwar period.

Months before the fall of the Berlin Wall, in autumn of 1989, an international jury chose this astonishing design—the first building commissioned to Daniel Libeskind, a then hardly known but now world-famous architect, born in 1946 in Lodz to Polish Jewish survivors of the Holocaust.

Two years before the opening of the permanent exhibition in September 2001, hundreds of thousands of visitors had already wandered through its corridors and irregular spaces—shuddering in the Holocaust tower, growing disoriented in the Garden of Exile, and overwhelmed by the large voids slicing through several floors. These empty spaces, five in total and called voids by Libeskind, have been placed at irregu-

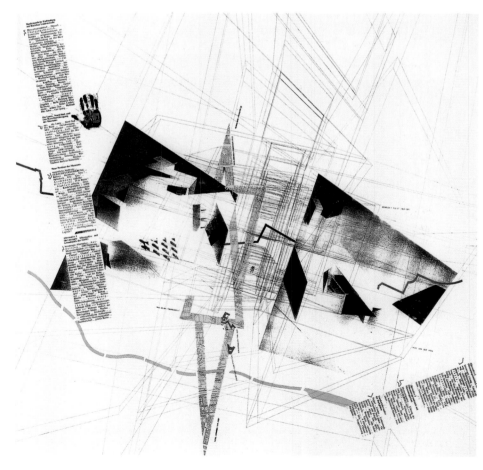

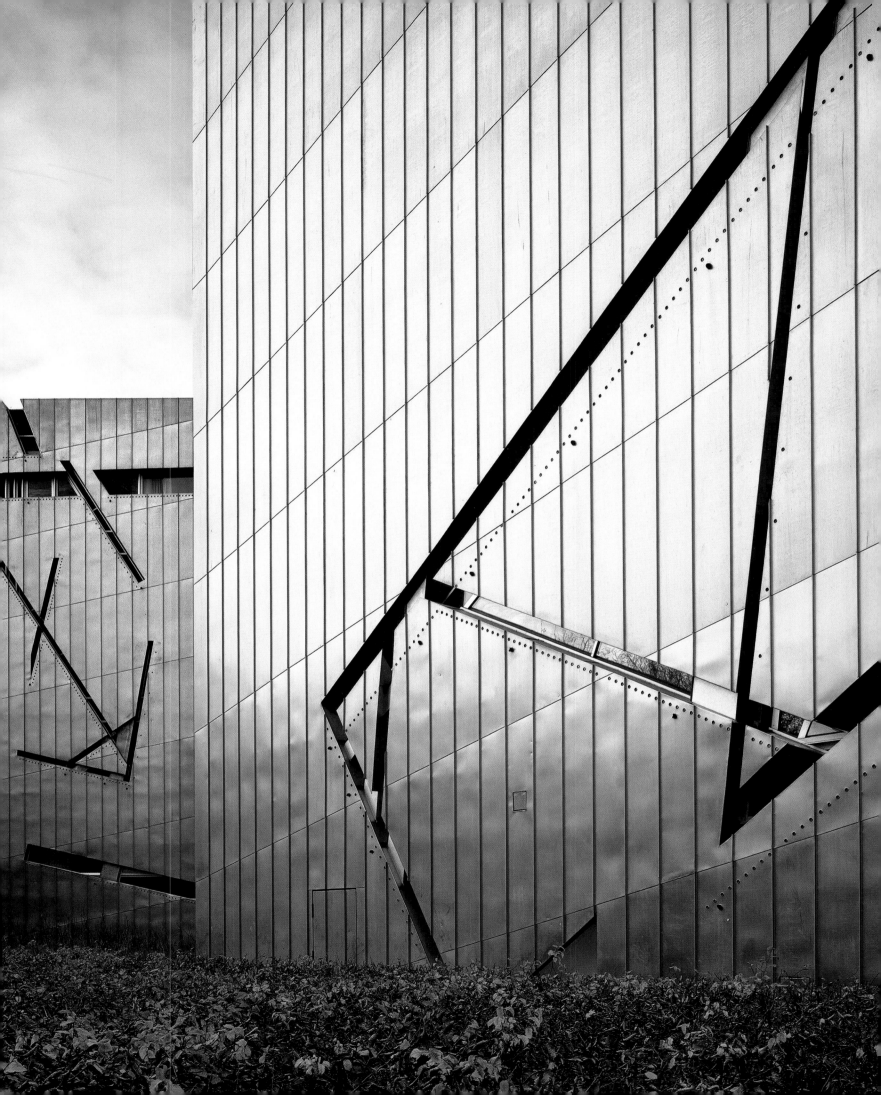

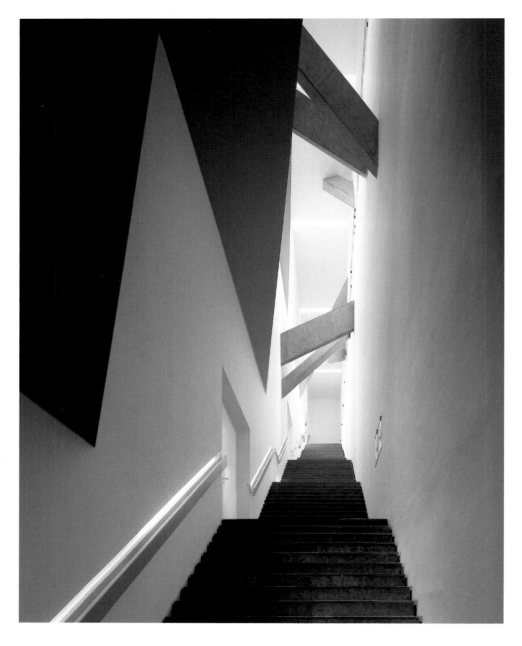

Left: Main staircase

Below: Floor plan,
third floor

lar intervals within a structure of over 7,000 square meters of exhibition space. They symbolize the absence of Germany's Jews—forced to emigrate, murdered, or driven into oblivion. The building offers a truly visceral experience.

The museum is accessed through the adjacent baroque Kollegienhaus via stairs leading to the basement. Here, the path divides into two corridors, intersected by a third. The right hand corridor leads into the Garden of Exile outside the building, with its 49 slanted columns. The intersecting corridor, the Axis of the Holocaust, leads to the Holocaust tower. The Axis of Continuity, the corridor leading straight ahead, rises gradually to the main stairway, providing access to the museum's two exhibition floors.

Libeskind's Jewish Museum, this shrine of absence, has now been filled with objects, and yet visitors from all over the world remain overwhelmed by a sense of

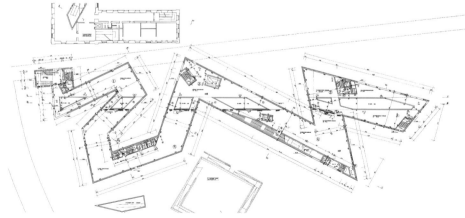

vacancy; a vacancy left by a once vibrant and multi-faceted Jewish culture and religion, at one time part and parcel of German culture, which is only now experiencing a gradual revival.

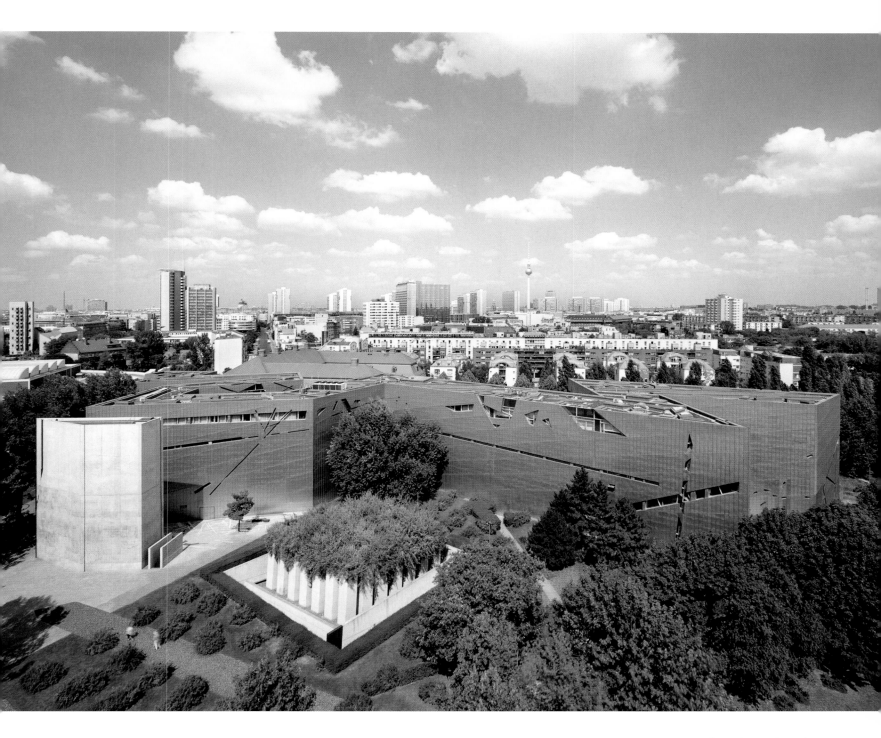

View from the south, with
the Holocaust tower on the
left and the garden of Exile
in the middle

Rebellion against Conventions

Nan Goldin

Self-portrait on Bridge, Golden River, Silver Hill Hospital, Connecticut, 1998

The life and career of Nan Goldin (b. 1953) have evolved very differently than might have been expected on the basis of the middle-class Jewish milieu in which she was initially raised in Washington, D.C., and later in the suburbs of Boston. After leaving her family home, she grew up with foster families in Massachusetts, and at the age of fourteen was deeply traumatized by the suicide of her elder sister. Goldin increasingly sought comfort in her friends. Like so many of her generation, she eschewed the liberal optimism of the Kennedy era in a climate of growing unease about the war in Vietnam and the continuing abuse of civil rights in the U.S., and was attracted by the mood of angry dissent found in books such as the *Autobiography of Malcolm X*. This attitude implied a rejection of the traditional values of the American establishment and of her own family, and an embrace of the role of the outsider—the "fate" of Jews throughout most of their history. In Goldin's particular case, this took the form of abandoning the conventional Jewish-American path towards greater security and respect, and embarking on an experiment with an end that could not have been foreseen.

Goldin, who is now regarded as one of the world's leading photographers, started taking photographs at the age of 15 with the aim of creating a record of her own memories and of her life with her friends, whom she already regarded as an alternative "family." She was thereby drawn into the world of transsexuality, of cross-dressing, and of the drag-queen subculture, all of which she regarded non-judgmentally, seeing in it a means of self-reinvention. She was particularly fascinated by the blurring of the boundaries fixed by conventional assumptions regarding gender. In the 1980s she attracted a great deal of attention with *The Ballad of Sexual Dependency*, a serial "family album" of her circle, compiled over ten years. In the preface to the catalogue edition of 1986, she wrote of the need "to live fully and for the moment...a need to push limits." This was expressed not only in the extreme nature of the relationships recorded, but also in the reckless abuse of alcohol and drugs. It was at this time that AIDS began to claim its first victims, among them some of Goldin's closest friends.

In 1988, Goldin's own struggle with alcohol and drugs led to her first experience in rehabilitation. During her stay in a detoxification clinic she produced a series of self-portraits, searingly honest in their depiction of her situation. But this was not the end of the story for Goldin. Her *Self-portrait on Bridge, Golden River, Silver Hill Hospital, Connecticut, 1998* is the last image in the nine-part photographic series *Relapse/Detox Grid #2*, made between 1998 and 2001, which illustrates the passage from relapse, by way of each stage of dependency, to the solution to this vicious circle: complete withdrawal from addiction. It is a highly symbolic image, as Guido Costa has observed in *The Devil's Playground*. Here, for the first time in the series, we see sunlight; it is reflected in the Golden River—a play on Goldin's name. Goldin herself is visible as a silhouette on the bridge, itself a symbol of transition, just as the river may be seen as a symbol of life. In this snapshot of her own existence, there emerges a motif of hope. But, like other photographs by Nan Goldin, this image should not be misunderstood as bearing a moral message. It is the snapshot of a life-long battle, the outcome of which remains uncertain; a snapshot that, in its effective "abstraction," points far beyond the future of the individual.

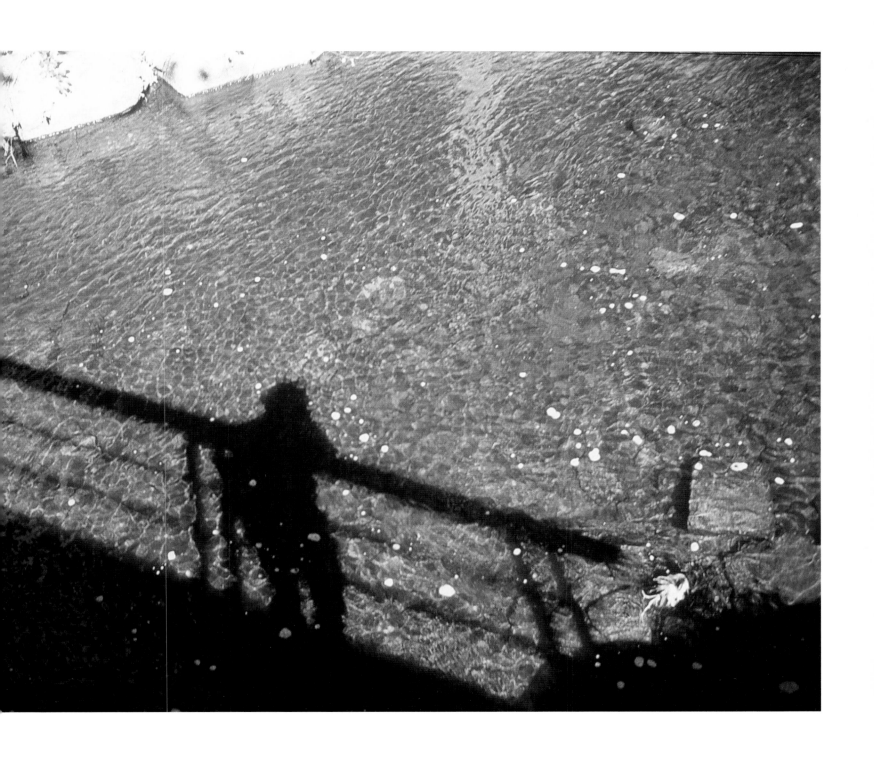

Nan Goldin, *Self-portrait on Bridge, Golden River, Silver Hill Hospital, Connecticut,* 1998.

Cibachrome print,
76.2 × 101.6 cm (30 × 40"). Courtesy Matthew Marks Gallery, New York, USA and Yvon Lambert Gallery, Paris, France

The Fictitious Jewish Artist

Ilya Kabakov
Life and Creativity of Charles Rosenthal, 1999

This installation is a retrospective of a fictitious artist, created and curated by Ilya Kabakov (b. 1933). Kabakov characterizes himself as a stray dog; Ukrainian born, his parents and his wife Emilia are Jewish, his language is Russian, and his mentality Soviet. Kabakov was trained in Samarqand and Moscow to be an artist in the service of the state, and was destined to become the painter of the leader, the worker, and the farmer.

Yet, his career took a different turn; he became the most famous artist of the Moscow underground, a kind of professional schizophrenic. In his day job he was the officially-supported illustrator of children's books, while in his own time his Moscow attic studio filled with unofficial work dealing with the boring, frightening, and banal aspects of everyday life in Soviet Russia, stirring debate amongst a small circle of friends. Beginning in the mid-1960s, his works and installations were occasionally exhibited in the west, and his underground existence ended in the late 80's when the Soviet Union collapsed. After having stayed in various European cities, Kabakov moved to New York in 1992.

In exile, the artist became the chronicler and ethnologist of the lost society that was the Soviet Union, with junk-laden, dust-collecting spaces that were exhibited all over the world. Has the unofficial Kabakov now become official? Not when we get to know him through an installation like *Life and Creativity of Charles Rosenthal.* Who is this Charles Rosenthal, this alter ego of the painter Kabakov?

As one might expect, the fictitious Rosenthal is a fellow Ukrainian, born in 1898 in Kherson, at the time one of the most important Jewish cities of Eastern Europe. And what is more, Charles is not his real name, but rather Sholom, which, not by coincidence, is the same as the great Yiddish storyteller Sholem Aleichem whose novel *Wandering Stars* Kabakov illustrated in 1957 as his diploma work for the academy. Rosenthal's imaginary biography contains all the relevant clichés about Jewish artists of his generation who moved from provincial Russian towns to the big city and then emigrated abroad—some to find success like Chagall, and others, like Rosenthal, to be forgotten

until retrospectively rediscovered (by Kabakov). Typically, Rosenthal studied in St. Petersburg at "Shtiglitz Academy" (reminiscent of the famous American Jewish modernist photographer Alfred Stieglitz), and became acquainted with modernist compositions in the realistic style, such as those of Paul Cézanne, the hero of so many Russian painters. Of course Rosenthal studied in Vitebsk with the magical storyteller Marc Chagall, where he would become equally fascinated with Kasimir Malevich's abstract art. And naturally, he immigrated in 1922 to Paris, the Mecca of art for so many Jewish painters (like Chagall). He died in a car accident in 1933, the year Kabakov was born.

Like Rosenthal, Kabakov can be found at the centers of modern art of his time; like Rosenthal, he perceives himself an outsider. Similar to Chagall, he is a dissenter with regard to modernism. Rosenthal/Kabakov oscillates between abstraction and realism: unable to escape the seductions of the absolute white of a Malevich—the great dictator of the Russian avant-garde with whom all Russian artists have a complex relationship—and yearning for the apolitical naturalism of the nineteenth century, which became tainted and misused by Socialist realism. The installation plays on these encounters with art history;

Ilya Kabakov, *Life and Creativity of Charles Rosenthal,* 1999–

Contemporary Art Gallery, Art Tower Mito, Mito, Japan, 1999; Kunstmuseum Bern, Bern, Switzerland, 2000; Städelsches Kunstinstitut, Frankfurt am Main, Germany, 2000–01; Kunstsammlungen Chemnitz, Chemnitz, Germany, 2001; Museum of Contemporary Art, Cleveland, Ohio, USA, 2004–05 (expanded version); Collection of the artist

Perspective sketch and section of the exhibition at the Art Tower Mito, 1999, 1997.

Felt-pen, correction fluid, 21 × 29.7 cm (8 1/4 × 11 11/16")

Ideal Drawing of Room 3
of the exhibition at the Art
Tower Mito, 1999, 1998.

Watercolor, felt-pen, colored pen,
pencil, crayon, chalk, and correc-
tion fluid, 27.8 × 43 cm
(10 $^{15}/_{16}$ × 16 $^{15}/_{16}$"), signed
C R 30

Drawing of Room 5, 1999.

Watercolor, colored pen, felt-pen,
chalk, pencil, and correction fluid,
27.8 × 43 cm (10 $^{15}/_{16}$ × 16 $^{15}/_{16}$"),
signed CH. Rosenthal 32.

"The plan for the arrangement of
the space was preserved, but the
conceived cycle was not realized
due to the tragic death of the
artist. Only the contour of the
future paintings were imposed
on the white surface of the can-
vas. It is clear that Rosenthal con-
ceived everything as a unified
ensemble, anticipating on what
has now come to be called the
'installation'."

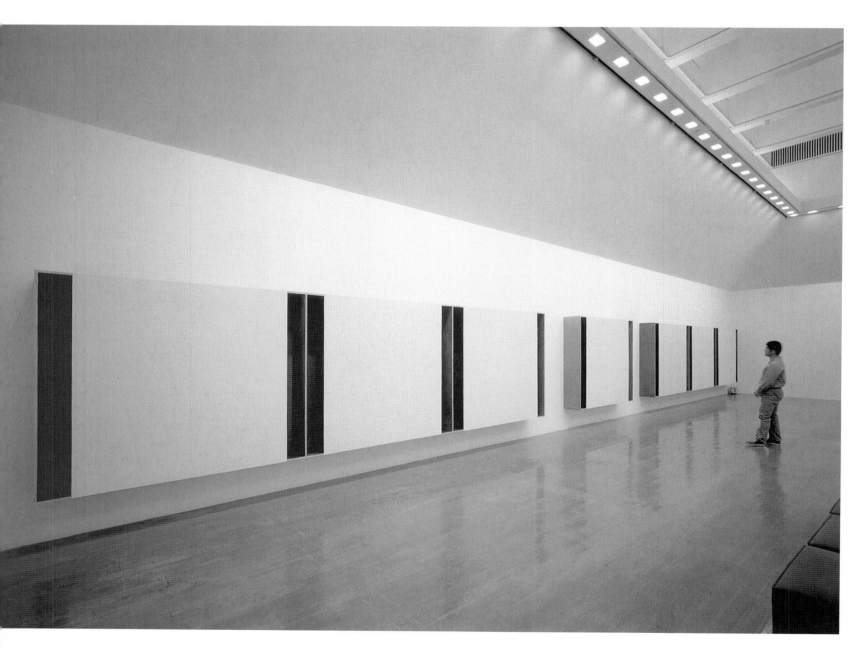

Kabakov combines the best of Russian storytelling with the descriptive language of Jewish tales that are able to equally encapsulate historical, personal, and artistic crises.

Kabakov offers his perspective as an outsider and émigré on another outsider and émigré, a forgotten Jewish artist. Through Rosenthal, Kabakov the artist sheds new light on Russian art and the fate of individual creators. At the same time, Kabakov the curator installs works in museum spaces, and orchestrates a sense of disorientation and confusion, forcing the viewer to ask questions about the role of the (Jewish) artist in society.

Installation view, Room 5.

Contemporary Art Gallery, Mito, Japan, 1999

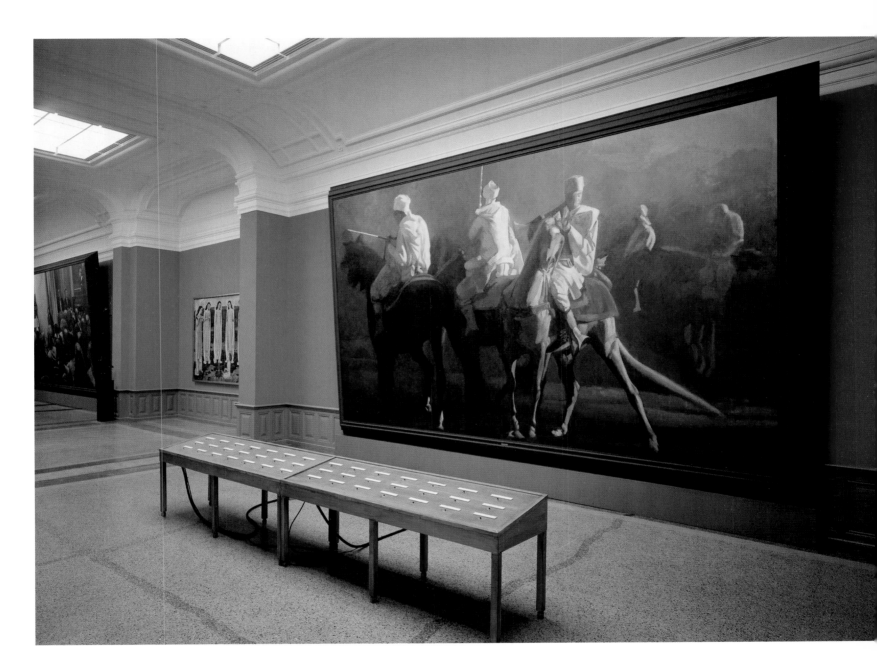

The Three Riders, one of the
larger realistic canvases of
Rosenthal/Kabakov, with a
panel inviting viewers to
respond and participate.

Room Installation, Kunstmuseum
Bern, Switzerland, 2000

Conflicts

Michal Rovner
Co-Existence Three Stages, 2002

Like many Israelis of her generation, Michal Rovner (b. 1957) can trace her formative years by the wars which raged about her; she was nine years old when the Six-Day War broke out (1967), fifteen during the Yom Kippur War (1972), and twenty-four when Israel invaded Lebanon (1981), this against the backdrop of the Israel-Palestine conflict. She served in the military, studied philosophy and cinema in Tel Aviv, and photography in Jerusalem before moving to New York in 1988 while maintaining a residence in Israel. Not surprisingly, war and conflict play an essential role in her work, not so much the actual atrocities committed by one side or another, but rather the personal conflicts between the individuals who figure primarily as shadows in her videos.

Apart from wars, Israel faces numerous internal conflicts. Israel is a relatively young immigrant country and while many groups successfully integrated, there are tensions between the usually well-educated, secular European Jews and the more religious and poorer oriental Jews from Africa and Asia. One million out of a total of six million Israeli citizens are either Christian or Muslim Palestinian. About a quarter of the population lives below poverty level. Religion, which kept Jews together for two thousand years in the Diaspora, became a divisive force in Israel; Zionism is secular and, in principle, so is the Jewish state. But in Israel there is no clear division between state and synagogue, leaving a great deal of influence with a small minority of extreme orthodox groups who do not even recognize the state.

Co-Existence seems to recall these conflicts—between different groups of Jews or between Israelis and Palestinians. At first, the figures in the video stand peacefully next to one another, but they become agitated and start to argue, and ultimately they kick and push each other. Exploring the fragile nature of human interaction, she deals with uneasy group relations, conflicts between communities or nations. Her images evoke the conflicts that afflict Israel as much as the ethnic struggles in the Balkans or the former Soviet Union. And though Rovner's figures are sometimes blurred and indistinct, the conflicts they depict are frighteningly realistic.

Michal Rovner,
Co-Existence Three Stages,
2002.

Multi-channel video projection.
Property of the artist, New York,
USA

Telling History

William Kentridge
Porter Series – Noah Tapestry, 2001

Originally, at least as the Bible wishes us to believe, there was harmony in the world. But this harmony did not last long; almost immediately after humans were created, the complications began—Adam and Eve are expelled from the Garden of Eden after eating the fruit from the tree of knowledge of good and evil (Gen. 3) and their son Cain kills his brother Abel (Gen. 4). Perhaps humanity was not such a good idea after all, and God decides to wipe out all of mankind from the earth, sparing just one man, Noah, and his family. After the flood, Noah plants a vineyard and the next problem arises—he gets drunk and lies naked. His son Ham sees him and calls to his brothers Shem and Japheth, who cover their father's nakedness without looking (Gen. 9:18–29).

According to the Bible, Shem, Ham, and Japheth are the ancestors of the nations of the earth: Shem would become the ancestor of Abraham and other Semitic tribes; Japheth would father the Greeks and other Europeans; and Ham, cursed by his father, begot the Egyptians and the Kushites, later identified as the blacks. Based on this story, and running counter to the biblical tenet that all men are created in God's image (Gen. 1:27 and 9:6), South African Apartheid justified racial discrimination. (In turn, the chart of nations in Genesis 10 expresses the unity of mankind without any identifiable racial pattern.)

William Kentridge, born in South Africa in 1955, was deeply disturbed by Apartheid's racism and continues to deal with the legacy of racial prejudice. As a Jew whose grandparents had emigrated from Lithuania to South Africa, Kentridge stands on the side of the victims without being exactly one of them—both his parents were involved as lawyers in the anti-Apartheid movement and represented many of its black victims.

Two white characters are omnipresent in Kentridge's work—animated films on Apartheid and post-Apartheid South Africa based on charcoal drawings, prints, photographs, and small figurines—and can be seen as his alter-egos: the sensitive artist Felix Teitlebaum, and the industrialist Soho Eckstein, founder of a coal mine, ruthless ruler with his telephone, and exploiter of black workers. While Jewish individuals (such as Kentridge's parents) and Jewish groups played a major role in resisting Apartheid, as whites they also benefited from the economic racism of the South African system.

Telephone and megaphone are the instruments of communication for both ruler and oppressed parading in front of the map. The concept of the Middle East as cradle of ancient civilizations has a bittersweet aftertaste—here lie the roots of humiliation for millions, just as it possesses the ideals of human equality. In procession, the two protagonists shout their messages loudly and clearly, hoping to reach the observer. Kentridge represents a political position that is never self-righteous, but focuses rather on the moral urgency of his message. His story is there for us to interpret, and appeals to our own responsibility, guilt, and grief.

William Kentridge, *Porter Series – Noah Tapestry*, 2001.

Tapestry designed by William Kentridge, woven by Marguerite Stephens Weavings Studio, mohair, silk, and embroidery, 400 × 300 cm (157 1/2 × 118 1/8"). Courtesy Marian Goodman Gallery, New York, USA and Paris, France

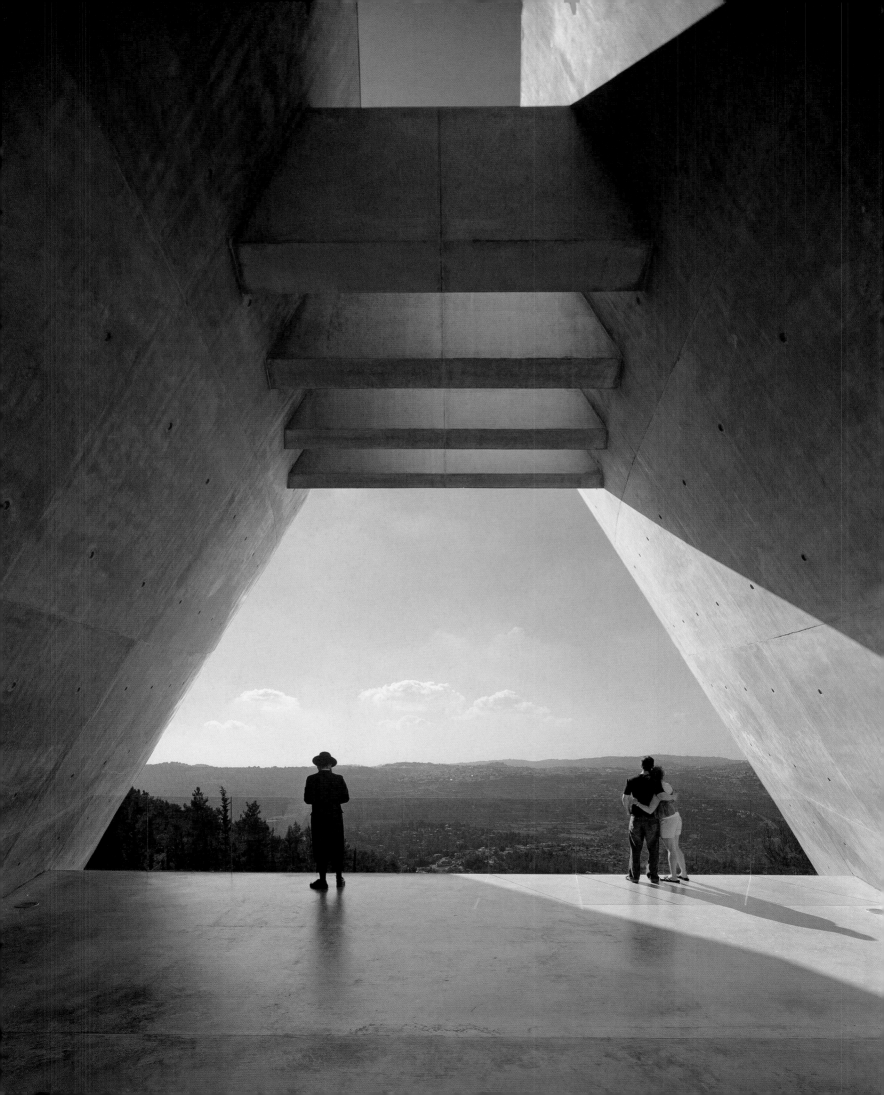

Acknowledgements

This book is the result of my long-time involvement with, and enthusiasm for, both Judaism and the visual arts. As a child, I accompanied my parents to museums and concerts; and they shared with me their passion for books and literature. Later on, my teachers, the late Hartog Beem and the late Mozes Heiman Gans, introduced me to the world of Hebrew and Yiddish texts, and Jewish history. The vast spectrum of art history was opened to me during my studies at Amsterdam University, and amongst my many teachers I am particularly thankful to my mentor, the late Professor Hans L. C. Jaffé.

With the years my love for all aspects of Jewish religion and culture has only increased, resulting in this book. For this publication, I was inspired by innumerable visits to museums, conferences, and exhibitions. But above all I benefited from talking to my museum colleagues in Europe, Israel, and the United States, some of whom I like to mention here in particular: Helmuth Braun, Nathalie Hazan, Norman L. Kleeblatt, Bernhard Purin, Laurence Sigal, and Fred Wasserman. Amongst the many scholars from whom I benefited I would like to single out my New York cousin Harriet Senie, Reesa Greenberg, Sam D. Gruber, and Walter Homolka. I would like to thank all of the artists, architects, institutions, and museums that provided me with excellent images; special mention goes to Mr. Klaus Richter of Richter Verlag in Düsseldorf. I am especially grateful to the Amsterdam Jewish Historical Museum for their support, in particular to my director Joel Cahen and to Anton Kras, who provided me with images.

I thank all of them for having shared their knowledge and appreciation, in their insightful writings and inspiring exchange of ideas.

My deep gratitude goes to Angeli Sachs, who stimulated me to write this book and was an inspiring editor, helped me develop the concept, and whose contribution to the contemporary art section was especially significant. Prestel Verlag's publishers Jürgen Tesch and Jürgen Krieger enthusiastically welcomed the idea for this book from its inception. I am thankful to Eckhard Hollmann, chief editor for art, for his support and Sophie Kowall, who researched the images, Rainald Schwarz, responsible for the creative book design, and Jonathan Fox, my patient English editor.

I hope the reader will enjoy this personal selection from the vast repository of Jewish art and culture.

Edward van Voolen

Biography

Edward van Voolen studied History and Art History at Amsterdam University and Rabbinics at the Leo Baeck College, London and Hebrew Union College, New York. Since 1978 he is curator of the Joods Historisch Museum Amsterdam. He has curated numerous exhibitions and has published extensively on Jewish art, religion, and culture in Dutch, German, and English. The topics include *Synagogues of the Netherlands*, Chagall, Nussbaum, and *Jewish Identity in Contemporary Architecture*. He has taught at several universities—currently at the Abraham Geiger College in Berlin—and sits on the editorial boards of *Jewish Art, Jewish Cultural Studies* and the *Journal of Modern Jewish Studies*.

A founding member of the *Association of European Jewish Museums* since 1989, he served as a juror for architectural projects (the Jewish Museum Berlin, the Felix Nussbaum House in Osnabrück, and the Museum for Polish Jewish History in Warsaw) and as consultant for a number of Jewish exhibitions and Jewish Museums. He was academic project leader of the exhibition *Patterns of Jewish Life* in Berlin (1990–92).

Bibliography

General

Amishai-Maisels, Ziva, *Depiction and Interpretation: The Influence of the Holocaust on the Visual Arts*, Oxford and New York, 1993

Apter-Gabriel, Ruth, ed., *Tradition and Revolution: The Jewish Renaissance in Russian Avant-Garde Art, 1912–1928*, Exhibition Catalogue, The Israel Museum, Jerusalem, 1987

Baigell, Matthew, and Milly Heyd, eds., *Complex Identities: Jewish Consciousness and Modern Art*, New Brunswick and London, 2001

Bilski, Emily, ed., *Berlin Metropolis: Jews and the New Culture, 1890–1918*, Exhibition Catalogue, The Jewish Museum New York, Berkeley and New York, 1999

Bland, Kalman P., *The Artless Jew: Medieval and Modern Affirmations and Denials of the Visual*, Princeton, 2000

Cohen, Richard I., *Jewish Icons: Art and Society in Modern Europe*, Berkeley, 1998

Cohen Grossman, Grace, *Jewish Art*, Southport, 1995

Cohen Grossman, Grace, *Jewish Museums of the World*, Southport, 2003

Gittelman, Zvi, *A Century of Ambivalence: The Jews of Russia and the Soviet Union, 1881 to the Present*, New York, 1988

Gruber, Samuel D., and Paul Rocheleau (photography), *American Synagogues: A Century of Architecture and Jewish Community*, ed. Scott J. Tilden, New York, 2003

Guttman, Joseph, *Hebrew Manuscript Painting*, New York, 1978

Herselle Krinsky, Carol, *Synagogues of Europe: Architecture, History, Meaning*, New York, Cambridge MA and London, 1985

Kampf, A., *Jewish Experience in Twentieth Century Art*, Exhibition Catalogue, Barbican Art Gallery, London, 1990

de Lange, Nicolas, *Judaism*, Oxford, 2003

Mann, Vivian B., *Jewish Texts on the Visual Arts*, Cambridge MA, 2000

Mendelsohn, Ezra, ed., *Art and its Uses: The Visual Image and Modern Jewish Society*, Studies in Contemporary Jewry 6, New York, 1990

Narkiss, Bezalel, *Hebrew Illuminated Manuscripts*, Jerusalem, 1969

Olin, Margaret, *The Nation without Art: Examining Modern Discourses on Jewish Art*, Lincoln and London, 2001

Robinson, George, *Essential Judaism: A Complete Guide to Beliefs, Customs, and Rituals*, New York, 2000

Sachs, Angeli and Edward van Voolen, eds., *Jewish Identity in Contemporary Architecture*, Munich; Berlin, London, New York, 2004

Sed-Rajna, Gabrielle, *The Hebrew Bible in Medieval Jewish Manuscripts*, New York, 1987

Sed-Rajna, Gabrielle, ed., *Jewish Art*, New York, 1997

Seltzer, Robert M., *Jewish People, Jewish Thought: the Jewish Experience in History*, New York and London, 1980

Soussloff, Catherine M., *Jewish Identity in Modern Art History*, Berkeley, 1999

Sujo, Glenn, *Legacies of Silence: The Visual Arts and Holocaust Memory*, Exhibition Catalogue, The Imperial War Museum, London, 2001

Tumarkin Goodman, Susan, ed., *The Emergence of Jewish Artists in Nineteenth Century Europe*, London, 2001

Wigoder, Geoffrey, *The Oxford Dictionary of Jewish Religion*, Oxford, 1997

Young, James E., *At Memory's Edge: After-Images of the Holocaust in Contemporary Art and Architecture*, New Haven and London, 2000

Young, James E., *The Texture of Memory: Holocaust Memorials and Meaning*, New Haven and London, 1993

Young, James E., ed., *The Art of Memory: Holocaust Memorials in History*, Exhibition Catalogue, The Jewish Museum New York, Munich and New York, 1994

1 The Image of Judaism

Dura-Europos Synagogue

Guttman, Joseph, *The Dura Europos Synagogue: A Re-evaluation, 1932–1992*, Atlanta, 1992

Weitzmann, Kurt, and Herbert L. Kessler, *The Frescoes of the Dura Synagogue and Christian Art*, Washington, DC, 1990

Beth-Alpha Synagogue

Levine, Lee I., *The Ancient Synagogue: the First Thousand Years*, New Haven, 2005

The Jewish Quarter of Prague

Altshuler, David, *The Precious Legacy: Judaic Treasures for the Czechoslovak State Collections*, New York, 1983

Berger, Natalia, *Where Cultures Meet: The Story of the Jews of Czechoslovakia*, Exhibition Catalogue, Beth Hatefutsoth, Tel Aviv, 1990

Pařík, Arno, *Prague Synagogues*, Prague, 2002

Synagogue "Santa Maria la Blanca", Toledo

Mann, Vivian B., et al., eds., *Convivencia: Jews Muslims and Christians in Medieval Spain*, Exhibition Catalogue, The Jewish Museum New York, New York, 1992

Ambrosian Bible

Ginzberg, Louis, *The Legends of the Jews*, Volume 1: 26–30, Philadelphia, 1967–69

Ginzberg, Louis, *The Legends of the Jews*, Volume 5: 41–49, Philadelphia, 1967–69

Gutmann, Joseph, "Leviathan, Behemoth and Ziz: Jewish Messianic Symbols in Art," in *Sacred Images: Studies in Jewish Art from Antiquity to the Middle Ages*, by idem, Northampton, 1989

Sarajevo Haggadah

Werber, Eugen, *The Sarajevo Haggadah*, Belgrade-Sarajevo, 1983

17th Century Synagogues in Amsterdam

Kaplan, Yosef, "For Whom did Emanuel de Witte Paint his Three Pictures of the Sephardic Synagogue in Amsterdam?", in *An Alternative Path to Modernity: The Sephardi Diaspora in Western Europe*, by idem, pp. 29–50, Leiden, 2000

Hanukkah Lamp

Berman, Nancy M., *The Art of Hanukkah*, Southport, 1996

Cohen, J.-M., J. Kröger and E. Schrijver, eds., *Gifts of the Heart: Ceremonial Objects from the Jewish Museum Amsterdam*, Zwolle, 2004

2 Jewish Emancipation and Jewish Art in Europe (in alphabetic order)

Jankel Adler

Jankel Adler, 1895–1949, Cologne, 1985

Marc Chagall

Goodman, Susan T., ed., *Marc Chagall: Early Works from Russian Collections*, Exhibition Catalogue, The Jewish Museum New York, New York, 2001

Harshav, Benjamin, *Marc Chagall and the Jewish Theater*, Exhibition Catalogue, Guggenheim Museum, New York, New York, 1992

Eugene Delacroix

Grossman, Cissy, "The Real Meaning of Eugène Delacroix's *Noce Juive au Maroc*," *Journal of Jewish Art* 14 (1988): pp. 64–73

Mann, Vivian B., ed., *Morocco: Jews and Art in a Muslim Land*, Exhibition Catalogue, The Jewish Museum New York, New York, 2000

Maurycy Gottlieb

Guralnik, Nehama, *In the Flower of Youth: Maurycy Gottlieb, 1856–1879*, Exhibition Catalogue, Tel Aviv Museum of Art, Tel Aviv, 1991

Solomon Alexander Hart

Kleeblatt, Norman I., *In Masterworks of The Jewish Museum*, by Maurice Berger and Joan Rosenbaum, pp. 126–127, New Haven and London, 2004

Tumarkin Goodman, Susan, ed., *The Emergence of Jewish Artists in Nineteenth Century Europe*, London, 2001, especially pp. 17–18, 59, and 173

Jozef Israëls

Dekkers, Dieuwertje, et al., eds., *Jozef Israëls, 1824–1911*, Exhibition Catalogue, Groninger Museum and Jewish Historical Museum Amsterdam, Zwolle, 1999

Eduard Knoblauch

Herselle Krinsky, Carol, *Synagogues of Europe: Architecture, History, Meaning*, New York, Cambridge, MA and London, 1985, especially pp. 265–270

Max Liebermann

Gilbert, Barbara, ed., *Max Liebermann: From Realism to Impressionism*, Exhibition Catalogue, Skirball Cultural Center, Los Angeles, 2005, especially articles by Chana Schütz and Hermann Simon

Frida Kahlo

Ankori, Gannit, "The Hidden Frida: Covert Jewish Elements in the Art of Frida Kahlo," *Jewish Art* 19/20 (1993/1994): pp. 225–247

El Lissitzky

Apter-Gabriel, Ruth, "El Lissitzky's Jewish Works,"
in *Tradition and Revolution: The Jewish Renaissance
In Russian Avant-Garde Art, 1912–1928*, by idem,
pp. 101–24 and 233–234, Exhibition Catalogue,
The Israel Museum, Jerusalem, 1987

Band, Arnold J., ed., *Had Gadya The Only Kid:
Facsimile of El Lissitzky's Edition of 1919*, introduction by Nancy Perloff, Los Angeles, 2004

Kleeblatt, Norman, *Masterworks of the Jewish
Museum*, ed. Maurice Berger and Joan Rosenbaum, pp. 180–181, New Haven and London,
2004

Maurycy Minkowski

Tumarkin Goodman, Susan, ed., *The Emergence
of Jewish Artists in Nineteenth Century Europe*,
London, 2001

Amedeo Modigliani

Klein, Mason, ed., *Modigliani: Beyond the Myth*.
Exhibition Catalogue, The Jewish Museum
New York, New York, 2004

Wayne, Kenneth, *Modigliani and the Artists of
Montparnasse*, New York, 2003

Moritz Daniel Oppenheim

Heuberger, Georg, and Anton Merk, eds., *Moritz
Daniel Oppenheim: Jewish Identity in Nineteenth
Century Art*, Exhibition Catalogue, Jewish
Museum Frankfurt am Main, Frankfurt am Main,
1999, especially the articles by Andreas Gotzmann, Norman Kleeblatt, and Shalom Sabar

Schorsch, Ismar, "Art as Social History: Moritz
Daniel Oppenheim and the German Vision of
Emancipation," in *From Text to Context: The
Turn to History in Modern Judaism*, by idem,
pp. 93–117, Hanover and London, 1994

Camille Pissarro

Pissarro, Joachim, and Claire Durand-Ruel
Snollaerts, *Pissarro: Critical Catalogue of
Paintings*, 3 vols., Milan, 2005

Man Ray

Baldwin, Neil, *Man Ray: American Artist*,
Cambridge MA, 2001

Heyd, Milly, "Man Ray/Emmanuel Radnitsky:
Who is Behind The Enigma of Isidore
Ducasse?", in *Complex Identities: Jewish Consciousness and Modern Art*, ed. Matthew Baigell and
Milly Heyd, pp. 115–141, New Brunswick and
London, 2001

Reuben Rubin

Heyd, Milly, "The Uses of Primitivism: Reuben
Rubin in Palestine," in *Art and its Uses: The Visual
Image and Modern Jewish Society*. Studies in
Contemporary Jewry 6, ed. Ezra Mendelsohn,
pp. 43–70, New York, 1990

Manor, Dalia, "The Dancing Jew and Other Characters: Art in the Jewish Settlement in Palestine
During the 1920s," *Journal of Modern Jewish
Studies* Vol. 1, No. 1, (2002): pp. 73–89

Issachar Ryback

Apter-Gabriel, Ruth, ed., *Tradition and Revolution:
The Jewish Renaissance In Russian Avant-Garde
Art, 1912–1928*, Exhibition Catalogue, The
Israel Museum, Jerusalem, 1987

Arnold Schoenberg

da Costa Meyer, Esther, and Fred Wasserman,
Schoenberg, Kandinsky and the Blue Rider, Exhibition Catalogue, The Jewish Museum New York,
New York, 2003

Kangas, William, "The Ethics and Aesthetics of
(Self) Representation: Arnold Schoenberg and
Jewish Identity," *Leo Baeck Institute Year Book* 45
(2000): pp. 135–169

Chaim Soutine

Kleeblatt, Norman L., and Kenneth E. Silver,
*An Expressionist in Paris: The Paintings of Chaim
Soutine*, Exhibition Catalogue, The Jewish
Museum New York, Munich and New York,
1998

Lesser Ury

Bilski, Emily, *Berlin Metropolis: Jews and the New
Culture, 1890–1918*, Exhibition Catalogue, The
Jewish Museum New York, Berkeley and New
York, 1999, especially article by Inka Bertz

3 Holocaust and Its Remembrance

Otto Freundlich

Barron, Stephanie, ed., *'Degenerate Art:' The Fate
of the Avant-garde in Nazi Germany*, Exhibition
Catalogue, Los Angeles County Museum, et al.,
New York, 1997

Menashe Kadishman

Schneider, Ulrich, Arturo Schwarz, and Mordechai Omer, *Menashe Kadishman. Shalechet: Heads
and Sacrifices*, Exhibition Catalogue, Suermondt-Ludwig-Museum Aachen, Milan, 1999

Dani Karavan

Scheurmann, Ingrid, and Konrad Scheurmann,
eds., *Dani Karavan: Homage to Walter Benjamin*,
Mainz, 1995

Jacques Lipchitz

Affron, Matthew, "Constructing a New Jewish
Identity: Marc Chagall, Jacques Lipchitz," in
*Exiles and Emigrés: The Flight of European Artists
from Hitler*, ed. Stephanie Barron, pp. 120–125,
Exhibition Catalogue, Los Angeles County
Museum, New York, 1997

Amishai-Maisels, Ziva, "The Artist as Refugee," in
*Art and its Uses: The Visual Image and Modern
Jewish Society*, Studies in Contemporary Jewry 6,
ed. Ezra Mendelsohn, pp. 111–148, New York,
1990

Wilkinson, Alan G., *The Sculpture of Jacques Lipchitz: A Catalogue Raisonné*, Volumes 1 and 2,
London, 1996 and 2000

Felix Nussbaum

Bilski, Emily D., *Art and Exile: Felix Nussbaum,
1904–1944*, Exhibition Catalogue, The Jewish
Museum New York, New York, 1985

Kaster, Karl Georg, *Felix Nussbaum: Art Defamed,
Art in Exile, Art in Resistance*, Bramsche, 1997

Moshe Safdie

Safdie, Moshe, *Yad Vashem: Holocaust Museum*,
Baden, 2006

Charlotte Salomon

Belinfante, Judith, et al., *Charlotte Salomon: Life ? or
Theater ?*, Zwolle and Amsterdam, 1998

Lowenthal Felstiner, Mary, *To Paint her Life: Charlotte Salomon in the Nazi Era*, New York, 1994

Steinberg, Michael P., and Monica Bohm-Duchen,
eds., *Reading Charlotte Salomon*, Ithaca, 2006

Micha Ullman

Meschede, Friedrich, *Micha Ullman: Bibliothek*,
Amsterdam and Dresden, 1999

Micha Ullman, Exhibition Catalogue, Museum
Wiesbaden, Wiesbaden, 2003

Ossip Zadkine

Lecombre, Sylvain, *Ossip Zadkine: L'oeuvre sculpté*,
Paris, 1994

4 Jewish Art in the Modern World

Mordecai Ardon

Schwarz, Arturo, *Mordecai Ardon: The Colors of
Time*, Exhibition Catalogue, The Israel Museum,
Jerusalem and Tel Aviv, 2003

Vishny, Michele, *Mordecai Ardon*, New York, 1973

Christian Boltanski

Gumpert, Lynn, *Christian Boltanski*, Paris, 1994

Landau, Suzanne, *Christian Boltanski: Lessons of
Darkness*, Exhibition Catalogue, The Israel
Museum, Jerusalem, 1989

Van Alphen, Ernst, "Deadly Historians: Boltanski's
Intervention in Holocaust Historiography,"
in *Visual Culture and the Holocaust*, ed. Barbie
Zelizer, pp. 45–73, New Brunswick, 2001

Jonathan Borofsky

Jonathan Borofsky, Exhibition Catalogue,
The Israel Museum, Jerusalem, 1984

Grisha Bruskin

Grisha Bruskin: Life is Everywhere, Exhibition
Catalogue, Pushkin Museum, Moscow, 2001

Grisha Bruskin: Modern Archeology, Exhibition
Catalogue, Marlborough Gallery, New York,
2004

Jim Dine

Livingstone, Marco, *Jim Dine: The Alchemy of
Images*, New York, 1998

Scholem, Gershom, "The Star of David: History
of a Symbol," in *The Messianic Idea in Judaism*, by
idem, New York, 1971

Moshe Gershuni

Moshe Gershuni, 1980–1986, Exhibition Catalogue, The Israel Museum, Jerusalem, 1986
Moshe Gershuni, 1980–1990, Exhibition Catalogue, Tel Aviv Museum of Art, Tel Aviv, 1990

Nan Goldin

Goldin, Nan, *The Devil's Playground*, London, 2003

Zvi Hecker

Omer, Mordechai, *Zvi Hecker: Sunflower*, Exhibition Catalogue, Tel Aviv Museum of Art, Tel Aviv, 1996

Eva Hesse

Eva Hesse, Exhibition Catalogue, Museum Wiesbaden and San Francisco Museum of Modern Art, New Haven and London, 2002
Eva Hesse: Transformationen — Die Zeit in Deutschland, 1964/65 / Transformations — The Sojourn in Germany, 1964/65, Exhibition Catalogue, Kunsthalle Wien, Cologne, 2004

Louis Kahn

Brownlee, David B., and David G. De Long, *Louis I. Kahn: In the Realm of Architecture*, New York, 1997, especially pp. 130–135
Larson, Kent, *Louis I. Kahn: Unbuilt Masterworks*, New York, 2000, especially pp. 124–198
McCarter, *Robert, Louis I. Kahn*, New York, 2005, especially pp. 412–413

Ilya Kabakov

Groys, Boris, David A. Ross, and Iwona Blazwick, *Ilya Kabakov*, London, 1998
Kabakov, Ilya and Emilia, *An Alternative History of Art: Rosenthal, Kabakov, Spivak*, Exhibition Catalogue, Museum of Contemporary Art Cleveland, Bielefeld, 2004

Anish Kapoor

Celant, Germano, *Anish Kapoor*, Milan, 1998
Lewison, Jeremy, *Anish Kapoor: Drawings, 1997–2003*, London and Cologne, 2005

William Kentridge

Cameron, Dan, Carolyn Christov-Bakargiev, and J.M. Coetzee, *William Kentridge*, London and New York, 2003
Benezra, Neal, Staci Boris, and Dan Cameron, *William Kentridge*, Exhibition Catalogue, Museum of Contemporary Art Chicago and New Museum of Art New York, New York, 2001

R. B. Kitaj

Barsky, Viviane, "'Home is where the heart is': Jewish Themes in the Art of R.B. Kitaj," in *Art and its Uses: The Visual Image and Modern Jewish Society*, Studies in Contemporary Jewry 6, ed. Ezra Mendelsohn, pp. 149–185, New York, 1990
Bilski, Emily D., *Golem! Danger, Deliverance, and Art*, Exhibition Catalogue, The Jewish Museum New York, New York, 1988

Gilman, Sander L., "R.B. Kitaj's 'Good Bad' Diasporism," in *Complex Identities: Jewish Consciousness and Modern Art*, ed. Matthew Baigell and Milly Heyd, pp. 223–238, New Brunswick and London, 2001
Livingstone, Marco, *Kitaj*, London, 1999
Livingstone, Marco, ed., *R.B. Kitaj: An American in Europe*, Exhibition Catalogue, Oslo, Madrid, Vienna, and Hannover, Oslo, 1998
Morphet, Richard, *R.B. Kitaj: A Retrospective*, Exhibition Catalogue, Tate Gallery, London, 1994

Lee Krasner

Hobbs, Robert, *Lee Krasner*, New York and London, 1993
Landau, Ellen G., and Jeffrey D. Grove, *Lee Krasner: A Catalogue Raisonné*, New York, 1995

Sol LeWitt

Garrels, Gary, ed., *Sol LeWitt: A Retrospective*, Exhibition Catalogue, San Francisco Museum of Modern Art, New Haven and London, 2000
Sachs, Angeli, *New types of memory. Two memorials by Jenny Holzer and Sol LeWitt in the Federal Republic of Germany*, Lecture, Thirtieth International Congress of the History of Art, London, 2000, unpublished

Daniel Libeskind

Dorner, Elke, *Daniel Libeskind: Jüdisches Museum Berlin*, Berlin, 1999
Feireiss, Kristin, ed., *Daniel Libeskind: Erweiterung des Berlin Museums mit Abteilung Jüdisches Museum / Extension to the Berlin Museum with Jewish Museum Department*, Berlin, 1992
Libeskind, Daniel, *Daniel Libeskind: The Space of Encounter*, London, 2001
Libeskind, Daniel and Bernhard Schneider, *Jewish Museum Berlin: Between the Lines*, Munich and New York, 1999

Morris Louis

Goldfarb Berkowitz, Mira, "Sacred Symbols in Morris Louis: The Charred Journal Series, 1951," in *Complex Identities: Jewish Consciousness and Modern Art*, ed. Matthew Baigell and Milly Heyd, pp. 193–205, New Brunswick and London, 2001
Upright, Diane, *Morris Louis: The Complete Paintings*, New York, 1985

Erich Mendelsohn

Zevi, Bruno, *Erich Mendelsohn: The Complete Works*, Basel, Boston and Berlin, 1999

Michal Na'aman

Schwarz, Arturo, *Love at First Sight: the Vera, Silvia and Arturo Schwarz Collection of Israeli Art*, Jerusalem, 2001

Barnett Newman

Dan, Joseph, *The Teachings of Hasidism*, New York, 1983
Temkin, Ann, *Barnett Newman*, Exhibition Catalogue, Philadelphia Museum of Art, Philadelphia, 2002
Zweite, Armin, *Barnett Newman: Paintings, Sculpture, Works on Paper*, Ostfildern-Ruit, 1999

Louise Nevelson

Celant, G., ed., *Nevelson*, Exhibition Catalogue, Palazzo delle Esposizioni, Rome and Milan, 1994
Louise Nevelson: Sculptures of the '50s and '60s, Exhibition Catalogue, New York, 2002

Larry Rivers

Hunter, Sam, *Larry Rivers*, New York, 1989
Kleeblatt, Norman, with Anita Friedman, *Larry Rivers' History of Matzah: the Story of the Jews*, Exhibition Catalogue, The Jewish Museum New York, New York, 1984

Mark Rothko

Nodelman, Sheldon, *The Rothko Chapel: Origin, Structure, Meaning*, Austin, 1997

Michal Rovner

Michal Rovner: Fields, Göttingen, 2006

Zelig Segal

Fishof, Iris, and Yigal Zalmona, *In a Single Statement: Works by Zelig Segal*, Exhibition Catalogue, The Israel Museum, Jerusalem, 1992

Richard Serra

Dornseifer, Gerhard, and Angelika Schallenberg, eds., *Art Projects Synagoge Stommeln Kunstprojekte*, Ostfildern-Ruit, 2000
Senie, Harriet F., "Perpetual Tension: Considering Richard Serra's Jewish Identity," in *Complex Identities: Jewish Consciousness and Modern Art*, ed. Matthew Baigell and Milly Heyd, pp. 206–222, New Brunswick and London, 2001
Senie, Harriet F., *The Tilted Arc Controversy: Dangerous Precedent?*, Minneapolis, 2002

Ben Shahn

Asmishai-Maisels, Ziva, "Ben Shahn and the Problem of Jewish Identity," *Jewish Art* 12/13 (1986/1987): pp. 304–319

Nancy Spero

Bird, Jon, Jo Anna Isaak, and Sylvere Lotringer, *Nancy Spero*, London, 1996
Luckow, Dirk, and Ingeborg Kähler, eds., *Nancy Spero: A Continuous Present*, Düsseldorf, 2002

Lawrence Weiner

Alberro, Alexander, *Lawrence Weiner*, New York and London, 1998
Waale, Renee, *Lawrence Weiner*, Exhibition Catalogue, Jewish Historical Museum, Amsterdam, 1990

Illustration credits

All reasonable efforts have been made to obtain copyright permission for the images in this book. If we have committed an oversight, we will be pleased to rectify it in a subsequent edition.

Numbers refer to pages.

t = top, b = bottom

Jacobo and Asea Furman Collection of Judaica, Santiago, Chile 6
Joods Historisch Museum, Amsterdam 13, 15/16
Private collection, courtesy Joods Historisch Museum, Amsterdam 17
Joods Historisch Museum, Amsterdam 18, 20 b
Shimon Attie, New York 19
Robert Capa © 2001 by Cornell Cap / Magnum Photos / Agentur Focus 21
Pinkas Synagogue, Prague 22
Jürgen Hohmuth, Berlin 23
Stefan Müller, Berlin 24 t
Joods Historisch Museum, Amsterdam, Photo: Lisedon Kamping 25
University Library, Leiden 34
University Library Amsterdam, Bibliotheca Rosenthaliana 35, 50
Art Resource, NY, Synagogue, Dura Europos, Syria 36
akg-images / Erich Lessing 37
Courtesy Israel Antiquities Authority 39
Jewish Museum, Prague 40–43
British Library, London 44
akg-images / Bildarchiv Monheim 45
Biblioteca Ambrosiana, Milan 4, 32/33, 46
Sarajevo National Museum 14, 49
Rijksmuseum, Amsterdam 51
NIHS, Joods Historisch Museum, Amsterdam 53
The Jewish Museum New York, gift of Mr. and Mrs. Richard D. Levy / Art Resource Scala Florence 57
Louvre, Paris / artothek, Weilheim 58/59
The Jewish Museum New York, USA / Art Resource Scala Florence 60/61
Stadtmuseum, Berlin 62
Collection of Plans and Drawings, Technical University, Berlin 63 t
Landesarchiv Berlin 63 b
Tel Aviv Museum of Art, Israel 64
Städtisches Museum, Gelsenkirchen 66/67
Stedelijk Museum, Amsterdam 68
Los Angeles County Museum of Art Lauros / Giraudon / Bridgeman Art Library 70/71
Galerie Schmit, Paris 73
Musée d'art et d'histoire du Judaisme, Photo: Christophe Fouin 72
Arnold Schoenberg Center, Vienna 74
The Jewish Museum, New York, gift of Lester S. Klein / Art Resource Scala Florence, Photo: John Parnell 76/77
Tel Aviv Museum of Art, Israel 4, 54/55, 78
The Jewish Museum, New York, gift of Leonard and Phyllis Greenberg / Art Resource Scala Florence, Photo: John Parnell 81
Waddington Galleries, London 80

The State Tretyakow Gallery, Moscow 82–85
Museum Boijmans van Beuningen, Rotterdam 86
Man Ray Trust Paris, ADAGP, Telimage 87
Rubin Museum Collection, Tel Aviv 88/89
Stedelijk Museum, Amsterdam 91
Jewish Museum Berlin, purchased through the Stiftung Deutsche Klassenlotterie, Berlin, Photo: Jens Ziehe, Berlin 92
The Museum of Modern Art, New York, gift of Allan Roos, M.D. and Matheu Roos / akg-images 95
The Museum of Modern Art, New York, USA, gift of Sam Salz 96, 97
Estate of Jacques Lipchitz, courtesy Marlborough Gallery, New York 101
Jewish Museum Berlin Photo: Jens Ziehe, Berlin 102
Micha Ullman, Stuttgart 104 t/105
SV-Bilderdienst: Scherl 104 b
Charlotte Salomon Foundation, Joods Historisch Museum, Amsterdam 106/107
Frank Mihm, Kassel 108/109
Berlinische Galerie. Landesmuseum für Moderne Kunst, Fotografie und Architektur 110/111
akg-images / Bildarchiv Monheim 113
ullstein bild, Berlin 112
Menashe Kadishman Photo: Marion Roßner, Berlin 4, 98/99, 114/115
Yad Vashem, the Holocaust Martyrs' and Heroes', Remembrance Authority, Jerusalem 116
Courtesy of Moshe Safdie and Associates. Inc. Photo: Timothy Hursley 117–119
Smith College Museum of Art, Northampton 123
Kunstsammlung Nordrhein-Westfalen, Düsseldorf Photo: Achim Kukulies, Düsseldorf 124
Daros Collection, Switzerland Photo: Dominique Uldry, Bern 125
Philadelphia Museum of Art, gift of the Aaron E. Norman Fund, Inc. 127
Louisiana Museum of Modern Art, Humlebaek 128/129
Bildarchiv Preußischer Kulturbesitz, Berlin, 2005 130/131
Collection of the Mishkan LeOmanut, Museum of Art, Ein Harod, Israel, Photo: Avraham Hai 132/133
Ecumenical Chapel, Houston Photo: Hickey and Robertson 136/137
The Estate of Eva Hesse. Hauser & Wirth Zürich London 140/141
Zvi Hecker, Berlin, Amsterdam 142/143
Private Collection, courtesy Marlborough Fine Art London 145
Private Collection, Photo: courtesy of Pace Wildenstein, New York 146/147
Tel Aviv Museum of Art, Israel 5, 120/121, 148/149
Courtesy of the Paula Cooper Gallery, New York 151
Private Collection, New York 152/153
Westfälisches Landesmuseum für Kunst und Kulturgeschichte, Münster Photo: Rudolf Wakonigg 154
Kulturbehörde der Freien und Hansestadt Hamburg 155 b
Courtesy Stephen Lloyd, AIA, Photo: Robert Benson 155 t
Rheinisches Bildarchiv, Stadt Köln 157 t

Kunsthalle Emden, Stiftung Eske und Henri Nannen und Schenkung Otto van de Loo 157 b
The Israel Museum, Jerusalem / Nachum Slapak 159
The Israel Museum, Jerusalem 161
Centre National d'Art Contemporain, Grenoble 162
Joods Historisch Museum, Amsterdam 164/165
Werner J. Hannappel, Essen 166/167
Tel Aviv Museum of Art, Israel 169
Lothar Sprenger, Dresden 170/171
courtesy Studio Daniel Libeskind, New York, Berlin, Photo: Stefan Müller, Berlin 172–175
Nan Goldin Studio, New York 176/177
Richter Verlag GmbH, Düsseldorf 178–181
Michal Rovner Studio, New York 183
Courtesy Marian Goodman Gallery, New York, Paris 184

© for drawings and plans are held by the respective architects

Front cover: Frida Kahlo, *My Grandparents, My Parents, and I (Family Tree)*, 1936. The Museum of Modern Art, New York, USA / akg-images
Frontispiece: Brother Haggadah, Catalonia, ca. 1350–1375. British Library London (Ms Or 1404, fol. 18r).
page 186: Courtesy of Moshe Safdie and Associates Inc. Photo: Timothy Hursley

The Library of Congress Cataloguing-in-Publication data is available.
British Library Cataloguing-in-Publication Data: a catalogue record for this book is available from the British Library. The Deutsche Bibliothek
holds a record of this publication in the Deutsche Nationalbibliografie; detailed bibliographical data can be found under: http://dnb.ddb.de

Prestel Verlag, Königinstrasse 9, 80539 Munich
Tel. +49 (89) 38 17 09-0, Fax +49 (89) 38 17 09-35

Prestel Publishing Ltd., 4, Bloomsbury Place, London WC1A 2QA
Tel. +44 (0)20 7323-5004, Fax +44 (0)20 7636-8004

Prestel Publishing, 900 Broadway. Suite 603, New York, N.Y. 10003
Tel. +1 (212) 995-2720, Fax +1 (212) 995-2733

www.prestel.com

Editorial direction: Angeli Sachs
Copyediting: Jonathan Fox
Editorial assistance: Sophie Kowall

Design and layout: Rainald Schwarz / zwischenschritt

Origination by Fotolito Longo, Bolzano, Italy
Printing: Aumüller, Regensburg
Binding: Conzella, Aschheim b. München

Printed in Germany on acid-free paper

ISBN 3-7913-3362-3
ISBN 978-3-7913-3362-5